digital
PHOTOGRAPHER'S
HANDBOOK

digital
PHOTOGRAPHER'S
HANDBOOK

TOMANG

LONDON, NEW YORK, MUNICH, MELBOURNE, DELHI

For Wendy

Senior Editor Nicky Munro
Designer Joanne Clark
Jacket Designer Mark Cavanagh
Production Editor Ben Marcus
Production Controller Mandy Inness

Managing Editor Stephanie Farrow
Senior Managing Art Editor Lee Griffiths

First published in Great Britain in 2012
by Dorling Kindersley Limited
80 Strand, London WC2R 0RL

Penguin Group (UK)
2 4 6 8 10 9 7 5 3 1
001 – 183053 – July/2012

A CIP catalogue record for this book is
available from the British Library.

ISBN 978-1-4053-9319-5

Printed and bound by
Hung Hing, China

Discover more at
www.dk.com

CONTENTS

1 CORE SKILLS

2 PHOTOGRAPHY PROJECTS

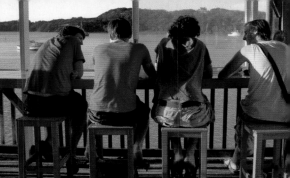

3 IMAGE DEVELOPMENT

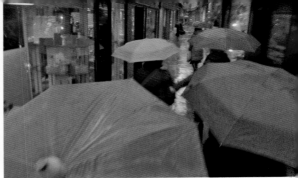

INTRODUCTION

This is the fifth edition of the Digital Photographer's Handbook. That it is still in print testifies to the fact that few of the fundamentals of image-making have changed since digital techniques came to dominate photography. That the book has received so many revisions shows not only the obvious need to keep up with changes in technology, but also that we need to keep abreast of the steady rise of photographers' skills.

Indeed, the most exciting recent development in photography is the steady improvement in photographic abilities. This is evident in the large numbers of stunningly inventive entries – from every corner of the planet – to photographic competitions; in the high quality of coverage of spot-news events by passers-by; and it is clear even from the casual photography seen on social network and picture-sharing sites. Without a doubt, the average standard of photography is far higher than ever. This is not only due to easy access to amazingly high-quality equipment at affordable prices. It is evident that skills and understanding of photography have genuinely grown, and continue to blossom.

We have responded to these developments with a complete overhaul of the Digital Photographer's Handbook. A thorough revision takes in developments such as RAW capture, tone-mapping techniques, and diversified approaches to image manipulation and management. We also cover new categories of equipment and software, and touch on the many changes in photographic practice.

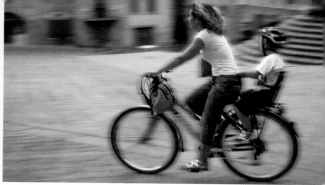

With this fifth edition, we find ourselves enjoying photography approaching its fecund prime. Major technologies are mature and deeply understood, so it's now time to enjoy the fruits of the previous years of trial, error, computer crashes, and corrupted files. We are all now familiar with the amazing potency of the internet, and its ability to make a so-called "still" image more mobile than a rocket, sending a picture to a million places around the planet in seconds. In short, the camera in your hand is unquestionably the most elaborate and potent visual tool ever invented. You can enjoy enormous fun with it. You can have your life hugely enriched by its creative returns. And you can make a difference to the world. That is photography's gift to you, and its power.

I hope this books helps you make the most of your photography's potential.

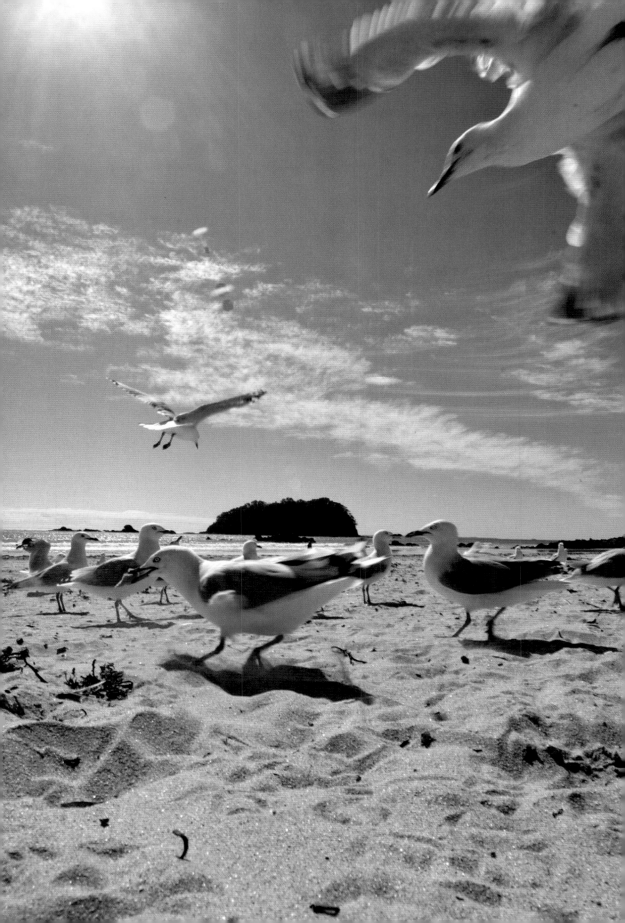

1 CORE SKILLS

HANDLING CAMERAS

The key requirement for handling cameras is to hold steadily during exposure. In addition, your grip on the camera should enable you to reach all the important and constantly used controls easily: this means it needs to be firm enough to hold the camera safely, but not so tight as to inhibit use – exactly the same principle as holding a tennis racket or a golf club.

Steady and steadfast

Whatever kind of camera you have, there are some simple pointers to ensure a stable position for sharp pictures. Many cameras are equipped with image stabilization, nonetheless, the more steadily you hold a camera, the sharper will your image be.
- Try holding the camera in different positions to find which is most comfortable for you; you do not have to hold it the same way as everyone else.
- Lean or prop yourself on any stable support that is available – a table, railing, wall, boulder, tree.
- Support your camera at three points, that is, in both hands and resting against your forehead, if possible. Avoid holding the camera in only one hand.

▲ **Using a camera phone**
Hold securely and steadily in both hands, using the wrist-strap, if available. Where possible, make exposures using button, rather than touch-screen, controls.

- Keep your elbows touching your body for the most stable hold.
- Support large lenses such as zooms for SLRs with an underarm grip: palm upwards and placed under the lens. This not only stops the lens from "drooping" downwards, but also eases strain on your wrist.

▲ **Unsupported imbalance**
Avoid this scenario: a shoulder-slung bag tending to twist the body; failure to support the weight of the camera in the left hand from underneath; and camera-strap not in use in a location where dropping the camera is almost certain to be disastrous.

▲ **Using a tripod**
Work close to the tripod for steadiness and hold it down to make the set-up more rigid and resistant to vibration. Extend the central column only if you need to obtain the full height of the tripod. Do not hang the neck-strap around your neck in case you absent-mindedly walk away.

Camera ergonomics

Larger cameras, such as super zoom compacts (*see p. 337*) and SLRs, are all designed to be highly ergonomic: fitting the hand well, with controls positioned for ease of use. Smaller point-and-shoot cameras tend to be designed with the compact dimensions as a priority, with ease of use a secondary consideration – this can be a drawback for those with larger hands who may find it tricky to use small buttons and touch-screen areas. Virtually all cameras are designed for right-handed people.

- Heavy SLR cameras are easier to hold if you use a wrist strap for the right hand.
- A large interchangeable tripod plate fixed under the camera can help give a steady hold.
- A shoulder mount or similar rig is useful for very heavy equipment, or when you wish to shoot video with your SLR.

Camera controls

Using your camera without taking pictures is rather like practising tennis or golf swings without hitting a ball. It familiarizes you with the feel of core actions such as selecting shutter or aperture settings, and zoom techniques. Such mastery of your camera controls allows you to keep your eye on the action, rather than the camera, the better to concentrate on your photography. A secure grip is part of the picture: always use the wrist-strap with compact cameras, or the neck-strap for larger models, so you need never fear dropping precious equipment.

(*see p. 337*)

TRY THIS

Rehearse taking pictures with your camera so that it becomes second nature. Learn how to adjust all the controls without looking at them – for example, there may two clicks to the left between the two modes you use most often. Do you know – without looking – which way to turn the focusing ring to focus more closely? Or how to zoom in? Learn how to lock focus and hold the exposure entirely by feel. Hold the camera in a variety of positions to find the one that is most comfortable and stable. Only when you really know your way around your camera with your eyes closed can you concentrate fully on whatever it is you are photographing.

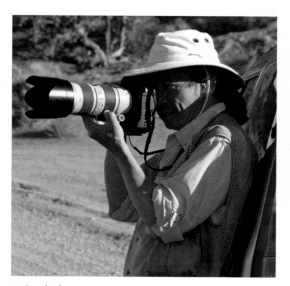

▲ **Body lean**
Whenever you use long focal settings on a zoom or a long lens, take advantage of any support that is available – a tree, lamp post, or car – that will help to steady the camera while you aim and shoot. Be aware that passing traffic can shake a car for a second or two.

▲ **Portrait format hold**
Almost all cameras are easier to hold for landscape format shots than portrait: practise to establish a hold that is comfortable for you. Support the camera from below, keep your elbows tucked in to stablize the hold, and ensure that you can release the shutter and make control settings easily.

YOUR FIRST PICTURES

Photography first became truly popular when photographers no longer had to be personally responsible for processing their pictures. In the digital era, you can simply press the button and your camera or computer does all the rest. Indeed, with many cameras you can start snapping away the moment you take it out of the box. There is no need to hold back, and certainly no immediate call for the instruction book.

First date

After the initial fun, however, it is worth making a few conscious decisions. It is a good idea to set at least the date and time before you begin any serious photography. If you are going abroad on holiday, remember to change to local time – and if you are travelling with friends or family it helps if you synchronize your cameras' clocks, as this makes it easier to sort and sequence images later.

Quality or ease

The default, or "out-of-the-box" settings will be designed to help you use the camera easily and also to give a good impression of its abilities. You may find that, for this early stage of experimentation,

the image files are unnecessarily large. Change the image size to the smallest while you are learning to use the camera.

You can, and should, shoot freely with the camera. Try out all the different modes and scene settings, different sensitivities, and colour settings to see what results they produce. Try the camera indoors, on friends and family, take it out-of-doors, use it in bright light, and in darkened places. While at this stage of learning, it is OK to make a quick review of the images you capture. However, the best way to assess images properly is by using a computer monitor (*see pp. 356–7*).

Regaining control

You can leave all settings on automatic, thereby putting the camera in control. You may be able to teach yourself the basics of composition with this set up, but the finer points of exposure and colour control will be in camera's hands, not yours. In short, you will not be making the most of your camera.

When you have an idea what each mode and setting does to your images, adopt a group of settings – for example aperture priority, high ISO, no flash, black-and-white, high sharpening – and

▶ **Unlikely beauty**
Photography has a unique talent for turning the unattractive into an intriguing image. The unlikeliest subjects, such as rusting doors, peeling paint and, as here in New Zealand, the worn bottom of a boat, can yield patterns of colours and textures that entertain the eye.

use it to make a whole series of images. This is a good way to learn all about your camera.

Chimping is for chumps

Chimping is short for "checking image preview" and seems very appropriate for photographers who exclaim "Oo! Oo! Ah! Aah!" while reviewing their images on the camera's LCD screen. If you allow yourself to be distracted by the preview image, you will miss many shots. It also breaks the rhythm of shooting, and interrupts the concentration you should be applying to the subject.

Try to reserve your reviewing to rest breaks and moments when you are sure nothing is going on. You do not have to go as far as some photographers, who tape up their camera screens to wean themselves off the habit, but turn off the preview and you will find you photograph more, and become more attuned to your subject.

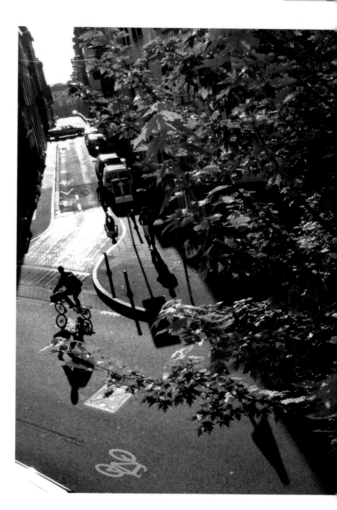

▶ Out of the window
If you have a window, you have source for images: there will be changes in the light, and there may be ever-changing activity in the street. Keep watch and pictures will present themselves.

▲ Even the kitchen sink
With its usual jumble of bright metallic pots and pans, colourful food, and areas of plain surface, a kitchen is a surprisingly rich source of images. Contrast colourful crockery with steel utensils, and place natural forms against machined surfaces. Take time to explore details with the camera set to close-up mode, with the flash turned off. Wait for sunny days to obtain the most light indoors.

▲ Family snaps
Do not hold back from pointing the camera at members of the family. Catch them at relaxed times with any camera – here with a cameraphone at a restaurant – for portraits that capture their character.

PICTURE COMPOSITION

Much advice on picture composition tends to be both prescriptive ("place the subject at the intersection of thirds") and proscriptive ("don't put the subject in the centre"), as if the adherence to a few rules can guarantee satisfactory composition. It may be better to think of any rules simply as a distillation of ideas about the structure of images that artists have, over many generations of experimentation, trial, and success, found useful in making pleasing pictures.

Any photographic composition can be said to work if the arrangement of the subject elements communicates effectively to the image's intended viewers. Often, the most effective way to ensure a striking composition is to look for the key ingredients of a scene and then organize your camera position and exposure controls to draw those elements out from the clutter of visual information that, if left cluttered, will ruin the photograph. Composition is therefore not only about how you frame the picture, but how you use aperture to control depth of field, how you focus to lead the viewer's attention, and how you expose to use light and shade to shape the image.

If you are new to photography, it may help to concentrate your attention on the scene's general structure, rather than thinking too hard about very specific details – these are sometimes of only superficial importance to the overall composition. Try squinting or half-closing your eyes when evaluating a scene; this helps eliminate details to reveal the scene's core structure.

▶ Symmetry

Symmetrical compositions are said to signify solidity, stability, and strength; they are also effective for organizing images containing elaborate detail. Yet another strategy offered by a symmetrical presentation of subject elements is simplicity. In this portrait of a Turkana man, there was no other way to record the scene that would have worked as well. The figure was placed centrally because nothing in the image justified any other placement – likewise with the nearly central horizon. The subject's walking stick provides the essential counterpoint that prevents the image appearing too contrived.

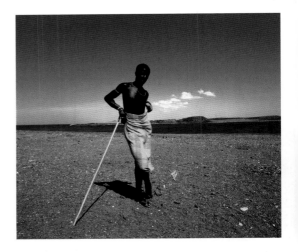

◀ Radial

Radial compositions are those in which key elements spread out from the middle of the frame. This imparts a lively feeling, even if subjects are static. In this family portrait, taken in Mexico, the radial composition is consistent with the tension caused by the presence of a stranger (the photographer). The image suggests a modest wide-angle lens was used, but it was taken with a standard focal length.

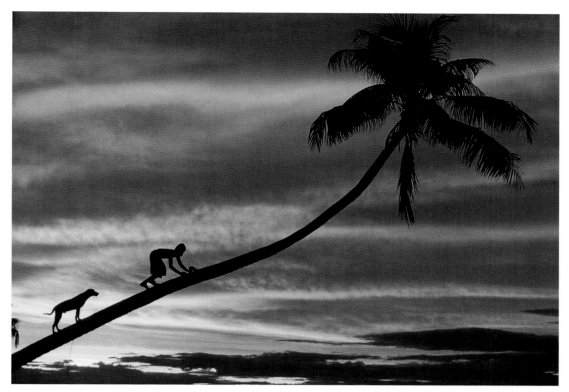

▲ Diagonal

Diagonal lines lead the eye from one part of an image to another and impart far more energy than horizontals. In this example, it is not only the curve of the palm's trunk, but also the movement of the boy and his dog along it that encourage the viewer to scan the entire picture, sweeping naturally from the strongly backlit bottom left-hand corner to the top right of the frame.

◄ Overlapping

When subject elements in a photograph overlap, not only does it indicate increasing depth perspective, it also invites the viewer to observe subject contrasts. In the first instance, distance is indicated simply because one object can overlap another only if it is in front of it. In the second, the overlap forces two or more items, known to be separated by distance, to be perceived together, with the effect of making apparent any contrasts in shape, tone, or colour. These dynamics are exploited in this low table view, aided by areas of bright and contrasting colours that fight for dominance.

► **The golden spiral, or "Rule of Thirds"**
This image, overlaid with a golden spiral – a spiral based on the golden ratio – as well as with a grid dividing the picture area into thirds, shows that, as photographers, we almost instinctively compose to fit these harmonious proportions – the proportions that "look good".

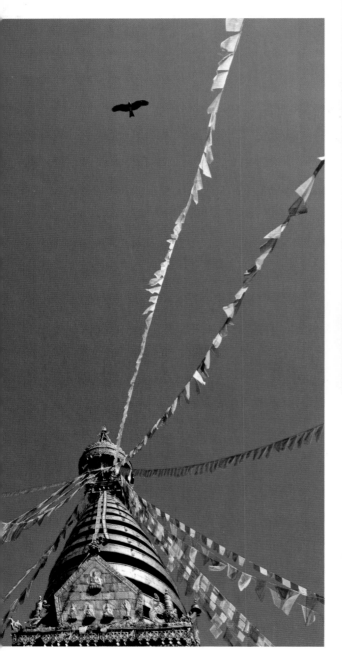

◄ **Tall crop**
The opposite of a letter-box composition (*right*) is a tall and narrow crop, which emphasizes an upward sweeping panorama – a view that can be taken in only by lifting the head and looking up. As with all crops based on a high aspect ratio, it usefully removes a lot of unwanted detail around the edges.

► **Letter-box composition**
A wide and narrow letter-box framing suits some subjects, such as these prayer flags in Bhutan, perfectly. Such a crop concentrates the attention on the sweep of colours and detail, cutting out unwanted – and visually irrelevant – material at the top and bottom of the image.

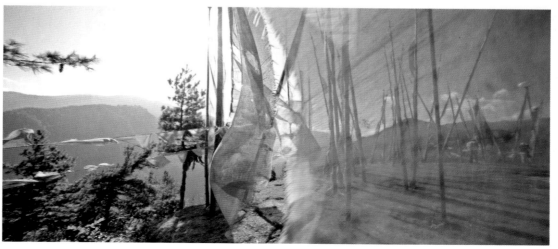

PICTURE COMPOSITION CONTINUED

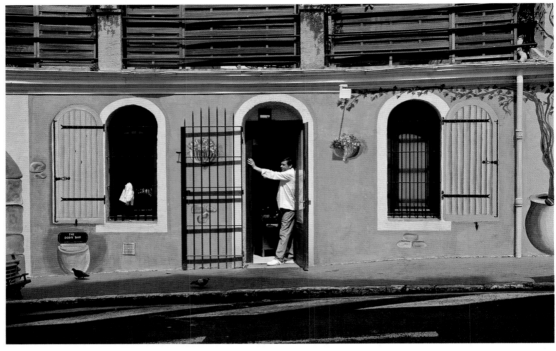

▲ Framing

The frame within a frame is a painterly device often exploited in photography. Not only does it concentrate the viewer's attention on the subject, it often hints at the wider context of the subject's setting. The colours of the frame may also give clues about where the photograph is set. In this image, taken in Cannes, France, multiple frames divide the image up into compartments, which circle around the figure of a bistro chef taking a break from his duties. Without the figure, the image would be too symmetrical and dull; but without the rhythmic framing, the figure would be rather static.

◄ Geometric patterns

Geometrical shapes, such as triangles and rectangles, lend themselves to photographic composition because of the way they interact with the rectangle of the picture frame. Here, in this corner of the Ciudad de las Artes y las Ciencias in Valencia, Spain, shapes from narrow rectangles and acute triangles are all at work. In some parts they work harmoniously (the gaps between the slats); in others (the thin wedges created by diagonally crossing intersections), they create tension in the composition.

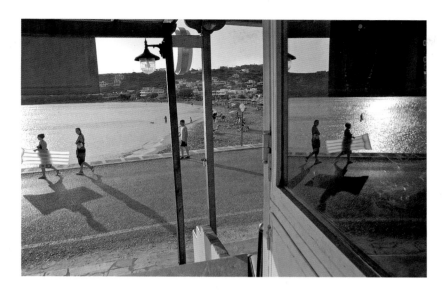

◀ Symmetry

The glass of this window in Batsi, Andros, Greece, acts like a mirror to the beach scene, automatically giving a sense of symmetry to the image, but it is a partial symmetry. The subtle and not-so-subtle differences between the reality and the reflection give energy and tension to the image, as well as providing visual puzzles such as being able to see more of the sun in the reflection, but without the sky.

TRY THIS

Look out for patterns whenever you have a camera to hand. When you find an interesting example, take several shots, shifting your position slightly for each. Examine the pictures carefully and you may find that the shot you thought most promising does not give the best result. Often, this is because our response to a scene is an entire experience, while photographs have to work within the proportions of the format.

▼ Rhythmic elements

These regular columns of a courtyard in Sarzana, Italy, organize the haphazard groups of people, and together they create repeated lines and rectangles to form irregular bands of light and dark. These in turn form the rhythmic framework for the distant mountains that contrast with the diagonals of sunlight finding its way between the clusters of people.

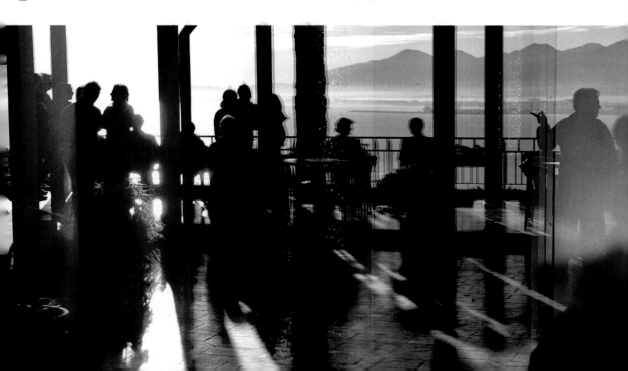

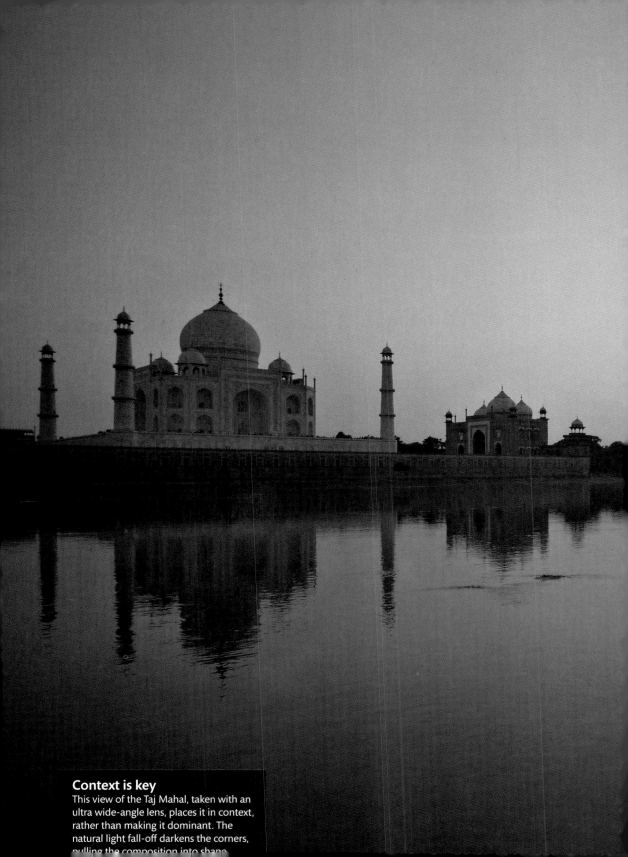

Context is key
This view of the Taj Mahal, taken with an ultra wide-angle lens, places it in context, rather than making it dominant. The natural light fall-off darkens the corners, pulling the composition into shape.

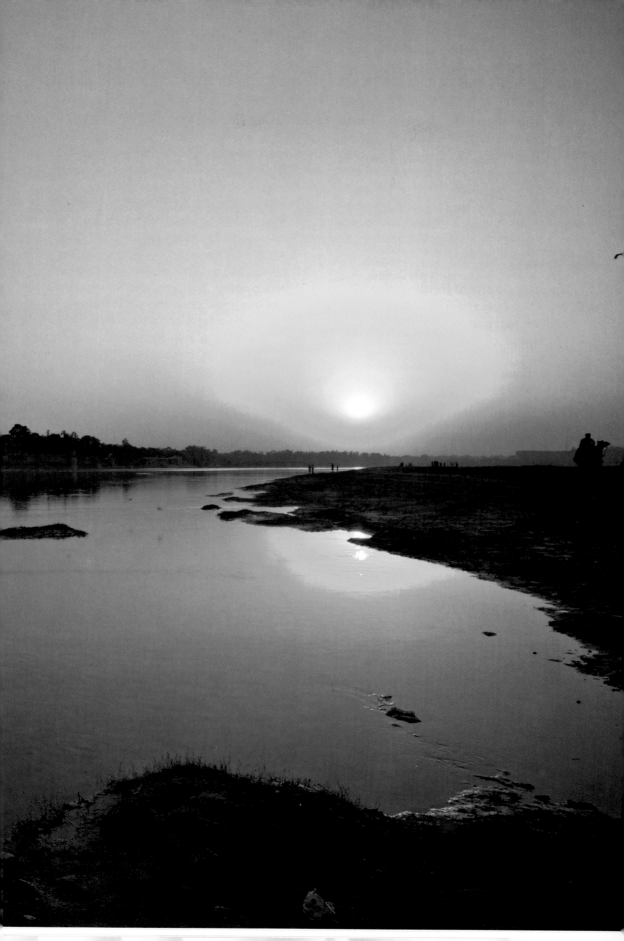

COMPOSITION AND ZOOMS

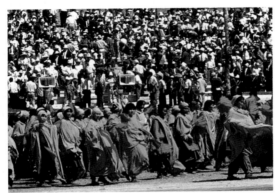

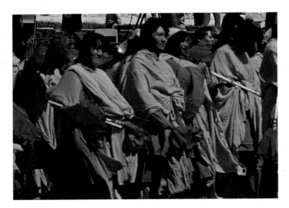

▲ Zooms for framing
Zoom lenses come into their own when you find it difficult or time-consuming to change your camera position, as they allow you to introduce variety into what would otherwise be similarly framed images. In this large outdoor performance, one shot was taken at 80 mm (*top*), one at 135 mm (*middle*), and the other at 200 mm (*above*), all from approximately the same camera position.

Zoom lenses allow you to change the magnification of an image without swapping lenses (*see pp. 343–5*). Zooms are designed to change the field of view of the lens while keeping the image in focus. When the field of view is widened (to take in more of the subject), the image must be reduced in order to fill the sensor or film area. This is the effect of using a short focal length lens or a wide-angle setting on a zoom. Conversely, when the field of view is narrowed (to take in less of the subject), the image must be magnified, again in order to fill the sensor or film area. This is the effect of using a long focal length lens or a zoom's telephoto setting.

Working with zooms
The best way to use a zoom is to set it to the focal length you feel will produce the approximate effect you are aiming for. This method of working encourages you to think about the scene before ever raising the camera to your eye to compose the shot. It also makes you think ahead of the picture-taking process, rather than zooming in and out of a scene searching for any setting that seems to work. This is not only rather aimless, it is also time-consuming and can lead to missed photographic opportunities.

A professional approach
Many professional photographers use zooms almost as if they were fixed focal length, or prime, lenses, leaving them set to a favourite focal length most of the time. They then use the zoom control only to make fine adjustments to the framing. Zooms really are at their best when used like this – cutting out or taking in a little more of a scene. With a prime lens, you have to move the camera backward or forward to achieve the same effect. Depending on the type of subject you are trying to record, you could leave the zoom toward the wide-angle or telephoto end of its range. On some digital cameras, however, zooms are stepped rather than continuously variable, and so cannot be used for making small adjustments.

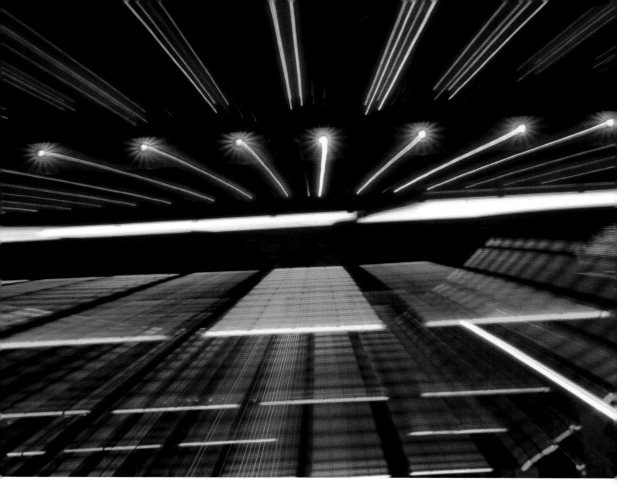

▲ Zoom movement

Lights and colour explode out from this photograph of a shop display – an effect achieved by turning the zoom ring to increase the lens's focal length during a relatively long exposure, causing lights to smear across the sensor. The slow start to the zoom shows up as the brighter end of the light trail. The pulsing of lamps creates the spots of light.

▲ Zooms for composition

Zooming from 80 mm (*above left*) to 200 mm (*above right*) produced an intriguing abstract image by allowing patterns of light and dark, colour and non-colour, to reveal themselves. But as the focal length increases, depth of field also diminishes (*see pp. 24–7*), so select the lens apertures with care.

POINTS TO CONSIDER

- **Distortion:** Most zoom lenses distort the image by making straight lines look curved. This is especially the case at wide-angle settings.
- **Camera shake:** At the very long effective focal lengths some digital cameras offer – such as a 35efl of 350 mm – there is a great danger that camera shake during exposure will reduce image quality. Make sure you hold the camera steady, preferably supported or braced, and use a short shutter time.
- **Lens speed:** As you set longer focal lengths, the widest available aperture becomes smaller. Even in bright conditions, it may then not be possible to set short shutter times with long focal lengths.
- **Lens movement:** Some lenses may take a few seconds to zoom to their maximum or to retract to their minimum settings. Don't be tempted to rush the action by pushing or pulling at the lens.

MOVEMENT BLUR

The generally accepted advice is that you should hold the camera steady when capturing pictures. Any movement during exposure causes the image to move across the sensor. If that movement is visible, it is seen as a blur, which causes the image to look unsharp at best and, at worse, quite unrecognizable. Nonetheless, there is certainly a place for pictures that display a thoughtful or expressive use of subject blur.

Try it and see

The effects are of exposure during movement are unique, and no other recording medium represents the blur of movement in quite the same way as a camera. However, since what you capture in the image will vary with the level of movement of the subject and with distance, its effects are hard to predict. Experiment freely with different settings and evaluate results on a computer monitor, rather than the camera's review panel.

With experimentation and experience, you will find that brighter areas quickly become too bright when overlapped. At the same time, dark areas tend to be reduced by overlapping with lighter areas. The net result is a tendency to overexpose. You can exploit this to create high-key images or set exposure overrides to force tones to be darker, which helps to maintain intense colours (*see pp. 70–1 and 72–3*). The tendency to overexpose also means that results are best in dull light with a limited number of light-sources.

Contrasting blur

The appearance of blur is usually enhanced when it is seen in contrast against sharply defined forms or shapes. By the same token, sharpness appears

▼ Moving camera

The blur produced by taking a photograph from a speeding car streaks and blends the rich evening light in a very evocative and painterly fashion in this example. To the eye at the time of taking, the scene was much darker and less colourful than you can see here. It is always worth taking a chance in photography, as you never know what might come of it.

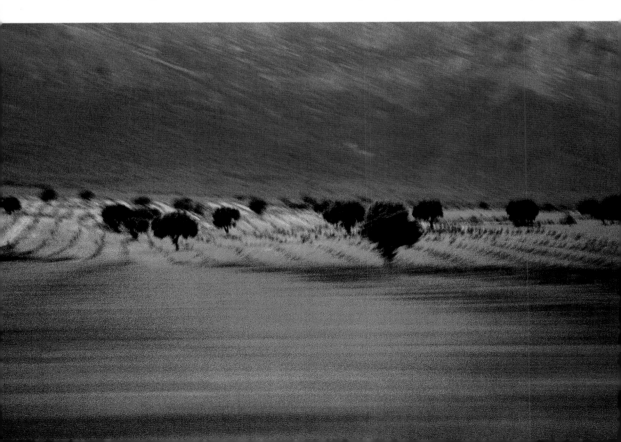

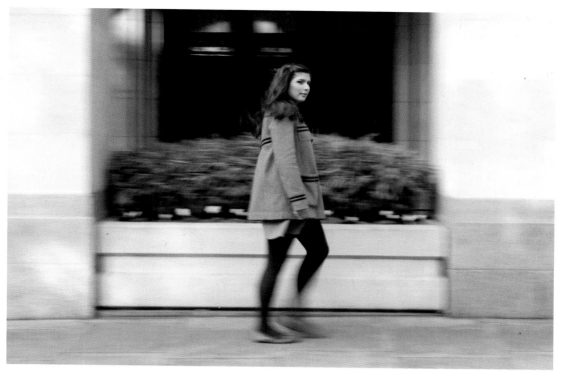

▲ Pan handling

Following the movement of a subject during during exposure – panning – exploits the fact that different speeds of movement produce different levels of blur. Parts of the image that are relatively stationary in the image – such as the girl's face – appear sharper than elements that move more rapidly, such as her legs or the background.

greater where it contrasts with blur, so it is worth arranging for some part of the scene to remain sharp. This may call for the use of a tripod. Start with exposure times not longer than ⅛ sec with a normal lens. Very long exposures cause so much blur that it becomes difficult to identify the subject. They are also a lot more difficult to control.

Quality blur

It may seem unnecessary to bother with focus since you are working with blur, but you will find that it is worth focusing as carefully you would if you were aiming for a sharp image. By doing this you produce a solid "core" to the image, against which the viewer can more readily appreciate the blur.

For similar reasons, it is just as important to maintain image quality as ever. Movement blur produces smooth or milky tones, so any break-up of the image either from resolution that is too low for the output size (*see pp. 180–1*), or noise caused by high sensitivity (high ISO) settings can detract from the overall effect.

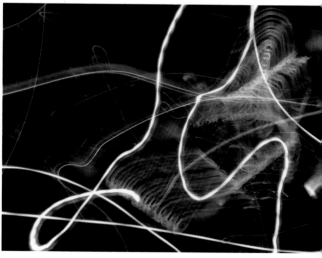

▲ Tossing the camera

This is a technique that can be huge fun and totally unpredictable: set shutter priority with an exposure time of 1 or more seconds. Hold on to the camera strap, press the shutter button, then toss the camera into the air with a spinning action (ensuring that the camera does not hit the ground). For the best results, try this at night with street lights or neon signs.

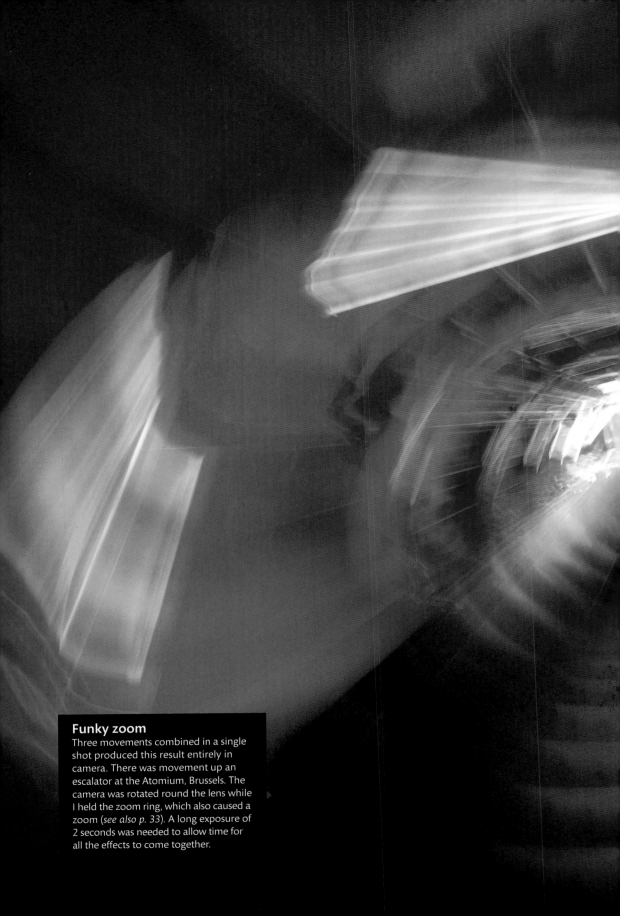

Funky zoom
Three movements combined in a single shot produced this result entirely in camera. There was movement up an escalator at the Atomium, Brussels. The camera was rotated round the lens while I held the zoom ring, which also caused a zoom (*see also p. 33*). A long exposure of 2 seconds was needed to allow time for all the effects to come together.

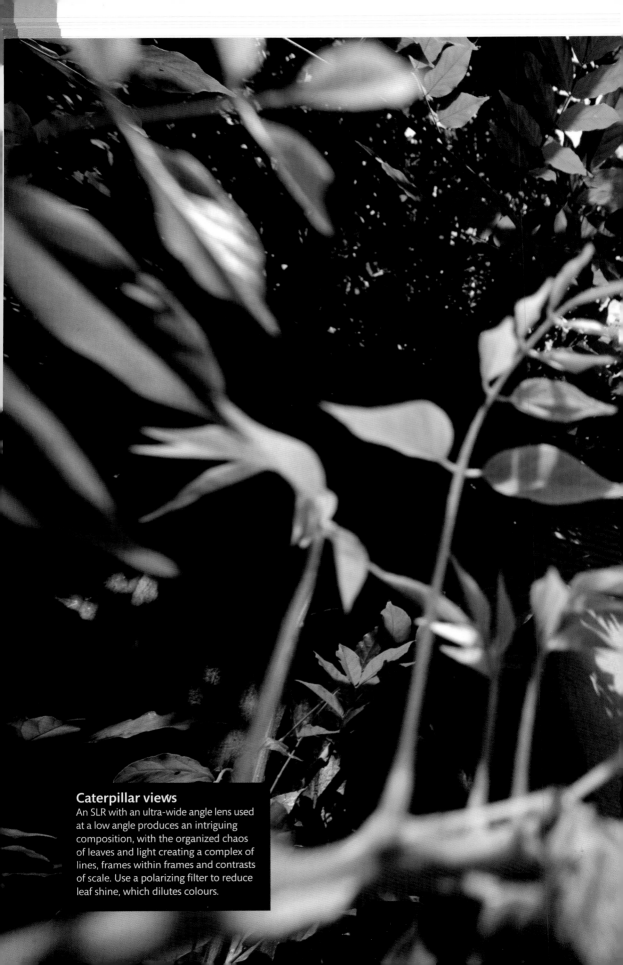

Caterpillar views
An SLR with an ultra-wide angle lens used at a low angle produces an intriguing composition, with the organized chaos of leaves and light creating a complex of lines, frames within frames and contrasts of scale. Use a polarizing filter to reduce leaf shine, which dilutes colours.

▶ Long close-up

A long focal-length lens with close-focusing ability allows you to get close to small, easily disturbed subjects such as this dragonfly, and so obtain a useful image size. In addition, the extremely shallow depth of field with such a lens throws even nearby image elements well out of focus. The central bright spot is, in fact, a flower.

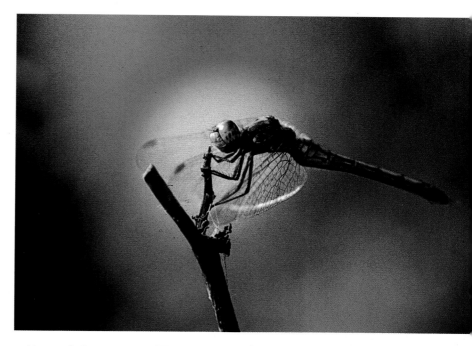

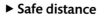

◀ Normal close-up

With static or slow-moving subjects, a normal focal-length lens used at its macro setting will suffice.

▶ Safe distance

It was dangerous to get too close to this constrictor, so a close-focusing, long lens was the best way to obtain good magnification.

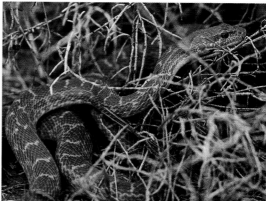

TIPS CLOSE-UP

The combination of shallow depth of field at close distances with the need for high magnifications offers many technical challenges. Here are some ideas to help you:

- Set focusing to manual. This is often faster and more accurate than auto-focus: when it misses its mark, it may focus all the way to infinity and back again in search of the subject.

- Once focus is found, it may be easier to keep the subject in focus by moving backwards and forwards with it, instead of follow focusing.

- Set very small apertures to maximize depth of field:

f/11 or f/16 are good, but avoid the smallest, such as f/22 or f/32, as image quality will be reduced.

- If you are not using flash, set the highest ISO available: it is usually preferable to have a sharp but noisy image than a blurred noise-free image.

- Image stabilization systems are a big help in ensuring sharp images, assuming the subject does not move during exposure.

- The best way to prevent blur from movement is to use electronic flash: at short distances this is immensely powerful, and the very brief exposures freeze all but the fastest movements.

EXTREME LENSES

Some lenses have special capabilities – such as the ability to take ultra wide-angle views or focus at very close subject distances – and these call for extra care when in use. And since they are often costly to buy, you need to know how to get the very best from them.

Ultra-wide-angles

Wide-angle lenses with a 35efl (equivalent focal length) of down to around 28 mm are easy to use, but when focal lengths become shorter than about 24 mm, successful results are less certain.

■ To ensure the image is evenly lit (all wide-angle lenses project significantly more light onto the centre of the image than the edges), avoid using the widest apertures available.

■ To avoid accessories such as filters intruding into the lens's field of view, never use more than one filter at a time; also make sure lens-hoods are designed for the focal length of the lens.

■ With their extensive fields of view, ultra wide-angles can catch a bright source of light, such as the sun, within the picture area. These highlights can cause flare or strong reflections within the lens barrel. Using smaller apertures help control this.

■ Avoid having very recognizable shapes – a face, say, or a glass – near the edges of the frame. It will

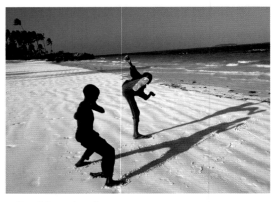

▲ Problem horizons

In the hurry to record this scene on a beach on Zanzibar, the slight tilt of the camera, which went unnoticed while using the 17 mm setting on the lens, has produced an uncomfortable looking horizon. Though far from a disaster, the picture would have benefited from a moment's extra thought before shooting.

appear obviously distorted if a small-sized image is then produced (*see below*).

■ Line up wide-angle lenses very carefully with the horizon or some other prominent feature, as the broad sweep of view will exaggerate the slightest error in picture alignment.

■ Avoid pointing the lens up or down unless you want to produce a distorted effect.

▶ Wide-angle "distortion"

An ultra wide-angle lens encompassed both the stall holder and her produce, but not only does she appear very distorted by being projected to the corner of the frame, so, too, are the tomatoes in the bottom right-hand corner. If, however, you were to make a large print of this image and view it from close up, the apparent distortion disappears.

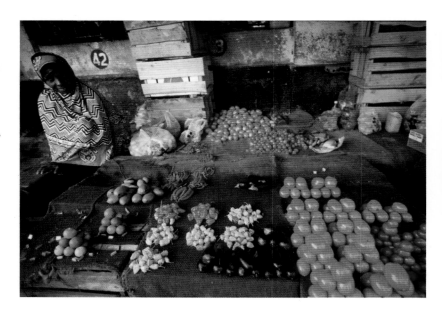

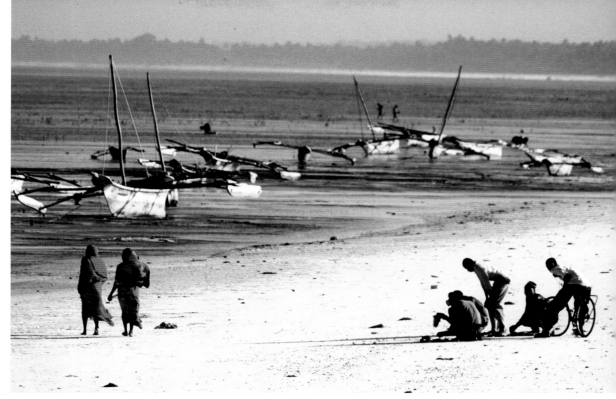

▲ Long telephoto

In this version of the scene shown on the right, the zoom lens was set to 400 mm and a 1.4x extender was also used, giving an effective focal length setting of 560 mm.

■ Avoid using the minimum aperture: you rarely need the depth of field produced and image quality is likely to be degraded. However, selecting a small aperture may improve image quality when focusing on very close subjects.

Wide-ranging zooms

Zooms that offer a wide range of focal length settings, such as 35efl of 28–300 mm or 50–350 mm, are attractive in theory but, in practice, may require special handling.

■ Zooms with a wide range of focal lengths are far bulkier than their single focal length counterparts: a 28 mm lens used in a street is inconspicuous, but a 28–300 mm zoom set at 28 mm is definitely not.

■ The wide-angle setting is likely to show considerable light fall-off, with the corners of the image being recorded darker than the middle, so avoid images that demand even lighting to be effective.

■ Image distortion is always the price you pay for a wide range of focal lengths, so avoid photographing buildings and items with clearly defined sides and straight lines. There will be a setting, usually

▲ Short telephoto

This view shows a beach scene on Zanzibar as imaged by a moderate 100 mm telephoto setting. At this magnification, the lens shows the general scene but not any of the activity or recognizable subject details (*compare this with the top image*).

around the middle of the range, where distortion is minimized; but even here, straight lines may appear very slightly wavy.

■ As you set longer and longer focal lengths on a zoom lens, the maximum available aperture becomes smaller and smaller. This can reduce the scope you have for setting short shutter times, and the need for brighter shooting conditions increases as lens apertures become smaller.

QUICK FIX OPTICAL PROBLEMS

Anybody whose photography involves taking accurate pictures of buildings or other prominent architectural, or even some natural, features is likely at some stage to come up against the problems associated with image distortion.

Problem: When using an extreme wide-angle lens, or an accessory lens that produces a "fish-eye" effect, the straight lines of any subject elements – such as the sides of buildings, the horizon, or room interiors – appear to be bowed or curved in the image. With ordinary lenses, this effect (known as distortion) is usually not obvious, though it is a feature of many zooms. Don't confuse this problem with converging verticals (*see p. 208*).

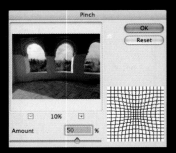

Analysis: Distortion is caused by slight changes in magnification of the image across the picture frame. Lenses that are not symmetrical in construction (in other words, the elements on either side of the aperture are not similar) are particularly prone to this type of imaging distortion, and the asymmetric construction of zoom lenses means that they are highly susceptible.

Solution: Corrections using image-manipulation software may be possible, but turning curves into straight lines is more difficult than adjusting straight lines. Try using the Spherize distortion filter; the degree of flexibility in Photoshop is not very great, but some other software packages offer more control and a better chance of correcting distortion. You could try applying a succession of filters – first, slight Perspective Distortion, then Spherize, then slight Shear – or apply filters to just a part of, rather than to the entire, image.

▲ **Barrel distortion**
In the original shot (*top*), a wide-angle attachment led to barrel distortion. Using Pinch filter, to squeeze the image from all sides, with the Shear filter engaged, has helped correct the problem.

HOW TO AVOID THE PROBLEM

- Do not place straight lines, such as the horizon or a junction of two walls, near the frame edges.
- Avoid using extreme focal lengths – either the ultra-wide or the ultra-long end of a zoom range.
- Use a focal length setting that offers the least distortion, usually around the middle of the range.
- Place important straight lines in the middle of the image – this is where distortion is usually minimal.

Although many optical problems can be solved, or at least minimized, using appropriate software, prevention is always better than cure.

Problem: The image looks unsharp, blurred, or smudged. Contrast is not high and the highlights are smeared.

Analysis: A dirty lens or lens filter, lack of sharp focus, damaged optics, camera shake, or subject movement may separately, or in combination, be the cause of blurred pictures.

Solution: You can increase contrast to improve image appearance using the Levels or Curves controls of image-manipulation software. Applying a Sharpen or Unsharp Mask filter is also likely to improve the image. The main subject can be made to appear adequately sharp if the background is made to look more blurred. To do this, select areas around the main subject and apply a Blur filter.

▶ **Camera movement**
While trying to catch the light on the dust raised by a running zebra, the camera slipped a little, giving this blurred image – most evident in the highlights on the zebra's back and in the grass. However, blur can suggest mood and setting.

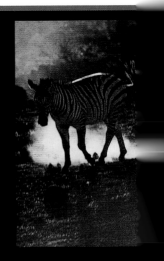

HOW TO AVOID THE PROBLEM

Clean the lens or lens filter if it is marked; use a tripod to steady the camera for long shutter times or when using a telephoto lens or setting; if available, use an image-stabilization lens.

Problem: Bright spots of light, sometimes fringed with colour, can be seen in the image. Spots can be single occurrences or appear in a row, and stretch away from a bright point source of light in the scene. Similarly, a bright, fuzzily edged patch of light, known as veiling flare, fills part of the image area.

Analysis: These types of fault are most likely the result of internal reflections within the lens. Stray light entering the lens from a bright light source has reflected around the lens and then been picked up by the sensor.

Solution: Working with a digital file, small spots of light can easily be removed by cloning or rubber-stamping adjacent unaffected areas of the image onto them. Large areas of flare, however, are more difficult to correct, since they cover a significant area of the picture and contain no information to work with.

▶ **Flare**
An unobstructed sun in the frame causes light to reflect within the lens, resulting in flare. By changing camera position, it was possible to mask the sun with a column of the building, while allowing a little flare through to suggest the brilliance of the light. Some of the reflections may be removed, but probably not all of them.

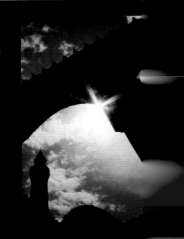

HOW TO AVOID THE PROBLEM

Use a correctly designed lens-hood to stop light entering the periphery of the lens; and avoid pointing the lens directly towards bright light sources. If shot framing demands you include any intense light source in the image, select a small aperture to reduce the size of any resulting

QUICK FIX OPTICAL PROBLEMS CONTINUED

Even if you compose your shot and capture a scene beautifully, you may need to address technical image issues.

Problem: A blue sky is rendered almost black. This type of effect seldom looks realistic or believable.

Analysis: This is probably the result of a polarizing filter on the lens combined with underexposure. This can reduce the sky to the point where most, or even all, colour is removed.

Solution: First, highlight the problem sky area and then use Replace Color in Photoshop, or a similar software package, to restore the colour. The best way to work is by making small changes repeatedly rather than a single, large change. Check that you do not introduce banding, or artificial borders, in the areas of colour transition. You can also try using a graduated layer (*see below*).

HOW TO AVOID THE PROBLEM

Don't set a polarizing filter to produce maximum darkness: in the viewfinder you may still be able to see the blue of the sky but the recording medium may not have sufficient latitude to retain colour if the image is then underexposed.

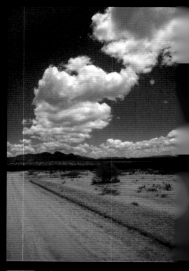

1 Original image
The skies of Kenya seldom need a polarizing filter in order to emphasize their colour – indeed, it may even cause a portion of the sky to turn too dark, as you can see here in the top left-hand corner of the image.

2 Gradient Fill
To correct this, you must remove the dark gradient while leaving the rest of the image unaffected. This calls for a transparent-to-solid gradient that runs counter to the darkness. Here a Gradient Fill of black-to-transparent, with its Blend mode set to Screen, was applied. The gradient was adjusted until the dark corner

3 Sky correction
Once the new layer was applied to the image, the carefully positioned Gradient Fill restored the natural colour of the sky. Once you have made one adjustment you may find the image needs more work – for example, the top right-hand corner may now seem too dark. With digital photography it is easy to create

Problem: Corners of the image are shadowed or darkened, with a blurred edge leading to blackness, or the middle of the image looks significantly brighter than the periphery.

Analysis: Images showing dark corners with a discernible shape have been vignetted. This is usually caused by using a filter with too deep a rim for use with a (usually) wide-angle lens, by stacking too many filters on a lens, or by using an incorrectly aligned or overly deep lens-hood.

Solution: If the areas affected are small, vignetting can be corrected by cloning adjacent portions of the image. Light fall-off may be corrected using a Radial Graduate or Gradient Fill (*see opposite*) – experiment with different values of darkness and opacity.

▲ Darkened corners
It is easy not to notice a lens-hood interfering with the image; here the shadows in the corners here were not spotted until afterwards. Small apertures give deeper, sharper shadows.

HOW TO AVOID THE PROBLEM

Vignetting is easy to avoid if you are careful with your filters and lens-hoods. Light fall-off, as an optical defect, can only be reduced, not eliminated altogether: use either smaller working apertures or a higher-quality lens.

Problem: The quality of images taken at the closest focusing distances is disappointing; they are not sharp or lack contrast.

Analysis: Lenses usually perform best at medium or long distances: the degree of close-up correction depends on lens design.

Solution: Poor image sharpness may be improved by applying Sharpness or Unsharp Mask filters. Contrast will be improved with Levels or Curves. Try localized burning-in to improve contrast, which will also increase apparent sharpness without increasing visual noise.

HOW TO AVOID THE PROBLEM

Small apertures are likely to improve sharpness. Try using different focus and zoom settings – there will be a combination that gives the best possible quality. An alternative solution is to attach a close-up lens to the main lens. This acts as a magnifying glass and can improve close-up performance.

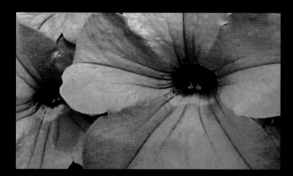

▲ Improving close-ups
The original image (*top*) shows the features characteristic of a low-quality close-up: poor sharpness and reduced contrast. Applying an Unsharp Mask filter and an increase in contrast significantly improves results (*above*).

INFLUENCING PERSPECTIVE

You can exercise control over the perspective of a photograph by changing your camera position. This is because perspective is the view that you have of the subject from wherever it is you decide to shoot. Perspective, however, is not affected by any changes in lens focal length – it may appear to be so but, in fact, all focal length does is determine how much of the view you record.

Professional photographers know perspective has a powerful effect on an image, yet it is one of the easiest things to control. This is why when you watch professionals at work, you often see them constantly moving around the subject – sometimes bending down to the ground or climbing onto the nearest perch; approaching very close and moving further away again. Taking a lead from this, your work could be transformed if you simply become more mobile, observing the world through the camera from a series of changing positions rather than a single, static viewpoint.

Bear in mind that with some subjects – still-lifes, for example, and interiors or portraits – the tiny change in perspective between observing the subject with your own eyes and seeing it through the camera lens, which is just a little lower than your eyes, can make a difference to the composition. This difference in perspective is far more pronounced if you are using a studio camera or waist-level finder on a medium-format camera.

Using zooms effectively

One way to approach changes in perspective is to appreciate the effect that lens focal length has on your photography. A short focal length gives a

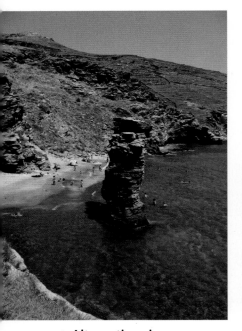
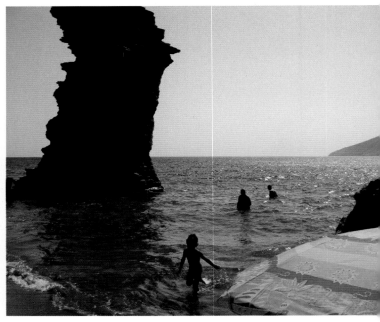

▲ Alternative views

This wide-angle view (*above left*), shows an unremarkable snapshot of a holiday beach, in Andros, Greece. It is a simple image of the place, but it lacks an engaging interpretation or inventive viewpoint of the scene. Once on the beach, the temptation is to take in a wide shot that summarizes the whole scene. Instead, a low viewpoint that takes in the corner of a parasol gives a more intimate and involving feel: by using the parasol to balance the large rock, the picture is almost complete. Waiting for the right moment – a child runing into the foreground – brings the whole perspective to life.

perspective that allows you to approach a subject closely yet record much of the background. If you step back a little, you can take in much more of the scene, but then the generous depth of field of a wide-angle tends to make links between separate subject elements, as there is little, if any, difference in sharpness between them.

A long lens allows a more distant perspective. You can look closely at a face without being nearby. Long lenses tend to pull together disparate objects – in an urban scene viewed from a distance, buildings that are several blocks apart might appear to crowd in on top of each other. However, the shallow depth of field of a long lens used at close subject distances tends to separate out objects that may actually be close together by showing some sharp and others blurred.

PERSPECTIVE EFFECTS

Wide-angle lenses
- Take in more background or foreground.
- Exaggerate the size of near subjects when used in close-up photography.
- Exaggerate any differences in distance or position between subjects.
- Give greater apparent depth of field and link the subject to its background.

Telephoto lenses
- Compress spatial separation.
- Magnify the main subject.
- Reduce depth of field to separate the subject from its background.

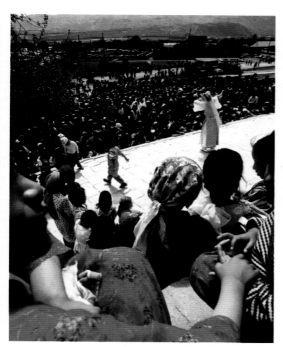

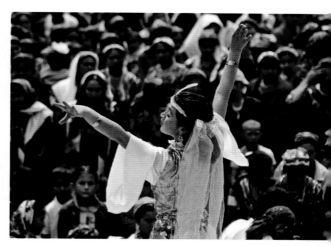

▲ Telephoto perspective
Overlooking the action there is a sense of the crush of people at this festival in mountainous Tajikistan (*above*). Two children holding hands complete the scene. The long focal length version (*above right*) focuses attention on the dancer, but excludes all sense of setting beyond the crowd watching the traditional performance.

TRY THIS
For this exercise, leave your zoom lens at its shortest focal length setting. Look for pictures that work best with this focal length – ignore any others and don't be tempted to change the lens setting. This will help to sharpen your sense of what a wide-angle lens does. You may find yourself approaching subjects – including people – more closely than you would normally dare. The lens is making you get closer because you cannot use the zoom to make the move for you. Next, repeat the exercise with the lens at its longest focal length setting.

CHANGING VIEWPOINTS

Always be on the look-out for viewpoints that give a new slant to your work. Don't ignore the simple devices, such as shooting down at a building instead of up at it, or trying to see a street scene from a child's viewpoint rather than an adult's.

Your choice of viewpoint communicates subtle messages that say as much about you as they do your subject. Take a picture of someone from a distance, for example, and the image carries a sense that you, too, were distant from that person. If you photograph a scene of poverty from the viewpoint of a bystander, the picture will again have that distant look of having been taken by an aloof observer. Lively markets are popular photographic subjects, but what do they look like from a stall-holder's position? If you enjoy sports, shoot from within the action, not from the sidelines.

Practical points

Higher viewpoints enable you to reduce the amount of foreground and increase the area of background recorded by a lens. From a high vantage point, a street or river scene lies at a less acute angle than when seen from street or water level. This reduces the amount of depth of field required to show the scene in sharp focus.

However, from a low camera position subjects may be glimpsed through a sea of grass or legs. And if you look upward from a low position, you see less background and more sky, making it easier to separate your subject from its surroundings.

▲ **Less can say more**
At markets and similar types of location, all the activity can be overwhelming – and the temptation is often to try to record the entire busy, colourful scene. However, if you look around you, there could be images at your feet showing much less but saying so much more. In Uzbekistan I noticed next to a fruit stall a lady who had nothing to sell but these few sad tulips.

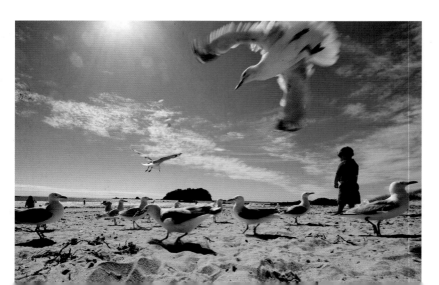

◄ **Child's eye view**
From almost ground level, the swooping gulls feel quite threatening and pull the viewer into the action. At the same time, looking upwards gives the viewer a sense of open skies – this would be lost with the gaze directed downwards.

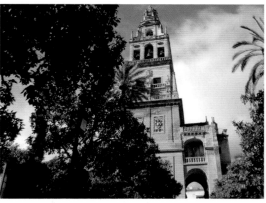

▲ Changing viewpoint

This conventional view of the Mesquita of Cordoba, Spain (*above*), works well as a record shot, but it is not the product of careful observation. Looking down from the same shooting position, I noticed the tower of the building reflected in a puddle of water. Placing the camera nearly in the water, a wholly more intriguing viewpoint was revealed (*right*). An advantage of using a digital camera with an LCD screen is that awkward shooting positions are not the impossibility they would be with a film-based camera.

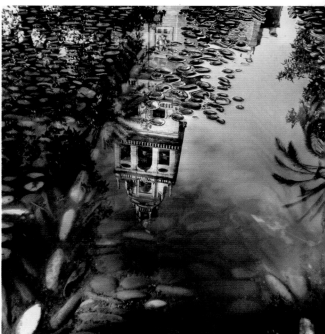

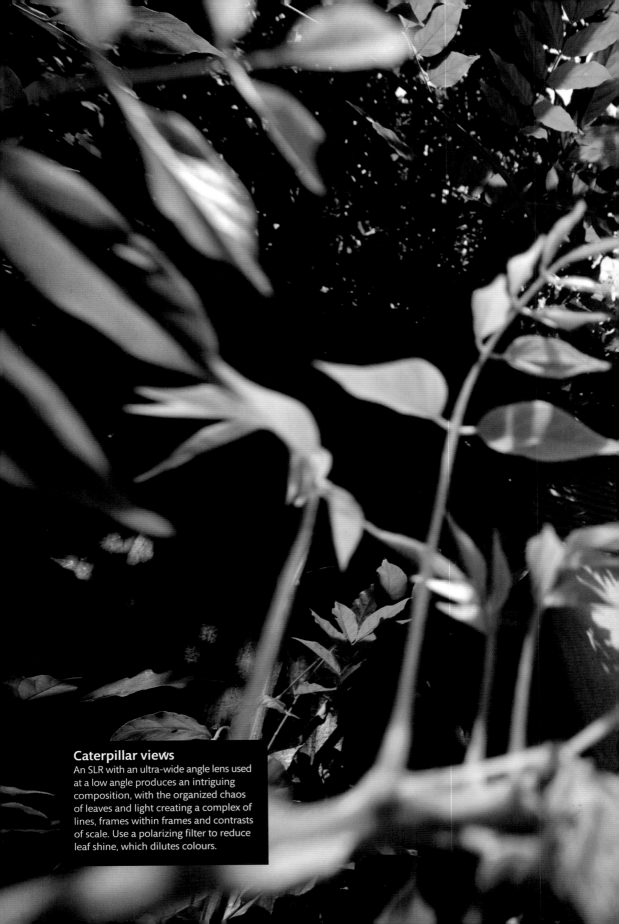

Caterpillar views

An SLR with an ultra-wide angle lens used at a low angle produces an intriguing composition, with the organized chaos of leaves and light creating a complex of lines, frames within frames and contrasts of scale. Use a polarizing filter to reduce leaf shine, which dilutes colours.

QUICK FIX LEANING BUILDINGS

Buildings and architectural features are always popular photographic subjects, but they can cause annoying problems of distortion.

Problem: Tall structures, such as buildings, lamp posts, or trees, even people standing close by and above you, appear to lean backward or as if they are about to topple over.

Analysis: This distortion occurs if you point the camera up to take the picture. This results in you taking in too much of the foreground and not enough of the height of the subject.

Solution: Stand further back and keep the camera level – you will still take in too much of the foreground, but you can later crop the image.
- Use a wider-angle lens or zoom setting, but then remember to hold the camera precisely level – wide-angle lenses tend to exaggerate projection distortion.
- Take the picture anyway and try to correct the distortion by manipulating the image.
- Use a shift lens or a camera with movements. This equipment is specialist and expensive, but technically it is the best solution.
- Exaggerate the leaning or toppling effect to emphasize the height and bulk of the subject.

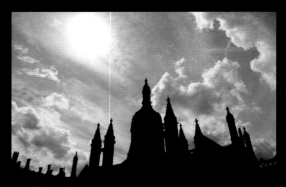

▲ **Tilting the camera**
An upward-looking view of the spires of Cambridge, England, makes the buildings lean alarmingly backward.

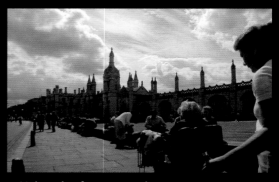

▲ **Using the foreground**
By choosing the right camera position, you can keep the camera level and include foreground elements that add to the shot.

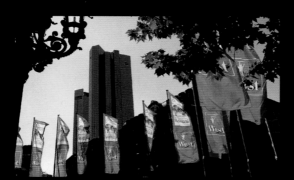

▲ **Losing the foreground**
To record the red flags against the contrasting blue of the building there was no option but to point the camera upward, thus dismissing much of the foreground. As a result, the nearest building appears to lean backward.

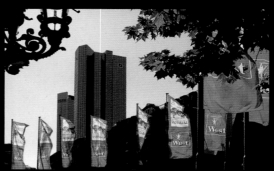

▲ **Alternative view**
Keeping the camera level, a shift lens was used, set to maximum upward movement. This avoided the problem of converging verticals. Although this is the best solution to optimize image quality, it does require a costly professional lens.

QUICK FIX FACIAL DISTORTION

Distorted facial features can be a problem with portraits. To make the subject's face as large as possible, the temptation is to move in too close.

Problem: Portraits of people taken close-up exaggerate certain facial features, such as noses, cheeks, or foreheads.

Analysis: The cause is a perspective distortion. When a print is viewed from too far away for the magnification of the print, the impression of perspective is not correctly formed (*see also p. 40*). This is why at the time you took the photograph, your subject's nose appeared fine, but in the print it looks disproportionately large.

Solution: Use a longer lens setting – a 35efl of at least 80 mm is about right, so that for a normal-sized print viewed from a normal viewing distance, perspective looks correct.

- Use the longest end of your zoom lens. For many, this is a 35efl of 70 mm, which is just about enough.
- If you have to work close-up, try taking a profile instead of a full face.
- Avoid using wide-angle lenses close to a face, unless you want a distorted view.
- Don't fill the frame with a face at the time of shooting. Instead, rely on cropping at a later stage if you need the frame filled (*see pp. 30–1*).
- Don't assume you will be able to correct facial distortions later on with image-manipulation software. It is hard to produce convincing results.
- If you have a digital camera with a swivelling lens, it is fun to include yourself in the picture by holding the camera at arm's length – but your facial features will then be so close they will look exaggerated.
- Make larger prints. With modern ink-jet printers it is easy to make A4-sized images, and at normal viewing distances they are far less prone to perspective distortion.

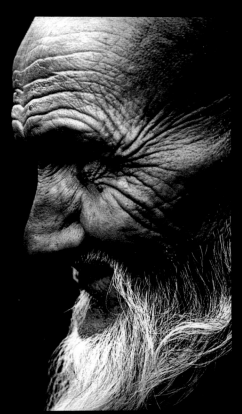

▶ Profile
Taking portraits in profile avoids many of the problems associated with facial distortion in full-frontal shots. Make sure you focus carefully on the (visible) eye – other parts of the face may appear unsharp yet be acceptable to the viewer.

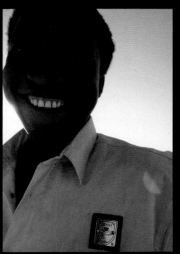

▲ Full-frontal
To emphasize the friendly character of this man, several "rules" were broken: a wide-angle lens was used close-up; the shot was taken looking upward; and the face was placed off in one corner, thus exaggerating the distortion already present. But the total effect is amiable rather than unpleasant.

COLOUR COMPOSITION

Colour can be used to express emotion in an image. Pale, soft colours are restful and tranquil, while rich, vibrant colours burst with energy and demand attention. Colour is integral to visual experience, but in photography it is almost a separate subject in itself. The basis of successful colour photography is to use colour in its own right, instead of merely capturing the many hues of a scene.

Colour as subject

One approach is to photograph colours themselves rather than the objects they imbue – that is, to try to treat the subject as if it were the incidental feature in the scene. You do not need to learn to see in colour, but you do need to learn to see colours for themselves – entirely separate from the thing that displays the colour.

This change of mental focus could radically transform the entire way you photograph. You evaluate a scene not in terms of whether it is a marvellous vista but in colour analytic terms. You will observe that colours vary not only with hue – the name given to a colour – but also with intensity, or saturation. Soon, you will appreciate another quality: the value, or brightness, of a colour. With more experience, you will appreciate that certain colours can be captured in their full richness, whereas others will appear weaker. Understanding each dimension adds to your ability to compose with colour.

Colour wheel

The colours of the rainbow can be arranged in a circle (the "colour wheel"): the basic primary colours are red, blue, and yellow. In between these are placed violet, green, and orange, and between these are all the intermediate colours. A hue that is directly to the left or right of a colour on the wheel is said to be an analogous, or adjacent, colour – such as light and dark green with yellow, or blue, purple, and cyan. A combination of these colours in your images will appear harmonious and will therefore be correspondingly easy to compose, as the colours work together and can help bind together disparate elements within the scene. Broadly speaking, landscape photographers tend

▶ **Fashion parade**
The saturated colours of the different T-shirts could lead to a chaotic composition. However, several other elements help to organize the image: the regular lines of the windows, chairs, and railing all cut the image into neat frames around the blocks of colour. At the same time the blue of the sky and water form an even background against which the T-shirt colours can glow.

▼ **Brilliance of pallor**
Colours do not have to be highly saturated or intense to be effective. In many cases subtle contrast works best, such as the tiny area of red petal against the overall green balance of this image. The sharpness of the flower against the vague shadows also helps define the colour regions.

▲ Betting on white
Any colour seen against white appears to be relatively stronger. The pale blue reflection of sky would be swamped by any other colours in the image, but with the large areas of neutral shades, even the very soft blues in the shadows become more apparent.

PERCEPTION OF COLOUR

If a pale subject is seen against a background of a complementary colour, its saturation seems to increase. Similarly, a neutral grey changes its appearance according to its background colour, appearing slightly bluish green against red, and magenta against green. If you compare the grey patches in the two-coloured panels below you can see this at work. If you were to cut small holes in a piece of white card, so that only the four patches are visible, you would see that the pale blues are, in fact, identical, as are the greys.

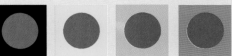

COLOUR COMPOSITION CONTINUED

to prefer working with analogous colours, so the viewer concentrates on forms and texture, whereas garden photographers tend to seek out contrasting colours, for livelier results.

A version of the analogous scheme is the monochromatic, in which all colours are variants of the same hue. Such images – think of seascapes with their infinite varieties of blue – offer tonal subtlety instead of colour contrasts. Close-ups of flowers are often rewarding because they offer narrow, subtle colour shifts.

Colours are said to clash where they lie opposite or far from each other on the colour wheel. While compositions with strong contrasts are appealing when initially experienced, they are more tricky to organize into a successful image. Look for simplicity in structure and a clear arrangement of subject matter – too many elements jostling for attention can lead to a disjointed, chaotic image.

Pastel colours

Referring to pastel colours as the weak versions of a hue is accurate, but also does them a disservice: it suggests that they are of limited use. Pastels are certainly more pale and less saturated or vibrant than full-on colours. They are nonetheless vital tools for the photographer.

Pale colours suggest tranquillity and calm, and are gentle where strong colours are more vigorous. They evoke responses of peace and wellbeing – which is why they are so popular for home interiors – and, for a photographer, they are also important as counter-balances to strong colours. You can achieve striking results by simply concentrating on pastel colours in their own right. You will find them where there is a good deal of light – which tends to dilute colours – and where pastel shades have been used decoratively in architecture, interior design, or garden planting schemes.

The easiest way to create pastel-dominated images is to over-expose them: this can be very effective for creating unusual effects in nature and landscape photography. Such images are often associated with high-key lighting (*see also pp. 70–1*) as the presence of dark shadows tends to make even pale colours look richer. Alternatively, many digital cameras can be set to record all the colours in a scene as pastels.

▶ **Strong structure**
The watered-down colours in this cityscape provide a canvas for the morass of steel structures that crawl up the buildings. It may be tempting to increase contrast and saturation, but that would over-dramatize the true nature of the view. In flat lighting, expose with care, as poor accuracy impacts on every tone in the image, and use the lens at its best aperture to ensure sharply defined details.

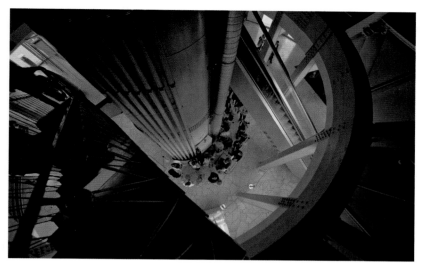

◄ **Grounded colour**
The neutral block of grey in the centre of the image provides a grounding for the opposing visual lures of the patches of deep blue and red. In addition, the structure imposed by strong lines and curves ensures this image, made in the Atomium in Brussels, presents a rich articulation of space and form.

▲ **Soft but strong**
Flowers of a Scottish Highland spring make a striking image despite being made up of largely pastel colours, all seen under a dull light. Compose to overlap contrasting colours and try zooming to a long focal length setting to compress space and juxtapose different patches of colour.

TRY THIS

One effective way to work with colours is to ensure the main colours in your pictures are complementary pairs – such as red–green, yellow–violet, orange–blue. Try to capture subject matter with complementary colours; it is not easy as you might expect. But you will find that, with practice, complementary colour pairs will catch your eye even if you are not consciously looking for them. As you refine your technique, see if you can use colour complementaries to separate out elements in your image – use the language of colour to express and communicate your response to a scene.

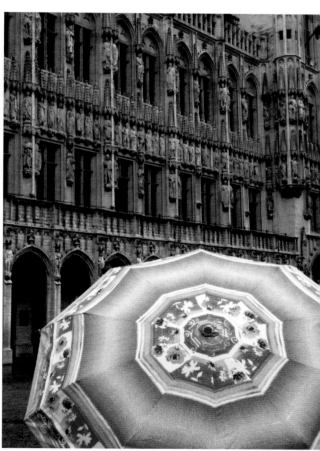

▲ **Saturation contrast**
The attention-grabbing colours of an umbrella appear to be even stronger than they are because of contrast with the grey tones of the buildings. This, together with the radial structure of the umbrella straining against the linear form of the building, creates a contrast that is almost too vigorous.

ADJACENT COLOURS

Colours that lie immediately next to each other on the colour wheel (*see p. 54*) are said to be analogous, or adjacent, colours. Examples of these include light green and yellow, dark green and blue, purple and cyan, and so on.

Colour and harmony

Although it is difficult to generalize about what are essentially subjective reactions to the inclusion of particular colours, as a general rule if you include combinations of adjacent colours in an image you create more of a harmonious effect. This is especially true if the colours are approximately equivalent to each other in brightness and saturation. As well as being pleasing to the eye, colour harmony also helps to bind together what could perhaps be disparate subject elements within a composition.

Colour and mood

There is much to be said for learning to work with a carefully conceived and restrained palette of colours. A favourite trick of landscape photographers at some times of the year, for example, is to select a camera viewpoint that creates a colour scheme that is composed predominantly of browns and reds – the hues redolent of autumn. Thus, not only does a harmonious colour composition result, all of the mood and atmosphere associated with the seasonal change from summer to winter are brought to bear within the image.

Depending on just how the photographer wants a picture to communicate with its intended audience, images that feature gardens as the principal subject might be dominated by colours such as various shades of green or blues and purples.

Monochromatic colour

Another type of picture harmony results when the colours are all of a similar hue. The subtle tonal variations can impart a sense of quiet tranquillity or reinforce the drama of the scene. Duotone or sepia-toned effects (*see pp. 238–41*) are highly monochromatic, as are views of the sea and sky containing a range of different blues. Red and orange sunsets may be lively or serene, while flower close-ups are often beautiful because of their delicate shifts in colour.

▶ Monochrome landscape

As the French painter Paul Cézanne taught us, every colour of the rainbow can be seen in any scene if you look hard enough, especially in a landscape. However, the dominance of yellows and browns in this image encourages the viewer to admire the chiaroscuro and shape of the slopes without the distraction of colour contrasts.

◄ Emotional content

Even though all the main colours in this photograph are tonally very close, the image lacks impact when it is rendered in black and white. The emotional content of the warm reds, pinks, and purples is essential to the success of the study.

▲ Blue on blue

Although the strong and adjacent blues, which have been given extra depth by the bright sunlight illuminating them, are what this picture is all about, a total absence of some form of contrast – provided here by the small red label and the subject's flesh tones – would have left the picture unbalanced and overstated.

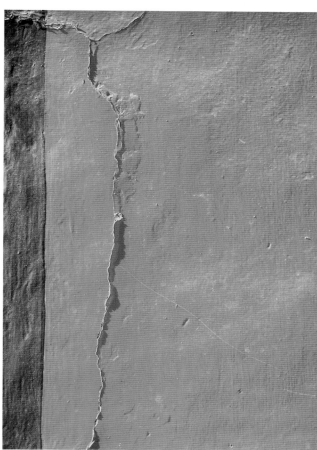

▲ Red and purple

When I first noticed this painted wall, it appeared to have promise, but it was not until it was strongly lit by oblique sunlight that the picture really came together – the dominance of the red and the strongly graphic crack both being powerful visual elements. A little post-processing work served to heighten the colours and strengthen the shadows.

TRY THIS

First, choose a colour. It could be your favourite one – blue, yellow, orange – or any other. Next, set out to photograph anything that is largely or wholly composed of that particular hue. Allow only variations of that colour within each picture. If any other colours are present, don't take the picture – unless you can get in close enough, or change your camera viewpoint, to exclude them. When you are done, put your collection of pictures together. The assembly of similar colours in different shades will have an impact that may surprise and delight you.

COLOUR CONTRASTS

Colour contrasts result when you include hues within an image that are well separated from each other on the colour wheel (*see pp. 54–6*). While it is true that strongly coloured picture elements may have initial visual impact, they are not all that easy to organize into successful images. Often, it is better to look for a simple colour scheme as part of a clear compositional structure – too many subject elements can so easily lead to disjointed and chaotic pictures.

Digital results

Modern cameras are able to capture very vibrant colours that look compelling on your computer's monitor screen. Because of the way the screen displays colour, these are, in fact, brighter and more saturated than those prints can produce. However, one of the advantages of using computer technology is that the apparent colour range can be enhanced by the application of image-manipulation techniques, giving you the opportunity, first to create, and then to exploit, an enormous range of colour palettes.

▲ Distracting composition
Combine strong colours with an unusual and an appealing subject, and you would think that you have all the elements needed for a striking photograph. In fact, there is far too much going on in this picture for it to be a successful composition. The painting in the background distracts attention from the man – himself an artist, from Papua New Guinea – while the white edge on the right disturbs the composition. A severe crop, to concentrate attention on the face alone, would be necessary to save the image.

◄ Strong contrasts
This image, captured in China Town, Singapore, is simply a celebration of colour contrast. But there is more than the colour opposition between the blue-painted walls and the pinks of the cherry blossoms. The cool light from low-energy lamps in the arcade contrasts with warm light coming from the street lamps: the result is that whites in the arcade are neutral, but whites on the outside are distinctly yellow-red.

▲ Polar balance

This image is dominated by grey or near-neutral tones but is dynamically organized around the contrast between the reddish light of the wooden blinds and the bright blue of the hydrangea flowers. The strong patches of colour appear even stronger because they are isolated in a neutral field (*see p. 55*), and they alternately demand a viewer's attention. This imparts energy to what would otherwise be a static composition.

COLOUR GAMUT

The intensity of computer-enhanced colours gives them real appeal, but it is in this strength that problems lie. Strong colours on the page of a book or website will compete with any text that is included; they are also likely to conflict with any other softer image elements. In addition, you need to bear in mind that even if you can see intense, strong colours on the screen, you may not be able to reproduce them on paper. Purples, sky blue, oranges, and brilliant greens all reproduce poorly on paper, looking duller than they do on screen. This is because the colour gamut, or range of reproducible colours, of print is smaller than that of the monitor.

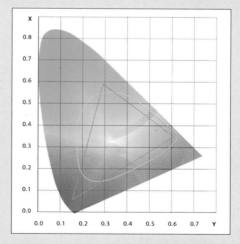

Of the many ways to represent a range of colours, this diagram is the most widely accepted. The rounded triangle encloses all colours that can be perceived. Areas drawn within this, the visual gamut, represent the colours that can be accurately reproduced by specific devices. The triangle encloses the colours (the colour gamut) of a typical RGB colour monitor. The quadrilateral shows the colours reproduced by the four-colour printing process. Notice how some printable colours cannot be reproduced on screen, and vice versa.

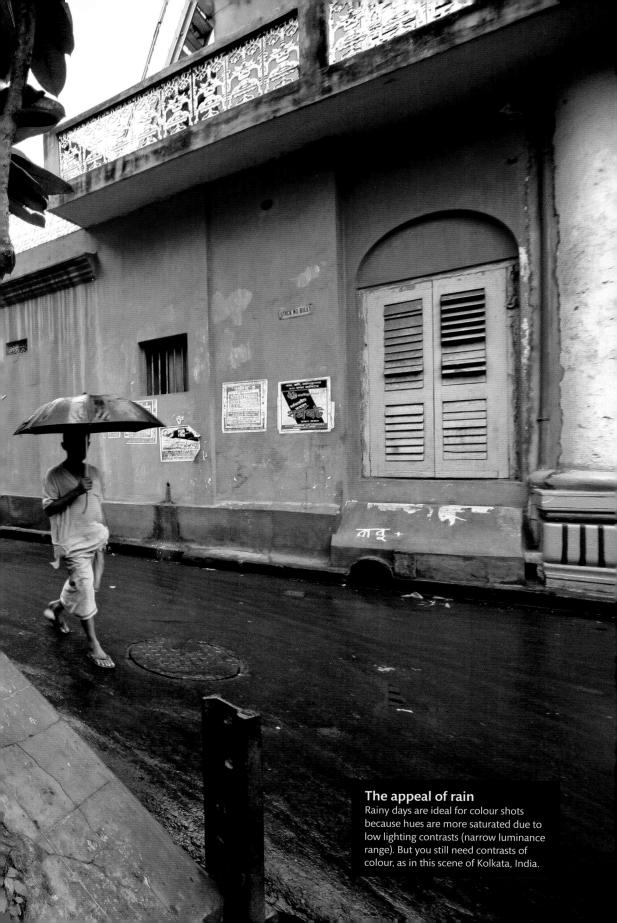

The appeal of rain
Rainy days are ideal for colour shots because hues are more saturated due to low lighting contrasts (narrow luminance range). But you still need contrasts of colour, as in this scene of Kolkata, India.

EXPOSURE CONTROL

The process of determining the amount of light that is needed by the sensor for the required results is called exposure control. Many digital cameras can change sensitivities to maintain practical camera settings. For example, in low light, sensor sensitivity increases (just as faster film might be used in film-based photography) to allow you to set shorter shutter times or smaller apertures.

It is important to control exposure accurately and carefully, as it not only ensures you obtain the best from whatever system you are using, but it also saves you the time and effort of manipulating the image unnecessarily at a later stage.

Measuring systems

To determine exposure, the camera measures the light reflecting from a scene. The simplest system measures light from the entire field of view, treating all of it equally. This system is found in some hand-held meters and some early SLR cameras.

Many cameras use a centre-weighted system, in which light from the entire field of view is registered, but more account is taken of that coming from the central portion of the image (often indicated on the focusing screen). This can be taken further, so that the light from most of the image is ignored, except that from a central part. This can vary from a central 25 per cent of the whole area to less than 5 per cent. For critical work, this selective area, or spot-metering, system is the most accurate.

A far more elaborate exposure system divides the entire image area into a patchwork of zones, each of which is separately evaluated. This system, commonly referred to as evaluative or matrix metering, is extremely successful at delivering consistently accurate exposures over a wide range of unusual or demanding lighting conditions.

As good as they are, the exposure systems found in modern cameras are not perfect. There will be times when you have to give the automation a helping hand – usually when the lighting is most interesting or challenging. This is why it is so crucially important to understand what exactly constitutes "optimum exposure".

Optimized dynamics

Every photographic medium has a range over which it can make accurate records – beyond that, the representation is less precise. This accuracy range is represented by a scale of greys either side of the mid-tone, from dark tones with detail (for example, dark hair with some individual strands distinguishable) to light tones showing texture (for example, paper showing creases and wrinkles, and perhaps some fibres). If you locate your exposure so that the most important tone of your image

▶ What is "correct"?
To the eye, this scene was brighter and less colourful than seen here. A technically correct exposure would have produced a lighter image – thus failing to record the sunset colours. Although it looks like this might challenge a basic exposure-measuring system, by placing the sun centre frame you guarantee underexposure, resulting, as in this example, in a visually better image than a "correct" exposure would produce.

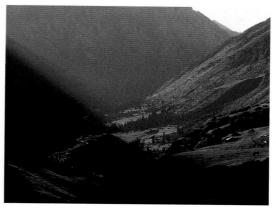

▲ Narrow luminance range

Scenes that contain a narrow range of luminance and large areas of fairly even, regular tone do not represent a great problem for exposure-measuring systems, but you still need to proceed with care for optimum results. The original of this image was correctly exposed yet appeared too light because, pictorially, the scene acquires more impact from being darker, almost low-key (*see pp. 70–1*). The adjustments that were made to darken the image also had the effect of increasing colour saturation, which is another pictorial improvement.

▲ Wide luminance range

The range of luminance in this scene is large – from the brilliant glare of the sky to deep foreground shadows. Exposure control must, therefore, be precise to make the most of the film's ability to record the scene. In these situations, the best exposure system is a spot meter, with the sensor positioned over a key tone – here, the brightly lit area of grass on the right of the frame. Evaluative metering may also produce the same result, but if you are using a film camera, you will not know until you develop the film.

falls in the middle of this range, the recording medium has the best chance of capturing a full range of tones.

Exposure control is, therefore, a process of choosing camera settings that ensure the middle tone of an image falls within the middle part of the sensor's or film's recording range in order to make the most of the available dynamic range.

Spot metering

The easiest and most reliable method for achieving precision in exposure control is to use a spot-metering system (see box below). In this way you obtain a reading from just one carefully selected tone within a scene. This could be, for example, a person's face or, in a landscape, the sunlit portion of a valley wall.

SENSITIVITY PATTERNS

Cameras use a variety of light-measuring systems, and the representations shown here illustrate two of the most common arrangements. With a centre-weighted averaging system, most of the field of view is assessed by the meter, but preference is given to light coming from the middle of the frame. This produces the correct exposure in most situations. However, the optics of a light meter can be arranged so that all its sensitivity is concentrated into a small spot in the very middle of the field of view. This spot-metering system gives a precision of control, which, if used with care and knowledge, produces the best reliability.

▲ Metering systems

Centre-weighted metering (*above left*) takes in all of the view but gives more weight, or emphasis, to the light level around the centre of the image, tailing off to little response at the edge. A spot-metering system (*above right*) reads solely from a clearly defined central area – usually just 2–3 per cent of the total image area. So a bright light at the edge of the image will have no effect on the reading.

SILHOUETTES/BACKLIGHTING

Although the results may look different, silhouetted and backlit shots are variations on the same theme. In terms of exposure, they differ only in how much light is given to the main subject.

Silhouetted subjects

To create a silhouette, expose for the background alone – whether the sky or, say, a brightly lit wall – so that foreground objects are recorded as very dark, or even black. Make sure the exposure takes no account of the foreground. For this technique to be most effective, minimal light should fall on the subject, otherwise surface details start to record and the form loses impact. Your aim is to exploit outline and shape, and to help this a plain background is usually best.

When taking pictures into the light, you need to be aware of bright light flaring into the lens. As a rule, try to position yourself so that the subject itself obscures the light source, though it can be effective to allow the sun to peep around the subject to cause a little flare. Using a small aperture helps reduce unwanted reflections inside the lens.

Backlit subjects

The classic backlit subject is a portrait taken with a window or the sky filling the background, or figures on a bright, sandy beach or a ski slope.

The challenge in terms of exposure in these types of situation is to prevent the meter from being over-influenced by the high levels of background illumination. If you don't, you will end up with a silhouette. To prevent this, either override the automatics or manually set the controls to "overexpose" by some 1½–2 f/stops.

Another approach is to set your camera to take a selective meter reading (see pp. 66–7). Alternatively, with a centre-weighted averaging meter reading, fill the viewfinder with the shadowy side of your subject, note the reading, or lock it in, move back, and recompose the image.

Backlit scenes are prone to veiling flare – non-image-forming light – which is aggravated by the need to increase exposure for the subject. In strong backlighting, however, it is hard to prevent light spilling around the subject edges, blurring sharpness and reducing contrast.

◄ **Conflicting needs**
In this strongly backlit portrait of a Kyrgyz shepherd (which has been cropped from a wide-angle shot), I positioned myself so that the subject shielded the lens from the direct rays of a bright sun. It is very difficult to achieve the right balance of exposure – if the horse is fully exposed, the sheep will be too light. This is clearly the type of situation that would benefit from a little fill-in flash (see pp. 80–1). However, there was just enough light to pick out the colour of the horse when the sheep were correctly exposed.

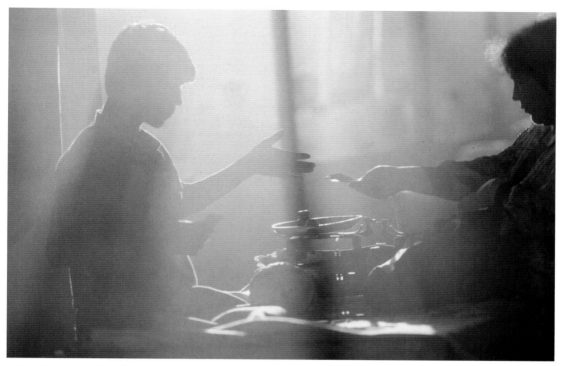

▲ Dealing with flare

As the sun sets on a market in Tashkent, Uzbekistan, the dust raised by street cleaners fills the air, catching and spreading the still bright sunlight. The lower the sun is in the sky, the more likely is it to become a feature in your composition. In the example here, the flare has been caused as much by the atmospheric dust as by any internal reflections within the lens itself. A normal averaging light reading taken in these conditions would be massively over-influenced by the general brightness of the scene, and so render the backlit subject as featureless silhouettes. Therefore, what may seem like a gross overexposure – an additional 2 f/stops – is needed to deal with this type of lighting situation.

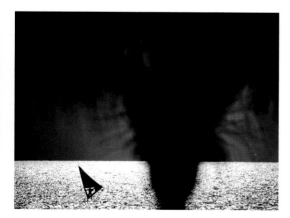

▲ Sky exposure

Strong light from the front and a symmetrical foreground shape immediately suggest the potential for a silhouette. A passing windsurfer, in the Penang Straits of Malaysia, completes the picture. Simply by exposing for the sky, all the other elements fall into their correct place – the black, shadowy palm tree, the sparkling water, and the surfer are transformed. Using a catadioptric (mirror) lens produces the characteristic "hollow" look of the out-of-focus palm.

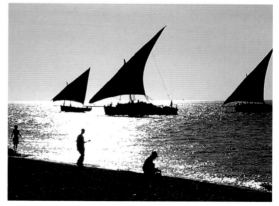

▲ Virtue of necessity

When shooting into a fierce, tropical sun, you may have no choice other than to produce a silhouette. If so, the strategy then becomes a search for the right type of subject. Here, on Zanzibar, dhows and beachcombers are complementary in terms of tone, yet contrasting in shape. Notice how the central figure seems diminished in size as his outline is blurred by the light flaring all around his body.

HIGH-KEY IMAGES

The key tone in the majority of images lies at or near the mid-point between the darkest or black tones and the brightest or white ones. This is what we see in average lighting and is what camera meters are designed to deliver. By deliberately shifting the key tone away from the average, we do not merely make an image appear lighter or darker overall, but we signal a mood or feeling to the viewer. By our control of the key tone we use the tonality of the image to convey meaning. We use high-key images most often to express a light and airy mood: this is ideal for modern interior shots and wedding photography, and is often used for fashion shoots and portraiture.

Bright and high

High-key images are those in which tones are all lighter than mid-tone, with a minimum of mid- and shadow tones. This is achieved primarily by lighting to reduce the mid-tones and eliminate shadows, but it can also result from combining of over-exposure with lighting. Image manipulation can also be used to reduce shadows and give an impression of high-key.

You can create a high-key image by lighting your subject evenly from both sides, using a fill-in or a ring flash, by using reflectors to reduce shadows, or by shooting from a position that minimizes shadows. However, if you are working in low-contrast conditions (with poorly defined shadows), you may simply need to increase exposure (*see box opposite*).

The easiest method is to base exposure on the shadow areas by ensuring that your meter reads light values in these areas alone. If your camera has a spot or selective-area meter, point it at a shadow that still retains some subject detail, lock the reading in, and recompose the shot. If you don't have this facility, you may need to move close enough to a suitable shadow so that it fills the sensor area. If you place the darkest area with detail as your mid-tone, all the other tones in the image will be lighter and you should have very little in the image that is darker than mid-tone.

Alternatively, you can record the image normally (in RAW format if possible) then create the high key effect in post-processing using image manipulation software. By recording in RAW, you will have the most data in reserve for exposure manipulations (*see pp. 234–5*).

◀ Snow seen

Both snow and white sand seen in full sun reflect back a lot of light, which can, if not corrected, lead to dark, underexposed images. To retain the texture of snow or sand, you will need to set your exposure one or two stops higher than normal. The resulting deliberate overexposure lightens the snow to produce a high-key tonal rendering with minimal areas, such as the figures, darker than mid-tone.

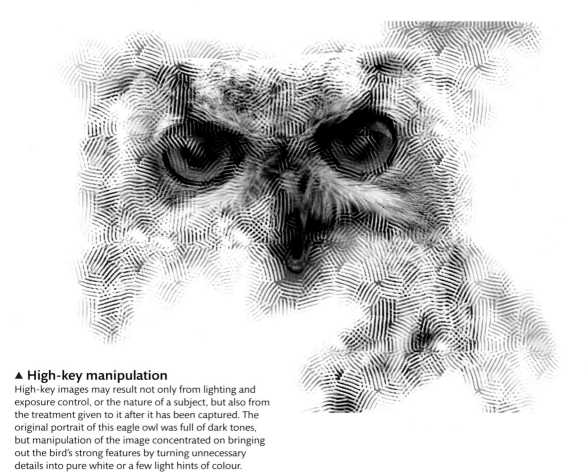

▲ High-key manipulation

High-key images may result not only from lighting and exposure control, or the nature of a subject, but also from the treatment given to it after it has been captured. The original portrait of this eagle owl was full of dark tones, but manipulation of the image concentrated on bringing out the bird's strong features by turning unnecessary details into pure white or a few light hints of colour.

▲ Modernist interior

This corner of a minimalist hotel in Prague presented ideal surfaces for a high-key rendering. Originally a dimly lit scene, use of a generous overexposure softened the differences in colour between the daylight and tungsten lighting and filled the surfaces with high-key tones.

TRY THIS

While high key is essentially a result of lighting that reduces shadows to a minimum, you can simulate the result by overexposing subjects that have a narrow range of luminances. Look for subjects with small differences between their brightest and darkest parts – such as flatly lit subjects on an overcast day. With portraits, use a reflector to bounce light into the shadow-side of the face. If accessory flash is available, use a ring-flash adaptor to even out the light and eliminate shadows.

Make a series of exposures, starting with the metered correct exposure, and steadily increase exposure. You will need an overexposure of at least one stop over the metered setting to fill the shadows with light. Choose the setting that gives you the results you prefer. Note that cameras with dynamic range correction or highlight preservation may need less overexposure.

LOW-KEY IMAGES

The mood of low-key images is in complete contrast to that of high-key: the dominant darkness casts a more sombre and literally darker mood. More than with high-key, low-key images tend to simplify the content of an image, as there is no room for detailed renditions.

Swing low

Technically, low-key images are easier to create than high-key ones, as less lighting, less exposure, and somewhat less control is required. Ideally you light a subject with a single weak light. For example, with a portrait a single source such as a window lights the face from an acute angle so that textures and features cast sharp shadows. You expose for the bright areas: this renders them as mid-tones or lower, which automatically forces all darker tones into deep shadows and blacks.

In a similar approach to high-key imaging, the most flexible technique for determining the exposure for low-key pictures is to concentrate your exposure reading on the light values that still retain subject detail. If you point your spot or selective-area meter at such a region of your subject, that tone will be rendered as a mid-tone grey. This means that everything darker than the light area (most of the image) will be darker than mid-tone grey. Shadows with detail will, therefore, become featureless black.

Note that underexposure with digital cameras can introduce unwanted visual noise, so it may be best to create a low-key effect from a normally exposed image via image-manipulation software. When it comes to printing out low-key images, beware – ink-jet prints with large areas of black can easily become overloaded with ink.

▲ By design
You can force mid-tones and highlights to be darker than usual through manipulation. Here, an image from Tuscany produced through the Hipstamatic app has been further darkened to emphasize the storm-laden atmosphere.

▲ Twilight
The natural time for capturing low-key images is the evening and night. Here a hotel guest reads by lamplight while the day darkens around her. Almost every tone is darker than mid-tone.

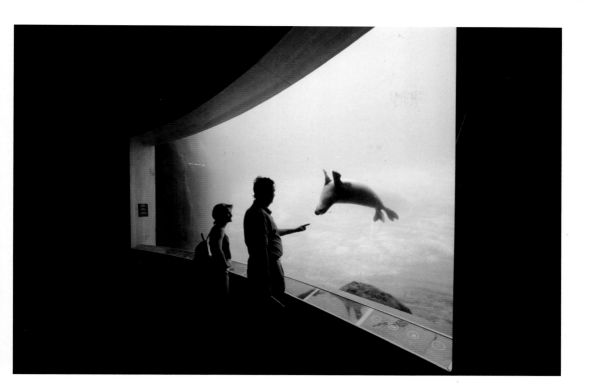

◄ **Dramatic portrait**
For a low-key portrait, all that is required is sidelighting from a low angle, as here, with enough underexposure to send the majority of tones into the shadow. The absence of really bright areas creates a moody feel. This type of portrait is much favoured for older subjects, as it conceals imperfections and wrinkles.

▲ **Two-toned**
Silhouettes – in which the subject is seen only in dark outline against a relatively bright background – are a special kind of low-key imaging. By forcing mid-tones to be very dark, we lose all shadow detail and retain only shape.

TRY THIS

Seek out scenes with a broad subject-luminance range, such as a building with one side lit by sun leaving the other in deep shadow. Make a series of decreasing exposures, starting with the correct one. As the mid-tones progressively deepen to black, the bright areas simply shrink until the image consists of sharply drawn highlights. Notice that the image can work well at many stages.

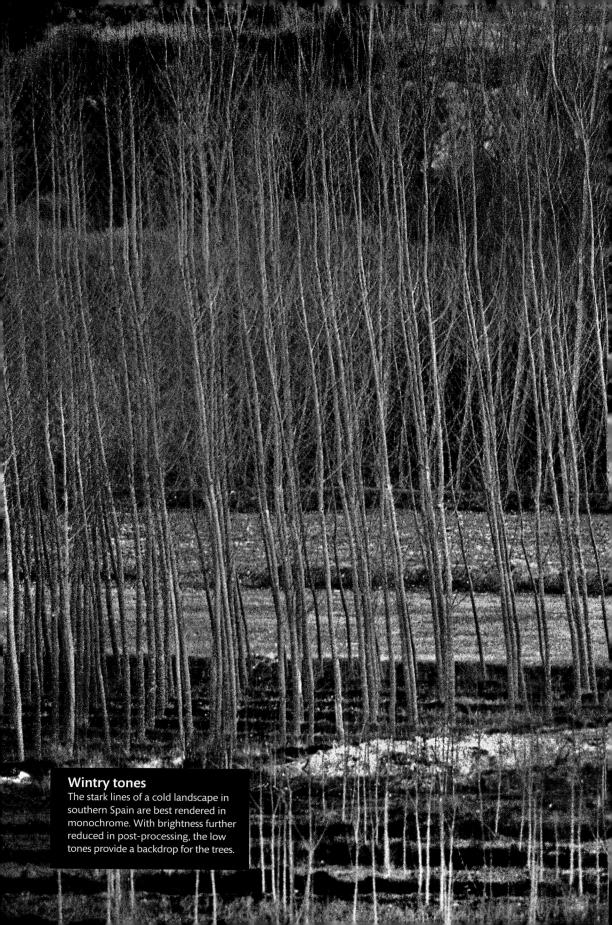

Wintry tones
The stark lines of a cold landscape in southern Spain are best rendered in monochrome. With brightness further reduced in post-processing, the low tones provide a backdrop for the trees.

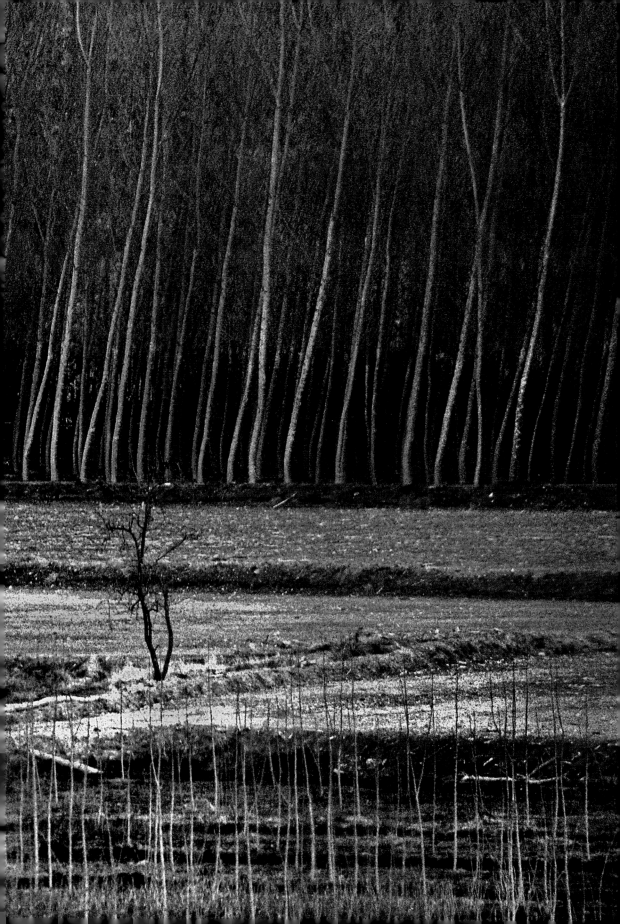

ADVANCED METERING

Determining correct exposure with precision is a challenge to any automated system. For experienced photographers, there is no substitute for taking more or less full control of the process. Unfortunately, this requires not only skill, but also time and careful attention to detail. However, not all work is hurried and, even with digital photography, precisely correct exposure always saves time and work later.

Incident-light metering

For much studio photography, taking an incident-light reading is a much-favoured technique for determining exposure. The light-sensitive cell of a hand-held meter is covered with a translucent white hemisphere that collects light from a very large area. The meter is held at the subject position with the hemisphere pointing toward the camera. Thus, the meter integrates all light falling on the subject to arrive at a cumulative average.

The meter cannot distinguish between one side of the subject being in shadow while another is in bright light; it simply adds the two together. It also takes no account of the nature of the subject itself, which could be dark and absorbent or bright and reflective. In either case, the meter reading would be exactly the same.

The advantage that this method has over a reflected light reading is simplicity; and it always provides a good basis for bracketing exposures (see box below). However, you do need to move from the shooting position to the subject position, which may sometimes be difficult. In addition, small differences in the meter position can make a big difference to the reading, facing you with the problem of deciding which is the "correct" reading. Incident-light metering is, therefore, most useful where bright light is falling on the subject from the side or from behind the camera position; it is tricky to use in backlit situations.

▲ Deciding which method to use

Bright, contrasty lighting from behind the camera or from the side, as in this scene, is ideally measured using an incident-light meter. The key tones in the image are the fish and chair, and if you get those correct then the rest of the scene falls into place. It would have been easy to underexpose this scene, as a normal reflected-light reading could be misled by the light-toned foreground and middle ground, and so set a smaller aperture or shorter shutter time.

BRACKETING EXPOSURES

Since correct exposure is central to good image and reproduction quality, many techniques have evolved to ensure that pictures are properly exposed. The simplest is to take several bracketed exposures, using slightly different settings each time, so that they run from having more exposure than the metered "correct" setting through to having less exposure. It is then likely that one of the images will have just the qualities of exposure you want to see.

Some cameras offer an automatic bracketing mode: they take several exposures in quick succession, all at different settings. Alternatively, you can take a series of manual exposures yourself, each time setting a different value on the override – for example, + 0.5, +1, -0.5, -1 (in addition to the meter's recommended exposure) – in order to produce a bracketed set. Steps of ½ stop are generally recommended: steps of 1 stop are too large except for colour negative film, while steps finer than ½ stop are needed by professionals working with colour transparency material.

Spot metering

Many SLR cameras and some hand-held meters enable you to take a reading from a very small area of the subject – typically from some 5 per cent of the total field of view, down to just 1 per cent (with professional-grade cameras). For work on location, spot metering has two major advantages: first, it allows you to be highly selective in choosing the key tone; and, second, even when you cannot approach your subject, it allows you to take a reading as if you were close up.

The easiest way to use a spot-meter is to decide which patch of colour or tone in the subject should be exposed normally, which should be the mid-tone, in other words. Then you simply take a light reading from that area and ignore the rest of the image (as far as exposure is concerned). Some authorities suggest taking several readings – of highlight, shadow, and mid-tones – in order to determine the mid-point. Indeed, some cameras will automatically make the calculations for you. However, not only is this time-consuming, multiple readings do not deliver results that are any more reliable than those from a single reading.

However, multiple spot metering is useful for determining the luminance range of the scene – its

▼ Preset metering

With fast-moving clouds, Nelson's Column in London was bathed in changing light, while the blue sky behind remained relatively constant. I wanted to catch the sun just bursting through the rim of a cloud – too much sun created excessive flare, while too little lost the attractive burst of rays. If the meter had been left on automatic, the instant the sun appeared the exposure settings would compensate for the extra light and so render the sky almost black. In anticipation of this, I set the camera controls according to a manual meter reading of the sky, which included some bright cloud – thus ensuring the sky was a deep blue. The rest simply consisted of waiting for the sun to emerge, resisting the urge to respond when the meter reading shot up to indicate massive overexposure.

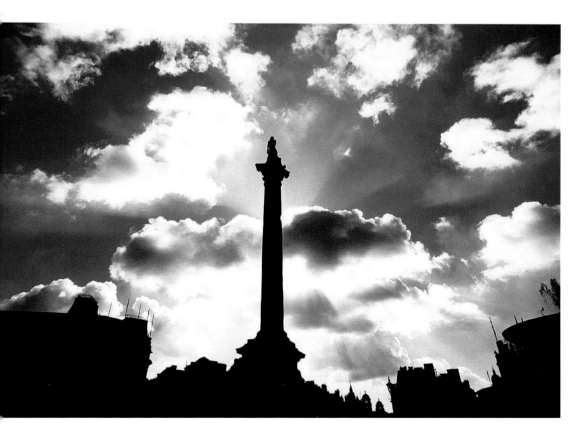

ADVANCED METERING CONTINUED

span of brightness values. You can take a reading from a shadow area with detail and from a highlight area with detail and see by how many stops they differ. If this difference is less than about 3 stops, you can comfortably record the entire scene. If, though, the subject luminance range is greater than about 5 stops (10 stops for SLRs), then because of the sensor's recording limitations, you will need to decide to sacrifice some subject details in the shadows or in the highlight values of the scene. The only other option is to adjust the lighting ratios (*see pp. 68–9 and 80–1*) to reduce the luminance range, if lighting is under your control.

Technical readings

One technique for dealing with variable lighting conditions is to present your exposure meter with a standard target, such as a grey card. This target is printed in a neutral grey colour with 18 per cent reflectance: in other words, it reflects back 18 per cent of the light falling on it. Instead of measuring the light reflecting from the subject or scene, you take your reading from the card instead. Not only is this a cumbersome method, but there are also variations in readings when the card is illuminated by directional light, depending on the angle at which the card is held (even though the card has a matte surface).

However, the grey card is an excellent control where image density or colour accuracy is crucial, as it provides a standard patch whose density and colour neutrality is a known quantity, and this enables an image to be calibrated to a standard. This degree of accuracy is important for technical imaging, such as copying artwork, clothing, or certain types of products for catalogues.

You can go further by including the grey card in the image itself. This provides a target when you make white balance adjustments (*see also pp. 210–11*): when you click on the grey, you tell the software "This bit is reliably neutral grey". When this is corrected to grey, every other colour in the image should be accurate. However, sensors vary in their reproduction accuracy: for the most reliable results include a colour card printed with standard colours which are recognized by the industry from manufacturers such as Macbeth, X-Rite, or DataColor.

▶ **Full of light**
It may look like overexposure, but equally it could be said that the darkest corner under the verandah is correctly exposed. When you aim the spot metering into the darkest area of a scene to fully expose that area, you ensure that everything else is filled with light. For this shot, losing highlight detail is acceptable, as this helps convey the sense of brilliant airiness in this scene from Auckland, New Zealand.

▲ Taking a spot reading

Light from in front of, or to one side of, the camera, as in this late afternoon scene, is best measured using the camera's spot-metering option (if available). You can then select the precise area of the scene that you want correctly exposed. In this shot, the reading was taken from the men's shadowy faces and bodies. The crucial goal is to ensure that the brighter areas of the scene are not rendered too light while retaining details in the shadows. Here, shadow detail has been helped by the reflective qualities of the sand.

▲ Colour accuracy

You can use a grey card – one printed with a mid-tone grey – as a standard target for the exposure meter when faced with subjects that are very dark or very light. However, grey cards are also useful when you need objective accuracy – as in this shot of a rare embroidery from Afghanistan. If you include the grey card, as you can see here, it provides a known standard for accurate colour reproduction. The coloured tabs also included with the object are useful for comparison with any paper print.

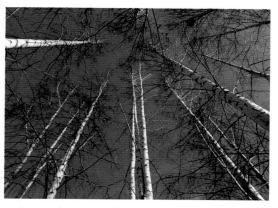

▲ Averaging metering

This view of silver birches is the ideal subject for meters that average light values throughout a scene. Indeed, it demonstrates how rare it is that this method of metering is applicable, as not many scenes have such a small dynamic range and even tone distribution. This scene is such that every method of metering should produce the same result – one that ensures the blues are rendered to mid-tone while the narrow tree trunks retain both highlights and shadows.

ACCESSORY FLASH

Digital cameras, almost without exception, are equipped with a built-in electronic flash. What makes the modern flash so universal is that it is both highly miniaturized and "intelligent". Most units, for example, deliver extremely accurate computer-controlled dosages of light that suit the amount of available, or ambient, light in the scene.

Making flash work for you

Whatever you might gain in terms of convenience by having a ready source of extra light built into the camera, you lose in terms of lighting subtlety. To make flash work for you, you need to exploit what limited control facilities your camera offers.

First, use the "slow-synch" mode if your camera is equipped with it. This allows the ambient exposure to be relatively long, so that areas that are beyond the range of the flash can be recorded as well as possible, while the flash illuminates the foreground (*see below*). This not only softens the effect of the flash, it can also give mixed colour temperatures – the cool colour of the flash and the

often warmer colour of the ambient light – which can be eyecatching.

Second, try using a reflector on the shadow side of the subject. If angled correctly, it will pick up some light from the flash and bounce it into the shadows. Any light-coloured material can be used as a reflector – a piece of white paper or card, a white sheet, or a shirt. Professional photographers like to use a round, flexible reflector that can be twisted to a third of its full size when not in use. It is very compact, lightweight, and efficient, and it usually has two different surfaces – a gold side for warm-coloured light and a matte white side for softly diffused effects.

Third, an advanced option is to use slave flash. These are separate flash units equipped with sensors that trigger the flash when the master flash (built into or cabled directly to the camera) is detected. If you have a flash unit, then adding a slave unit is not expensive. However, you need to experiment with your camera to check if the synchronization of the multiple flash units is correct.

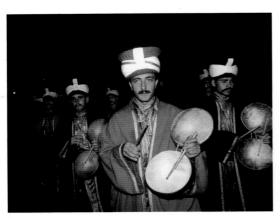

▲ Flash limitations

Dusk in Istanbul, Turkey, and traditional musicians gather. The standard flash exposure used for this image lights only the foreground subjects and the rapid light fall-off, characteristic of small light sources, fails to reach even a short distance behind the first musician. Adding to the problems, camera exposure is not long enough for the low ambient, or available, light levels prevailing at the time. As a consequence, the background has been rendered black. This type of result is seldom attractive, nor does it display any sound photographic technique.

▲ Effective technique

When illumination is low, make the most of what light is available rather than relying on electronic flash. Here, exposure was set for the sky: this required a shutter of ¼ sec, giving rise to the blurred parts of the image. At the same time, the flash was brief enough to "freeze" the soldier in the foreground, so he appears sharp. Utilizing all ambient light ensures that the distant part of the scene is not wholly underexposed – some colour can even be seen in the background building. Compare this with the image in which flash provided all the illumination (*above left*).

Using any set-up with more than one flash means trying out different levels of flash output to discover the best results. Start by setting the slave to its lowest power output, bearing in mind that the task of this unit is to relieve subject shadows, not act as the main light. Some models of camera are designed for multiple-flash photography.

Flash synchronization

Because the pulse of light from electronic flash is extremely brief, even when compared with the shortest shutter time, it is crucial that the shutter is fully open when the flash fires. Only then will the entire film area be exposed to the flash light reflected back from the subject. There is usually a limit to the shortest shutter time that synchronizes with the flash, often known as "x-synch". For most SLRs, this is between $\frac{1}{60}$ and $\frac{1}{250}$ sec. In some of the latest cameras, x-synch corresponds to the shortest available shutter time, which may be $\frac{1}{8,000}$ sec. To obtain this, however, you must use flash units dedicated to that particular camera model.

FLASH EXPOSURE

All flash exposures consist of two separate processes occurring simultaneously. While the shutter is open, or the light sensor is receptive, light from the overall scene – the ambient light – produces one exposure. This ambient exposure takes on the colour of the prevailing light, it exposes the background if sufficient, and it is longer than that of the flash itself.

The second exposure is in addition to the ambient one. The burst of light from a flash is extremely brief, possibly less than $\frac{1}{10,000}$ sec (though studio flash may be as long as $\frac{1}{200}$ sec) and its colour is determined by the characteristics of the flash tube (which can be filtered for special effects).

The fact that there are two exposures means that it is necessary to balance them in order to produce good results. But it also allows you to make creative use of the process by, for example, allowing the flash to freeze movement, while the longer ambient exposure produces blurred results.

▲ **Without flash**
Bright, contrasty sunshine streaming in through large windows behind the subjects – a troupe of young singers dressed in traditional costume from Kyrgyzstan – produced a strongly backlit effect. Without the use of flash, the shadows would appear very dark, but in this case a wall behind the camera position reflected back some light from the windows to relieve the contrast a little, and so retain some subject details.

▲ **With flash**
In this interpretation of the previous scene (*above left*), flash has been used. This produced enough light to fill most of the shadows. Now we can clearly see the girls' costumes, but note the shadows that still remain on the carpet. It is important to set the camera to expose the background correctly: since in this example it was very bright, a shutter time of $\frac{1}{250}$ sec was needed. The f/number dictated by the exposure meter was set on the lens, and the flash was set to underexpose by $1\frac{1}{3}$ stops. This ensured that the foreground was exposed by both the flash and by the available window light.

QUICK FIX ELECTRONIC FLASH

Modern electronic flash units are versatile and convenient light sources, ideal for use when light levels are low (and the subject is relatively close), or when image contrast is high and you want to add a little fill-in illumination to the shadow areas. However, due to the intensity of their output as well as their limited range and covering power, obtaining naturalistic lighting effects and correct exposure can be problematic.

Problem: Common types of problem that are encountered when using electronic flash include overexposed results – particularly of the foreground parts of the image – and underexposed results – particularly of the image background. In addition, general underexposure of long-distance subject matter is very common, as is uneven lighting, in which the corners or foreground are less bright than the centre of the image.

Analysis: Modern electronic flash units have their own light-sensitive sensor to measure automatically the light utput from the flash or the amount of light reflecting back from the subject and reaching the film or camera sensor. As a result, they are as prone to error as any camera exposure meter. Furthermore, the light produced by a flash unit falls off very rapidly with distance (*see above right and p. 80*).

Overexposed flash-illuminated pictures are usually caused by positioning the flash too close to the subject or when the subject is the only element in an otherwise largely empty space.

Flash underexposure is caused by the unit having insufficient power to cover adequately the flash-to-subject distance. For example, no small flash unit can light an object that is more than about 10 m (33 ft) away, and even quite powerful flash units cannot adequately light an object that is more than about 30 m (100 ft) distant.

Uneven lighting is caused when the flash is unable to cover the angle of view of the lens – a problem most often experienced with wide-angles. And another problem occurs when an attached lens or lens accessory blocks the light from a camera-mounted flash.

▲ Light fall-off
Light from a flash unit mounted on the camera falls off, or loses its effectiveness, very rapidly as distance increases. This is evident in this close-up image of a bride holding a posy of flowers. The subject's hands and the roses nearest the flash are brightly illuminated but even just a little bit further baçk, the image is visibly darker. This is evident if you look at the back edge of the wedding dress, for example. The effects of this light fall-off can be greatly minimized by using a light source that covers a larger area – hence the very different lighting effect you get when using bounced flash (*opposite*).

Solution: For close-up work, reduce the power of the flash if possible. When photographing distant subjects in the dark – landscapes, for example, or the stage at a concert, using flash is usually a waste of time and is best turned off. A better option is to use a long exposure and support the camera on a tripod or rest it on something stable, such as a wall or fence. With accessory flash units – not built-in types – you can place a diffuser over the flash window to help spread the light and so prevent darkened corners when using a wide-angle lens.

▲ Mixed lighting

The result of balancing flash with an exposure sufficient to register the ambient light indoors delivers results like this. The lighting is soft but the colour balance is warmed by the ambient light. Also, the background is bright enough for it to appear quite natural. If a greater exposure had been given to the background, there would have been an increased risk of subject movement spoiling the image.

▲ Bounced flash

Direct flash used at this close distance would produce a harshly lit subject and a shadowy background. In this shot, the flash was aimed at the wall opposite the child. In effect, the light source then becomes the wall, which reflects back a wide spread of light. Not only does this soften the quality of the light, it also reduces the rapid light fall-off characteristic of a small-sized source of light. But bounced flash is possible only if you use an auxiliary flash unit. Note, however, that the background is rather darker than ideal – to overcome this, there must be sufficient ambient light to mix with the flash illumination to provide correct exposure overall (*above right*).

▲ Uneven light

On-camera flash typically delivers these unsatisfactory results. The lighting is uneven, the shapes the flash has illuminated look flat, and there are hard, harsh reflections on all shiny surfaces. In addition, the flash has created unpleasant shadows (note the shadow of the lip-brush on the background woodwork). Always be aware of any flat surfaces positioned behind your subject when using flash from the camera position.

HOW TO AVOID THE PROBLEM

The best way to obtain reliable results with flash is to experiment in different picture-taking situations. With a digital camera you can make exposures at different settings in a variety of situations to learn the effects of flash. Some flash units feature a modelling light, which flashes briefly to show you the effect of the light – this is a useful preview, but it can consume a good deal of power and is likely to disturb your subject.

2 PHOTOGRAPHY
PROJECTS

STARTING PROJECTS

A project gives you something to concentrate on, something on which you can focus your ideas or around which you can define a goal. Committing yourself to a specific project can give you a purpose and help you develop your observational and technical skills. In addition, a project provides you with a measure against which you can determine your progress as a photographer.

One of the most frequently asked questions is how you come up with project ideas – and a common mistake is to think that some concept of global interest is needed. In fact, the most mundane subjects can be just as rewarding and – even more important – achievable.

An action plan

■ It could be that your skills as a photographer could be put to use by some local community group. So, instead of giving money, you could provide photographs – perhaps with the idea of holding a local exhibition to raise funds.

■ If you try to do too much too quickly you are heading for disappointment. For example, you want to digitize all the pictures in your family albums. Fine; but don't try to complete the project in a month.

■ You have to be realistic about the money involved in carrying through a project, but preoccupation with cost can freeze your enthusiasm, kill the sense of fun, and become, in itself, the cause of the waste of money.

■ Nurturing a project idea is more about cooperation than coercion. You have to learn to work with the idiosyncrasies and character of the subject you have set your sights on. And doubts and misgivings are very common. If you find yourself inhibited or you are afraid to look silly, or if you think it has all been done before, then you may start to wonder what the point is. If so, then just bear in mind that you are doing this for yourself, for the fun of it. As long as you think it is worthwhile, why care what anyone else thinks?

▲ **Illuminating domesticity**
This is the type of domestic scene that could easily pass unnoticed at home, unless your concentration is sharpened by having a project in mind. Yet, if you were to see the exact same scene on your travels, the simple fact that you were not in your familiar surroundings may make the light and balance of the complementary colours and the rhythm of the vertical or near-vertical lines immediately striking.

▲ **Shadows**
Strong light casting deep, well-defined shadows and the warm colours of the floor make for an abstract image. To ensure that the lit area was properly exposed, I took a spot reading from the bright area of floor, entirely ignoring the shadows.

▲ Juxtaposition

A monument to three wartime commandos in Scotland reflects the three benches erected for visitors to sit and enjoy the view. A long wait in a bitingly cold wind was rewarded when a spectacular burst of sunlight broke through a gap in the cloud-laden sky.

▲ Interior arrangements

The paraphernalia of a restaurant under construction produced a complex of lines and tones that caught my eye. The picture benefited from having the left-hand side slightly darkened to balance the darkness toward the top right of the image.

TRY THIS

Make a list of objects you are familiar with. These can be as simple and ordinary as you like – dinner plates, for example, bus stops, drying clothes, or chairs. Do not prejudge the subject. If the idea comes to you, there is probably a good reason for it. Choose one subject and take some pictures on the theme: again, do not prejudge the results, just let the subject lead you. Be ready to be surprised. Don't think about what others will think of what you are doing. Don't worry about taking "great" pictures. Just respond to the subject – if it is not an obviously visual idea, then you might have to work that bit harder to make it work as an image. Don't abandon the subject just because it initially seems unpromising.

ABSTRACT IMAGERY

Photography has the power to isolate a fragment of a scene and turn it into art, or to freeze shapes that momentarily take on a meaning far removed from their original intention. Or chance juxtapositions can be given significance as a result of your perception and the way you decide to frame and photograph the scene.

Close-ups and lighting

The easiest approach to abstracts is the close-up, as it emphasizes the graphic and removes the context. To achieve this, it is usually best to shoot square-on to the subject, as this frees the content from such distractions as receding space or shape changes due to projection distortion.

Longer focal length settings help to concentrate the visual field, but take care not to remove too much. It is advisable to take a variety of shots with differing compositions and from slightly different distances, as images used on screen or in print often have different demands made on them. For example, fine detail and texture are engrossing but if the image is to be used small on a web page, then a broad sweep may work better. And since you will usually be shooting straight onto flat or two-dimensional subjects, you do not need great depth of field (see pp. 24–7). This is useful, as it is often crucial to keep images sharp throughout.

▶ **Complicated abstract**
Abstract images do not need to be simple in either execution or vision. Try working with reflections and differential focus (focusing through an object to something further away). Here, in Udaipur, India, a complex of mirrors, coloured glass, and highlights from window shutters battle for attention – and bemuse the viewer. Control of depth of field is critical: if too much of the image is very sharp, the dreamy abstract effect may be lost.

▼ **Found abstract**
Here, the decaying roof surface at a busy railway station must have been glanced at by thousands of commuters every day but seldom seen. Perhaps it is a simple expression of the process of ageing, the origins of which can only be guessed at.

ABSTRACT IMAGERY CONTINUED

▲ Modern forms

Contemporary architectural details are rich sources of abstract imagery. Their strong graphic design invites you to take – and delight in – small elements and examine their interaction with other, equally graphic elements. Here, the frosted glass of an apartment block gives a partially obscured view of the courtyard beyond. To increase the abstract look of the image, I simply turned it on its side.

▲ Light play

Observe shadows closely and you will find a challenging and constantly changing source of images. Clear, clean light helps give well-defined shadows that contrast sharply with man-made textures and surfaces. Take care not to overexpose, because that will cause you to lose highlight textures. This type of image often benefits from increased contrast and saturation, as seen here.

COPYRIGHT CONCERNS

You may think that because a poster or other subject is on public view, you can photograph it with impunity. If you are taking the photograph for research or study, for example to illustrate a school essay on advertising, then this may be true. In other cases, however, you may be infringing someone's copyright. If you use a recognizable and sizeable portion of an image on public view as a significant part of another image that you go on to exhibit, publish, or sell, then in many countries you would be in breach of copyright. If you really want to use the image, then at least be aware of the potential legal situation. Note that sculptures, buildings, logos such as McDonald's arches, cars such as the Rolls-Royce, the French TGV train, certain toys, for example Disney characters – even landmarks such as the Lone Cypress tree at Pebble Beach, USA – all enjoy a measure of copyright protection. In reality you may never be taken to court for photographing them – but be aware that, theoretically, you could be.

ARCHITECTURE

The built environment can provide endless photographic opportunities – the problem is not in finding subject matter, but in reducing it to a manageable scale. At the same time, digital techniques make it easier than ever to create stunning images. For example, we can work with a wider range of lighting options than ever before, thanks to tone-mapping software, which blends different exposures into a tonally compressed image (*see pp. 266–7*).

Technical considerations

You can approach photography of buildings in broadly two ways – artistically, in which you treat the architecture as a subject for free interpretation; or you can attempt to be faithful to the architect's design intentions. For technical renderings, you need to ensure that straight lines appear straight and, where possible, that parallel lines are also recorded as parallel. This means using lenses with accurate drawing; that is, those that produce images with minimal distortion. A secondary requirement is that the illumination of the image is as even as possible, so that the corners of the image are not darkened. In practice this is achieved with medium-

KNOW YOUR RIGHTS

Areas open to the public such as shopping malls, or even landmarks such as London's Trafalgar Square, may be privately owned, so if you intend to publish pictures of a particular building, you may need to obtain permission first. Avoid using professional-looking equipment, and make your shots swiftly to avoid drawing attention.

Fears that photographs may be used for planning terrorist acts have caused some police and security forces to prevent pictures being taken in certain urban locations. In many countries you cannot be made to delete your images or to hand over your memory card without being charged with an offence, but it is always best to cooperate with the authorities when you are abroad.

▼ Dramatic highs

The architect may not thank you for this vertiginous view (of Singapore's first high-rise apartment block), but it effectively conveys the structure and its height. Wide-angle views looking directly upwards or downwards are usually quite disorienting, but added to the strongly converging lines, the result is visually powerful.

ARCHITECTURE CONTINUED

speed prime or single-focal length lenses such as 35mm, 28mm, or 24mm – all of around f/2.8 maximum aperture. Note that almost all zoom lenses cause unacceptable levels of distortion and uneven illumination, although some defects can be corrected in image manipulation software.

Foreground reduction

You can also use software to improve the shape of buildings – correcting converging parallel lines and turning distorted rectangules into a squared-off (orthogonal) shape (*see pp. 208–9*). But there are limits to how convincing image adjustments can be, compared to correct capture. Aim the camera level and square to any subject that you do not wish to distort. If you cannot capture the whole height of the building, photograph from further away, if possible, or use a lens with wider angle. Both options result in capturing a great deal of foreground, but this is easily cropped off. For professional architectural work, the shift lens (*see p. 345*) is indispensable: the lens slides upwards to crop out foreground.

View variety

Extreme wide-angle views, that is, focal lengths less than 24mm or equivalent, are tempting, but objects near the edge of the frame appear distorted in small images when viewed close up. If you need really wide views, you can stitch several shots together to create a panorama (*see pp. 298–9*): this is best done with the aid of a panoramic head and tripod (*see p. 346*).

Although it is natural to reach for a wide-angle lens to photograph buildings or interiors, a wide view is not always best. A carefully chosen, narrower field of view can reveal more of a building and its surroundings, so remember to look for telling details, such as a high-up window or decorative elements. In fact, the best way to improve your architectural photography is not by buying a new lens, but by being painstaking about choosing perspective and framing.

Dynamic colour

Photography of buildings needs perhaps greater flexibility with white balance than any other field of photography. This is because lights originating inside the building are usually of a different colour temperature to the light coming from outside. A contrast of colours can be attractive, but too great a difference can distract from the building itself. For the greatest amount of flexibility in adjustment, capture in raw format (*see pp. 234–7*). You do not always have to correct colour balance fully: improvements can often be made simply by reducing the saturation of reds, or increasing their lightness – or a bit of both (*see pp. 214–15*).

◄ Vernacular
Pictures of buildings usually focus on the grand and the monumental, but there are many more possibilities. Buildings locally made without design pretensions – ranging from animal shelters, barns, sheds, and farm houses to fishing huts – are all rich imagery sources. Use local signage and street furniture to enrich picture content.

◄ Distant charms

When in search of the perfect Italian piazza and the grandest duomo, you can start shooting long before you arrive. Here, in Urbino, great towers dominate street views, guiding your exploration of the town and inspiring each step of the way. You can include the ephemera of street signs, hanging washing, and bunting or flags to provide context – or avoid them, to reinforce the atmosphere of timelessness.

▲ Leaning back

Pointing a camera upwards to capture a building seldom flatters it, but for specific pictorial effect, a steeply upward view can work well. Use contrasting foreground elements to help articulate the space in an engaging way.

TRY THIS

Photographing from one spot, using a zoom lens to vary framing, helps train the eye to find compositions. Choose a location to shoot from, then create the greatest variety of images you can by using only the zoom to change the framing. Return to the same spot at different times of the day and in different weather conditions to obtain an even greater variety of images.

▲ Opportunities

Even as you enter a hotel, you may spot a picture possibility. Take a second out to make the shot, for the light may change or you may lose the inspiration of the moment. If your lens does not take in a sufficiently wide-angle view, tilt the camera to use the diagonal of the frame.

INTERIORS

Essential for advertising property for sale or rental, interior views have long been a staple of the professional photographer. Produced with the aim of showing the space in as favourable light as possible – spacious, tidy, airy, and attractive – the potential for creativity and experimentation is limited. But if you are not working for clients, there is no reason to restrict yourself.

Mania for mood

Interior views are most interesting when they convey a mood – the faded charm of a once luxurious hotel, the mysterious ruins of an abandoned house, the remains of a grand palace.

To capture atmosphere, work with light, compose to make the most of intriguing details, but do not feel that you have to get everything into one shot. The best way to use flash to light dark spaces is to aim the light into a specific area to create an atmospheric accent, but not to provide the main illumination. You might manipulate the image to introduce a vintage look, if that will help create a sense of times past and lost.

◄ Vintage interior
For a vintage hotel in Brussels, a faded look, as provided by the Hipstamatic app, was more appropriate than a straight shot. The app applies a filter that turns the overall tone to yellow-green, reduces contrast and desaturates the majority of colours. The result is similar to that obtained from out-of-date high-speed transparency film of the 1980s.

HINTS AND TIPS

- Rooms usually look their largest from a corner, often the one facing the door. A view in which the adjacent corners can be seen will make the room appear large and spacious, but in a small room you may need an extreme wide-angle lens to capture it all. Extreme wide-angle views will appear to elongate objects near the edge so that, for example, round mirrors appear egg-shaped. It is best to avoid such apparent distortion by moving round objects away from the edge of the image.
- Light the room evenly to avoid extensive areas of deep shadow: small lights hidden behind furniture are very effective, and do not have to be perfectly colour balanced. Avoid views that look directly out of a window as the bright light from outside is tricky to balance with the dimmer interior light.

◄ Chateau grandeur

With grand spaces made to impress, it is easy to obtain an eye-catching image. You can shoot from any corner of the room – although it is best to have your back to the windows – and you can shoot from a high vantage point. From an atrium balcony you need only a moderately wide-angle lens to give good account of the space.

▲ Transit zones

Architects love transit zones or areas: they are often neglected by the average visitor, but of course no building can do without them. They are usually used more than the main rooms, and they structure the character and style of the spaces, so make room for them in your photography.

▲ Restored glory

The extensively restored throne-room of Frederick II, in Gioa del Colle, Italy, is seen here from the throne itself. This viewpoint was chosen to show that subjects entering the room are very well lit by large windows. In contrast, the throne itself is in darkness.

Modern in retro tones
Sleek hotel interiors may be most natural when captured in colour but can take on more style and character when toned as if the image were created with dark-room processes.

DOCUMENTARY PHOTOGRAPHY

The full spectrum of documentary photography covers prosaic recording, or the "soft" story, such as construction progress or family life, through to the "hard" stories, such as a civil war or drugs trafficking. Whatever the subject, what matters is the approach: classic documentary is about recording with empathy the everyday existence of people, wherever they may live – if necessary revealing unpalatable truths, and recording for posterity events that some would prefer to be forgotten.

Preparation

In this, perhaps the most vocational of all genres of photography, subjects tend to choose you, the photographer. Injustices in an occupied territory may suddenly come to your attention, and you feel you must do something about it. Orphans in a city may break your heart, and you are moved to tell the world about them. While it is important to be motivated, it is also important to be a dispassionate observer. Study the subject area: read relevant legislation, speak to people affected, talk to local experts and charity workers: become expert yourself. This prepares you for the photography by informing your vision and directing your search for the telling image. It will also prepare you for the essential step of writing informative, accurate captions.

When it is clear to your subject that you are serious in your intentions, know what is going on, and can be trusted, you will find it easier to obtain cooperation. This is vital a step, if only to ensure your safety: do not be too eager, nor believe that you have to be pushy and determined. And never forget that your safety is more important than any images you could obtain.

Softly, softly

Technically, documentary photography is 90 per cent being there, 10 per cent pressing the button. Small, discreet cameras such as point-and-shoot or compact interchangeable lens (CIL) models attract less attention and are less intimidating than large SLR models with long zoom lenses. Cameras without mirrors are also quieter than SLRs – some are totally silent in operation. Point-and-shoot

cameras are also much less expensive, so you can use two or three at the same time and you do not have to worry too much about damaging them in rough conditions.

When choosing a camera, look for good low-light operation – rapid autofocusing and images with low noise (*see pp. 194–5*) – so you do not have to use flash indoors or at night. Cameras with larger sensors – APS-C or larger – give the best performance at high ISO settings, and CIL cameras can be fitted with very fast (large maximum aperture) lenses, for example 24mm f/1.8. The ability of modern cameras to capture high-definition (HD) video can also be invaluable in documentary work – more and more documentary photographers are combining moving images and sound with still images.

Formal requisites

Reliable documentary work relies on the unaltered digital image in order to be a truthful, unvarnished record. It is acceptable to make tonal, exposure, and colour balance corrections, and to convert to black-and-white. There should be no change of content such as the removal of distracting elements.

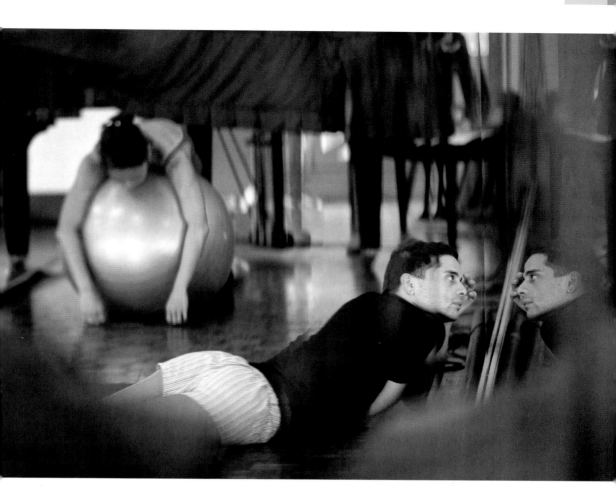

◄ Container movements

Even if circumstances – such as safety concerns – prevent you from being close to the action, there is always a way to pull the viewer into the shot. Here, by holding the camera with an ultra-wide-angle lens close to the operator's head, I made him appear large compared to the workers behind. Converging parallel lines draw attention into the "back" of the image.

▲ Intermezzo

Dancers of the Singapore Dance Theatre relax between rehearsals in an image that may not be first choice for publicity or promotion, but is an affectionately truthful portrayal of a moment in the lives of hard-working dancers.

CITIZEN REPORTING

With over a billion cameras and camera phones in use around the world, there is sure to be a photographer not far from any incident. Today, ordinary people are recording news instead of being passive witnesses. It is important to understand the responsibility of accurate reporting, and not to alter or manipulate images of news events: staging or re-enacting an event is unacceptable. Camera phones are ideal for posting images to a newspaper or television news desk, but before submitting images to anyone, including photo-sharing and social network sites, ensure you do not lose your rights in the image.

DOCUMENTARY PHOTOGRAPHY CONTINUED

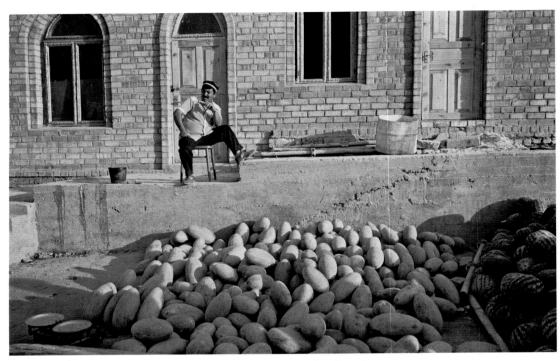

▲ Proud portraits

Some people can be too cooperative, sitting to attention with a broad smile when they see a camera pointing at them – as this melon-seller in Tajikistan did. Make the exposure anyway, thank them and expose again when they return to a relaxed, more natural pose.

▼ Wordless image

The ideal documentary photograph says it all in the image; there is no need for a caption to tell you what is going on. All you might need to identify it is location: in this case, Tashkent in Uzbekistan, where heavy rain in a desert-dominated country is unusual.

MODEL RELEASE FORM

If you take pictures of people and intend to use them in commercial ventures, this legally binding agreement between subject and photographer allows you to use the pictures without any further financial obligation or reference to the person depicted. For the personal use of a photograph, it is generally not necessary to obtain the model's release; however, if an image is intended for commercial use it is advisable to obtain signed consent. A simple form of words is: "I permit the photos taken of me (subject's name) by (photographer's name) to be printed and published in any manner anywhere and at any time without limit." The consent form should also note the date the pictures were taken, the location, and carry the signature and contact details for both the subject (or parent/guardian) and the photographer. Both parties should sign two copies – one is kept by the photographer, the other by the subject. In some countries, a consideration (the payment of a sum of money or the giving of a print) is required to make the contract binding.

▲ Combining elements

In documentary photographs everything counts: there is information in every corner of the image, and every portrait of a person is also a portrait of the place and the situation. Make it all count: a boy tailing me wears local clothes, the door casts shadows on carpets – all have stories to tell.

▼ Eloquent scenes

It is easy to capture pictures of buildings and living spaces, but it is always worth waiting for a little of ordinary life to pass by. You never know what will turn up and what it will tell you. Here neglect of a traditional district is brought into focus by a woman crossing the road.

STREET PHOTOGRAPHY

The invention of 35mm miniature film and small cameras completely freed photographers from the studio to photograph the world at large. Since then the urban street, with its unending, bustling activity and unpredictability, has proved to be an inexhaustibly rich source of images. With your camera, you can explore any city's streets: the photographic rewards can be great, and you will also get to know your surroundings better.

Fortune telling

The core of street photography is the spontaneous juxtaposition of the different elements of a street scene – people, objects, and features of the urban landscape – in such a way that the composition gains a meaning or significance that is greater than the mere accident of its subjects being in the same place.

This means that composition and timing are crucial, but more importantly, street photography is driven by a keen, highly tuned awareness of movements and objects in the street. With practice this leads to what is almost an ability to read the future. This is essential because meaningful compositions or juxtapositions usually appear with only a faction of a second of lead-in time, and

dissolve in even less time. Therefore street photographers must anticipate every shot: a little experience will show that if you merely try to respond to a situation that you are witnessing, you will already be too late.

Street wise

The great French photographer, Robert Doisneau, explained that the secret of his success at street photography was to "Walk, walk, and walk some more". Explore your city on foot, watching and experiencing the variety of scenes and subjects on offer. Take advantage of the fact that many cameras are extremely compact and lightweight, and can be easily carried all day – keep your camera in your hand, powered up and ready to use.

Use manual focus set, for example, to 4 m (13 ft), and ensure you capture action within that distance: this greatly speeds up your camera's responsiveness. Remember that an imperfect shot perfectly timed is preferable to a perfect shot badly timed. Be mindful of your own safety while you are shooting on the street, especially at night; conversely, if you sense that your presence is making someone uncomfortable, desist immediately.

▲ No room for boredom
While waiting for your bus or train, or even for a thunderstorm to clear, you can help pass the time by being observant and taking an interest in how people behave. Here, a camera phone was the perfect tool for capturing reactions to a downpour in London.

PRIVACY AND SECURITY

In some countries, the legal view is that people have a right to private lives even in public. Therefore taking photographs of people in public spaces without their permission may be an offence. In other countries, photography of people may be offensive on cultural grounds. With increased awareness of photography worldwide, the safest and most polite course is always to obtain permission whenever you wish to photograph someone in such a way that they will become the main focus of the image. For an image to be used commercially, a model release will be mandatory (*see p. 107*). Street photography featuring large numbers of people is not usually problematic, but even so, you should be sensitive to people's feelings, which take precedence over your right to photograph.

▲ Opportunistic juxtaposition

From a vantage point in a Brussels café, the signage on the window provided a stylish framing for the activity on the street below. By adjusting the camera's position, the curves fitted around the table below. All that remained was to pay attention to what was going on. A compact camera is ideal for such shots because it is easy to hold for long periods.

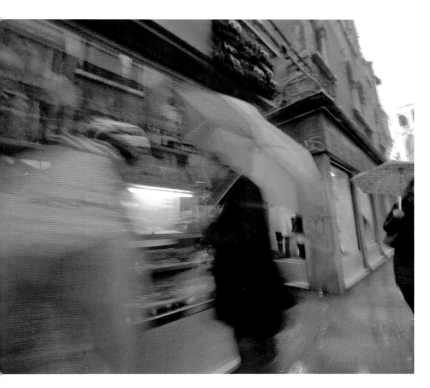

◄ Blur of life

There are no rules in photography: you do not have to frame or time your shots precisely, you do not have to capture expressions, and your image do not have to be sharp. Enjoy yourself by working with random occurences such as unexpected combinations of colour and light – you can even capture them while on the move. In this shot, the varying degrees of blur add textural variety.

HOLIDAYS AND TRAVEL

Modern cameras make it a fun pursuit to capture pictures of your holiday that will remind you of the trip for years to come. But you will find it far more satisfying to create images that can stand on their own, and that have an appeal and interest that goes beyond your circle of friends and family. At the same time, if photography is not a priority for other members of the group, you need to be careful not to spoil their fun or keep them waiting around while you take pictures.

▲ Food and drink
Part of the fun of holidaying is experiencing different food in new locations. You can incorporate this into your photography: record not only the meals, but the place settings, the reflections of a sunset on the table and the refractions of candlelight in your wine glasses.

This is us
An effective way to get everyone used to you pointing the camera at them is to start shooting from the very beginning – for example, from the moment you meet up at the airport. Avoid arranging everyone into a formal group shot, but capture your friends as they chat to each other, consult maps, or send last-minute texts. Keep shooting as you move from one location to another. Before long, you will be creating a natural, sequential record of your holiday, in which the more obvious shots of landmarks and monuments will have a fitting context.

Subjects and approaches
Looking to your broader surroundings, you can develop photography projects that tell the viewer

something about the location – for example, local street food, posters, transport, or graffiti – whatever interests you. As you travel, your portfolio will grow in depth and extent in a most rewarding way. More importantly, you will find that as you become attuned to your subject matter – perhaps pursuing a particular theme and actively seeking out interesting or unusual examples – your eye for all kinds of other detail will be sharpened, with great benefit to your photography.

▶ Sunbed views
Even from a lazily prone position, you will see picture opportunities. Be prepared to grab your camera phone to snap the shot, and then you can get back to the serious business of relaxing.

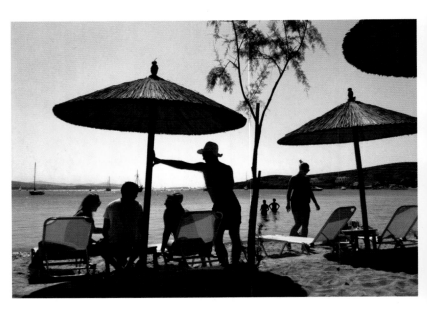

▲ Changing emphasis

Even when the weather is less than perfect, the observant photographer can always find picture opportunites. In this view of downtown Auckland, New Zealand, rain from a storm beats on the windows of an observation tower. It is usual to focus on the distant view, but by concentrating on the raindrops the scene shifts, and there is suddenly a picture to be made.

Looking beyond

However, your travel pictures do not have to be simply a record of a place, or of the day-to-day minutiae of your visit. If you can capture a human emotion, tell a story in which one picture entices the viewer to look forward to the next, and create images that inform as well as delight, you will make a breakthrough. This takes skill: you will need sharp reflexes to respond to changing circumstances – your subjects may move unpredictably, you will be in unfamiliar situations, and light conditions may change without warning. This calls for well-practised camera technique, and it helps if you have equipment that can react quickly.

Even more important is acute sensitivity to the friendliness or antipathy of your subject, and to the cultural and social subtleties of your surroundings. You will also find it much easier if you are engaged and involved with your subject on a personal level that goes beyond simply photographing them in passing.

▲ Key components

Instead of posing them in front of the sunset, try incorporating your travel companions into the scene, so that their presence enhances the image.

SHARING MEMORIES

Of the many tasks to follow up after you return home, perhaps the most easily forgotten is the promise to send prints to people you have made friends with and photographed on your trip. However, digital photography makes this easier than ever before. You can make individual prints from files, or even travel with one of the very small, portable printers available. You can also post images onto social networking or picture-sharing websites, then contact people you have met and direct them to the sites.

HOLIDAYS AND TRAVEL CONTINUED

Recording relationships

A photograph of someone you meet on a trip is much more than a likeness: it is a record of your encounter, the meeting of two worlds. Pictures of people are perhaps the single most rewarding aspect of travel photography, particularly since developing genuine relationships with people opens doors that would otherwise remain closed to you.

A useful practice is to restrict your focal length (see box opposite). In order to fill the frame with your subject, you will have to move physically closer. This is easier if you have first formed a relationship with them – even if it is a fleeting one. Indeed, if you have created a rapport – often all that is needed is eye contact and a friendly smile – it is actually more comfortable to photograph from close up than from a distance.

The eyes have it

The most eloquent part of a portrait image is a person's eyes; that is what we instinctively look at first. Face to face, a glance at a person's eyes tells us their mood and intention, and likewise with images: we immediately gather information about the person from their eyes. The expression in your subject's eyes concisely conveys the nature of your relationship with them: if there is warmth and cordiality, we will be drawn to the image.

When you see someone you want to photograph, get your equipment ready. Set aperture depending on whether you want minimum depth of field with a blurred background, or if you want your image to be sharp throughout. If your subject is dark-skinned, set any exposure compensation to underexpose by around ⅔ stop. Anticipate the best angle, bearing in mind the direction of ambient lighting and the background, as well as what the subject is doing. Only when prepared should you reveal your intention to photograph. The rest involves simple life skills: approach honestly and openly, make eye contact, and say hello in the local language.

▼ Evocative imagery

The receding parallel lines of these railway tracks in Uzbekistan powerfully evoke a sense of space. In this image I balanced the need to show a long stretch of track with the size of the people on the line. If they were too far away, they would appear too small to have impact, and if they were too near, they might overpower the background.

▲ Fresh views

Every corner of Burano, one of the prettiest settlements in the bay of Venice, cries out to be photographed. If you are not satisfied making the same old images, there is still room for innovation. You need a little more patience – here, to wait for water to settle to mirror-like calm – and a bit of luck too. By seeking out the unexpected, the surprising shots will come to you: be ready for the unusual, and stay alert for you may get only one chance.

◄ Incongruities

A glamorous pirate in sunglasses is not something you encounter everyday. But if you are in Arezzo, Italy, you may see a band of "pirates" rampaging through its most perfect piazza regularly as an event put on for tourists. Treat such unexpected opportunities as a gift, and photograph freely.

TRY THIS

Restricting the focal lengths available to you helps improve agility, composition, and your ability to get close to subjects. Start with a maximum of 90 mm or equivalent and compose your images by moving towards or away from your subject. Try to fill the height of a landscape format or width of a portrait format with a person's head and shoulders. Next, learn to use a 50 mm setting. Then a 35 mm setting: try to fill the frame with action and content. You can do this only by stepping inside the action. As you gain experience, try to use even shorter focal lengths; however, 24 mm or less is widely considered very tricky for general use.

HOLIDAYS AND TRAVEL CONTINUED

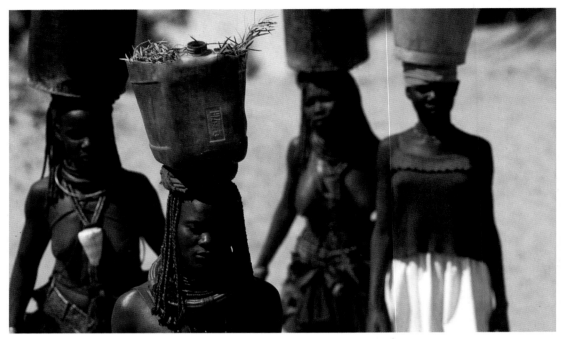

▲ An outsider's eye

There is no clear distinction between travel and documentary photography. A single shot of Himba and Herrero women collecting water makes an engaging travel shot. But they are walking in the heat of the day instead of the cool of evening: this tells us something is amiss. Indeed, there was a lion attack earlier, so it was safer to walk during broad daylight. Revealing aspects of a subject's life can lend a documentary element to your holiday photographs.

RESPECT YOUR HOSTS

You will find that when you dress and behave appropriately, you will receive a warmer, more cooperative reception when you want to photograph. Treat your hosts' country with the same respect you would expect of tourists in your homeland. Dress in a style that is appropriate to the cultural or social expectations of the country you are in: wear long sleeves and cover your legs if you expect to visit religious sites. By the same token, be respectful of the locals: don't insist on taking pictures of people if they wave you away or seem unhappy about it. And always keep in mind the sustainability principle that you should leave a country as you would wish to find it.

▶ Selective view

Ostensibly this is a study of contrasts – between the baby's hands and those of his grandmother; of colourful clothes against tanned skin – but this view also delicately draws the viewer's gaze from the subject's faces, making an unusual portrait.

▼ On the road

The advantages of staying awake while travelling cannot be stressed enough. After six hours on a bus it is easy to nod off, but you would miss telling moments such as this: the driver had to be paid from outside because the bus was so full.

◀ Way of life

It is natural to concentrate on the exotic beauties of a country, its customs and way of life. While it may not be very beautiful, the realities of day-to-day existence in a foreign land are not only more true and useful for an understanding of the country, they are vastly more interesting. You do not need to seek out poverty or destruction – you are not working on a documentary story. All it takes is to keep your eyes open and camera at the ready: this scene in Tajikistan came and went in a second.

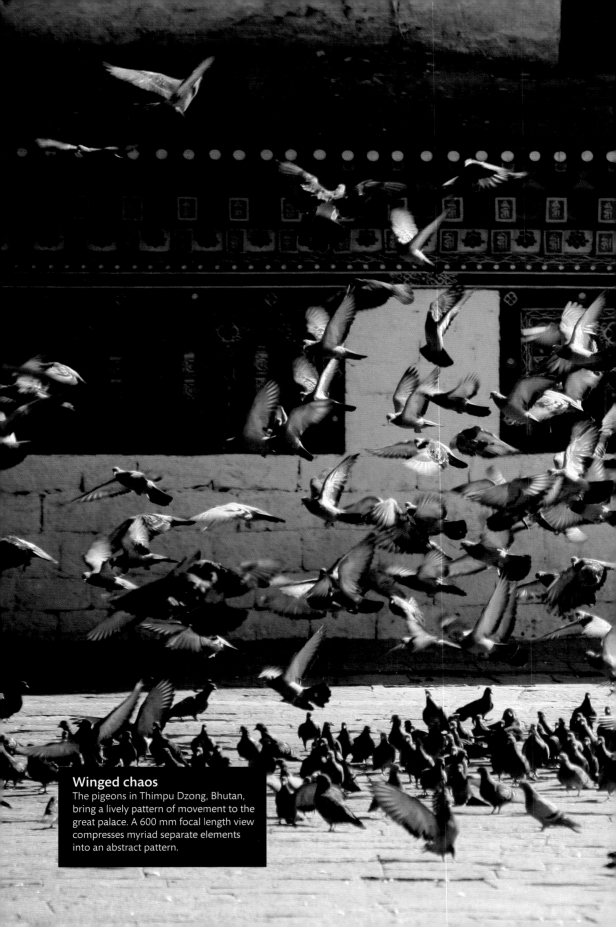

Winged chaos
The pigeons in Thimpu Dzong, Bhutan, bring a lively pattern of movement to the great palace. A 600 mm focal length view compresses myriad separate elements into an abstract pattern.

WEDDINGS

The documentary approach to weddings is as much a reaction against stiffly posed formal shots as it is a product of improved cameras. This enables every wedding guest – from grandmother to toddler – to capture pictures of the event. If you are not the official photographer, you can shoot freely without concerns for comprehensive coverage of all guests and ensuring all the formal groupings are captured.

Professional challenge

The role of the professional wedding photographer is to provide a set of unique images that will record and evoke the experience one of the biggest days in a couple's lives. To do this they must search for angles and interpretations that, as well as being creative and inventive, raise their images well above the ordinary: a celebration of a special day should be matched with some very special pictures. A popular solution is to capture the couple in a fantasy setting. Use an off-camera flash to balance against twilight skies or shoot the couple against a plain screen (green is preferred but any plain or black background can work) ready to composite against a glorious sunset or woodland scene.

At the same time, you need to capture all the key moments too. Make sure you are familiar enough with the ceremony to position yourself ready to take the shot of the exchange of rings, the signing of the register, or the first married kiss. Take care not to interrupt delicate moments such as the exchange of vows or the blessing from the presiding person.

One straightforward way to distinguish professional work from others is to work with a very large-aperture lens – for example, a 85 mm f/1.4 or 135 mm f/2 – which you can use exclusively at large aperture settings. The resulting shallow depth of field and softness is unlikely to be matched by people using compact point-and-shoot cameras. Besides, the soft focus also perfectly suits the romantic nature of the subject.

Another way to stand out from the crowd is to use available light instead of flash when working indoors or at night. Full illumination by flash is often necessary, but it easily destroys the atmosphere of dim or coloured lights.

Rounded views

The inventive wedding photographer does not neglect to record those aspects which others may not think of capturing, but which create a rounded record of the event. Often the most charming and amusing moments occur in the run-up to the main

▶ **Bride showered**
The intimate moments of preparation may be barred to all but female photographers or close relatives, but it is worth capturing the process of adorning not only the bride but the bridesmaids, as well as best man. The images display the process of transformation – from the ordinary to the celebratory. Use limited depth of field to emphasize key elements such as the jewellery and accessories.

event: seek out fleeting moments in the frenetic activity of preparation. A lot of effort goes into the details, so make sure you look at the rows of champagne glasses, the furniture decorations, and the details of the costumes and flowers.

Follow on

Once you have captured all the happy moments, you have completed only half the work. Unlike many photography assignments, the choice of images is one in which the photographer may be expected to lead, as clients are usually not experienced in picture editing. In addition, some images are obligatory, whatever small technical defect they may have.

Remember to be clear to the couple about the images rights at all times, and when handing over the images remind them that the pictures should not be reproduced or posted on social networking sites without further fees.

▶ Supporting cast

Everyone and everything is important on the big day: the bride's flowers will be seen in many pictures taken by the guests, so aim for a shot that is less obvious. Here, backlighting and graceful continuation of lines gives charm to the complementary beauty of bride and bouquet.

▲ Hilarity seriously shot

The funny moments of a wedding are essential for recreating happy memories of the event. However, you can shoot them with some sophistication. Wide-angle views lit with flash are commonplace. Try using a long focal length setting and exploit blur and overlap. In this shot, the blurred figures frame the beautiful profile of the bride, while the champagne glass helps anchor attention around the smiling faces.

▲ Transistional states

While the key moments, such as the exchange of rings and the kiss, are must-have shots, the quiet moments also make up the event as a whole. These transitions often reveal touching moments and true relationships between family members and guests. Here, a bridesmaid walks happily between older family members, her head of dark hair framed by backlighting against the dark jacket of another guest in front of her.

CHILDREN

Children tend to be photographed in different ways according to whether they are known to us or not. The reason for this is that we tend to approach familiar subjects in a different way to unknown ones. For example, most people prefer to photograph their own children when they are looking their best in attractive, clean clothes, and smiling for the camera. However, the opposite approach may present itself when, for example, you are visiting another part of the world and you photograph a child as part of the local colour of a street scene. This will naturally give your image a very different feel.

A change of attitude

So the photographic challenge is clear: how to bring the two approaches together, being more honest when photographing our own children, while being respectful and considerate when our photographs feature other people's children, especially those from other cultures.

Informed photography is the key, as the more we know, the more perceptive our photography becomes. For example, try to learn about the games that children play, or take an interest in their pastimes. If you are photographing your own children, try to avoid obviously staged images, and instead concentrate on capturing some of the spontaneous moments that occur in everyday family life. Children tend to pose either too readily or not at all. The trick is to wait for them to get bored of you. Keep shooting, whatever they do: aim at them if they are acting up, or aim away if they are being shy. Sooner rather than later, young children will tire and let you get on with shooting. All you need is to have more patience than they do.

PUBLIC STANDARDS

Taking photographs of children may create unexpected risks for the photographer because of the – entirely understandable – desire to protect children's safety. Photography of children who are not your own should be approached with caution, particularly in public spaces such as parks and beaches, and near schools. Always seek the permission of parents or legal guardians (carers may not have sufficient authority) before starting to photograph. If you are at all in doubt, err on the side of caution.

◀ Having a chat
Children often learn to pose for the camera from an early age. If you are looking for a more natural portrait, try engaging your subjects in conversation. When they become interested in what you are talking about, they will stop playing up to the camera. They also stop running about and become easier to keep in focus, giving you a chance to set maximum aperture to throw the background out of focus, and use a shorter exposure time.

▲ The eyes of mistrust

A lad in the high mountains of Tajikistan looks decidedly cautious, as well he might. More important to him than how he looks on camera is whether he will have to fight to keep the birds he has captured in his makeshift cage. Once he overcame his mistrust, a very different image resulted, but it is this edgy image that is more interesting.

▲ Child's world

Images of children are not only about them, but also about the space they inhabit. By zooming out, you can show the child in relation to the world at large.

▲ Otherwise occupied

A distraction can be beneficial for the photographer: it not only takes the child's eye off the camera, it can show your subject lost in his or her world. Recording the best of these moments may call for many exposures, but do not be tempted to keep only "the best": these judgements vary over time, so hold on to everything you shoot. With cheap mass storage readily available, your only regret will be deleting an image.

CHILDREN CONTINUED

HINTS AND TIPS

Children can be a challenge in technical terms, as they are small, low down, and move quickly. They require stamina and fitness on the part of the photographer, as well as quick reflexes. You can help yourself by trying out these techniques:

- With very small children, work at a fixed distance: focus your lens manually to, say, 0.5 m (18 in) and keep your subjects in focus by leaning backward or forward as they move. Small children move very quickly but usually only over short distances. This method requires little effort and can be superior to relying on autofocus.
- When you first photograph a group of children, fire off a few shots in the first minute – they need to get used to the sound of the camera or light from the electronic flash, while you need to exploit their short attention span. Once they have heard the camera working, they will soon lose

interest and ignore you. If, however, you wait for them to settle before taking your first picture, they will be distracted by the noise.

- For professional photography of children, the best cameras to use are CXL (compact interchangeable lens) or SLR cameras, preferably equipped with a prime lens. These give you more flexibility than compact point-and-shoot cameras. You also need the shortest possible shutter lag (the time interval between pressing the shutter and actually recording the picture) if you are not to miss out on the really spontaneous images.
- In low light, increase the ISO setting in preference to setting the lens's maximum aperture when using non-professional lenses. If you have high-quality optics, use the widest aperture freely, but you will need to focus more carefully. Avoid using flash lighting except as a fill-in (*see pp. 80–9*).

◄ A candid approach

A large fountain in hot weather is irresistible to children anywhere in the world. The problem here was trying to photograph the boys without them realizing – otherwise they would start playing to the camera. I mingled with the crowds, enjoying the sun, and waited for a suitable grouping and rare moment of repose.

► Sibling rivalry

A set of nothing but smiling, happy pictures of children quickly makes for predictable and dull viewing. Children also get cross, cry with frustration, exhaust themselves, and fight or play with siblings. With compact and responsive cameras and camera phones, you can be on hand to record all those telling moments.

LANDSCAPES

The natural landscape – topographies of land and water decorated with plant forms and lit by sun and sky – is one of the most accommodating yet challenging areas of photography. A landscape may be photographed from any angle, at any time, and in any weather. But you have to do all the work. Stylistically, you also have decisions to make about how much of your own individual mark you wish to to make in your images.

Patience and perseverance

A vital but little-appreciated truth about landscapes is that anywhere can look wonderful at some point in time. A ploughed field, the edge of a forest, or a grand sweeping vista is, photographically, a set of ingredients just waiting for the key elements of light, sky, and your personal vision to come together to concoct a stunning result. You just need to be sure to be there for the occasion. A glorious landscape photograph is seldom the product of a happy accident. While practice can prepare you to be in the right place at the right time, the truly great

▲ Clarity and tranquility
Use man-made structures to contrast with topography: these sharply-defined silhouettes provide a foil to the soft clouds and distant hills of New Zealand's Northlands.

images are usually the result of a photographer returning to the same spot again and again, sometimes over a period of years. From time to time they may obtain a successful shot, but they know there will always be a better one – tomorrow, next month, perhaps next year. Over time, these photographers also explore and refine their viewpoint and composition, until, one quiet and perfect moment, everything comes together.

▼ Self inclusion
It is fun to include yourself in a view, but there are many ways to do it. Here, the long, late-afternoon shadows suggested a natural way to put ourselves into the shot.

▲ Upstaging

As one's eye is drawn to the monumental landforms – here in Valley of the Gods, USA – it is natural to focus on the distant features. You could use extensive depth of field to keep the foreground in focus too, but a more inventive variation is to focus on the small elements at the front, using a large aperture to blur the giants further away.

Bare necessities

There are therefore three essentials of landscape photography – place, time, and means – but the most crucial of all is place. Once you see a view that is promising, it is best to slow down completely – even put your camera away. Then just walk and look, walk a little more and look a little harder. What you are seeking is a manipulation of the relative scale of elements in the scene, with which to create a powerful sense of space within the picture frame. For example, flowers in the foreground appear as tall as mountains in the distance, and pebbles in a river bed are the size of trees further upstream. Your viewers share your experience of the world and the distorting effects of perspective, so they understand the real relative sizes of objects. What they see in your image leads them to reconstruct the spirit of the landscape in their minds, but guided by you. You will find that miniscule changes in position or height can make the difference between a revealing image and one that is unsurprising and ordinary.

▲ Three in one

Tone compression is effective not only for scenes with extremely wide dynamic ranges, but also flatly lit scenes where you wish to extract shadow detail. Combining three different exposures of this subject, in the Welsh Marshes, provided great flexibility over tonal control.

LANDSCAPES CONTINUED

Once you find your position, you may need to wait for the light to add the finishing flourish. This might mean pausing while a cloud makes its way across the sky, or returning again and again until you catch the perfect moment. Light may be raking and dramatic in effect, or flat, bringing out subtleties of tone. On three different days you might obtain three very different images – and all from the same position.

Style and means

A tradition has developed that demands large, high-resolution cameras for "proper" landscape photography. This is an issue of style rather than technique. If you wish to make poster-sized prints and you prize extreme detail, by all means use the highest quality equipment you can afford. However, even a camera phone is perfectly acceptable, if you actively use the imperfections of the capture – such as light fall-off – as features of your images. Furthermore, any lens may be used, from ultra wide-angle through to the longest telephoto.

Working in black and white is another way to individualize your landscapes: the exact way you remove the variety of hues to translate a full-colour facsimile of the view turns any black-and-white image into an artistic interpretation. You might also manipulate the image towards a vintage look, to make it appear to be the product of irregularities of processing. Other ways to build a personal style include consistent use of extremely shallow depth of field, by setting apertures not smaller than f/2, for example. Some photographers use long telephoto lenses, while others exploit motion blur through long exposure. Or your could try over-exposure in flat lighting to obtain pale, bright results.

▼ Unconventional views

In a world saturated with beautiful travelogue-style landscape images, there is a place for the more dispassionate view, one that does not flinch from showing scarring from agriculture or the impact of industry. This image, from the Marche of Italy, was made with a long telephone zoom to pull far-separated elements onto the same plane.

◄ Vintage views

While it always pays to capture the best image you can at the time, the demands of the enviroment may mean that you have to grab what you can when you can. This image of a snow-line walk in Tajikistan, was improved in post-processing by adding a layer of tone and vignetting to suggest it was captured by early processes.

▲ Friendly shadows

Often treated as an enemy, shadows are in fact a landscape photographer's friend: they sculpt shapes, define textures, and delineate distance. Fully lit, this scene lacked depth, but when a cloud darkenened the foreground, it was visually separated from the valley sides that were still in sun. A duotone effect (*see pp. 238–9*) recompresses the tones.

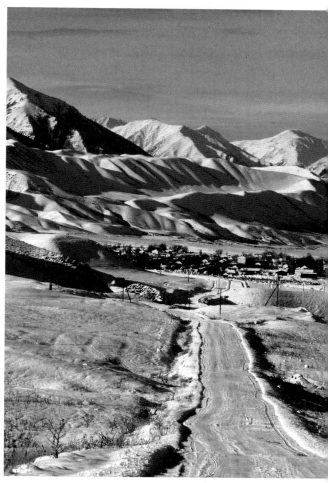

HINTS AND TIPS

All landscape views respond well to being shot as black-and-white or converted from colour. However, default conversions often deliver a lack-lustre result.

- Convert colour using channel mixing or similar controls that allow different tones to be assigned to bands of colour, for example, to make greens lighter, or to darken the blues (*see pp. 224–9*).
- After conversion, exposure and contrast may need improvement: use tonal controls such as Levels (*see pp. 188–9*) or Curves (*see pp. 218–21*) to effect this.
- Try applying unsharp masking (*see pp. 196–9*): this applies a micro-contrast adjustment to edges, which adds sparkle to an image.

▲ Cold toning

Conversion from colour darkened the blue shadow areas in this snowy scene in Kazakhstan, allowing sunlit areas to define the topography. Changing to Duotone mode, a blue tone was added to enhance the effect – with special care taken to keep the highlights white (*see pp. 238–9*).

LANDSCAPES CONTINUED

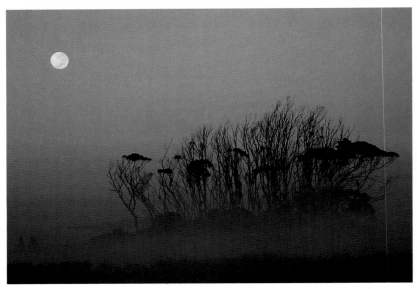

▲ Dawn mist

Landscape photography may seem leisurely, but often you have to act quickly. As I drove out of Auckland airport just after dawn, this mist-shrouded scene presented itself. I knew that it would disappear quickly, so I jumped out of the car and raced back down the road to record it. Just seconds later, the rising sun masked the delicate hues in the sky and the mist evaporated.

▶ Receding lines

It is unusual to find strong parallels running from side to side in a landscape. Here, in the Cinqueterre, Italy, the eroded strata of the rocks in the foreground inspired a composition that strongly converges to the point of land at the extreme right-hand edge of the picture. A gull helpfully defines the principal Golden Section of the image.

POLARIZING FILTERS

One of the most popular accessories for the landscape photographer is the polarizing filter. This is a neutrally dark filter in a rotating mount. When fixed on the front of a lens, pointing away from the sun, then rotated, it has the effect of making blue skies appear much darker at certain settings compared to others. This is because blue light from a clear sky vibrates in a small range of angles: as you turn the filter it passes some light at most positions but when it reaches the "crossed" position it maximally blocks the light from the sky, making it dark.

Note that maximum darkening may not be a good idea as the sky can appear almost black. The filter can also be used to reduce reflections on glass, leaves, or water. This makes it useful for controlling scenes with a large luminance range, as it reduces the specular shine on smooth surfaces. This filter is best used on an SLR, where you can monitor changes through the viewfinder. The circular type of polarizer should be used with SLRs, but linear polarizing filters may be useable with some cameras, such as compact interchangeable lens cameras (CILs); check your instructions to confirm.

◄ Lowly views
With experience, you will find it helpful to work within the framework of a project, rather than searching for any kind of promising landscape. This image was taken with a fish-eye lens as part of a project that views the world as seen by local wildlife – from close to the ground, or partly obscured by foliage, or both.

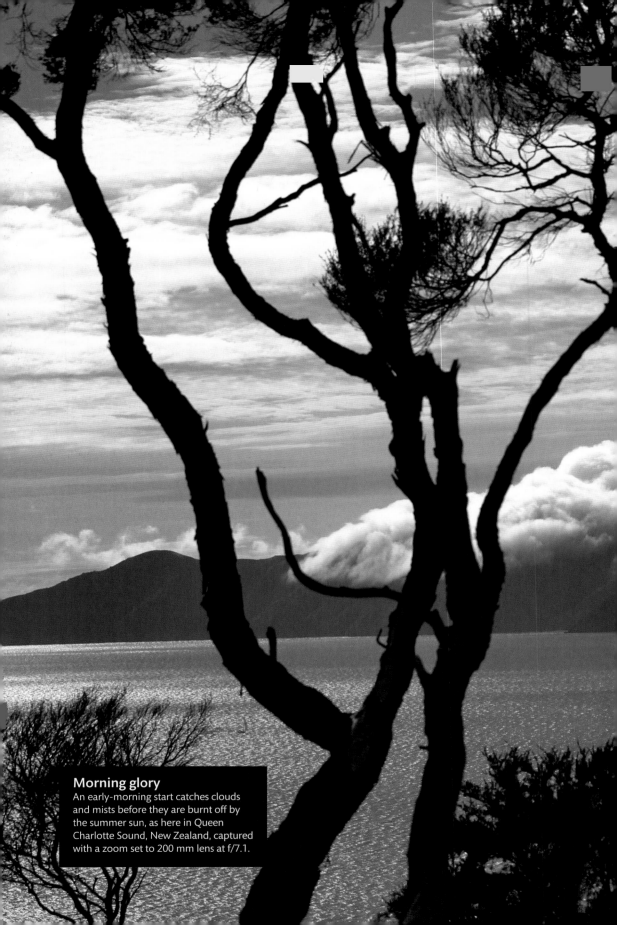

Morning glory
An early-morning start catches clouds and mists before they are burnt off by the summer sun, as here in Queen Charlotte Sound, New Zealand, captured with a zoom set to 200 mm lens at f/7.1.

CITYSCAPES

As most of the world's population lives in cities, it is natural that the city is one of the richest sources of pictures. In any city in the world, whether drab or stunning, medieval or modern, you will find endless potential for photography. Indeed, entire careers in photography have been built on the photogenic qualities of cities as diverse as Prague, New York, Delhi, and Paris. Cityscapes concentrate on the architecture of the built environment and its layout, shapes, and structure. While it does not actively exclude people, cityscape photography largely ignores them, unlike street photography.

Finding inspiration

In choosing an approach, it is instructive to follow in the footsteps of great photographers who have portrayed their beloved cities, such as Alfred Stieglitz of New York, Josek Sudek of Prague, and Eugene Atget of Paris. Their achievement was to show the myriad aspects of their cities without any kind of artifice, and all in black-and-white. In fact, working in black-and-white can simplify your compositions, allowing the viewer to appreciate form, texture, and depth without the distraction of colour.

However, you have important advantages over photographers of the past: you are highly mobile and can work in just about any lighting condition. Exploit the capabilities of your camera and work to capture images not only in bright sunshine, but on rainy days, in the fog, or at night.

Exploration

You can go further than the masters of the past: use colour in an abstract way, capture the surprisingly deep and rich colours of the city at night, or zoom into the distance to find magnified views that are not visible to the naked eye.

The city is a rich source of reflections and un-intended juxtapositions – of shapes, colours, and signs. Just as a landscape can be seen in overview as well as in detail, you will find cities yield different layers of meaning and possibility with each change of scale. You could also choose one prominent landmark and investigate the way it can be seen from different places all over the city.

▲ London Eye

Capturing the colours of city lights at night is less of a challenge than it used to be. This shot was taken from London's giant ferris wheel at the top of its trajectory, using a high ISO and underexposing by 1.5 stops.

BUILDING RIGHTS

In the majority of cities you can photograph buildings freely. But exercise caution if any that are in view are flying a national flag or appear to be military in character. In some countries photography of bridges, airports, police stations, armed forces barracks, and government buildings is illegal. Beware that commercial use of images featuring certain iconic buildings such as the Rockefeller Centre, the Flatiron Building (New York), the Eiffel Tower, the Louvre, and the Pei Pyramid (Paris) may be subject to legal processes by various rights holders. Restrictions may also apply to commercial use of images that show works of art, such as installations or sculptures.

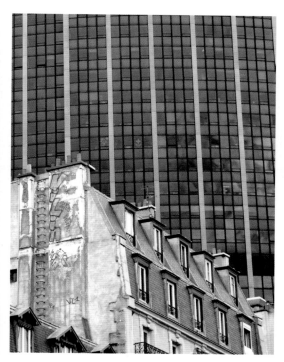

▲ City skies

The skyline of a city is defined as much by the sky above – the so-called "negative space" – as by the outlines of the buildings themselves. And if we are given a gloriously fluffy-clouded sunset, so much the better. This view of Singapore needs to give emphasis to the sky as the "hero" of the shot with the skyline taking a secondary role, so it can be allowed to go into deep tones.

▲ Contrasts and conflicts

Using a long-focal-length lens brings relatively distant objects together, emphasizing their differences – old apartments in Paris and the tower block appear to be right next to each other, but are in fact hundreds of metres apart. Frame from as far away as possible, using a zoom to adjust image size and composition.

▼ Working with the enemy

Cars rarely contribute to city scenes in a positive way, yet they are perennially present, and are therefore a common problem for photographers. Try to use them to your advantage, for example by making a feature of the red lights of a traffic queue at night, or by looking for interesting reflections in their windscreens, and so on.

REFLECTIONS

Apart from light emitted directly from a lamp or the sun, every ray of captured light reaches your camera having been reflected from a surface. These rays literally write the image of the scene; in that sense every image is made of reflections. But it is when the light reflects off a smooth surface that the magic happens: the light rays bundle together to form a new image of the scene, yet one that lies within the scene.

Going deep

Working with reflections doubles the number of calculations you need to make when composing an image: every shift in position causes a different shift in the reflection. For reflections with the greatest depth or largest reflected image, you need to place the camera as close to the reflecting surface as possible. Compact cameras are best for this, as you can place their lenses almost at the same level as the surface. When working with reflections in water be very careful not to break the surface: you do not want to ruin the reflection (never mind the camera).

Virtual images

The illusion of a scene-within-a-scene imbues images of reflections with an ethereal quality; they seem other-worldly. Indeed, in physical terms, a reflection is known as a "virtual image": it cannot be reproduced on a screen, or projected, but instead it appears to exist in three-dimensional space, because of a fundamental property of light-paths.

Optically, there are two features that impact on how you capture images of reflections. The first concerns the fact that the reflection is located as far "inside" the reflecting surface as the actual scene that is reflected. This often delivers far more depth of field than usual in your image. The second is that the reflection may be much darker than the actual scene reflected, particularly when the reflecting surface is glass or water. This can create problems with balancing exposure between brighter and darker parts. This can be tackled using tone-mapping techniques (*see pp. 266–7*), provided there is no strong flare, as this can disrupt tone mapping at brightly lit edges.

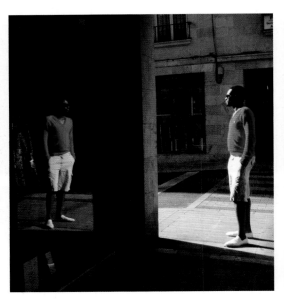

▲ **Borrowed colour**
Working with reflections usually calls for precision positioning and careful observation. As I paid my bill at a restaurant, I noticed that the bank notes flashed bright blue as I placed them on the metal tray, because their metal strips reflected the colour of the evening sky. In order to capture this image, I had to place the lens in a very particular position – near the table and close to the candle-light – cue the entry of a camera phone.

▲ **Parallel worlds**
In a town centre, a dark shop window suddenly comes to life when a bright reflection appears. The red sweater is so brilliant it appears to be at the same exposure in the reflection as in the original, helping to balance the image.

▲ Depth of feeling

Still water provides the best of reflecting surfaces, as long as it is dark; light reflected from the bottom of this pool would have diluted the intensity of colour. By placing the camera very low – almost touching the surface of the water – at wide-angle, with minimum aperture set, I captured the greatest extent of reflection.

▲ Art in the mundane

The humblest subject can be turned into a tapestry of geometry through distorting reflections. Keep your eyes open for the potential in everyday objects. Here, a wait for service in a café was turned into a creative interlude.

PLAIN POLARIZATION

The polarization of light is a tricky subject – as is demonstrated by the fact that it took a number of great scientists, from Bartholin to Brewster, Young to Faraday, to pin it down. Today, the exploitation of polarization effects is commonplace, for example in Polaroid® sunglasses. Using the same technology, we can control reflections in photography: light reflected from certain surfaces such as glass, water, and leaves (but not metals) is strongly polarized, so if you fit a filter that cuts out polarized light, you can reduce the reflection to varying degrees. With an SLR camera lens, ensure that you use a circular polarizing filter (*see also p.128*) to avoid confusing the auto-focus system.

LOW-LIGHT PHOTOGRAPHY

Taking photographs in low light used to involve extra lighting, the use of ultra-large aperture lenses, or inevitable loss of image quality – or all of these things. No longer. The sensitivity of sensors has improved to the point that images can be captured by the light of the moon. The result is an extension of the world of available light photography. Simply set a high ISO setting, for example, ISO 1600 or greater, and a large aperture: you are then ready to concentrate on artistic issues, rather than struggle with technical limitations. If your camera produces noisy images at high ISO settings, you can deal with the problem in post-processing (*see pp. 194–5*).

Perception shift

The most thrilling aspect of low-light photography is that the camera sensor is not subject to the same limitations as the human eye when perceiving colour in low light. In brief, sensors see almost as much colour in low light as they do in bright light (there is a slight reduction due to increase in noise). This means that scenes that appear lacking in colour, or where lights appear white, will record with much more colour than you can see. This is particularly true of the evening sky: what appears grey to our eyes can be recorded as brilliant dark blues, while colourless city lights can be recorded as yellows, reds, or even greens. With a little experience, you will learn how to exploit these differences between our own visual experience of low light and the images that can be captured on camera.

Staying in the dark

One aspect of low light photography that poses problems for many photographers is how to allow dark subjects to stay dark. In general, you are aiming for low-key images (*see pp. 72–3*), that is, images in which the key tones are darker than mid-tones. The key tone should convey the sense of low light, while important details are distinguished and, at the same time, coloured lights are not over-exposed. This means that you over-ride auto-exposure to -1 to -2 stops, in other words, you set the exposure as under-exposed to the usual meter reading from -1 stop to -2 stops, or even more.

Remember to set any automatic flash to remain off. If the flash is effective at all, it is effective in destroying the character of the lighting. And at distances greater than about 3 m (10 ft), built-in flash has no effect whatsoever on the scene.

◄ Twilight zone
The half-light between the day and the onset of full night-time darkness is a truly magical time as you can easily balance foreground and sky light. At the same time, colours seem much more intense than at any other time, with the sensors capturing all the perceived brilliance. Under-expose by at least 1 stop to obtain rich colours.

▲ Noisy interior

Even when there is dazzling sunshine outside, the interiors of buildings can be very dark – as was the case here in the hall of The Casino, Venice. Tripods were not permitted, so I pressed the camera against the mirror to keep it steady during the exposure, which I set at 1 stop less than metered. As noise is greatest in dark shadow areas and this image is almost all dark shadow, noise levels were judged to need post-processing. For normal purposes, noise reduction filters in standard software such as Adobe Lightroom, Apple Aperture, and Adobe Photoshop produce acceptable results. For high and obtrusive levels of noise, use specialist software such as Topaz Denoise or Noise Ninja.

▲ Night blindness

To the eye, this scene appeared to be hopelessly dark, relieved only by the bright points of the city lights, and the pale blue glow of the pool's underwater illumination. Exposed at -1.3 stop to the metered reading, the image revealed blues and purples in the distant hills and the city. The image also made the light in the trees, which came from distant street lamps, more easily visible.

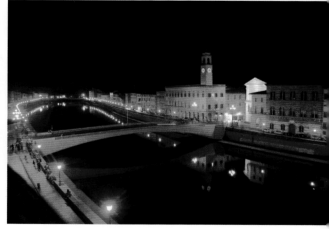

▲ Black as night

When there is very little light in the sky, any attempt to capture it will result in over-exposure of lights on the ground. In this image of Pisa and the River Arno, the main concern is to expose the street lamps correctly: the better-lit buildings are over-exposed and the sky is featureless. But what we really want is the lovely reflection in the river.

ANIMALS CONTINUED

Know your subject

Animals can be notoriously tricky subjects. They do not respect your wishes – in fact, it often seems that they know precisely what you do not want them to do, and then do it. In these circumstances, knowledge of the animal's behaviour can be as important as photographic skill.

Having an appropriate lens for the kind of image you want to make will also save you a great deal of time and trouble. Normal to medium-long focal lengths are the most useful for portraits, and wide-angle lenses are good for shooting in aquaria, and for scene-setting shots. The smaller the animal, the longer the focal length needed to fill the frame. Very long focal length lenses are best for following highly mobile animals, as you only need to pan the lens a little to follow them as they move about. Animals with very long heads such as horses are also much easier to photograph from a distance: set a medium-small aperture to ensure depth of field covers the whole length of the head.

Animals in captivity

Modern zoos in major cities are taking on the role as centres for the study and preservation of wildlife; they are often models of animal care. You can see well-fed animals in something that resembles their natural habitat, and for many people, zoos offer the only chance to get up close to wild or exotic animals. Of course, this offers many opportunities for photographing animals you would not normally come into contact with.

Zoos are ideal places to practise elements of wildlife photography before venturing into the field. You will learn that if you set up at the right place at the right time, your wait for the right shot can be greatly shortened – and from this you learn the importance of knowing your animal and its habits. Try to pick a time for your visit when the zoo will not be too busy, for example midweek mornings. It may be possible to gain privileged access to some of the animals by approaching the relevant keepers or the zoo director, and offering free photographs for use in the zoo's publicity material or on its website.

▶ The right moment

When taking pictures of animals in zoos, you can take your time to wait for a perfect expression or composition – family groups are especially interesting to watch. Keep shooting and pick the best shots later: try not to review your images while on location because you are bound to miss something.

▼ Eye to eye

It is thrilling to be close to a normally elusive animal, such as this giant otter. Even if you know it is tame, it is wise to keep your distance: use the long end of a zoom with a high ISO setting to enable you to set a combination of relatively small aperture and short exposure time.

◄ In their element
In modern zoos it is possible to photograph animals in their element, such as a polar bear underwater, which only a very few specialists ever see in the wild. Make full use of the unusual level of access provided by the artificial environment.

PLANTS AND GARDENS CONTINUED

Organized wilderness

Whatever the style or level of organization, a garden is essentially an attempt to bring order to wild things. Whether it is a Japanese *karesansui* of exquisitely natural forms, or simply an untidy urban patch, gardens offer limitless photo opportunities. You can work at many different levels, both conceptually and physically: from the ground looking upwards, for a worm's eye perspective. Or you could concentrate on bird's-eye views, such as from the upper floors of a house.

As the subject is almost static, you can experiment freely, focusing at different points, and zooming from one extreme to the other. You might work with variations in depth of field and vary lighting by using flash for some shots. You can try different colour settings, and set very high ISO settings too –

all with the aim of finding a visual "voice" or a personal style that corresponds with the way you see, and feel about, the subject.

But, of course, a garden is not quite static: it is in constant, if understated, motion. And a garden can be radically transformed over the course of a day, thanks to the movement of the sun. Plants and gardens also undergo dramatic changes with the seasons, so a view that is unpromising one month could be a treasure-trove the next.

Problems may occur due to the extended dynamic range arising from shiny leaves and the combination of bright sky and deep shadow. Use reflectors or supplementary flash to fill shadows; record in RAW to capture a broad enough range of data to make extensive changes, or use tone-mapping techniques (*see p. 266*) to compress tones.

▲ Filter variation

Image post-processing can reproduce the majority, but not all, the effects of plastic or glass filters placed over a lens. Using a multiple prism over a 135 mm lens helps to disguise an unattractive steel fence in an urban garden by overlaying it with a partial triple repeat of the scene. These small, random effects and variations in focus and depth of field would take hours of work to re-create using post-processing.

◄ Change of emphasis

The security light is usually entirely functional. But on this occasion – with the tall, spikey flower heads in evidence, and a tapestry of petals scattered over the decking – the lights revealed a very different garden to the one that could be seen during the day. The darkness beyond the reach of the lights hides distractions and flattens the perspective, making the image appear somewhat painterly.

◄ Depth in shallowness

By minimizing depth of field – produced here by a 135 mm lens set to f/1.8 – almost nothing is sharp in this image. But what we lose in sharpness we actually gain in clarity – a Japanese maple seen by the light of a weak evening sun.

► Just passing

Although it is easy to think of plants as stationary, unchanging subjects, insects and other creatures can add an extra dimension to your shots, if you can catch them in passing. If you are shooting hand-held, an image-stabilized lens or camera helps ensure sharp images, but when you are shooting this close up and with a limited depth of field, you will need to focus critically to create the right emphasis within the image.

◀ Change of emphasis

The security light is usually entirely functional. But on this occasion – with the tall, spikey flower heads in evidence, and a tapestry of petals scattered over the decking – the lights revealed a very different garden to the one that could be seen during the day. The darkness beyond the reach of the lights hides distractions and flattens the perspective, making the image appear somewhat painterly.

◀ Depth in shallowness

By minimizing depth of field – produced here by a 135 mm lens set to f/1.8 – almost nothing is sharp in this image. But what we lose in sharpness we actually gain in clarity – a Japanese maple seen by the light of a weak evening sun.

▶ Just passing

Although it is easy to think of plants as stationary, unchanging subjects, insects and other creatures can add an extra dimension to your shots, if you can catch them in passing. If you are shooting hand-held, an image-stabilized lens or camera helps ensure sharp images, but when you are shooting this close up and with a limited depth of field, you will need to focus critically to create the right emphasis within the image.

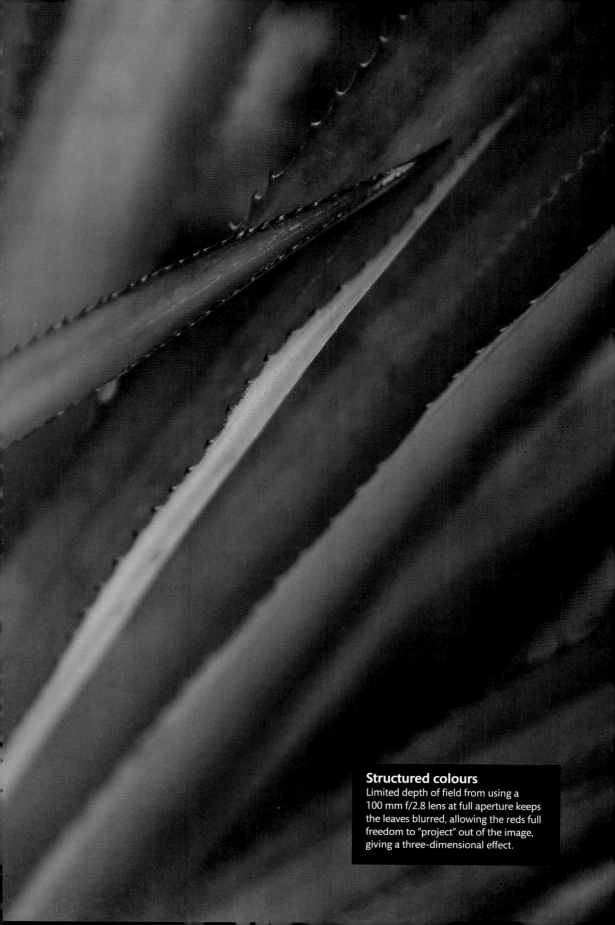

Structured colours
Limited depth of field from using a
100 mm f/2.8 lens at full aperture keeps
the leaves blurred, allowing the reds full
freedom to "project" out of the image,
giving a three-dimensional effect.

PANORAMAS

The basic concept of a panorama is that the recorded image encompasses more of a scene than you could see at the time without having to turn your head from one side to the other. In fact, to obtain a true panoramic view, the camera's lens must swing its view from one side to the other.

Visual clues

The give-away visual clue to a panorama is that there is necessarily some distortion – if the panorama is taken with the camera pointing slightly upward or downward, then the horizon, or any other horizontal line, appears curved. Alternatively, if the camera is held parallel with the ground, objects positioned near the camera – usually those at the middle of the image – appear significantly larger than any objects that are more distant from the camera.

▼ Landscape view

The landscape is the natural subject area for the panorama and it also presents the fewest technical problems. In addition, it can transform a dull day's photography into a breathtaking expanse of quiet tones and subtle shifts of colour. Here, in Scotland, a still day creates a mirror-like expanse of water to reflect the fringing mountain, thus adding interest to an otherwise blank part of the scene. This image consists of six adjacent shots, and it was created using Photoshop Elements.

Digital options

In recent times, the concept of panoramas has been enlarged (confusingly) to include wide-angle shots that have had their top and bottom portions trimmed or cropped into a letter-box shape. As a result, images have a very long aspect ratio – which means that the width is much greater than the depth of the image. These pseudo-panoramas do not show the curvature of horizon or exaggerated distortion of image scale of true panoramas.

The digital photographer has a choice. Pseudo-panoramas can be created simply by cropping any wide-angle image – all you have to do is ensure that the image has a sufficient reserve of detail to present credible sharpness after you have cropped it. Don't forget that a panorama can be oriented vertically as well as horizontally (*see pp. 28–9*).

True panoramas are almost as easy to create digitally. First, you take a number of overlapping images of a scene from, say, right to left or from top to bottom. Then, back at the computer, you can join all these individual views together using readily available software such as Spin Panorama, PhotoStitch, or Photoshop Elements. These software packages produce a final, new panoramic image without altering your original image files in any way (*see pp. 298–9*).

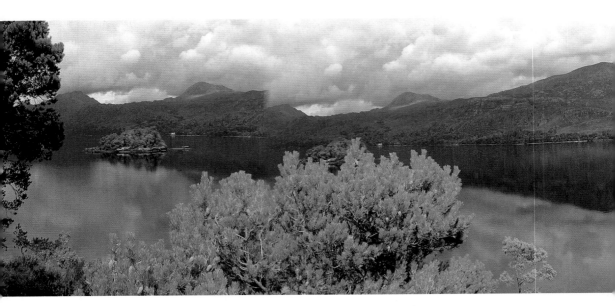

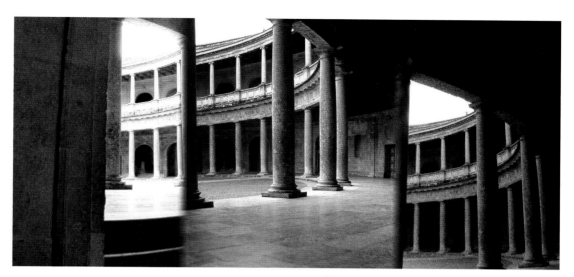

▲ Unlikely subjects
You can experiment with component images (*left*) that deliberately do not match, in order to create a view of a scene with a rather puzzling perspective. The software may produce results you could not predict (*above*), which you can then crop to form a normal panoramic shape. While the final picture is by no means an accurate record of the building, in Granada, Spain, it may give the viewer more of the sense of the architecture – of the never-ending curves and columns. This image was created using the PhotoStitch application.

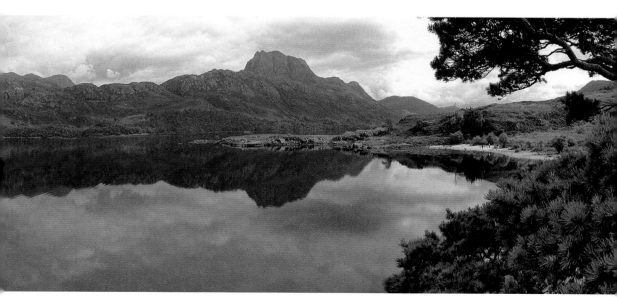

PANORAMAS CONTINUED

▶ Canal scene

The distortions in scale that are caused by swinging the view from one side to another, so that near objects are reproduced as being much larger than distant ones, can produce spectacular results. In this view, taken under a railway bridge crossing a canal in Leeds, England, one end is reproduced as if it is the entire width of the image, while the other end takes up only a small portion of the centre. The mirror calm of the canal water helps to produce a strong sense of symmetry, which is in opposition to the powerful shape of the wildly distorted bridge.

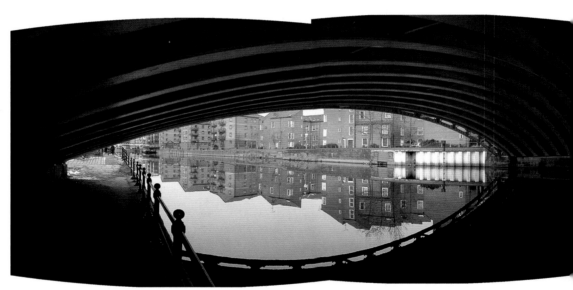

REAR NODAL POINT

The image projected by a lens appears to come from a point in space: this is the rear nodal point. Rotate a lens horizontally about an axis through this point and features in the scene remain static even though the views change. A virtual reality head (*see opposite*) allows the axis of rotation to be set to that of the rear nodal point to give perfect overlaps between successive shots.

HINTS AND TIPS

In order to obtain the best-quality panoramic images, you might find the following suggestions helpful:

- Secure the camera on a tripod and level it carefully.
- Use a so-called "virtual reality head": this allows you to adjust the centre of rotation of the camera so that the image does not move when you turn the camera. If you simply turn the camera for each shot, the edges of the images will not match properly.
- Set the camera to manual exposure and expose all the images using the same aperture and shutter speed settings. As far as you can, select an average exposure, one that will be suitable for the complete scene.

- Allow for an ample overlap between frames – at least a quarter of the image width to be safe.
- Set your lens's zoom to the middle of its range, between wide-angle and telephoto. This setting is likely to produce the most even illumination of the whole image field and also the least distortion.
- If possible, set the lens to a small (but not the smallest) aperture – say, f/11. Larger apertures result in unevenness of illumination, in which the image is fractionally darker away from the middle.
- Ensure that important detail – a distinctive building, for example – is in the middle of a shot, not an overlap.

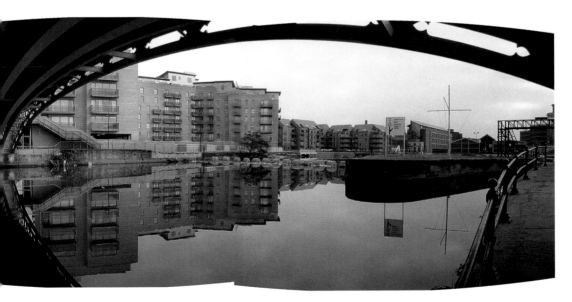

◀ **Table setting**
It can be fun to create panoramas of close-up views: here, a collection of views were blended together, playing with the pastel colours and repeated elliptical shapes.

LIVE EVENTS

Photographing live events such as parades, street parties, demonstrations, or open air concerts presents many challenges: crowds, moving subjects, varied lighting conditions, and ever-changing action that may be over in seconds. This is also true of weddings, family gatherings, or school sports days. Fortunately, with today's marvellous cameras, you do not need to worry too much about camera settings: "Sports" mode should cover most of your needs. However, if you want more control, set medium ISO of around 400 in good lighting, and ISO 1000 or more indoors, with shutter priority and an exposure time of ½₅₀ sec or shorter.

Right place, right time

The most important question in events photography, however, is nothing to do with equipment: where exactly you should stand to be sure to get the shots? The answer relies on one part instinct, one part planning, and a big dose of luck.

Instinct is what might prompt you to walk that bit further than you intended, or to look around a corner. It is what tells you to wait a little longer to capture an unexpected moment. The vital element to improving your photography at events is taking the time to go this extra distance.

Combine your instinct with careful planning and you will find that luck favours you. Once you have explored the location thoroughly, choose the best vantage points, and have your camera ready at all times. Then, when the bride unexpectedly turns around to flash a gorgeous smile, for example, you have your picture, not only because you were lucky but also because you were prepared.

Golden rules

Begin covering the event before it starts: images of preparations, such as set-building or make-up artists at work, produce a well-balanced view. During the height of the event, keep the camera switched on and close to your face, or hold it at arm's length above your head to shoot over the crowd. You need to be quick, so do not record at the highest resolution or in RAW format if this slows down your camera's operations.

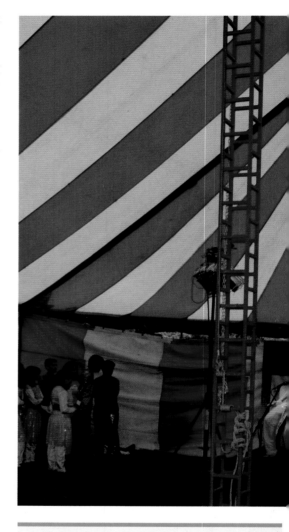

STAYING SAFE

There are no medals for bravery in photography. By all means pursue a picture if you have sufficient expertise to ensure your safety. But if you are inexperienced in attending potentially dangerous events, do not expose yourself to any risks. Ask for advice from staff if you are unsure, and obey all safety notices.

When photographing high-speed vehicles, do not shoot from corners unless there is adequate protection. Keep your wits about you at all times, and pay attention to your surroundings, as well as the viewfinder.

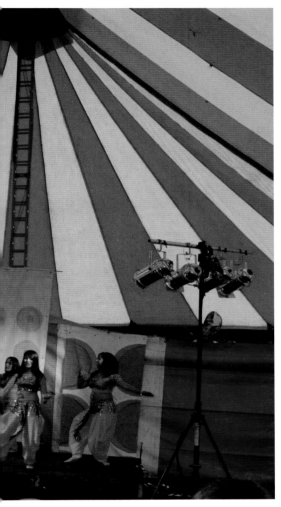

◄ All aspects, great and small

Use the full capabilities of your equipment to cover the different aspects of live events – the main event, the supporting activities, and the action on the periphery. Use wide-angle settings and get into the thick of things whenever possible. Use normal or wide-angle settings when shooting people to ensure a good level of involvement. Look out for colourful details, such as souvenirs and merchandising (above).

► Character study

The reputations of live events lie not only in the central attractions but also in their environments. A full account of an event records its context – whether it is a theatre festival in a Greek amphitheatre, a car rally in the desert; or, as here, at Glastonbury, in England, where the music festival famously turns into a sea of mud when it rains, as it usually does.

LIVE EVENTS CONTINUED

Sports coverage

While many professional sports events are now inaccessible to amateurs, there is still a vast number of other sporting events open to photography. Outdoor events such as marathons and triathlons often welcome photographers, as do sailing events and gymkhanas. It is worth hiring a long lens such as 300 mm or even 400 mm, used with a monopod or tripod to enable you to "reach" right into the action. Amateur sportsmen like to have good images of their exertions, so you might find a market for your work.

When using a zoom lens, choose a setting for the event and avoid changing it while framing shots, as this will slow you down. You should never, ever check the image preview while the event is in full flow: wait until half-time or a break in the action before reviewing your shots. Remember: the event is not over until you are off-site – even when the action is over, you can shoot the clean-up, the exhausted players, and more.

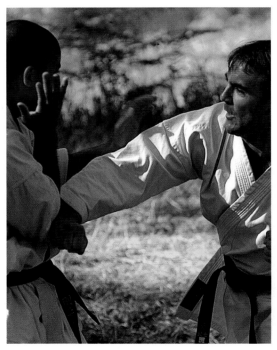

▲ Sharpness and blur
It takes the reflexes of a martial artist to photograph sports well, and the better you know a sport, the greater your chance of catching the moment of truth. But remember that

The essence of the sports photograph lies in choosing the right moment to press the shutter. A split second can represent the moment one tennis ace turns the tables on another, or one misjudged tack separates the winner of a sailing regatta from the also-rans. The strategy for sports photography is, therefore, constant vigilance to ensure you are at the right place at the right time.

- **Allow for shutter lag:** The time interval between pressing the shutter and actually capturing the image is usually at least $\frac{1}{10}$ sec, but can be as long as ¼ sec, depending on your camera.

- **Use balanced flash:** For best results when using flash to capture movement, balance the flash exposure with daylight. Take care not to endanger competitors by setting off your flash in their eyes from close by.

- **Position yourself carefully:** Try to view the event from a point at which you not only have a good view of the action, but also from where your target is not moving impossibly swiftly.

- **Know your sport:** Use this knowledge in your photography. As a race track becomes worn down, for example, do the riders take a slightly different route around it? As the sun moves across the sky, do the players pass the ball from a different direction to avoid the glare? In dry conditions, do rally drivers take a corner faster than in the wet?

sports are about movement, so sometimes it is appropriate to use long exposures to capture action as a blur – this is certainly true of fast-moving full-contact sparring.

▲ Keeping up

Where you want to photograph a lot of activity concentrated into a short period of time, the best chance of covering it all is to work with two cameras. Use your compact point-and-shoot in addition to your SLR, or supplement your compact with a camera phone. The cameras can be set at different focal lengths – one to capture wide-angle views (*top*), the other to zoom in on the action (*above*). And if one slows down, you can give it a rest and use the other.

PORTRAITS

The possibility of easily making life-like representations of family and friends was what most excited everyone about the invention of photography, and portraiture remains the most cited reason for making photographs today. With changes in society, a portrait now means any image that shows an aspect of a person's personality. This means the face may not even be visible or clear. In short, stylistically, there are no limits.

Anything goes

It is a very exciting time to take up portraiture: while you cannot rest on formulaic solutions, you are also no longer limited by them. In fact, anything goes. Faces can be hidden in the dark with only a sliver of hair visible, or distorted by blur from movement or lack of focus. You can photograph from behind, above, or below; you can have your subject pose naturally or with exaggerated artifice; and props, clothes, and makeup offer endless possibilities.

Relationship matters

Central to portraiture is your relationship with the sitter. How well you know them, and how much they trust you, may dictate the kinds of poses and expressions your sitter can give you. Even with paid models, a session will go more smoothly once they understand what you are trying to achieve and are able to work with you on it.

A great variety of portraits is possible when photographing a willing sitter. Once you have covered the basic, straight-on shots, it is time to explore other approaches. Have fun, be inventive and, above all, work at a creative partnership with your partner. The following tips will help you get the best results from your portrait session:

- Agree with your sitter the kind of image you wish to create, or that they wish to see.
- Review the first few shots with the sitter to show them what you are trying to achieve.
- After the first shots, do not show the model any images until the end of the session unless you wish to try some other pose or effect. Constant reviewing interrupts the flow of photography.

Technical pointers

We humans retain extremely clear ideas about the normal range of facial features: departures from the norm are obvious. As a result, it is best to avoid approaching within touching distance of your subject when using short focal length lenses or a zoom set to the short end of the range, unless you

◀ At work
To photograph someone at work, it is best to let them do what they normally do: if they move quickly, watch out for moments of quiet, or learn when it is safe to ask them to hold a position. Use all local props such as tools, desks, and computers. In this shot, the light from a lap-top perfectly balances the dim evening light in rural Guyana.

BOKEH

In portraiture more than in any other genre of photography, the quality of the blur in the out-of-focus parts of the image – the bokeh – is vital to the picture's success. Whether you expose with maximum depth of field or not, it is usual for the majority of the image to be rendered blurred. If the lens creates blurs that do not blend smoothly with each other, but instead create distinct disc-shaped blobs of colour, the result is very distracting. Good bokeh produces a fuzzy or feathered blur, even at high-contrast junctions. At full aperture, virtually the entire image is composed of blur, so if you intend to use a portrait lens at full aperture it is vital that its bokeh is good, and that is usually a product of top-class design and construction – in other words, an expensive lens.

▶ Best foot forward
According to some therapeutic systems the entire body is represented on one's feet, and a whole portrait project could be founded on that thesis. Limited depth of field ensures that all the distractions of highlights from sunlit spots and building structures in the background are well suppressed behind a curtain of blur.

▲ Transitional mystery
Portraits are most interesting when they do not tell the whole story, and when they raise more questions than they answer. In this image, the contrasts between the refined clothing and the prosaic background, the strong shadow, and the cool colour tones all intrigue, yet the whole is visually appealing.

▲ Editorial accuracy
Newspaper and magazine markets are the hungriest for good portraits. There is a constant demand for images that depict personalities in an attractive but accurate way in an atmosphere or context that is appropriate to the feature article or interview. Here the out-of-focus highlights frame the profile effectively and sympathetically.

PORTRAITS CONTINUED

intend to distort your subject comically. On the other hand, being able to get so close to someone suggests trust and intimacy, so that can be a useful signifier to exploit.

It is hard to go wrong if you focus on the eye nearest the camera, particularly if you are using a large aperture (f/2 or greater). This forces attention on the all-important eye, while painting the rest of the scene with broad, blurred brush strokes. If your camera uses multiple focusing points, it is easiest if you set it to use the focusing point over or nearest to the eye. It always helps to ensure there are no highlights or specular reflections in the background, unless it is an important part of the scene – a desk lamp or the setting sun, for instance.

Environmental impact

By making portraits outside the studio, you can take full advantage of your sitter's environment – their living or working space – as part of the observation about the person. Remember that the size of the person in the image relative to the space shown is intuitively proportionate to the importance of the context to the person's life. For example, if you make someone appear small in their work space

you are commenting on their relative power in that context: you could have shown them dominant in the same space. The environment and person reciprocally contribute significance to a portrait. The following points are also worth bearing in mind:

■ Locating the sitter in the centre of the image signifies that they truly are intended to be the centre of attention, even if they are small in relation to the background.

■ Locating the sitter to one side suggests that atmosphere, mood, or the environment is just as important as the person, particularly if they are small relative to the background.

■ If you are working in colour, pay particular attention to colours of objects in the background: they can contribute information and visual interest, or they can tear the image apart. Intense, hot colours are distracting, as are bright highlights and shiny objects with strong, geometrical shapes. Movement blur in the background is also distracting.

■ Compositional techniques such as converging lines and framing devices, such as doorways or tree branches, help direct attention to your sitter.

■ Shallow depth of field with a varied background works well to bring the sitter forward visually.

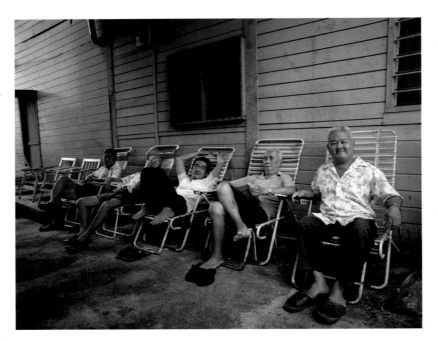

◀ Team work
Group photographs may concentrate on the team, in which everyone is equally important: the photograph is really about the team as a whole and is best composed as such. Or groups may be made up of individuals: it is part of accuracy in visual language that the composition reflects the dynamics of the group of people. Here, each person is shown relaxing in different ways, paying varying levels of attention to the photographer, all held by the receding lines and repeated chairs.

▲ Grace under fire

Even when exhausted from hard training in stifling hot conditions, this dancer holds herself with peerless elegance, surrounded by the paraphernalia of her studio. Greens, browns, and pinks in the scene were too distracting, but rendered in black-and-white, we can concentrate on the dancer who is framed by the geometric shapes around her. Unfortunately, the light behind her head is too bright to be welcome, but this can be easily removed digitally.

▲ Handyman

While the face is the most emotional and evocative part of the body, telling much of the story, it does not tell the whole story. Hands, feet, hair and arms can all contribute. In the case of working hands, they may be able to tell the story by themselves. You usually have to work in low light, so prepare your settings – high ISO and large aperture for short exposure time – then approach closely and observe.

▲ Keep it simple

For many purposes, such as small business websites, pamphlets, and picture albums, the straight-forward posed shot remains the best option. A smile and an example of the product in the context of the business is the kind of image that is equal to a thousand words. Shoot such images in flat lighting, with centred composition with a normal or moderately wide-angle lens.

PORTRAITS CONTINUED

▲ Involved spectator

Informal, candid portraiture is only an eye contact away from more formal approaches. You can ask a third party to talk to your subjects, particularly if they are nervous about being photographed. The result can be more lively and relaxed: they are relating to a person and no longer trying to keep up appearances for the camera, which then becomes a spectator to their exchanges. Although you may be photographing a couple, you do not have to render both equally sharp. It may be more important to reveal the differences in the character: one open and relaxed, the other a little more reserved and shy. Try varying the depth of field until you get the desired effect.

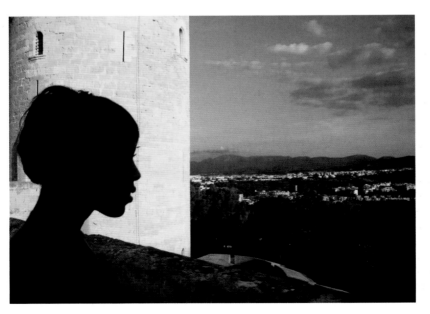

◀ In profile

In difficult lighting conditions, try working with the profiles of your subject's face. Allow the face to be in shadow while the background is bright. This technique is particularly effective when photographing people with dark skin tones, as dark-skinned faces are notoriously difficult to render correctly. Here, sudden and clear differences in distance have been exploited to create space in the composition.

▲ Room for the view

Leaving lots of room for the subject to breathe can be as effective as filling the image with the subject. Here, space is used actively to contain the subjects, while coloration is very subtle: essentially monochrome with browns and flesh tones against blacks and near-whites.

▲ App expression

As they are almost constantly to hand these days, camera phones have become the most-used kind of camera for portraits. For unusual or imitation vintage effects, you can use built-in apps to apply tones and tints, to give a change from the norm.

▶ Close-ups

The 105 mm or equivalent focal length is ideal for revealing close-ups of faces without the change of proportions that results from working with too short a focal length at close distances. When working at close quarters, set medium to small apertures, as depth of field is very limited, and failure to capture sharp highlights in the eye becomes obvious.

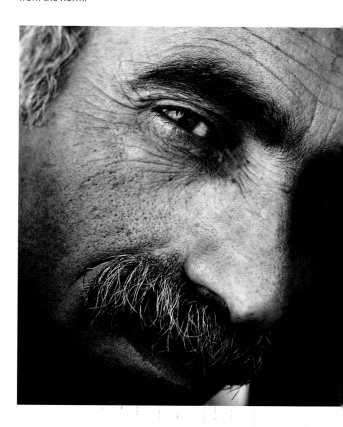

TRY THIS

A common question is "what is the best way to photograph strangers?" The answer is that the key lies in eye contact. If you can make and hold eye contact, you are half-way across the bridge to creating a relationship. And it is not until you have a relationship of trust – however fleeting, however shallow – that you can make a portrait. Next time you travel or have your camera with you, try looking into people's eyes if you wish to photograph them. If they are not comfortable with you, move on. If they respond positively, develop the relationship before lifting your camera. Never approach children without their parents' permission.

CAMERA PHONE PHOTOGRAPHY

▲ Project compilaton

As image quality is more than acceptable in many camera phones, there is no reason not to use them for photography projects. They are especially useful for ongoing projects, where you need to keep a camera with you at all times, such as capturing a variety of weather conditions, collecting interesting cloud formations, or cataloguing landforms. If you need to make wide-angle views, you can take overlapping shots that you then stitch together as if making a panorama (*see pp. 298–9*).

The cameras built into modern mobile or cell-phones comfortably surpass the quality and capability of early digital cameras. By combining utmost convenience – you always have a camera with you because you always carry your phone with you – with fair- to good-quality imaging, camera phones have become the most widely used type of camera. It is worth noting that the company making the most cameras (by a very large margin) is, in fact, primarily in the business of making phones.

Bare necessities

One of the main attractions of camera phone photography is that you are forced back to the very basics: with minimal controls, you have no choice but to concentrate simply on picture-making. Some camera phones allow digital zooming, some offer touch-screen choice of focus point and exposure, and many allow images to be shot in various modes such as vintage (usually sepia), or with filter effects applied, either after normal capture or as part of image processing (*see pp. 232–3*). But simplicity is the overriding virtue.

Bare technique

For all its simplicity, you can help your camera phone to produce superior results. The Achilles heel of the camera is the tiny lens: as it is so small, even the smallest smudge or smear will reduce the quality of the image. Use a micro-fibre cloth to keep the lens scrupulously clean.

■ Hold the phone steadily during exposure: squeeze or tap gently for the shot.

■ Give the sensor plenty of light to work with: low light produces noisy images.

■ Give the camera time to focus: camera phones cannot focus as quickly as larger cameras.

■ Use features that give more accurate focus or exposure control; for example, on touch-screen camera phones such as the iPhone, touching on the image shifts the focus and exposure determination to that part of the scene.

■ The flash on camera phones is very weak and is effective only to about 2m (6ft). Turn it off for more distant objects.

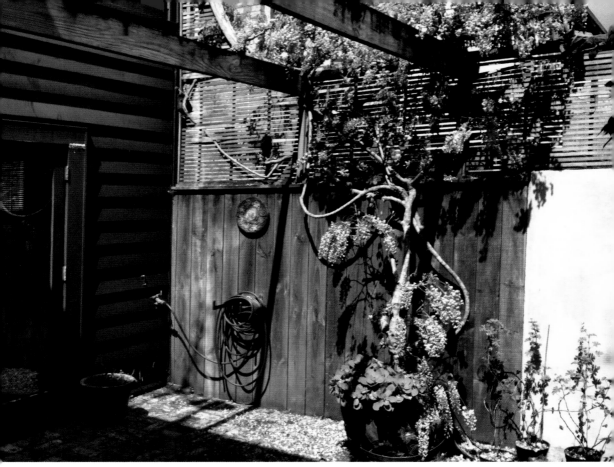

▲ Visual notebook

Camera phones are the ultimate visual notebook: you can use them to snap images of captions in exhibitions, make visual notes of items of furniture or objects for interior design, or to help document a house-hunt. The ability to attach GPS and other data to images increases their value for documentation. And, despite everyone being familiar with phones being used as cameras, a camera phone attracts much less attention than even a compact camera.

▲ App effects

There are a number of applications available that allow you to apply effects to your camera phone images. Some, such as Instagram, apply the effect to a normally captured image. Others, such as Hipstamatic apply the effects as part of the capture process. This commits you to the effect, and is a challenging and refreshing way to work.

DIGITAL HUB

For many, the modern mobile phone is a camera that can make calls and connect to the worldwide web. Images captured on a camera phone are restive. They are eager to be sent round the world to social network sites such as Facebook to be viewed by friends, uploaded to picture-sharing sites such as Photobucket or Flickr, or attached to an email or text message.

- Ensure the orientation of portrait format images is correct before sending them out.

- Resize the images to not larger than 640 pixels on the longer side if that facility is available.

- If you are not in your home country, sending images can be expensive. Check with your provider to ensure that you do not exceed your quota.

RECORD-KEEPING

Digital cameras have revolutionized record-keeping. Not only are they unencumbered by the need to process film, the amount of equipment required can be minimal and little or no physical materials are consumed. And once the information is recorded, you can send it around the world in an instant.

Applications

The everyday applications of digital technology are numerous. If you want to sell your car, just take a picture and upload it to a website with your details. For insurance, take images of your valuables and possessions, room by room, but keep the computer image files separate from the computer in case it is destroyed or stolen.

Digital photography is also useful if you need to transfer information. You may, for example, want an expert at the other end of the country to identify a document or object – emailing an image of it is quicker and easier than making the journey yourself or posting it. And sometimes a quick response can save lives – a doctor can email or phone through advice after seeing images sent in from the field via camera phone, for example. And in some circumstances it is crucial to record the time, date, and a sequential number along with each digital image. This is invaluable for many types of scientific work, such as an archaeological excavation.

The combination of digital photography for making straightforward records and software for managing images makes it very easy to print out lists and notes to accompany images.

▲ Reassembly

This fine sculpture from Sri Lanka is designed to protect a home from illness, but for transportation it needs to be disassembled into numerous small parts. A series of photos quickly records the positions and orientations of every piece so that eventual reassembly is both easy and accurate.

Colour accuracy

If you have to produce an image of an object and maintaining colour accuracy is crucial, you should include a colour bar along with the subject. Such a bar need be visible only on the edge of the image and does not have to be an expensive, standard type. At its most basic, the coloured subject divider tabs of a loose-leaf folder will do. The crucial factor is that you have the colour bar to hand to compare with the printed image.

GOOD WORKING PRACTICES

- Carefully preserve your back-up copies, and always keep them separate from your working files.
- Lock your archive files to prevent accidental or malicious tampering, especially if the contents are crucial to your work. Non-rewritable optical disks, such as CD-R, DVD-R, DVD+R, or BD-R, are most secure and are also archival. Keep more vulnerable disks physically secure, in different premises from the computer.

- Once your images number more than a few hundred, regularly print out a list of file names with notes about image content. You cannot hope to remember details of them all, and these notes will help.
- Use cataloguing software (*see pp. 178–9*) to keep track of pictures. This software makes it easy to print out indexes of pictures, which are easier to search through than scrolling down long lists of names on a monitor.

▲ Art preview
Digital photography proved to be incredibly useful for the Russian artist of this picture. Being rather isolated in Kazakhstan, he photographed it and emailed the picture file to an expert gallery owner for an opinion on its value before committing to a sale. In this instance, it is not of crucial importance that the flash has lit the painting unevenly.

▲ Identification
Even if jewellery is not very valuable, it may still be precious. One problem police encounter when they recover stolen goods is matching items with their rightful owners. If you have ink-jet prints of your possessions, it will be a great help to everybody concerned. But take care to keep the prints separate from the items they depict to prevent them being stolen along with the items they are recording.

▲ Car for sale
If you are offering an item such as a car for sale, it is a matter of just a few seconds to take a picture of the item and email it to the newspaper or website, along with a full written description and your details.

FLAT COPYING

The purpose of flat copying is to make a record of a print, map, or drawing. The easiest method is to scan the original, provided you have a scanner of sufficient size. If, however, the original is too large, you will have to take a photograph of it instead. There are three main considerations:

- The image must be geometrically undistorted and at a known reproduction ratio.
- Lighting must be even and exposure accurate.
- The colour reproduction should match the colours of the original as closely as possible.

For accurate alignment of camera and original, a specialist copystand is ideal, but a tripod can be used if you can ensure that the camera is exactly parallel to the original being copied. For the best results, use an SLR camera with a 35efl of a 50 or 55 mm macro lens. If using the zoom, set it to the middle of its range, as this is where distortion is likely to be minimal. The lighting should be arranged as shown in the diagram (*see right*), and to ensure colour fidelity, reproduce a colour bar or step wedge with the original. It is not necessary to use an expensive type – any set of standard colours is more useful than none.

Crank handle to adjust height of camera platform

Central column

Camera

Adjustable lighting unit

Adjustable lighting unit

Baseboard with grid lines

▲ Copying set-up
The copying of flat documents, such as maps, artwork, drawings, and printed material, requires even lighting at a constant level, consistent colour temperature, as well as a steady support for the camera, as shown in the copying set-up here.

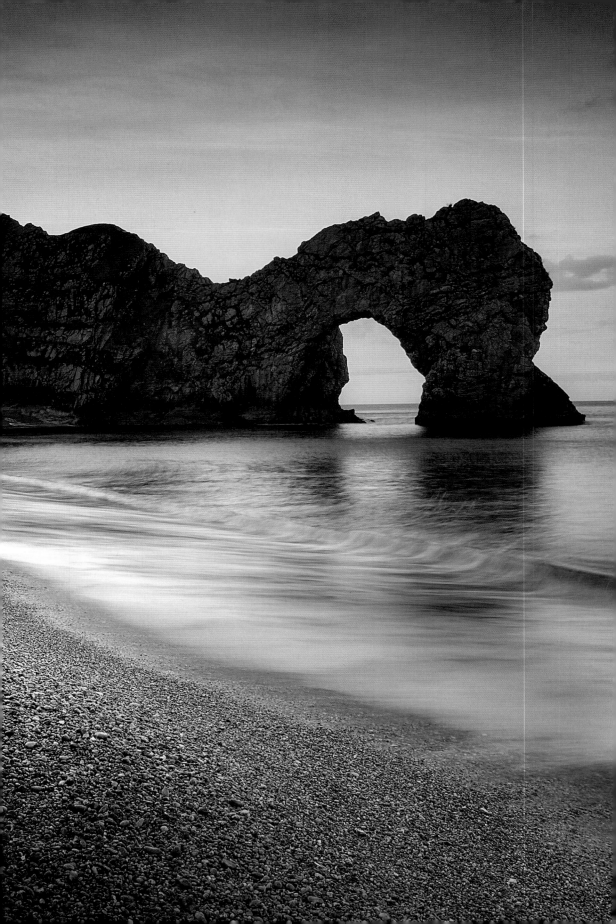

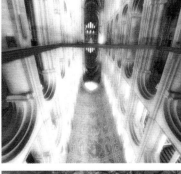

3 IMAGE DEVELOPMENT

SCANNING BASICS

Scanning is the bridge that takes film-based negatives and transparencies or printed images into the digital world. The process converts all colour, brightness, and contrast information into digital data for your software to use. The quality of the scanner and the skill with which it is used are the key factors that determine the quality of the digital information and, hence, the quality of the image you have to work with.

Scanning steps

You can think of scanning as a three-stage process:
- Gather together originals for the job in hand. You may wish to make prints of family portraits, say, or collect archive images for your club's website.
- Next is the actual scanning. To do this, the scanner makes a prescan to allow you to check that the original is correctly oriented, or to set the scanner so that it scans only as much of the original as you want, or to set the final image size and resolution. You then make the real scan and save the result onto the computer's hard-disk.
- The final stage is basic "housekeeping" – put your originals somewhere safe, somewhere you can readily find them again, and, if the work is critical, create a back-up copy of the scans.

Basic procedures

To get the most from scanning, it is a good idea to follow some commonsense procedures designed to help streamline your working methods.
- Plan ahead – collect all your originals together.
- If you have a lot of scans to make from a variety of different types of original, sort them out first. If, for example, you scan all black and white originals and then all colour transparencies you will save a huge amount of time by not having to alter the scanner settings continually.
- Scan landscape-oriented images separately from portrait-oriented ones. This saves you having to rotate the scans. And you will minimize visits to dialogue boxes if you classify originals by the final file size or resolution you want.
- If you are using a flat-bed scanner, clean your scanner's glass plate, or platen, before starting.
- Make sure originals are clean. Blow dust off with compressed air or a rubber puffer. Wipe prints carefully to remove fingerprints, dust, and fibres.
- Align originals on the scanner as carefully as you can: realigning afterwards may blur fine detail.
- Scan images to the lowest resolution you need. This gives you the smallest practicable file size,

SETTING UP A SCANNER

Many scanners give excellent results with practically no adjustment at all. However, it pays to calibrate your scanner carefully right from the outset. Follow the procedure set out below to ensure best results.

- Obtain a standard target. The IT 8.7/1 is intended for use with colour transparency film, and the IT 8.7/2 is for colour prints. These targets may be supplied with your scanner; if not, a camera store may be able to order them. Alternatively, choose an original for scanning that is correctly exposed and contains a good range of colours and subject detail.

- Make an initial scan using the machine's default settings – those set at the factory.

- Check the image produced by the scan against the original. If necessary, make adjustments using the scanner driver's controls so that the scan matches the original. Some scanners require you to make these changes in the preview window. However, be aware that on some scanners the preview image is not really an accurate representation of the final scan. It is always best to open the image in your image manipulation software, and view it on a calibrated and profiled monitor (*see pp. 182–3*)

- Once you have a scan you are happy with, save or note down the settings. Call it by the name of the film used – such as "Kodak Elite 100" or "Fuji Provia".

- Repeat these steps with all the various types of film you scan – colour negatives and transparencies use different scanner settings.

- Then, for all subsequent scans, load the relevant saved settings as your starting point.

which, in turn, makes image manipulation faster, takes up less space on the hard-disk or other storage media, and gives quicker screen handling.

■ Use file names that are readily understood. A file name you choose today may seem obscure in a few months' time.

■ When scanning, crop as much extraneous image detail as is sensible in order to keep file sizes small, but allow yourself room to manoeuvre in case you decide to crop further at some later stage.

■ You may need to make your output image very slightly larger (say, an extra 5 per cent all around) than the final size. This may be essential if, for example, you want your image to "bleed", or extend to the very edge of the paper so that no white border is visible.

TRY THIS

In essence, the scanner is a specialist kind of camera: it captures images at 1:1 or same-size, it has an extremely narrow depth of field so it is best for flat objects and it scans with a very high dimensional precision. In addition, it provides its own light. So any object placed on the glass of a flat-bed scanner can be captured: it is particularly good for small objects such as leaves, flowers, shells and pebbles, even parts of the body. This is fun to experiment with as the depth of field and lighting effects are unusual and unique, with very rapid fall-off in lighting and sharpness. Of course, it is also ideal for serious pursuits too, such as stamp or coin collecting; here, dimensional precision is a valuable attribute.

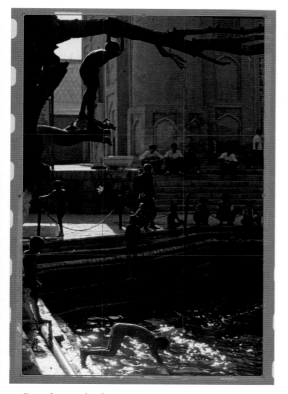

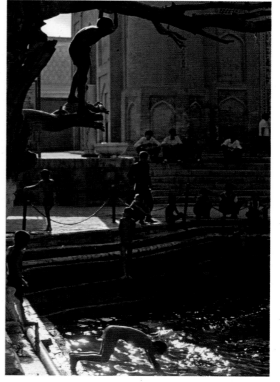

▲ Preview window

All scanners show a representation of the image in a preview window (*above*) prior to the final scan (*right*). This gives you a chance to make improvements before committing to a final scan. While it will save you time and effort later if you make the preview image as good as you can, bear in mind that it is only a general indication of the final scan. With some scanners, the preview may actually be rather inaccurate: if yours is one of these, you may need to experiment in order to learn how to compensate for its quirks.

WORKFLOW ESSENTIALS

Digital workflow is similar to processing black-and-white film in that there are efficient ways and less efficient ways of working. And just like film processing, an error can reduce the quality of your images, or even ruin them. The big difference is in the numbers of images you can work with: now you could have thousands of images after only a wedding. It is important to avoid having to spend hours in front of the computer wading through them. A little time planning a workflow will save days over the course of a year.

Horses for courses

It makes sense to match the flow of images to suit the project. If you shoot for yourself, a scheme that fine-tunes one image at a time is fine: this is how it was done in the early days of digital photography. One simple scheme is to set up your camera so that you can use the images immediately – on photo-sharing and social networking sites, or for printing out – without any post-processing. This workflow is almost effortless and all that is needed for many users. It is only when you want higher quality and more control that the extra effort is justified.

Soft options

One of the key decisions you need to make is whether to use the same software application – such as Google Picasa, Adobe Photoshop or Lightroom, ACDSee, or Apple Aperture – to manage and correct your images throughout. Lightroom, ACDSee, and Aperture treat all images non-destructively, operating only on proxy files. Alternatively you can use a different software package for each task – for example, Photo Mechanic for managing files, then Adobe Photoshop Elements for manipulation. Match the type of software and its cost with your needs. (See also pp. 360–1.)

Basic steps

The principle of workflow is to minimize time at the computer by never duplicating work unnecessarily and ensuring that at any time in the future, it will be easy to find an image. At the time you upload your

images is when all the details of the shoot are fresh in your mind and you know where, when, how, and why you made the images. This is when crucial tagging data and notes should be appended to the image. Following the sequence below will give you an efficient and time-saving workflow:

- **Ingest:** on your computer, create a new folder named by subject, date, or location, and upload your images into this. Add metadata such as subject, date, location, and copyright to each image. If necessary, you can rename the images with sequential numbering. Finally, you should back-up the images to a secondary disk.
- **Inspect:** check the technical quality of a sample of your images. Ensure that they are sharp, well-exposed, and have accurate white balance. If your camera does not turn images that you have shot in portrait format to the upright orientation, you

▲ **Plain sailing**
In the early stages of editing images, you may have wildly differing images to choose from. Leave the final selection until you have become very familiar with the shoot. Making tonal and colour adjustments is easiest with proxy-working software such as Lightroom, Aperture, and ACDSee.

should do that now. If any of the images appear corrupted, upload them again.

- **Evaluate:** locate the first choices, second choices, and reject images, and apply ratings to rank them.
- **Apply metadata:** write information-rich captions. Make sure that you add identifying tags and other descriptive keywords.
- **Set up:** create a new folder for work in progress. Save images with new filenames if you are making changes to the original files. Use a storage device different from that holding the original image. Straighten, crop, or re-size images as required.
- **Enhance:** normalize the blacks and highlights with exposure and curve correction.
- **Soft proof:** check how the image will look when outputted by reviewing proof colours. Adjust the image settings as required.
- **Clean up:** remove any flaws such as dust spots.

- **Final effects:** apply any drastic changes, such as conversion to black and white or sepia. Leave noise reduction to this step; apply sharpening, if required.
- **Prepare:** if you used layers, use Save As to keep the layered image in case you wish to modify the corrections you applied. Prior to export, flatten the image, re-size it, and save it in the required format.
- **Use:** export directly to the target destination; for example, from Lightroom straight into your Facebook page. If you cannot export directly, create a transit folder for exports.
- **Archive and tidy up:** Make back-up copies of new files on hard-disks. If you have created any folders for temporary files or files for download, remove them from your main machine. Double-check that you have two copies of images from your memory cards, then reformat the cards in your camera so they are empty and ready to use.

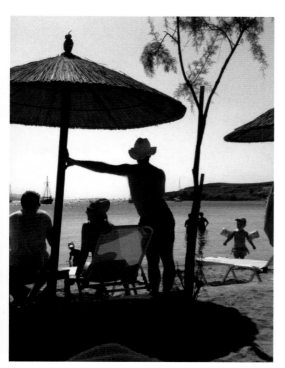

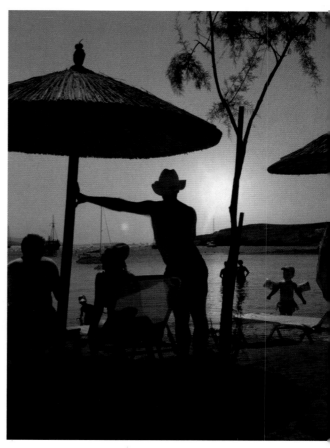

▲ Drastic changes

Substantial image changes, such as layering a sunset with a mid-afternoon scene, should be made on a copy of the original file. Work at full resolution even if you need only a small final image: perhaps one day someone will want to use the image large, having seen it on your website.

DOWNLOADING

Like it or not, the centre of your photographic work is the computer. It is crucial to download images captured on your camera to hard-disks under the control of the computer, as you can then back-up and work on the images. Then, when images are ready to be used, you will upload them from your computer to picture sites or into emails.

Computer by-pass

However, there are ways to avoid using the computer. You can download images from a memory card directly to a portable storage device that combines a hard-disk drive with a card reader. Also, you can send images from camera phones directly to social networking sites. Cameras equipped with WI-FI can connect to the internet and upload images to distributed networks – this is popularly known as Cloud computing. Having logged-on to your cloud account using, for example, Google Docs, Dropbox, or Box.net you can upload your images to the storage space in your account. Sooner or later, however, the images will need to pass through your computer. One reason for this is security: your digital images are safe as long as you keep copies in different places at the same time.

Quick download

The fastest way to download images is to remove your camera's memory card and use a card reader connected to your computer via USB 3.0, Firewire 800, or Thunderbolt – whichever is your fastest connector. You can connect your camera directly but if you have multiple cards, it saves wear and tear on the camera to use a dedicated card reader.

The key to keeping your images safe is to download the pictures – as soon as possible – to your computer's hard-drive or a mounted drive, leaving the images on the memory card. When you can, copy the images to another hard-disk, or DVD or Blu-Ray disc; then they will be in three different places and pretty safe from loss. If you are working wirelessly and subscribe to services such as Apple iCloud or Adobe Carousel, then upload to these services. Only when you are sure your images are backed-up should you re-format the memory card.

▲ **Bit error**
Errors in the memory card or occurring during download cause a break in the sequence of data, so part of the image looks fine but the rest is corrupted. Download it again to isolate the error: if it recurs, the memory card is at fault.

▲ **Incomplete scan**
If data recording or downloading was interrupted for some reason, this results in a blank area. The preview may be visible but the full file may not open at all. The memory card may be faulty or the download might need repeating.

▲ **Auto correction**
Images may be corrected automatically by the camera when they are saved or downloaded. If there was a serious error at the time of capture, the image may appear but be seriously degraded, but the file itself is not faulty.

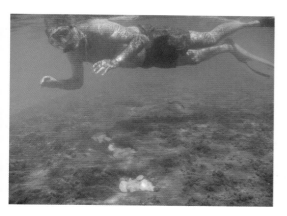

▲ Choosing colour mode

An image's colour mode is crucial to the success and quality of manipulation. RGB is useful for most image enhancements, but it is not the only mode. LAB is less intuitive to understand, but it is most flexible and versatile when preserving colour data to maintain image quality is a high priority. Here, the initial RGB capture underwater (above) was low in contrast and carried an overall green cast. If left in RGB, Auto Levels correction gives it a bright, colourful, but not accurate result (above right). In LAB mode, Auto Levels correction produces true-to-life colours with accurate tonality (right).

CHECKING THE IMAGE

- Check the colour mode and bit depth. Files from scanners may be saved as LAB files. Most image-manipulation software works in 24-bit RGB colour, and if the image is not in the correct mode, many adjustments are unavailable or give odd results.
- Check that the image is clean – that there are no dust spots or, if a scan, scratches or other marks. Increasing the contrast of the image and making it darker usually helps to reveal faint dust spots.
- Ensure that the image has not had too much noise or grain removed.
- Assess the image sharpness. If the image has been overly sharpened, further manipulation may cause visible edge artefacts.
- Is the exposure of your pictures accurate? If not, corrections may cause posterization or stepped tonal changes.

- Is the white balance accurate? If the file is not in RAW format, corrections may cause inaccurate colours and tones.
- Are the colours clear and accurate? If not, corrections may cause posterization, stepped tonal changes, or less accurate hues.
- Check that there is no excess border to the image. It may upset calculations for Auto Levels or other corrections.
- Check the file size. It should be adequate for your purposes but not much larger. If it is too small, you could work on it for hours only to find it is not suitable for the output size desired. If it is too large, you will waste time as all manipulations take longer than necessary.
- Check the colour profile for the image: for general purposes, use sRGB; for demanding uses, set Adobe RGB (1998).

FILE FORMATS

File formats define different ways of organizing information. While the bulk of an image file is the image data itself, in order for software to know how to read the data, it needs to know how it has been organized – just like headings on instruction sheets tell you where to find the Chinese, French, or English language versions. Fortunately, digital photography has a universal "language", JPEG, which is used for all common purposes, from emails and web-sites, to printing and sharing.

JPEG

JPEG is a way to compress data. We trade small file size against lower image quality by compressing files. Generally, high compression gives lower quality, and vice versa. However, the data that is discarded cannot be recovered, so it is best to err on the side of caution. When capturing images, save them at high quality (low compression) to allow for later manipulation. When working with large images (with a high pixel count) you can use a lower quality setting than if you capture very small images.

FILE SIZE

For the internet and basic printing, small, compressed files, such as JPEGs, are adequate. For books and magazines, larger, uncompressed images, such as TIFFs, are commonly used.

Ink-jet print	7.5 x 12.5 cm (3 x 5 in)	1.9 MB
	10 x 15 cm (4 x 6 in)	2.7 MB
	20 x 25.5 cm (8 x 10 in)	5 MB
	A4	6.9 MB
	A3	12.6 MB
Image for webpage	480 x 320 pixels	0.45 MB
	600 x 400 pixels	0.7 MB
	768 x 512 pixels	1.12 MB
	960 x 640 pixels	1.75 MB
Book/ magazine printing	A4	18.6 MB
	20 x 25.5 cm (8 x 10 in)	13.6 MB
	A5	9.3 MB
	12.5 x 17.5 cm (5 x 7 in)	6.7 MB

It is often recommended that you do not save and re-save files in JPEG because each save loses more data. In practice, numerous re-saves at mid- to high-quality settings make little difference to quality. See the panel opposite on JPEG compression.

TIFF

TIFF is popular with publishing professionals as the format can hold more colour information than JPEG, but at the cost of much larger files. The LZW compression of TIFF comes without any data loss.

RAW format

RAW files comprise the image data that comes directly from the camera sensor, with minimal processing, such as pixel-based balancing. In contrast, JPEG files pass through several image processing stages and also drop data during compression. Therefore the promise of working in RAW is that the data is unadulterated, therefore promising the best potential image quality. (*See also pp. 234–7.*)

If you process the RAW files yourself, you obtain maximum flexibility with the images' tonal range and white balance (although that is not a licence to be careless about exposure control). Performing your own processing also removes the limitations of fixed in-camera processing such as sharpening, colour space, noise reduction, and even the basic extraction of colour data. Most importantly, RAW processing does not alter the original file at all; you always save a new image file. This means that, as RAW conversion methods evolve, you can return to the old RAW files to extract even better images.

Other formats

Many other formats are in use, such as BMP, PNG, GIF, and PICT. Some store data in a specifically efficient way, such as GIF for graphics, but other formats were created for manufacturers' convenience – for example, to evade patents – rather than that of consumers. Modern imaging software easily converts images from one format to another. For most practical photographic purposes, JPEG is all that you need to output or deliver.

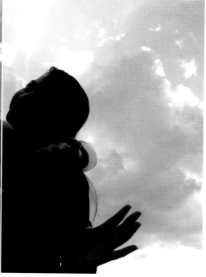

◀ RAW

By not committing to full image development when saved, RAW formats give you plenty of scope for adjustment. This is clearly demonstrated in this shot deliberately captured against the light without reflectors or fill-in. The improvement in both highlight and shadow detail, as well as the recovery of colours from the shadows is remarkable (left side). With low-noise cameras, a little under-exposure is permissible. Avoid over-exposure of bright areas.

JPEGs IN DETAIL

JPEG compression is efficient due to the fact that several distinct techniques are all brought to bear on the image file at the same time. Although it sounds complicated, thankfully modern computers and digital cameras have no problem handling the calculations. The technique, known as "jay-pegging", consists of three steps.

1 The Discrete Cosine Transform (DCT) orders data in blocks measuring 8 x 8 pixels, which creates the characteristic "blocky" structure you can see in close-up (*see right*). Blocks are converted from the "spatial domain" to the "frequency domain", which is analogous to presenting a graph of, say, a continuous curve as histograms that plot the frequency of occurrence of each value. This step compresses data, loses no detail, and identifies data that may be removed.

2 Matrix multiplication reorders the data for "quantization". It is here that you choose the quality setting of an image, balancing, on the one hand, your desire for small-sized files against, on the other, the loss of image quality.

3 In the final stage of jay-pegging, the results of the last manipulation are finally coded, using yet more lossless compression techniques.

The effect of these compressions is that JPEG files

▲ JPEG artefacts

This close-up view of a JPEG-compressed image shows the blocks of 64 pixels that are created by the compression feature. This can create false textures and obscure detail, but on areas of even tone, or where image detail is small and patterned, such artefacts are not normally visible – even with very high levels of compression. Note how the pixels within a block are more similar to each other than to those of an adjacent block.

can be reduced by 70 per cent (or, reduced to just 30 per cent of their original size) with nearly invisible image degradation; you still have a usable image even with a reduction of 90 per cent. However, this is not enough for some applications, and so a new technology, known as JPEG2000, based on another way of coding data, offers greater file compression with even less loss of detail.

IMAGE MANAGEMENT

Whether you are a casual, amateur, or professional photographer, your photographs represent a considerable investment. It is not just the cost of the camera and the computer equipment, but also the time spent learning how to use the equipment and software, not forgetting the time spent on chasing photos. And, no false modesty here, there is also the valuable input of your artistry and skill.

There are two sides to managing your photographic assets. One is ensuring that you do not lose any, and that they last forever. The other is to make them easily available – at least to yourself and, at best, to anyone who wishes to use them.

Safety in numbers

In the current state of technology, no digital medium can match film-based images for archival safety – the ability to survive unchanged and easily used for more than a hundred years. Those who would like their legacy to stretch into the next century or two may be best advised to return to shooting on film. For the more modest, the best strategy is to keep digital image files in multiple storage systems and in multiple places. For small numbers of images, use DVD or Blu-Ray disks to archive your images, even though these are slow to write and access. Hard-disk systems are much better for working with, but are less reliable (see p. 358).

Hard-disk systems called RAID (redundant array of independent disks), which allow for the failure of one or more disks without any loss of data, are now affordable to anyone who takes photography seriously. They may cost as much as an SLR, but they are arguably more important than an extra camera if you value your photos. The RAID's contents can be backed up on inexpensive desktop drives that are kept in different locations – for example, at a relative's house.

Soft gold

The total number of pictures on the internet is climbing well beyond a trillion, thanks to your contribution, among several hundred million other photographers. Locating a particular image, for example, to illustrate a magazine feature or use on a leaflet, must be text-based. Metadata or tags (also called soft data) are descriptive words, names, and other data added to or embedded in an image.

We find an image of Cape Town, for instance, not by examining millions of images on the lookout for features belonging to South Africa's great city, but by first looking for images carrying the name tag "Cape Town". What is more, you might have no idea what Cape Town looks like, yet you can collect dozens of excellent shots merely by searching for the tag. In fact, any image failing to carry the tag is very unlikely to be found, even if it is the best possible shot of the city.

The addition of metadata is an essential skill. Minimally, metadata should identify the subject or event, the date, the location, the copyright holder, and the photographer. The information should be enough for anyone to know for sure what the picture is about and to be able to contact you, so it should carry a caption and your details. In addition, keywords that refer to key elements of the image and a unique identifier, such as a serial number, can help anyone to locate your image.

Caption marvel

The rule for an effective caption is simple: answer the what, when, where, and who questions. Many agencies have a limit to the number of characters you can use, so it takes some skill and planning to get down all the information in the space available. While keywords are essential in helping a potential user to locate your photograph, the caption may clinch the deal as it can confirm the exact details and timing needed.

Start today

It may seem unnecessary to organize a collection of a few hundred images, but it is an easy task, and you will learn through the process. If you start when you really need to – with a collection of thousands of images – the task could be discouragingly onerous. So your most important decision is to decide to start right now, before you lose any precious images in a hard-disk crash and long before it is really necessary.

CALLING NAMES

- There two main ways your can name your images. You can use the names given by the camera, usually a generic DSC1234 or _IMG1234. (The underscore prefix means that the embedded profile is Adobe RGB.) Alternatively, you can name files more specifically, such as _ANG1234. Professional users will benefit most from using specific image names.

- File names are most easily changed at download time or renamed in a batch.
- If you create specific names, keep a running catalogue to ensure that each is unique – for example, by job number or date.
- Camera-generated names usually repeat after 9,999 images.

◀ File lists

Image files can be shown in lists that display a thumbnail of the image together with all its associated metadata. Selecting one of the images allows the metadata to be edited. In software such as Apple Aperture (shown here) or Adobe Lightroom, image-enhancement controls are available alongside tools for organizing material for slide shows, web pages, or books.

◀ Management software

One of the best ways to organize your images is to use management software. Applications worth considering include Adobe Lightroom, Apple Aperture, Extensis Portfolio, ACDSee, and Camera Bits Photo Mechanic (shown here). Not only do all these programs help you to keep picture files organized, they can also create "contact prints" and slide shows, as well as publishing picture collections to the web.

CAPTURE DEFECTS

There is a story about a group of great photographers who decided to make a list of what could go wrong in photography. They gave up when they reached 200 items. The defects highlighted here are only the common errors that are easy to miss – some even for the experienced photographer – leaving out the obvious such as poor focus or camera shake.

Original sins

There are two kinds of image defect: those arising from inadequacies of equipment such as poor image quality, flare, noise, and problems with colour.

The other defects result from inadequacies in technique, such as poor focus or exposure, camera shake, and unwanted distractions – such as an object sticking out of a subject's head, or telephone wires across the sky.

To varying degrees, all defects can be corrected or hidden: this is one of the glories of digital photography. However, you will find that you save yourself a great deal of time and frustration at the computer by taking utmost care when capturing the image. Your ultimate aim is never to have to manipulate an image to make it usable.

▲ Distractions
Some distractions may be avoided altogether through careful choice of position and framing, but wires and cables that stretch between buildings, spoiling the view of the sky, are notoriously difficult to avoid. Treat them as an image defect, whose removal is part of post-processing.

▲ Highlight clipping
When overexposure causes highlights to lose all colour and detail they are said to be clipped. It is impossible to recover these areas, so they are best avoided altogether. Recording in RAW format and bracketing exposures for tone compression (*see pp. 266–7*) may help.

▲ Noise
When visible, irregular spots of colour or large "clumps" of light or dark pixels disrupt image detail and colour. Noise is commonly blamed on sensor performance, but can also be made apparent by post-processing; it is the price you pay for rescuing under-exposed images.

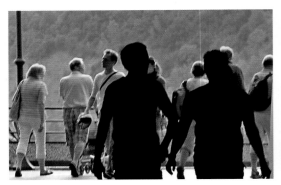

▲ Shadow clipping
The opposite of highlight clipping (*above*) is loss of detail and colour in shadows due to underexposure. It is usually easier to extract some detail and colour from clipped shadows than from clipped highlights. Recording in RAW (*see pp. 234–7*) increases the chance of a successful fill.

Avoid if possible

Certain defects are impossible to correct fully. If a lens hoods for a wide-angle lenses is misaligned it will cause shadowing or vignetting in the corners: the only way to remove them is to crop the image. The same applies to tilted horizons. Flare caused by pointing the camera at the sun can be extremely troublesome to remove or disguise. And, of course, poor focus leads to loss of details that cannot be recaptured. However, some unsharpness or blur resulting from movement can be reduced using modern algorithms.

WORSHIPPING QUALITY

Image quality is usually over-rated. While the combination of a stunning image with technical perfection is a very fine thing, it is a common mistake to focus on quality alone. Remember that many of the greatest pictures in the history of photography were made on equipment and film far inferior to even today's amateur cameras. But no-one complains about their grain or poor colour. Concentrate on making a wonderful image; quality comes a long way behind.

▲ Tilted horizon
This problem is commonly caused by cameras that are heavier on one side than the other, also by using small live image screens. A tiny tilt looks like an error, but very obvious tilts look deliberate and can be acceptable. Correcting the tilt is easy but always involves cropping (*see pp. 208–9*).

▲ Excessive depth of field
A common problem arising from the widespread use of small sensors, too great a depth of field gives too much prominence to the background, distracting the viewer from the main subject. Use post-processing to blur the background selectively (*see pp. 200–3*).

▲ Leaning verticals
Tilting the camera up to take in the full height of a building usually causes the building to look as if it is leaning back awkwardly. This often looks like poor technique. But tilting up strongly is often accepted as a deliberate visual effect. Small amounts of lean can be corrected (*see pp. 208–9*).

▲ Unbalanced colour
Until more cameras use intelligent white balancing, a common defect is the inaccurate capture of neutrals in the presence of a strong illuminating colour, such as here, where the red candles cause the white walls to look blue. This may need careful, hue-specific correction (*see pp. 210–13*).

CROPPING AND ROTATION

The creative importance of cropping, to remove extraneous subject detail, is crucial in digital photography – it can even be used as a compositional tool in its own right. A single image can have many different interpretations according to how it is cropped, although you should not let this affect your decisions when composing and framing your images.

Not only does digital cropping reduce picture content, it also reduces file size. Bear in mind that you should not crop to a specific resolution until the final stages of image processing, as re-sizing by interpolation will then be required (*see pp. 206–7*). This reduces picture quality, usually by causing a slight softening of detail. Image cropping without a change of resolution does not require interpolation.

Image rotation

The horizon in an image is normally expected to run parallel with the top and bottom edges of the image. Similarly, you may want to make sure that vertical lines in your image are correctly aligned, particularly when photographing buildings (*see pp. 97–9*) or other subjects with strong geometry. Slight mistakes in aiming the camera – not an uncommon error when you are working quickly or your concentration slips – can be corrected by rotating the image before printing.

With film-based photography, this correction was carried out in the darkroom during the printing stage. In digital photography, however, rotation is a straightforward transformation, and in some software applications you can carry out the correction as part of the image-cropping process.

Note that any rotation that is not 90°, or a multiple of 90°, will need interpolation. Repeated rotation may cause image detail to blur, so it is best to decide exactly how much rotation is required, and then perform it all in a single step.

Correcting scans

Cropping and rotation are also useful tools if you are scanning old film images from your archive. For example, you may want to remove the border caused by inaccurate scanning. This area of white or black not only takes up valuable machine memory, it can also greatly distort tonal calculations, such as Levels (*see pp. 188–9*). If a border to the image is needed, you can always add it at a later stage using a range of different applications (*see p. 209*).

Rotation can also be used to correct any innacuracies in placement on the scanner. However, always check that scanned negatives are correctly oriented – that left-to-right in the original is still left-to-right in the digital image.

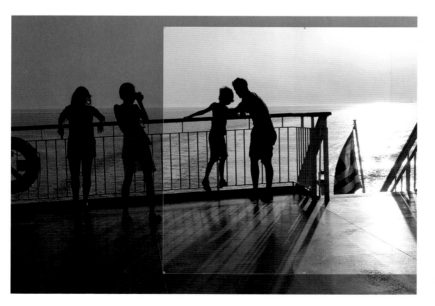

◀ **Creative cropping**
Cropping can help rescue an image that was not correctly framed or composed. By removing elements that are not required or are extraneous to what you intended, you can create a more visually coherent final image. Beware that crops to one side of a wide-angle image may appear to distort perspective, since the centre of the image will not correspond to the centre of perspective. Cropping decreases the size of the image file and calls on the image's data reserves to maintain image quality.

SAVING AS YOU GO

When working on image manipulations, make sure you adopt good working practices: always work on a copy of the original file, and get into the habit of saving your working file as you proceed: press Command + S (Mac) or Control + S (PC) at regular intervals. It is easy to forget in the heat of the creative moment that the image on the monitor is only virtual – it exists just as long as the computer is on and functioning properly. If your file is large and what you are doing is complicated, then the risks of the computer crashing are increased (and the resulting loss of the work more grievous). A good rule to remember is that if your file is so large that making frequent saves is an inconvenient interruption, then you definitely should be doing it, inconvenient or not.

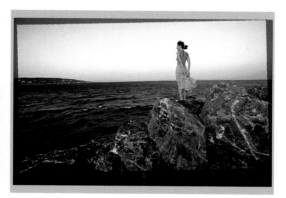

◀ Sloping horizon

A snatched shot taken with a wide-angle lens left the horizon with a slight but noticeable tilt, disturbing the serenity of the image. But by rotating a crop it is possible to correct the horizon (*below*), although, as you can see from the masked-off area (*left*), you do have to sacrifice the marginal areas of the image. Some software allows you to give a precise figure for the rotation; others require you to do it by eye.

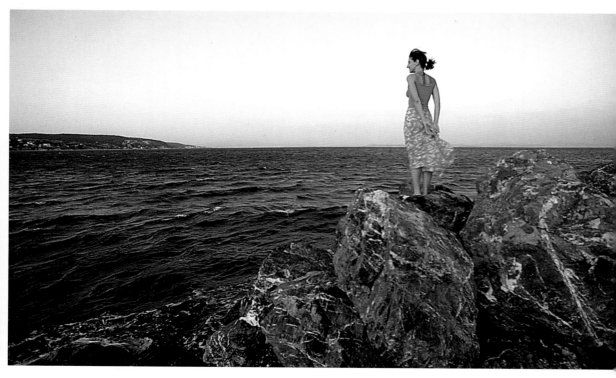

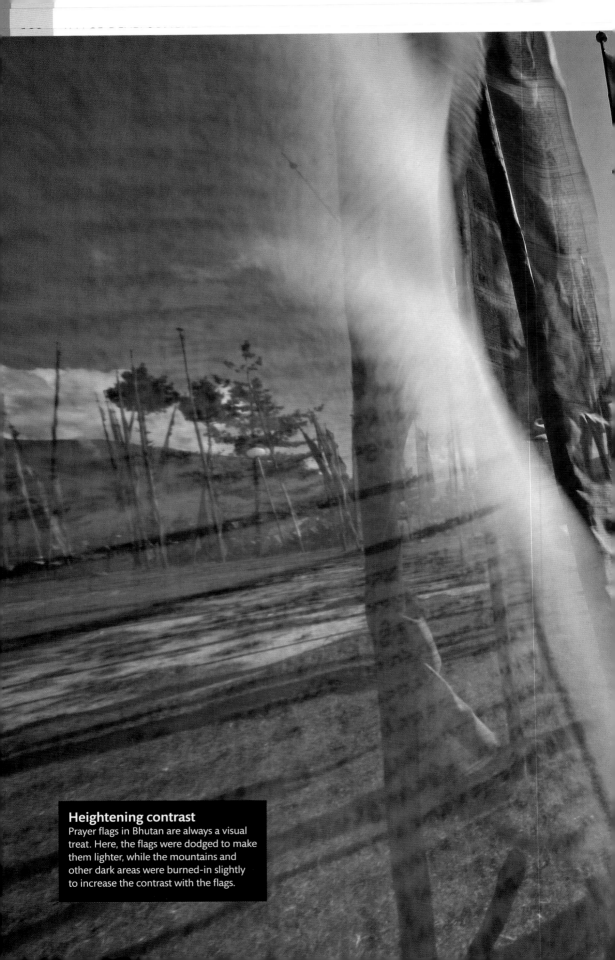

Heightening contrast
Prayer flags in Bhutan are always a visual treat. Here, the flags were dodged to make them lighter, while the mountains and other dark areas were burned-in slightly to increase the contrast with the flags.

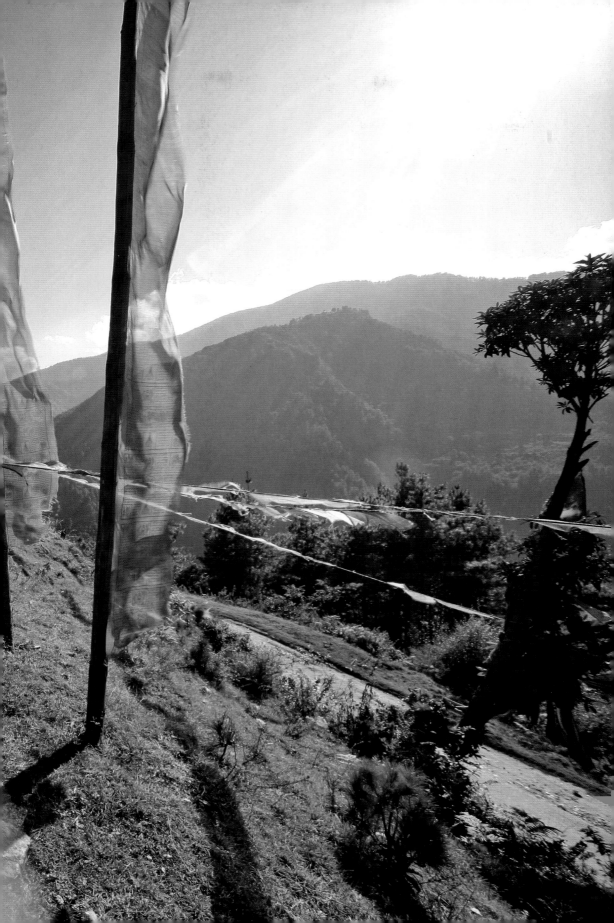

DUST AND NOISE

Two factors are the "forever enemies" of image quality: dust and noise. Dust spots on the image result when material lands on the photosensor of a camera or on film to be scanned. It is a serious problem with SLRs as the debris is recorded on every image. Noise – usually seen as pixels markedly different to neighbouring pixels and not caused by subject features – arises from the electronic properties of the photosensor of a camera or scanner.

Noise control

You can reduce noise where the noise has a higher frequency than the image detail itself – in other words, if the specks are much smaller than the detail in the image. This is one advantage of increasing the pixel count of images. In low-resolution images, applying a noise filter smudges image information along with the noise signals. Digital filters such as Noise Ninja are effective at reducing noise only where required, and all raw converters can reduce noise. DxO Optics stands out by reducing noise before applying colour interpolation.

Dust-removal options

Some scanners provide features to mask dust damage, replacing the resulting gaps in the image with pixels similar to those adjacent to the problem areas. These can work well, although some may disturb the film's grain structure, while others work only on colour film.

Many cameras incorporate mechanisms to reduce dust, using, for example, rapid vibration to shake off particles or anti-static coatings to avoid attracting particles. Certain SLRs offer dust-removal software: you photograph a plain surface, have the result analyzed by the software, which then creates a "mask" that can be applied to images to remove the dust. You can also help the camera directly by cleaning the sensor using ultra-soft micro-porous swabs or ultra-fine brushes that sweep up the dust and reduce static charges.

Manual removal

The key image-repair technique is to replace the dust with pixels that blend in with neighbouring pixels. Depending on your tool of choice, you either

▲ **Dust on sensor**
A 300 per cent enlargement of the corner of an image shows a few faint specks of dust. They are blurred because they lie some distance above the sensor, which "sees" only their shadows. However, with manipulation, the pale spots will become more visible.

◄ **Dust revealed**
The full extent of the dust spots is revealed when we apply an adjustment layer to increase contrast and decrease exposure of the image. This presents the worst-case scenario and makes it easy to identify and eliminate the spots.

▲ **Dust removed**
Use the Spot Healing Brush, Healing Brush or Clone Stamp tool to remove the dust spots. Set the brush to just slightly larger than the average spot, with a sharply defined brush edge, and sweep systematically in one direction.

manually select the source for the pixels to cover the dust – this is Cloning – or you let the software sample from around the dust and apply an algorithm that blends local pixels with the dust to hide the spots – in Photoshop, this is called Healing. Where the spots are too numerous, a blurring filter may help, but this will also blur image detail that is the same size as the spots.

HINTS AND TIPS

- Clone with the tool set to maximum pressure, as lighter pressure produces a smudged clone.
- In even-toned areas, use a soft-edged or feathered Brush as the cloning tool. In areas with fine detail, use a sharp-edge Brush instead.
- You do not always have to eliminate dust specks – reducing their size or contrast may be sufficient.
- Work systematically from a cleaned area into areas with specks, or you may find yourself cloning dust.
- If cloning looks overly smoothed, introduce some noise to make it look more realistic. Select the area for treatment and then apply the Noise filter.

▲ Noise in detail

In this close-up view of an image, it is clear there is more noise, or random pixels (seen as specks and unevenness of tone), in the darker areas than in the brighter ones. Compare the blue shadow area, for example, with the white plate. This is because noise in the photosensor is normally drowned out by higher signals, such as those generated by strong light.

▲ Noisy image

Poor noise-suppression circuitry and an exposure of 1/8 sec gave rise to this "noisy" image. Long exposures increase the chance of stray signals, which increase noise in an image.

▲ Screen shots

Examining the different channels (*above*) showed that the noisiest was the green one. This was selected and Gaussian Blur applied (*top*). The radius setting was adjusted to balance blurring of the specks while retaining overall sharpness.

▲ Smoother but softer

The resulting image offers smoother tones – especially skin tones – but the cost is visible in reduced sharpness of the orchids. You could select the red and blue channels to apply Unsharp Masking to improve the appearance of the flowers.

SHARPENING

The ease with which modern image-manipulation software can make a soft image appear sharp is almost magical. Although software cannot add to the amount of information contained in an image, it can put whatever information is there to the best possible use. Edges, for example, can be given more clarity and definition by improving local contrast.

Digitally, sharpen effects are true filters, as they hold back some components and selectively let others through. A Sharpen filter is, in reality, a "high-pass" filter – it allows high-frequency image information to pass while holding back low-frequency information.

Unsharp Masking

The most versatile method of image sharpening is Unsharp Masking (USM). This takes a grid of pixels and increases edge definition without introducing too many artefacts. Unsharp Mask has three settings. In Photoshop, they are called Amount, Radius, and Threshold. Amount defines how much sharpening to apply; Radius defines the distance around each pixel to evaluate for a change; Threshold dictates how much change must occur to be acceptable and not be masked.

It is possible to overdo sharpening. In general, assess image sharpness at the actual pixel level, so that each pixel corresponds to a pixel on the monitor. Any other view is interpolated (*see pp. 206-7*) and edges are softened, or anti-aliased, making sharpness impossible to assess properly.

As a guide, for images intended for print, the screen image should look very slightly over-sharpened, so artefacts (such as halos or bright fringes) are just visible. For on-screen use, sharpen images only until they look right on the screen.

Sharpening makes deep image changes that cannot easily be undone, so it is generally best to leave sharpening to last in any sequence of image manipulations, except for combining different layers. However, if you are working on a scan with many dust specks and other similar types of fault, you should expect the final sharpening to reveal more fine defects, so be prepared for another round of dust removal using cloning (*see pp. 194–5*).

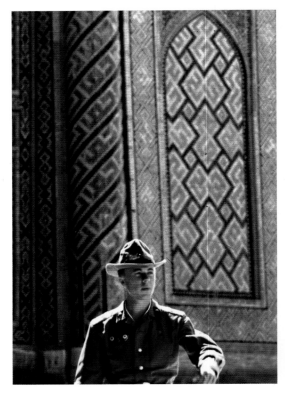

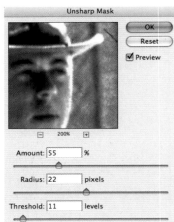

▲ Under-sharpening

In images containing large amounts of fine detail, such as this scene taken in Uzbekistan, applying a modest strength of USM filtering (55) and a large radius (22), with a threshold set at 11 does little for the image. There is a modest uplift in sharpness, but this is due more to an overall increase in contrast rather than any other effect.

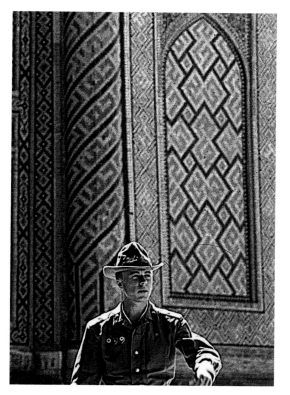

▲ Over-sharpening

The maximum strength setting used for this version results in over-sharpening – it is still usable and is arguably a good setting if you intend to print on poor-quality paper. The same setting applied to the Kashgar image (*pp. 198–9*) would simply bring out all the film grain – a technique for increasing noise in the image.

▲ Ideal setting

The best settings for images with fine detail is high strength with a small radius and a very low threshold: here, strength was 222, the radius was 2, and the threshold was kept at 0. Details are all well defined and if large-size prints are wanted, details are crisper than those obtained with sharpening using a larger radius setting.

SHARPENING CONTINUED

▲ Original image

This photograph of the main town square in Kashgar, Xinjiang, China, has large areas of smooth tone with little fine detail, and it would clearly benefit from the effects of image sharpening.

HINTS AND TIPS

Using an advanced Photoshop technique for image sharpening, first mask off areas (such as a face) to be protected from oversharpening and any associated increase in defects. Next, produce a duplicate layer of the background and set it to Soft Light mode. This increases contrast overall. Then apply the High-Pass filter (found under the Filter menu in Other > High Pass). Increasing the radius strengthens the effect (passes higher frequencies, or more detail). You can now enter Quick Mask mode or add a layer mask to control which areas of the image will be sharpened by the High-Pass filter. This method is also effective for sharpening an image overall and can be controlled by direct settings and by opacity. However, the preview window in the dialogue box does not give an accurate view because it samples only the top layer.

▲ Over-sharpening

If you increase the sharpening effect (222 in this version) and reduce the threshold (0), but reduce the radius to 2, virtually everything in the image increases in sharpness. The result is that film grain and fine detail are sharpened to an undesirable extent. Compare the result of these settings with that of an image that contains a mass of fine detail (see p. 196).

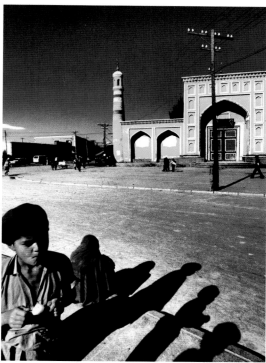

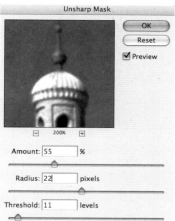

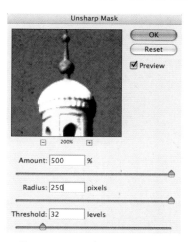

▲ Sharpening areas of tone

A moderate amount of sharpening (55) and a relatively wide radius for the filter to act on (22) improves sharpness where there is subject detail, without bringing out film grain or unwanted information, such as in the subject's skin-tones. A threshold setting of 11 prevents the filter from breaking up smooth tonal transitions, as the sharpening effect operates only on pixels differing in brightness by more than 11 units.

▲ Extreme settings

This version results from maximum amount and radius settings. The effect is extreme, but a threshold of 32 controls coloration. Even so, the image has highly saturated colours and brilliant contrast. In addition, film grain is emphasized. The random appearance of film grain gives more attractive results than the regular structure of a digital image, so if you want to use this effect introduce image noise first.

BLURRING

Blur can be introduced by lowering contrast to give boundaries a less-distinct outline. This is the opposite of sharpening (*see pp. 196–9*). Paradoxically, blurring can make images look sharper, for if you throw a background out of focus, then any detail in front looks sharper in comparison.

Blur options

Blur effects are seldom effective if applied to the whole image, since they often fail to respond to the picture's content and character. The Median and Dust & Scratches filters produce an effect like looking through clear, moving water. For some subjects this is appropriate, but for blur with some clarity, other methods are better. One approach depends on the data-loss caused by interpolation (*see pp. 206–7*) when reducing file sizes. First, increase the image size by, say, 300 per cent, using Resampling, and then reduce it to its original size. Check its appearance and repeat if necessary. This does take time, but it can give well-detailed, softly blurred results. A quicker, though less-adaptive, method is to reduce the file size, and then increase it, repeating this step as necessary.

▲ Selective blur

Although you will not often want to blur an image in its entirety, selective blurring, and thus the softening of subject detail, can be extremely useful on occasion. To take one example, the blurred areas of an image could become the perfect background for typography – perhaps on a web page – as the wording would then be easier to read. Another example could be to introduce digital selective blur to simulate the appearance of using a special effects, soft-focus lens filter. This type of glass filter is designed to soften all but a central region of the image in order to help concentrate the viewer's attention on a particular feature. In the example shown here – an informal portrait of a traveller on a ferry on the River Danube, Hungary – the high-contrast sunlight and the sharpness of background detail was softened to emphasize the girl's features.

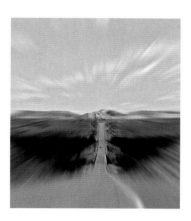

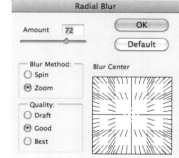

▲ Motion blur

This filter simulates the effect of rapid movement across the field of vision. Usual controls for this filter include altering the angle of the "smear" as well as its length: greater lengths suggest higher speed motion. For unusual results apply different angles to different parts of the image.

▲ Dust and scratches

While it is not strictly a blurring filter, at large radius settings the Dust & Scratches filter does an excellent job of blurring details while retaining outlines to give a watery effect. Setting the Threshold to higher values retains more details. Reduce saturation to create a water-colour look.

▲ Radial blur

Use this filter to apply the blur along lines radiating out from the centre of the image. This can simulate the effect of speeding into the distance. For best results, apply in steps to selectively smaller areas. In Adobe Photoshop, the filter also offers an option for simulating a zoom blur (see p. 33).

BLURRING CONTINUED

Having spent a fortune on lenses that deliver super-sharp images, it seems madness to introduce blur into your images. But targeted blur is an essential part of the visual language: it can depict movement, it can be used to indicate centres of interest, and it can imitate effects created by articulated lens movements. The key to targeted blur is combining masks with blur filters.

Motion parallax

Blur is the result of an image moving a visible distance across the sensor. As nearby objects appear to move much more than distant objects, even if they are actually travelling at the same speed, they always appear more blurred. You see this when travelling on a train: the trees nearby are always blurred, but the mountains in the distance are

CREATING MOVEMENT BLUR

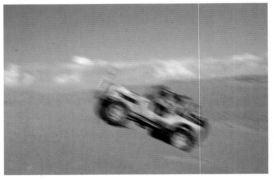

1 **Original image**
This travel shot is clearly taken in an exotic location, but lacks energy and a sense of movement. The four-wheel-drive vehicle looks as though it is stuck in the sand or about to roll backwards. We need a sense of forward movement.

2 **Motion blur**
On a duplicate layer, we apply a Motion Blur filter: we line up the motion blur with the long axis of the vehicle, adjusting its strength to avoid losing too much detail.

3 **Mask**
We now apply a mask over the majority of the image – the sky, the landscape, and the front of the vehicle. It now appears that the exposure time was too long to capture a sharp image. But a reality check will show that this is a manipulated image: the difference in sharpness in the vehicle gives the game away.

sharp. You can simulate this effect by applying blur to the objects close to the camera while keeping distant parts of the scene relatively sharp.

Lens movements

A blur effect that is completely different from motion is created by movement of the lens: this means that the lens is articulated so it can rotate at right-angles to its optical axis. A forward tilt can increase apparent depth of field, while a reverse tilt strongly reduces depth of field, making a scene resemble a small scale model. The strength of the effect depends on the angle of tilt and the working aperture set. You can simulate this effect by using graduated masks to control a blur applied to the whole image.

REVERSE TILT EFFECT

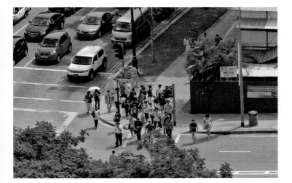

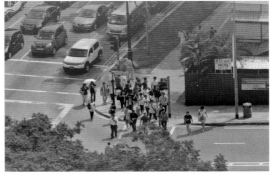

1 High-angle original
Tilt shift gives the impression of a model, so it works best on shots taken from a high angle, and is effective with objects such as people and cars. This street scene taken from a hotel window is perfect for this effect.

2 Quick Mask
In Quick Mask mode, select the gradient tool, draw a gradient from the centre of the part you want to be in focus to the edges of the image. A few attempts may be needed to get the right area. The Quick Mask mode allows you to see clearly what will be blurred.

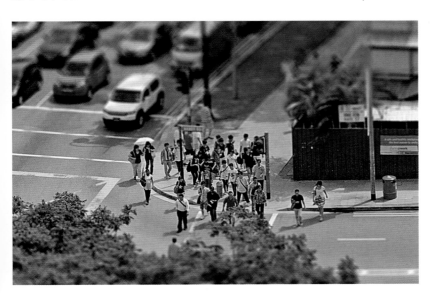

3 Apply blur
Back in standard mode, the lens blur filter can be applied; again this may take a few attempts to get it right. You are able to preview the amount of blur before you actually apply it. Although the effect will look finished now, using the unsharp mask filter makes the people more clearly defined and adds to the toy model effect.

QUICK FIX IMAGE DISTRACTIONS

Unless there is a fundamental problem with your image, most minor distractions can be removed, or at least be minimized, using digital techniques.

Problem: While concentrating on your subject it is easy not to notice distracting objects in the picture area. This could be something minor, such as a discarded food wrapper, but out-of-focus highlights can also be a problem.

Analysis: The small viewfinders of many cameras make it difficult to see much subject detail. Furthermore, though something is distant and looks out of focus, it may still be within the depth of field of your lens (*see pp. 24–7*). At other times, you simply cannot avoid including, say, telephone wires in the background of a scene.

Solution: You may not need to remove a distraction completely – simply reducing the difference between it and adjacent areas may be enough. The usual way to achieve this is with cloning – duplicating part of an image and placing it into another part (*see pp. 288–91*). For example, blue sky can be easily cloned onto wires crossing it, as long as you are careful to use areas that match in brightness and hue. If you clone from as close to the distraction as possible, this should not be too much of a problem.

You could also try desaturating the background: select the main subject and invert the selection; or select the background and lower saturation using Color Saturation. You could also paint over the background using the Saturation or Sponge tool set to desaturate.

Another method is to blur the background. Select the main subject and invert the selection, or select the background directly, and apply a Blur filter (*see pp. 200–1*). Select a narrow feather edge to retain sharpness in the subject's outline. Choose carefully or, when Blur is applied, the selected region will be left with a distinct margin. Try different settings, keeping in mind the image's output size – small images need more blur than large ones.

HOW TO AVOID THE PROBLEM

Check the viewfinder image carefully before shooting. This is easier with an SLR camera, which is why most professionals use them. Long focal length lenses (or zoom settings) reduce depth of field and tend to blur backgrounds. And, if appropriate to the subject, use a lower viewpoint and look upward to increase the amount of non-distracting sky.

▲ Foreground distraction
An old man photographed in Greece shows me a picture of his sons. As he leans over the balcony, the clothes pegs in front of his chin prove impossible to avoid.

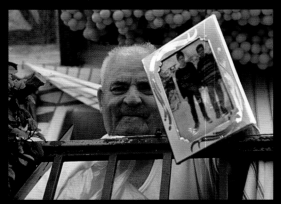

▲ Cloning
Luckily, in this example there was enough of the man's skin tone visible to give a convincing reconstruction. To do this, the skin part of the image was used to clone areas of colour over the adjacent distractions.

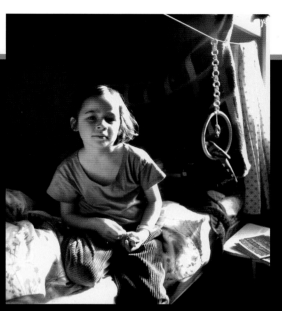

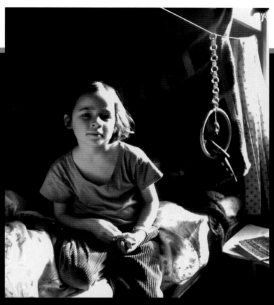

▲ Background distractions

In the chaos of a young child's room, it is neither possible nor desirable to remove all the distractions, but toning them down would help to emphasize the main subject.

▲ Desaturated background

Applying Desaturate to the background, turning all the colours into grey has helped separate the girl from the numerous objects surrounding her. A large, soft-edged Brush tool was chosen and the printing mode was set to desaturation at 100 per cent.

▲ Selective blur

Despite using a large aperture, a wide-angle lens setting still produced more depth of field than I wanted in this example (*above left*). To reduce the intrusive sharpness of the trees, I used the Gaussian Blur filter set to a radius of 9 pixels (*right*). First, I selected the figure with a feathering of 5 and then inverted this selection in order to apply the Gaussian Blur to the background alone (*above right*).

IMAGE SIZE AND DISTORTION

One of the most common manipulations is to change the output size of an image. There are three classes of change; the first two methods change size uniformly across the entire image, which does not change picture shape. You can change the output size of the image but keep the file size of the image the same: this is resize without resampling (or without changing the number of pixels). You can also resize with sampling, which changes the number of pixels in the image, in turn altering file size. Finally, the size change may be non-uniform – that is, you distort the image and change its shape.

Changing image size

In practice, you will probably set only a small range of sizes – from postcard to small poster, say. (For a table comparing the opened file size of an image to the maximum size it can be printed, see p. 176.) In general, you can increase the output size of your image by around 200 per cent, but techniques such as spline-based or fractal interpolation can give enlargements of 1,000 per cent of acceptable quality. Note that as print size increases, the assumption is that viewing distance also increases. Files with higher resolution will support greater proportional enlargement than smaller files. All image manipulation software can change image size, but specialist software, such as Genuine Fractals or Photozoom, may do a better job.

Why distort?

You may distort an image to make it fit a specific area, for humorous effect or for visual impact. Images with irregular-shaped subjects are best, as the distortion is not too obvious.

The Transform tool can be used to solve a common photographic problem: the projection distortion or key-stoning that occurs when the camera is not held square to a building or other geometrically regular subject. The digital solution to this problem is simple: a combination of cropping, allowing for losses at the corners if you have to rotate the image, followed by a controlled distortion of the entire image (*see p. 208*).

▲ Destructive interpolation

The original landscape-format image of a flower and strap-like leaves (*above*) was contracted on one axis only; so while depth remained the same, width was reduced to a third. This crams all the information into a narrow area and distorts the content of the image (*right*). If, however, you decided to restore this image's original shape, it would not be as sharp as it originally was because the distortion is a destructive interpolation and involves the irretrievable loss of image information.

▲ Unbundling

Distortion is a natural part of the photographic process: whenever any surface is not captured square on and the resulting image is not viewed at the correct magnification, the shape of the subject is not accurate and appears distorted. By changing the proportions of an image, you can either make some corrections by changing magnification on one axis or you can use it to cause deliberate exaggerations of shape. Here, it is not clear which of the two images of a piazza in Ascoli, Italy, is the original. (In fact, it is the vertical image.)

WHAT IS INTERPOLATION?

Interpolation is a mathematical discipline vital to processes ranging from satellite surveys to machine vision (the recognition of number plates on speeding cars, for example). In digital photography, three methods of interpolation are used to alter image size.

- "**Nearest neighbour**" simply takes adjacent values and copies them for new pixels. This gives rough results with continuous-tone images but it is the best way for bit-map line graphics (those with only black or white pixels).

- "**Bilinear interpolation**" looks at the four pixels to the top, bottom, and sides of the central pixel and calculates new values by averaging the four. This method gives smoother-looking results.

- "**Bicubic interpolation**" looks at all eight neighbouring pixels and computes a weighted average to give the best results. However, this method requires more computing power.

▲ Image Size screen shot

If you have the professional image-manipulation software package Photoshop, you have the option of choosing your default interpolation method from the general application preferences menu, or you can override the default for each resizing operation using the Image Size dialogue box (*above*).

QUICK FIX CONVERGING PARALLELS

While the brain largely compensates for visual distortions – so, in effect, you see what you expect to see – the camera faithfully records them all.

Problem: Images showing subjects with prominent straight lines, such as the sides of a building, appear uncomfortable when printed or viewed on screen because the lines appear to converge. Regular shapes may also appear sheared or squashed (*see also p. 52*).

Analysis: The change in size of different parts of the image is due to changes of magnification – different parts of the recorded scene are being reproduced at different scales. This occurs because of changes in distance between the camera and various parts of the subject. For example, when you look through the viewfinder at a building from street level, its top is further away than its base – a fact that is emphasized by pointing the camera upward to include the whole structure. As a result, the more distant parts appear to be smaller than the closer parts.

Solution: Select the whole image and, using the Distortion or Transformation tool, pull the image into shape. If there are changes in magnification in two planes, both will converge, and so you will need to compensate for both.

HOW TO AVOID THE PROBLEM

- Choose your shooting position with care and try to compose the image in order to keep any lines that are centrally positioned as vertical as possible. In addition, look to maintain symmetry either side of the middle of the picture.
- Rather than pointing the camera upward, to include the upper parts of a building or some other tall structure, look for an elevated shooting position. This way, you may be able to keep the camera parallel with the subject and so minimize differences in scale between various parts of the subject as they are recorded by the camera.

1 Verticals converge
Shooting from ground level with the camera angled upward caused the scene to appear to tilt backward.

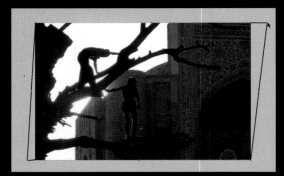

2 Image manipulation
Stretching the lower left-hand corner of the image using the Distortion tool is the solution to this problem.

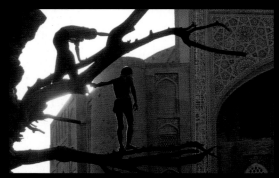

3 Verticals corrected
The corrected image looks better and corresponds more closely to the way the scene looked in reality.

QUICK FIX IMAGE FRAMING

Don't allow your images to become unnecessarily constrained by the sides of the camera viewfinder or the regular borders of your printing paper. There are creative options available to you.

Problem: The precise and clear-cut rectangular outlines around images can not only become boring, sometimes they are simply not appropriate – for example, on a web page where the rest of the design is informal. What is needed is some sort of controlled way of introducing some variety to the way you frame your images.

Analysis: In the majority of situations, producing images with clean borders is the most appropriate method of presentation. But with the less-formal space of a web page, a looser, vignetted frame might be a better option. On occasion, a picture frame can also be used to crop an image without actually losing any crucial subject matter.

Solution: Scan textures and shapes that you would like to use as frames and simply drop them onto the margins of your images. Many software applications offer simple frame types, which you can easily apply to any image and at any size. Specialist plug-ins, such as Extensis Photoframe, simplify the process of applying frames and provide you with numerous, customizable framing options.

HOW TO AVOID THE PROBLEM

The need to create picture frames usually arises from the desire to improve an image that has not been ideally composed. Nobody thinks about picture frames when looking at a truly arresting photograph. Inspect your pictures carefully, checking the image right to the edges. Tilting the camera when shooting creates a different style of framing, or simply crop off image elements you don't need.

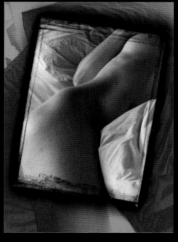

▲ Framing option 1
The first option applies a geometric frame in which it partially reverses the underlying tones of the image. It is effective in hiding unwanted details in the top left of the image, but its outline is perhaps too hard in contrast with the soft lines of the subject's body.

▲ Framing option 2
The simplest frame is often the best – here it is like looking through a cleared area of fogged glass. The colour of the frame should be chosen to tone in with the image. However, you should also consider the background colour: on this black page, the contrast is too high whereas against a white page or an on-screen background, the nude figure would appear to float.

▲ Framing option 3
Here a painterly effect is combined with a frame that reverses both hue and tone (a Difference mode). By carefully adjusting the opacity of the frame, the colours were toned down to match that of the main image. Finally, the frame was rotated so that the main axis nude figure runs across the diagonal.

WHITE BALANCE

The basis of accurate colour reproduction is neutrality – an equal distribution of colours in the whites, greys, and blacks in the image to help ensure accuracy of hue. The white balance control on digital cameras helps ensure neutral colours on capture. But when we open the image, we may have to take the process further and adjust the brightness and saturation, which are other dimensions of accurate colour.

What balance?

An image that is colour balanced is one in which the illuminating light offers all hues in equal proportion – in other words, the illumination is white and not tinted with colour. Colour balance is not to be confused with colour harmony (*see p. 58*). Thus, a scene can be full of blues or greens yet still be colour balanced, while another scene that features a well-judged combination of secondary colours may appear harmonious, but may not be colour balanced at all.

The aim of colour balancing is to produce an image that appears as if it were illuminated by white light; this is achieved by adjusting the white point. However, there are different standards for white light, and so there are different white points. For example, it would not look natural to correct an indoor scene lit by domestic lamps in order to make it look like daylight, so a warm-toned white point is called for instead.

Color Balance control

This control makes global changes to the standard primary or secondary hues in an image. In some software, you can restrict the changes to shadows, highlights, or mid-tones. This is useful for making quick changes to an image that has, for example, been affected by an overall colour cast.

▲ Warm white point

The original picture of a simple still-life (*above left*) has reproduced with the strong orange cast that is characteristic of images lit by domestic incandescent lamps. The corrected image (*above right*), was produced using Color Balance. It is still warm in tone because a fully corrected image would look cold and unnatural.

DROPPER TOOLS

A quick method of working when you wish to colour-correct an image is to decide which part of the picture you want to be neutral – that part you want to be seen as without any tint. Then find the mid-tone dropper, usually offered in the Color, Levels, or Curves controls in image-manipulation software. Select the dropper, then click on a point in your image that you know should be neutral. This process is made easier if you used a grey card in one of your images – all images shot under the same lighting as the grey card will require the same correction. Clicking on the point samples the colour data and adjusts the whole image so that the sampled point is neutral: the dropper maps the colour data of all the image pixels around the sampled point.

When working with raw files, the choice of colour temperature (blue to red) and of tint (green to magenta) is yours. Usually, you choose colour temperature and tint to ensure neutral (achromatic or colourless) colours are truly neutral.

Balancing channels

While the Curves control is most often used to adjust image tonality, by altering the Curves or Levels of the individual colour channels, you apply a colour balance to the high tones that is different from that of the shadows. This is helpful, for

◄ **Original image**
This original image has not been corrected in any way, and it accurately reproduces the flat illumination of a solidly cloudy sky.

example, when shadows on a cloudless day are bluish but bright areas are yellowish from the sun. It is easiest to work by eye, adjusting until you see the result you wish for, but for best control you can analyze the colour in neutrals and manually put in corrections to the curve. Working in CMYK, using Curves gives a great deal of control and the best results for print. The Color Balance control is essentially a simplified version of using the component RGB channels in Curves.

Channel mixing is effective where a small imbalance in the strengths of the component channels is the cause of colour imbalance, due to, for example, using a coloured filter or shooting through tinted glass.

The Hue/Saturation control can also be used, as it shifts the entire range of colours en masse. This can be useful when the colour imbalance is due to strong colouring of the illuminating light.

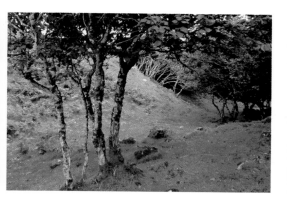

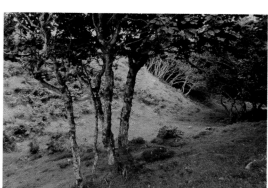

▲ **Color Balance control**
Strong changes brought about via the Color Balance control, mainly by increasing yellow in the mid-tones – which is the lowest slider in the dialogue box here – make the scene look as if it has been lit by an early evening sun.

▲ **Levels control**
A golden tone has been introduced to the image here by forcefully lowering the blue channel in the Levels control – the middle slider beneath the histogram – thus allowing red and green to figure more strongly. Red and green additively produce yellow, and this colour now dominates the highlights of the image.

COLOUR ADJUSTMENTS

One of the most liberating effects of digital photography is its total control over colour: you can control effects from the most subtle tints to the most outrageous colour combinations.

Curves

Manipulating Curves, either all at once or as separate channels, is a potent way to make radical changes in colour and tone. For best results, work in 16-bit colour, as steep curve shapes demand the highest quality and quantity of image data.

Hue/Saturation

This control globally adjusts hues, as well as colour saturation, and brightness. You may also select narrow ranges of colours to change, thus altering the overall colour balance. Beware of oversaturating colours, as they may not print out (*see pp. 61 and 304*).

Replace Color

This replaces one hue, within a "fuzziness" setting or wave-band, with another. Select the colours you wish to change by sampling the image with the Dropper tool, and then transform that part via the Hue/Saturation dialogue box (*see opposite*). By setting a small fuzziness factor, you select only those pixels very similar in colour to the original; a large fuzziness setting selects relatively dissimilar pixels. It is best to accumulate small changes by repeatedly applying this control. Replace Color is good for strengthening colours that printers have trouble with (yellows and purples), or toning down colours they overdo (reds, for example).

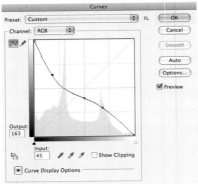

▲ Curves control
A simple inversion of colour and tone leaves dark shadows looking empty and blank. Manipulating tonal reproduction via the Curves dialogue box, however, gives you more control, allowing you to put colour into these otherwise empty deep shadows (the bright areas after inversion). In the dialogue box here you can see how the curve runs top left to bottom right – the reverse of usual – and the other adjustments that were made to improve density in the image's mid-tones.

COLOUR TEMPERATURE

The colour temperature of light has, in fact, nothing to do with temperature as we traditionally think of it; rather, colour temperature is measured by correlating it to the colour changes undergone by an object as it is heated. Experience tells us that cooler objects, such as candles or domestic lights, produce a reddish light, whereas hotter objects, such as tungsten lamps, produce more of a blue/white light.

The colour temperature of light is measured in degrees Kelvin, and a white that is relatively yellow in colouration might be around 6,000 K, while a white that is more blue in content might be, say, 9,500 K.

While colour slide film must be balanced to a specific white point, digital cameras can vary their white point dynamically, according to changing needs of the situation.

▲ Hue/Saturation control

In this dialogue box you can see that image hue has been changed to an extreme value, and this change has been supported by improvements in saturation and lightness in order to produce good tonal balance. Smaller changes in image hue may be effective for adjusting colour balance. Bear in mind that colours such as purples look brighter and deeper on a monitor than in print because of limitations in the printer's colour gamut (*pp. 61 and 302–5*).

▲ Replace Color control

Four passes of the Replace Color control were made to create an image that is now very different from that originally captured (*p. 211*). The dialogue box here shows the location of the colours selected in the small preview window, and the controls are the same as those found in the Hue and Saturation dialogue box (*above left*), which allow you to bring about powerful changes of colour. However, for Hue and Saturation to have an effect, the selected values must indeed have colour. If they are grey, then only the lightness control makes any difference.

WORKING IN RGB

The most intuitive colour mode to work in is RGB. It is easy to understand that any colour is a mixture of different amounts of red, green, or blue, and that areas of an image where full amounts of all three colours are present give you white. The other modes, such as LAB and CMYK, have their uses, but it is best to avoid using them unless you have a specific effect in mind you want to achieve. When you are producing image files to be printed out onto paper, you may think you should supply your images as CMYK, since this is how they will be printed. However, unless you have the specific data or separation tables supplied by the processors, it is preferable to allow the printers to make the conversions themselves. In addition, CMYK files are larger than their RGB equivalents and so are far less convenient to handle.

SATURATION AND VIBRANCE

Technically, saturation is the colourfulness of something judged in relation to brightness. Light, low-saturated colours become darker as they increase in saturation, while well-saturated colours look brighter and livelier when their saturation is raised. This change in quality helps explain why we love to make highly saturated images: they look gorgeous on the screen. In image manipulation, Vibrance, rather than meaning "full of energy", is a saturation control that adapts to certain colours.

Saturation

One of the most common enhancements made to images is an increase in saturation: colours look richer, images look brilliant and, indeed, greatly enhanced. Camera manufacturers deliberately process images conservatively because over-saturation is hard to recover: variations of hue take on the same values, so any differences in hue are lost forever. However, global increases in saturation rarely lead to better images. The most effective way

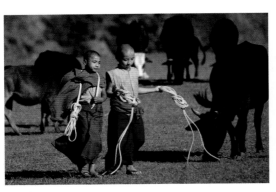

1 Original
Young monks in Bhutan chat as they run an errand on a sunny day – a delightfully photogenic scene. But overexposure in the capture leads to poor saturation after adjusting Levels. The yellows and reds are acceptable, but the greens are too dull.

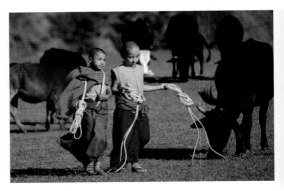

2 High saturation
Increasing saturation globally renders the grass rich and lively, and the robes and ropes stand out in brilliance. But the flesh tones look too tanned, and notice how the cattle have become more prominent in the image.

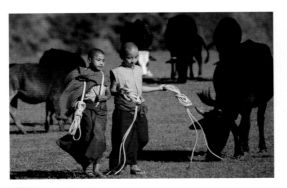

3 High vibrance
Returning to the Levels-adjusted original, the vibrance setting is increased: the result is a marked improvement over both the original and the high-saturation version, with rich colours in the robes and grass and natural skin tones.

4 Minimum vibrance
If we set minimum vibrance we see that colours around flesh tones are reduced to almost grey-scale: different applications vary in how strongly they reduce saturation of non-flesh tone colours and the effect also varies with white balance.

is to be selective: identify the colours that appear weakest. If you would like a bluer sky, for example, instead of increasing saturation over the whole image, select Blues in your software's saturation control and increase saturation only for blues. The result is powerful, yet subtle.

Vibrance

The Vibrance control adjusts saturation to minimize clipping, that is, loss of definition at high values.

Less-saturated colours increase their saturation more than the colours that are already saturated. Most importantly, Vibrance produces a flatter response with skin tones, which prevents them from becoming over-saturated. Vibrance is very useful for reducing the saturation of other colours while leaving flesh tones relatively unaltered. The cool pallor that results can be effective in a wide range of people-based photography – from fashion to photojournalism.

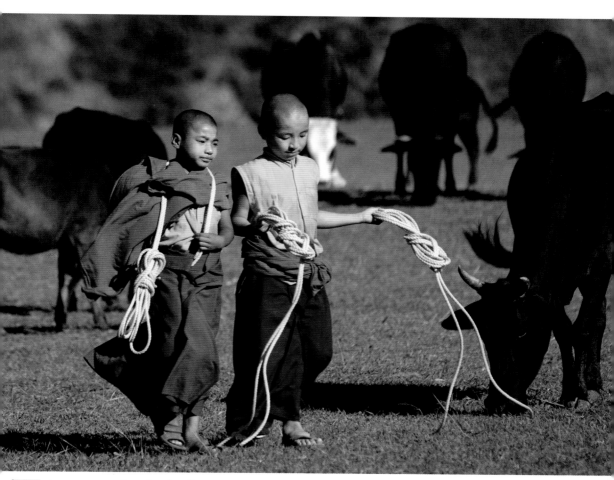

5 **Low saturation, high vibrance**
Combining the two controls can produce highly effective results, that balance delicate coloration with a strong sense of realism. If we set a low saturation, all colours are globally made greyer. Adding a high vibrance setting restores red-yellow colours closer to their natural levels. The difference in saturation helps the flesh tones to stand out against the naturally tinted background. Notice too how the cattle now "recede" into the background.

MANIPULATION DEFECTS

Post-processing techniques are brilliantly powerful. But it is good practice to avoid creating unintended defects while making corrections in some other part or aspect of the image.

Working methods

Like many other craft skills, post-processing proceeds most smoothly when you work methodically and steadily. Plan what you want to do with an image before you start working on it: you will make white balance, exposure, and tonal adjustments before tackling deeper changes to the image, such as cloning or working with layers. If you are using direct-working software such as Photoshop, make adjustments on Adjustment Layers where possible, to help preserve quality.

The majority of images will need only subtle or soft changes to make a vast improvement to their appearance: these types of change are unlikely to cause unwanted side effects. It is the application of strong changes that gives rise to the most problems. One useful trick that may help to reduce side effects is to make a series of smaller changes to achieve the same result.

▲ **Pixellation**
The disruption of image detail caused by using too few pixels to create the image is relatively rare, now that cameras use high-resolution sensors. However, it is possible to use an icon or low-resolution version of the image by mistake. Re-open with a larger file.

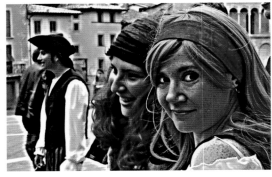

▲ **Over-sharpening**
Sharpening filters such as USM (UnSharp Mask) improve the appearance of sharpness but cannot make up for poor focusing or blur from movement. High levels of sharpening may improve blurred images but at the cost of creating haloes and unnatural tones.

▲ **Poor white balance**
Scenes lit by coloured lights such as candles or nightclub spots gain a strong colour cast. Even if the overall colour cast can be removed to create neutral whites, other colours – such as flesh tones – may be inaccurate. Record in RAW (*see pp. 234–7*) for the best chance of full correction.

▲ **Cloning or healing defects**
While cloning and healing tools for removing defects are very powerful, they can introduce defects of their own, such as the blurring of neighbouring boundaries and multiplying detail. Work at high magnification – at least 100 per cent – and use brushes just larger than the defects.

Principle of loss

A basic principle of digital photography is that loss of data from an image can never be recovered. Many manipulations, from adjusting levels and increasing sharpness or blur, to cloning – all destroy data. In recognition of this, if you are using applications such as Photoshop, Photo Painter or Paint Shop Pro, always work with a copy of the image, never the sole image file. If you wish to create a completely new version of an image, open up a new copy of the original; do not re-use one that has already been heavily manipulated.

DEEP POCKETS

A class of image defects, including highlight clipping, shadow clipping, and banding, can be avoided by working with the data reserve of RAW format. The data in RAW may be extended by outputting the image in high bits per channel. Instead of the usual 8 bits per channel, RAW converters allow images to be coded with 10 bits, 12 bits, even 32 bits per channel. This results in large files that are capable of being very extensively processed.

▲ Boundaries with haloes

Sharpening filters such as USM (UnSharp Mask) and adjustments such as Shadows/Highlights can cause contrasting bands, or haloes, to appear around edges when used with too high a setting (USM), or too small a radius combined with high settings (Shadow/Highlights).

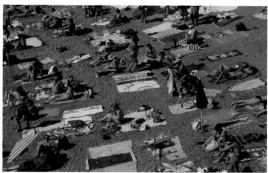

▲ Out-of-gamut colours

Brilliant colours can be made even more brilliant on the monitor screen. The result is eye-catching, but some colours may be impossible to print out, and some may lead to solid blocks of colour that look unnatural. Use the saturation control conservatively (*see pp. 214–5*).

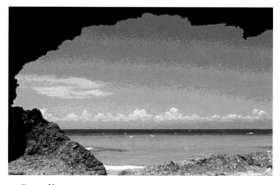

▲ Banding

Caused by having insufficient data to define smooth transitions, banding is seen as stepped changes as the result of applying strong tonal change via, for example, Curves, Levels, or Shadow/Highlights controls. It is less of a problem than it used to be, thanks to improved sensor processing.

▲ Noiseless

In the eagerness to eliminate all signs of noise from the image, you can cause the image to look too smooth, with silky textures that blur details. Where detail is near the size of the noise, for example, the fine wires in this image, noise reduction also smears the details.

CURVES

The Curves control found in image-manipulation software may remind older photographers of the characteristic curves published for films. This is a graph that shows the density of sensitized material that will result from being exposed to specific intensities of light. In fact, there are similarities, but equally important are the differences. Both are effectively transfer functions: they describe how one variable (the input either of colour value or of the amount of light) produces another variable (the output or brightness of the image).

The principal difference is that when it comes to image-manipulation software the curve is always a 45° line at the beginning. This shows that the output is exactly the same as the input. However, unlike the film curve, you can manipulate this directly by clicking on and dragging the curve or by redrawing the curve yourself. In this way, you force light tones to become dark, mid-tones to become light, and with all the other variations in between. In addition, you may change the curve of each colour channel separately.

▲ Original image and curve

Since the original negative was slightly underexposed, the image from the scan is tonally rather lifeless. You cannot tell anything about exposure by looking at the curve in the screen shot (*above*) because it describes how one tone is output as another. As nothing has been changed, when it first appears the line is a straight 45°, mapping black to black, mid-tone to mid-tone, and white to white. It is not like a film characteristic curve, which actually describes how film is responding to light and its processing.

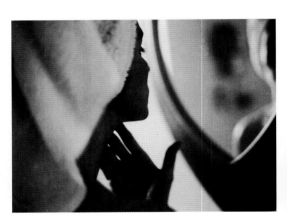

▲ Boosting the mid-tones

The bow-shaped curve displayed here subtly boosts the mid-tone range of the image, as you can see in the resulting image (*top*). But the price paid is evident in the quarter-tones, where details in the shadows and the details in the highlights are both slightly darkened. The result is an image with, overall, more tonal liveliness – note, too, that the outline of the subject's face has been clarified. With some image-manipulation software, you have the option of nudging the position of the curve by clicking on the section you want to move and then pressing the arrow keys up or down to alter its shape.

What the Curves control does

The Curves control is a very powerful tool indeed and can produce visual results that are impossible to achieve in any other way. By employing less extreme curves you can improve tones in, for example, the shadow areas of an image while leaving the mid-tones and highlights as they were originally recorded.

And by altering curves separately by colour channel, you have unprecedented control over an image's colour balance. More importantly, the colour changes brought about via the Curves control can be so smooth that the new colours blend seamlessly with those of the original.

Explore the image by running your cursor over the image: the majority of manipulation software give a 'running commentary' of colour values and will also show the position of the point under the cursor as a point on the curve. Click on the curve when you hit a tone you wish to alter, then use the arrow up/down keys to adjust the position of this curve. Make small changes progressively: this helps

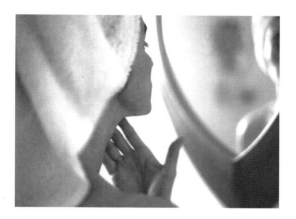

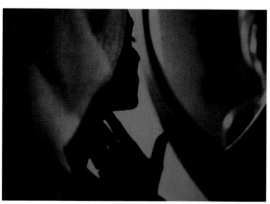

▲ Emphasizing the highlights

The scan's flat, dynamic range suggests that it could make an effective high-key image by changing the curve to remove the black tones (the left-hand end of the curve in the screen shot is not on black but is raised to dark grey) and mapping many highlight tones to white (the top of the curve is level with the maximum for nearly a third of the tonal range). The result is that the input mid-tone is set to give highlights with detail. Very small changes to the curve can have a large effect on the image, so if you want to adjust overall brightness, it is easier to commit to the curve and then use Levels to adjust brightness (*see pp. 188–9*).

▲ Emphasizing the shadows

The versatility of the original image is evident here, as now it can be seen working as an effective low-key picture. The mood of the picture is heavier and a little brooding, and it has lost its fashion-conscious atmosphere in favour of more filmic overtones. The curve shown in the screen shot has been adjusted not simply to darken the image overall (the right-hand end has been lowered to the mid-tone so that the brightest part of the picture is no brighter than normal mid-tone). In addition, the slight increase in the slope of the curve improves contrast at the lower mid-tone level to preserve some shadow detail. This is crucial, as too many blank areas would look unattractive.

CURVES CONTINUED

ensure you do not make dramatic changes which look impressive but usually lead to loss of quality.

Extreme curves

Curves are also a powerful and simple way to obtain extreme tonal effects, such as reversal of tones to imitate Sabattier effect *(see p. 244)*. In general, the subjects that react best to the application of extreme Curve settings are those with simple outlines and large, obvious features. You can try endless experiments with Curves, particularly if you start using different curve shapes in each channel. The following examples show the scope of applying simpler modifications to the master curve, thereby

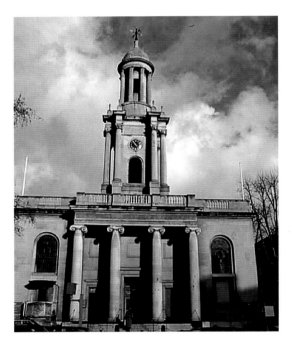

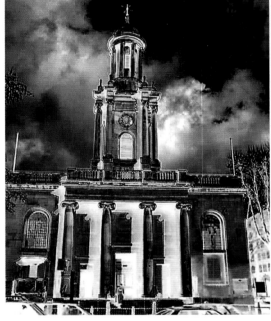

▲ Original image

The image you select for manipulating Curves does not have to be of the highest quality, but it should offer a simple shape or outline, such as this church. In addition, the range of colours can be limited – as you can see below, dramatic colours will be created when you apply Curves with unusual or extreme shapes.

▲ Reversing dark tones

A U-shaped curve reverses all tones darker than mid-tone and forces rapid changes to occur – an increase in image contrast, for example. The deep shadows in the church become light areas, giving a negative type of effect, but the clouds have darkened and greatly increased in colour content. The effect of using this shape curve is similar to the darkroom Sabattier effect, when exposed film or paper is briefly re-exposed to white light during development.

changing all channels at the same time. Note how seemingly even areas of tone can break up into uneven patches when an extremely steep curve is applied: this is due to a lack of data, which leads to aliasing or posterization.

The turning point of a curve also makes a great of demand on image data. If you wish to maintain smooth tonal transitions, you need access to as much image data as possible. Where extreme adjustments are anticipated, record your images in RAW format, then convert to RGB applying 16 bits per channel, or even more. With modern high resolution cameras and image processing, high-bit images are very resistant to break-up of the image.

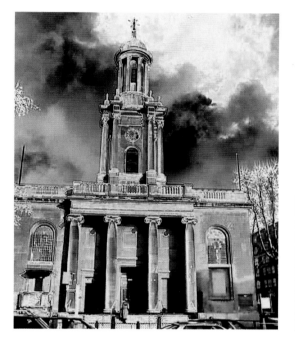

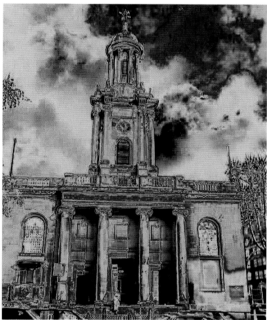

▲ Reversing light tones

An arc-shaped curve reverses the original's lighter tones, giving the effect shown here. Although it looks unusual, it is not as strange as reversing dark tones (*left*). Note that the curve's peak does not reach the top of the range – the height of the arc was reduced to avoid creating overbright white areas. The colour of the building changes as the red-green colour in the normal image was removed by the reversal, allowing the blue range to make its mark.

▲ Tone/colour reversal

Applying an M-shaped curve plays havoc with our normal understanding of what a colour image should look like. Not only are the tones reversed as a result, but areas with dominant colour whose tones have been reversed will also take on a colour that is complementary to their own. And since parts of the tonal range are reversed and others are not, the result is a variegated spread of colours.

BIT-DEPTH AND COLOUR

The bit-depth of an image file tells you its tonal resolution – that is, how finely it can distinguish or reproduce tones or shades. A bit-depth of 1 identifies just two tones – black or white; a bit depth of 2 can record four tones; and so on. The number of tones that can be recorded is 2 to the power of the bit-depth, so a typical bit-depth of 8 records 256 tones. When these are applied across the colour channels, bit-depth measures the resolution of colours. Thus, 8 bits over three colour channels – 8 bits x 3 channels – gives 24 bits, the usual bit-depth of digital cameras. This means, in theory, that each colour channel is divided into 256 equally spaced steps, which is the minimum requirement for good-quality reproduction.

Number of hues

The total number of hues available to a 24-bit RGB colour space, if all combinations could be realized, is in the region of 16.8 million. In practice this is never fully realized, nor is it necessary. A typical high-quality monitor displays around 6 million hues, while a colour print can manage fewer than 2 million, and the best digital prints reach a paltry 20,000 different hues at the most. However, the extra capacity is needed at the extreme ends of the tonal and colour scale, where small changes require much coding to define, and data is also needed to ensure that subtle tonal transitions such as skin tones and gradations across a sky are smooth and not rendered aliased (also described as stepped, or posterized).

Higher resolution

Increasingly, 24-bit is not measuring up to our expectations: tones are not smooth enough and there is insufficient data for dramatic changes in tone or colour. This is why, when applying curves with very steep slopes, the image breaks up. Better-quality cameras can record images to a depth of 36 bits or more, but images may be down-sampled to 24-bit for processing. Even so, such images are better than if the images had been recorded in 24-bit. When working in raw format, you may be working in 16-bit space: if you wish to maintain the quality inherent, though not guaranteed, of 16-bit, process and save the file as 16-bit (48 bits RGB).

File size

Once the image is ready for use, you may find that surprisingly few colours are needed to reproduce it. A picture of a lion among sun-dried grass stems on a dusty plain, for example, uses only a few yellows and desaturated reds. Therefore, you may be able to use a small palette of colours and greatly reduce file size. This is particularly useful to remember when optimizing files for the web.

Some software allows images to be stored as "index color". This enables image colours to be mapped onto a limited palette of colours, the advantage being that the change from full 24-bit RGB to an index can reduce the file size by two-thirds or more. Reducing the colour palette or bit-depth should be the last change to the image as the information you lose is irrecoverable.

▲ Colour bit-depth and image quality

When seen in full colour (*left*), this image is vibrant and rich, but the next image (*middle*), containing a mere 100 colours, is not significantly poorer in quality. Yet this index colour image is only a third of the size of the full-colour original.

With the colour palette reduced to just 20 colours (*right*), the image is dramatically inferior. However, since this change does not reduce file size any further, there is no point in limiting the colour palette beyond what is necessary.

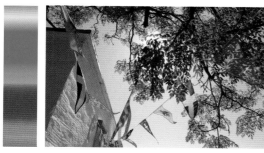

▲ Original full depth

This image of a church in Greece was recorded as a 12-bit (36-bit RGB) raw image, then processed into an 8-bit file (24-bit RGB). It retains full subtlety of the skies and the transparency and colours of the bunting.

▲ Two levels

With only two levels per colour channel, a surprising amount of the original image is retained, with many shapes still well defined. But note the wall in shadow is completely black, and many of the sky tones are blank.

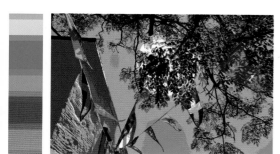

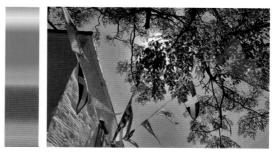

▲ Four levels

With four levels, the sky tones are filled in but they are very patchy and with large jumps in tone and no accuracy of colour, simply because the nearest available hue is used. Generally, colours are more saturated than in the original image.

▲ 24 levels

With 24 levels, the original image is almost fully reproduced, but the failures are in the sky: note that it remains much darker than in the original, and what was a light area in the lower part of the original is darker than the rest of the sky here.

▶ Limited palette, numerous colours

This image appears to use very few colours. However, the tonal variations of deep cyans, blues, and magentas are so subtle that at least 200 different hues are needed to describe the image without loss of quality. Nonetheless, an indexed colour version of the file is a quarter of the size of the RGB version.

COLOUR TO BLACK AND WHITE

Creating a black and white picture from a colour original allows you to change the shot's emphasis. For example, a portrait may be marred by strongly coloured objects in view, or your subjects may be wearing clashing coloured clothing. Seen in black and white, the emphasis in these pictures is skewed more toward shape and form.

The translation process

A black-and-white image is not a direct translation of colours into greyscale (a range of neutral tones ranging from white to black) in which all colours are accurately represented – many cameras favour blues, for example, and record them as being lighter than greens.

When a digital camera or image-manipulation software translates a colour image, it refers to a built-in table for the conversion. Professional software assumes you want to print the result and so makes the conversion according to a regime appropriate for certain types of printing press and paper. Other software simply turns the three colour channels into grey values before combining them – in the main giving dull, murky results.

There are, however, better ways of converting to black and white, depending on the software you have. But before you start experimenting, make sure you make a copy of your file and work on that rather than the original. Bear in mind that conversions to black and white loses colour data that is impossible to reconstruct.

Before you print

After you have desaturated the image (*see box below*), and despite its grey appearance, it is still a colour picture. So, unless it is to be printed on a four-colour press, you should now convert it to greyscale to reduce its file size. If, however, the image is to be printed in a magazine or book, remember to reconvert it to colour – either RGB or CMYK. Otherwise it will be printed solely with black ink, giving very poor reproduction.

Four-colour black

In colour reproduction, if all four inks (cyan, magenta, yellow, and black) are used, the result is a rich, deep black. It is not necessary to lay down full amounts of each ink to achieve this, but a mixture of all four inks (called four-colour black) gives excellent results when reproducing photographs on the printed page. Varying the ratio of colours enables subtle shifts of image tone.

DESATURATION

All image-manipulation software has a command that increases or decreases colour saturation, or intensity. If you completely desaturate a colour image, you remove the colour data to give just a greyscale. However, despite appearances, it is still a colour image and looks grey only because every pixel has its red, green, and blue information in balance. Because of this, the information is self-cancelling and the colour disappears. If, though, you select different colours to desaturate, you can change the balance of tones. Converting the image to greyscale at this point gives you a different result from a straight conversion, since the colours that you first desaturate become lighter than they otherwise would have been.

▲ Saturation screen shot
With the colour image open you can access the Saturation control and drag the slider to minimum colour. This gives a grey image with full colour information. In some software you can desaturate the image using keystrokes instead (such as Shift+ Option+U in Photoshop, for example).

▲ Colour saturation
While the original colour image is full of light and life, the colours could be seen as detracting from the core of the image – the contrasts of the textures of the water, sand, and stones. This is purely a subjective interpretation, as is often the case when making judgments about images.

▲ Colour desaturation
By removing all the colours using the Saturation control to give an image composed of greys, the essentials of the image emerge. The Burn and Dodge tools (*pp. 190–1*) were used to bring out tonal contrasts – darkening the lower portion of the picture with the Burn tool, while bringing out the sparkling water with the Dodge tool.

▲ Overcoming distracting colour
The strong reds and blues (*above left*) distract from the friendly faces of these young monks in Gangtok, Sikkim. However, a straight desaturation of the image gives us a tonally unbalanced result. Attempts to desaturate selectively by hue will founder because the faces are a pale version of the red habits. We need to compensate for the tonally unattractive product of desaturation

(*middle*) by redistributing the tones to bring attention to the boys' faces. This involves reducing the white point to control the sunlit area in the foreground, plus a little burning-in

to darken the light areas of the habit and the hand of the monk behind. Then, to bring some light into the faces (*right*), we use the Dodging tool set to Highlights.

◀ Levels screen shot
With the desaturated image open, move the white point slider in the Levels dialogue box to force the brightest pixels to be about a fifth less bright: in other words, to have a value no greater than 200.

COLOUR TO BLACK AND WHITE CONTINUED

Channel extraction

Since a colour image consists of three greyscale channels, the easiest way to convert the colour to greyscale is to choose, or extract, one of these and abandon the others. This process is known as "channel extraction", but it is available only as part of more professional software packages.

When you view the image on the monitor normally, all three colour channels are superimposed on each other. However, if you look at them one channel at a time, your software may display the image as being all one colour – perhaps as reds of different brightnesses, for example, or as a range of grey tones, according to the software preferences you have set. If your software gives you the option, choose to view the channels as grey (by selecting this from the preferences or options menu). Then, simply by viewing each channel, you can choose the one you like best. Now when you convert to greyscale, the software should act on the selected channel alone, converting it to grey.

Some software may allow you to select two channels to convert to grey, thus allowing you a great deal of experimention with the image's appearance. In general, the channels that convert best are the green, especially from digital cameras, because the green channel is effectively the luminance channel, and the red, which often gives bright, eye-catching results.

Another method, available in Photoshop, is to use Split Channels to produce three separate images. With this, you save the image you like and abandon the others. Note, however, that this operation cannot be undone – the extracted file is a true greyscale, and is just a third the size of the original file.

▲ Red-channel extraction

While the colours of the original image are sumptuous (*above left*), black and white seemed to offer more promise (*above right*). It is clear that the sky should be dark against the mane and cradling hand, so the green and blue channels (*right*) were of no help. Neither was the lightness channel (*opposite*), as it distributes tonal information too evenly. The red channel, however, presented the blues as dark and the brown of the horse as light. So, with the red channel extracted, no extra work was needed.

▲ Channels screen shot

If your software allows, select colour channels one at a time to preview the effects of extraction. Turn off the colour if the software shows channels in their corresponding colours.

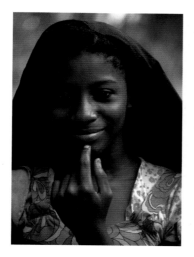

Blue channel

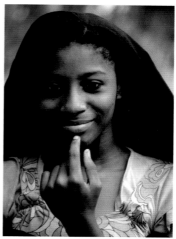

Red channel

▲ Comparing channels

RGB colour images comprise three greyscale images. Here, the B channel is dark while the R is too light, but the green is well balanced, as it carries the detail. This is confirmed by the L channel in LAB mode (far right).

Green channel

LAB (with Lightness channel extracted)

LAB MODE

When you convert an RGB colour image image to LAB, or Lab, mode (a shortened form of L*a*b*), the L channel carries the lightness information that contains the main tonal details about the image. The a* channel values represent green when negative and magenta when positive; the b* represents blue when negative, yellow when positive. Using software, such as Photoshop, that displays channels, you can select the L channel individually and manipulate it with Levels or Curves without affecting colour balance. With the L channel selected, you can now convert to greyscale and the software will use only the data in that channel. If your software gives you this option, you will come to appreciate the control you have over an image's final appearance, and results are also likely to be sharper and more free of noise than if you had extracted another of the channels to work on. The extracted file is a true greyscale, and so it is only a third of the size of the original colour file.

▲ LAB channels

In the Channels palette of Photoshop, you can select individual channels, as shown above. In this example, the screen will display a black-and-white image of the girl (*as above, right*).

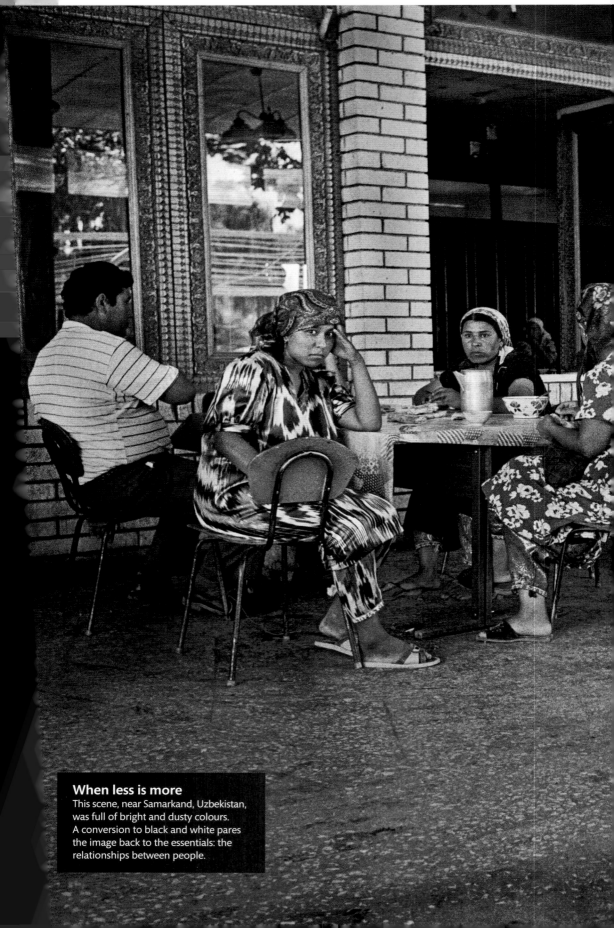

When less is more
This scene, near Samarkand, Uzbekistan,
was full of bright and dusty colours.
A conversion to black and white pares
the image back to the essentials: the
relationships between people.

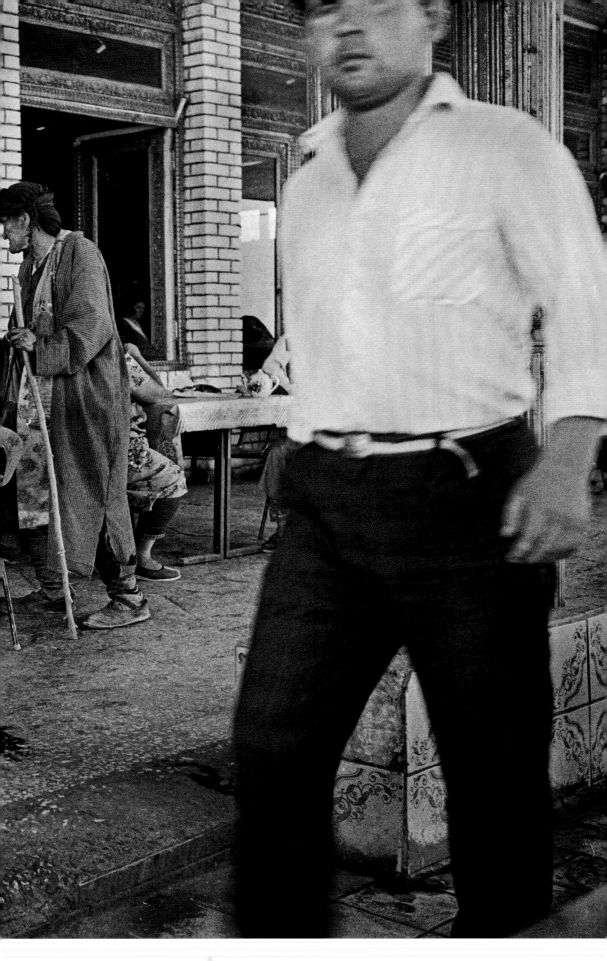

Accentuating form
The original full-colour image was turned into a tritone – using a blue tuned for lighter areas and red and black devoted to the darker tones – to bring out its simple, quasi-symmetrical composition.

SABATTIER EFFECT

When a partially developed print is briefly re-exposed to white light, some of the tone values are reversed. Although developed areas of the print are desensitized to light, partially undeveloped areas are still capable of being fogged. If these are then allowed to develop normally, they will darken. As the doctor and scientist who discovered this effect, Frenchman Armand Sabattier (1834–1910), described this process as "pseudo-solarization", it has become incorrectly known as "solarization" – which is, in fact, the reversal of image tones due to extreme overexposure.

Digital advantages

For the traditional darkroom worker, the Sabattier effect is notoriously time-consuming and difficult to control – it is all too easy to spend an entire morning making a dozen or more prints, none of which looks remotely like the one you are trying to create. Using digital image-manipulation techniques, however, this type of uncertainty is a thing of the past.

The first step is to make a copy of your original image to work on and convert that file to a greyscale (*see pp. 224–9*). Choose an image that has fairly simple outlines and bold shapes – images with fine or intricate details are not really suitable as the tone reversal tends to confuse their appearance. You can also work with a desaturated colour image if you wish (*see pp. 214–15*).

There are several ways of simulating the Sabattier effect using Curves and Color Balance. Another method, if you have software that offers Layers and Modes (*see pp. 278–83*), is to duplicate the lower, original layer into a second layer. You then apply the Exclusion Layer mode, and adjust the tone of the image by altering the Curves or Levels for either layer.

◄ Working in colour

Working digitally, you can take the Sabattier effect further than is possible in the darkroom. By starting with a slightly coloured image, you will end up with results displaying partially reversed hues. In this landscape, the greyscale was warmed using the Color Balance control to add yellow and red. On applying a U-shaped curve to this image, the highlights to mid-tones remained as they were, but the darker tones reversed – not only in tone but also in colour, as you can see here (*below*). An arch-shaped curve would produce the opposite effects.

GUM DICHROMATES

A gum dichromate is a flat colourization of a greyscale image with compressed tonal range. The dark-room technique is a bit messy but once you know the look of a typical gum dichromate, you can easily reproduce it digitally without handling dyes and sticky substances.

Clean working

Images with clean outlines and subjects without strong "memory colours" (colours that everyone recognizes, such as flesh tones) are suitable. Start by selecting the areas you want to colour. Next, fill your selection with a colour using the Bucket or Fill tool set to Color mode. Working in this way ensures that you add colours to the existing pixels, rather than replace them. Keep colours muted by choosing

light, pastel shades rather than deep, saturated hues – it is easy to create too many brilliant colours.

Another approach is to work in Layers, with a top layer filled with colour and the mode set to Color or Colorize. This colours the entire image, so you will need to apply some masking (*see pp. 274–5*) to remove colours from certain areas. Another layer filled with a different colour and different masks will apply colours to other parts of the image. If you want to lower the colour effect overall, use the opacity setting. In fact, this method is the exact digital counterpart of the traditional darkroom process.

▶ Colour and opacity

For this image (*below*), a scan of an old negative print (*left*) was made. Working in RGB and a new layer, an area was selected with the Lasso tool with feathering set to a high level, to ensure a soft-edged coloration. Colour was added to the selection, using the Fill Layer mode set to Color. This tints the underlying layer. Different selections on new layers were filled with colour and their opacities adjusted so that they balanced well to give the final image.

SPLIT TONING

Toning is a traditional darkroom technique – or workroom technique, as darkness is not essential for the process. Here, the image-forming silver in the processed print is replaced by other metals or compounds to produce a new image tone.

The exact tone resulting from this process depends, in part, on the chemical or metal used and, in part, on the size of the particles produced by the process. Some so-called toners simply divide up the silver particles into tinier fragments in order to produce their effect. Where there is variation in the size of particles, the image takes on variations in tone – from red to brown, for example, or from black to silvery grey. This variation in tone is known as split toning and is caused by the toning process proceeding at different rates.

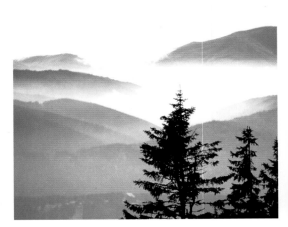

▲ Using the Color Balance control

Images with well-separated tones, such as this misty mountain view, respond best to split toning. To add blue to the blank, white highlights of the mist, an adjustment layer for Color Balance was created. The Highlight Ratio button was clicked and a lot of blue then added. Another adjustment layer was then created, but this time the tone balance was limited to the shadows. The Preserve Luminosity tick-box was left unchecked in order to weaken the strong corrections given: the screen shot (*above*) shows that maximum yellow and red were set. Further refinement is possible in software packages such as Photoshop (*see right*).

▲ Blending Options

This is part of the Blending Options box from Photoshop. The colour bars show which pixels from the lower and which from the upper layer will show in the final image. With the sliders set as here, there is partial show-through – enabling a smooth transition between the blended and unblended image areas. For this layer, the underlying area shows through the dark blue pixels. In addition, a wide partial blend was indicated for all channels, allowing much of the light blue to show over the dark, reddish tones.

These rates are dependent on the density of silver in the original image.

This, perhaps, gives you a clue about how the split-toning effect can be simulated digitally – by manipulating duotone or tritone curves (*see pp. 238–41*) you can lay two or more colours on the image, the effects of which will be taken up according to image density.

Another method is to use Color Balance (*see p. 210*), a command that is available in all image-manipulation software. This is easiest to effect in software that allows you to adjust the Color Balance control independently for highlights, mid-tones, and shadows. If your software does not allow this, you can achieve a similar effect with Curves, working in each colour channel separately (*see pp. 218–21*).

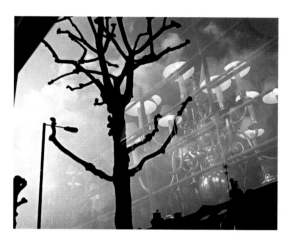

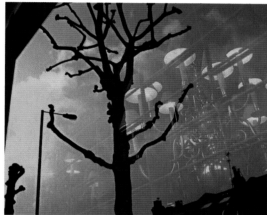

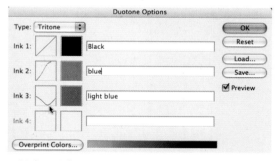

▲ Using Tritone
The Tritone part of the Options dialogue box for the final image shows a normal curve for the first, orange-brown, colour. The second, blue, colour is boosted to darken the mid-tones, while the third colour, another blue, supports the first blue. Without the addition of this third colour, the mid-tones would look a little too weak and lack visual impact.

▲ Using Color Balance
The aim here was to highlight the similarity in shape between the tree reflected in the shop window and the lamps within in the original image (*top left*). At first, two colours – brown and blue – were used, but it was hard to create sufficient contrast between the dark and light areas. To help overcome this problem, another blue was added to boost the dark areas, as shown in the Duotone Options dialogue box (*above left*) – the blue plus brown giving deep purple. Color Balance (*above*) was shifted to help shadow saturation, and the lamps were also dodged a little, to prevent them being rendered too dark.

HAND TINTING

Digital hand colouring is altogether a different proposition from the old method of painting directly onto prints. It allows you risk-free experimentation, no commitment to interim results, and freedom from the mess of paints. The core technique is to apply, using a suitable Brush tool, the desired colour values to the greyscale values of the image, leaving unchanged the luminance value of the pixels. That is the job of the Color or Colorize mode.

Techniques

The best way to imitate the effect of painting is to use the Brush set to Color mode and then paint directly onto your image. Set a soft edge for the brush, or use one that applies its effects in irregular strokes, like a true brush. You should also set the pressure and the flow to low values, so that application of the brush produces a barely visible change in the image.

Another method is to create a new layer set to Color mode above the image, and paint into this. This makes it possible to erase any errors without damaging the underlying image. You will also find it easier to see where you paint if you use strong colours, and then reduce the opacity afterwards. You may make extra layers

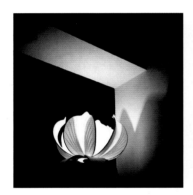

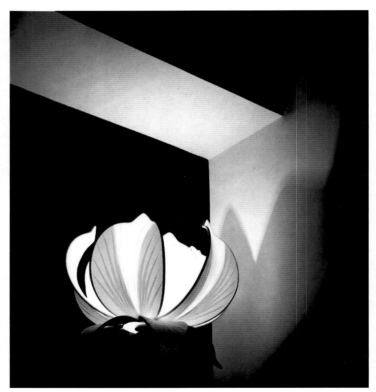

▲ Colour combinations

To suit the strong shapes of the original image (*top*), equally strong colours were called for. You can work with any combination of colours, and it is worth experimenting – not only will some combinations look better, some will print more effectively than others. Bear in mind that a blank area will not accept colour if the Color or Blending mode is set to Colorize. To give white areas density, go to the Levels control and drag the white pointer to eliminate pure white pixels. Once the pixels have some density, they have the ability to pick up colour. To give black areas colour, reduce the amount of black, again via Levels control. Although the "paint" is applied liberally (*above left*), note that in the finished print (*above*) colour does not show up in the totally black areas.

to experiment with different strokes or even blend two or more layers.

Weak colours and pastel shades – that is, those of low saturation, with a lot of white – are often out-of-gamut for colour printers and monitors (*see p. 61*), so you may need to bear in mind the limitations of the printed result while you work. As yet, the porcelain-like textured finish of a high-quality, hand-coloured print is beyond the capabilities of ink-jet printers. The careful use of papers with tinted bases can help the effect, as the paper's background helps narrow the dynamic range and soften the image contrast.

Graphics tablet

The ideal tool for hand tinting is the graphics tablet, with its pen-shaped stylus. A standard mouse can position the cursor or brush with high precision and is useful if you need to leave the cursor in position, but with a graphics stylus you can vary the pressure with which you apply "paint", thereby affecting both the size of the brush and the flow of colour. Some stylus designs also respond to the angle of the stylus. Another advantage of a stylus is that it is less tiring to use than a mouse. The downside is that a large graphics tablet requires far more desk space.

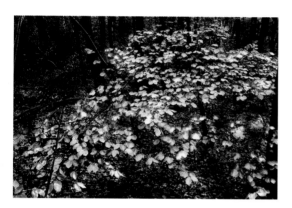

▶ Painting and opacity

You can apply the paint quite freely, using a range of colours – as in this image (*above right*) of the painted layer that lies above the base image. The spring foliage (*above*) was emphasized by a lot of dodging (*pp. 190–1*) to lighten individual leaves. To introduce some colour, a new layer was created and its Blending mode set to Color, so only areas with density can pick up colour (*above right*). The paint was then applied to this layer. Finally, the layer's opacity was reduced to 40 per cent for the final image (*right*) to allow the foliage to show through the colour overlay.

TINTS FROM COLOUR ORIGINALS

It is not necessary for colour images to be strongly coloured in order to have impact. You can, for example, use desaturated hues – those that contain more grey than actual colour – to make more subtle colour statements. In addition, selectively removing colour from a composition can be a useful device for reducing the impact of unwanted distractions within a scene (*see pp. 204–5*).

For global reductions in colour, you need only turn on the Color Saturation control, often linked with other colour controls, such as Hue, in order to reduce saturation or increase grey. By selecting a defined area, you can limit desaturation effects to just that part of the image.

Working procedure

While working, it may be helpful to look away from the screen for each change, since the eye finds it difficult to assess continuous changes in colour with any degree of accuracy. If you watch the changes occur, you may overshoot the point that you really want and then have to return to it. The resulting shuffling backward and forward can be confusing. Furthermore, a picture often looks as if it has "died on its feet" when you first remove the colour if you do it suddenly – look at the image again after a second or two, and you may see it in a more objective light.

For an extra degree of control, all image-manipulation software has a Desaturation tool. This is a Brush tool, the effect of which is to remove all colour evenly as it is "brushed" over the pixels. Work with quite large settings – but not 100 per cent – in order to remove colour quickly while still retaining some control and finesse.

Another way of obtaining tints of colour from your original is to select by colour, or range of colours. If you increase the saturation of certain colours, leaving the others unchanged, and then desaturate globally, the highly saturated colours will retain more colour than the rest of the image, which will appear grey in comparison.

Bear in mind that many pixels will contain some of the colour you are working on, even if they appear to be of a different hue. Because of this, it may not be possible to be highly selective and work only over a narrow waveband. Photoshop allows you to make a narrow selection: you can use Replace Color as well as the waveband limiter in Hue/Saturation.

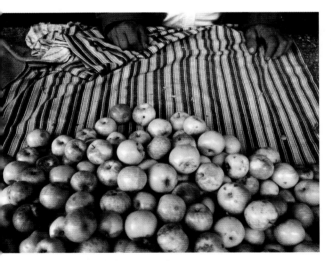
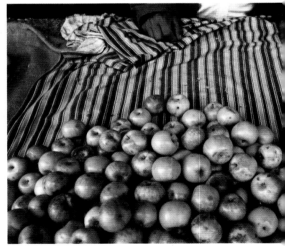

▲ Global desaturation

For a selective desaturation of the original (*above left*), the whole image was slightly desaturated, while ensuring that some colour was retained in the apples and hands (*above right*). The process was paused so that the apples and hands could be selected, and then the selection was inverted, with a large feathering setting of 22. This is easier than selecting everything apart from the hands and apples. Desaturation was again applied, but this time just to the selected area.

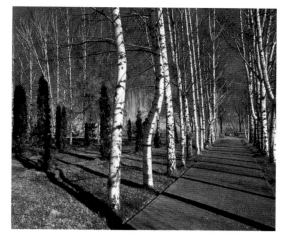

▲ Selective colour

The original shot of a park in Kyrgyzstan (*above left*) was too colourful for the mood I wanted to convey. In preparation for a selective desaturation based on colourband, I first increased the blues to maximum saturation in one action by selecting blues in the Saturation sub-menu. Then I opened Saturation again and boosted yellows (in order to retain some colour in the leaves on the ground and the distant trees in the final image). The result of these two increases produced a rather gaudy interpretation (*above right*). Normally, a 40 per cent global desaturation would remove almost all visible colour, but when that was applied to the prepared image, the strengthened colours could still be seen while others, such as greens, were removed (*right*).

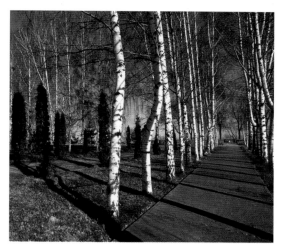

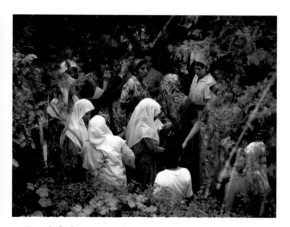

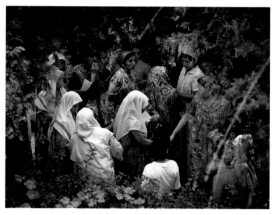

▲ Partial desaturation

The best way to desaturate the original highly colourful image (*above left*) was to use the Desaturation tool (also known as Sponge in the Desaturation mode), as it allowed the effects to be built up gradually and for precise strokes to be applied. Although the intention was to desaturate the trees completely, in order to emphasize the glorious colours of the women's clothes, as the strokes were applied it became clear that just a partial removal and toning down of the green would be more effective (*above right*). The image was finished off with a little burning-in to tone down the white clothing.

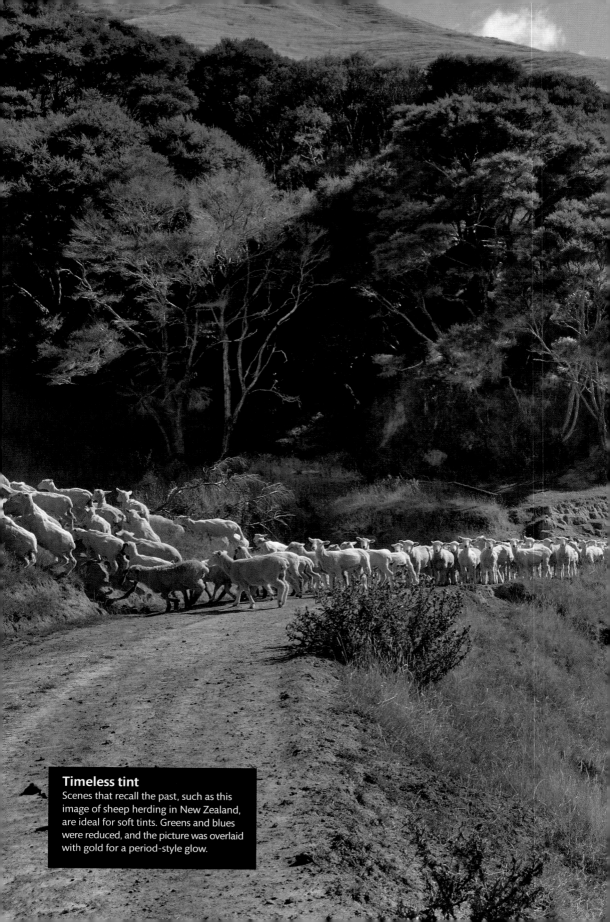

Timeless tint
Scenes that recall the past, such as this image of sheep herding in New Zealand, are ideal for soft tints. Greens and blues were reduced, and the picture was overlaid with gold for a period-style glow.

QUICK FIX PROBLEM SKIES

A common problem with views taking in both sky and land is accommodating the exposure requirements of both – a correctly exposed sky leads to a dark foreground, or a correctly exposed foreground gives a featureless, burned-out sky.

Problem: Skies in pictures are too bright, with little or no detail and lacking colour. This has the effect of disturbing the tonal balance of the image.

Analysis: The luminance range can be enormous out of doors. Even on an overcast day, the sky can be 7 stops brighter than the shadows. This greatly exceeds the capacity of all but the most advanced scanning backs.

Solution: If an area of sky is too light in a scan from a negative (black and white or colour), it is best to make a darkroom print and burn the sky in manually (*see pp. 190–91*). Then you can scan this corrected print if further manipulations are required. Digital solutions to the problem will be of no help if the sky presents plain white pixels devoid of subject information. For small overbright areas, you can use the Burn-in tool, set to darken shadows or mid-tones, at very low pressure. However, do not set it to darken highlights or the result will be unattractive smudges of grey.

Another method is to add a layer, if your software allows, with the Layer mode set to Darken or Luminosity (which preserves colours better). You can then apply dark colours where you want the underlying image darker. The quickest method to cover large areas is to add a Gradient Fill – this is equivalent to using a graduated filter over the camera lens.

A more complicated method requires some planning. You take two identically framed images – one exposed for the shadows, the other for the highlights. This is best done in a computer, where it is a simple matter of superimposing the two images with a Gradient Mask. See also pp. 266–9.

HOW TO AVOID THE PROBLEM

Graduated filters attached to the camera lens are as useful in digital as traditional photography – their greater density toward the top reduces exposure compared with the lower part of the filter, so helping to even out exposure differences between sky and foreground. It is worth bearing in mind that some exposure difference between the land and sky is visually very acceptable.

1 Gradient Fill
Areas of overbright highlight, as in the sky of this landscape, can be corrected using Gradient Fill. This mimics the effect of a graduated filter used on the camera lens.

2 Layers screen shot
First, a new layer was created and the Layer mode set to Darken. This darkens lighter pixels but not dark ones. A graduated dark blue was then applied to the top corners with medium opacity.

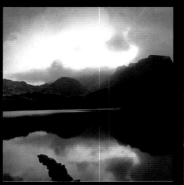

3 Final effect
This treatment does not increase graininess, as burning-in would do, but note how local darkening lowers overall image brightness. Further adjustments to brighten the lake are possible.

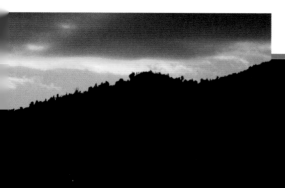

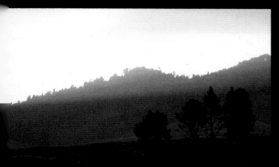

1 Masking overlays

The basis of this technique is to take two identically framed images – one exposed for the sky (*top*), the other exposed for the foreground (*above*) – and then composite them using a gradient or graduated mask to blend them smoothly. You need image-manipulation software that works with Layers and Masks (*see pp. 278–83*). This is easy for digital photographers but if you shoot on film, you can scan an original twice (once for highlights, once for shadows), ensuring the two are the same size, and copy one over to the other.

2 Making a gradient mask

Next, using the Layers control you have to create a gradient mask, which allows you to blend one image smoothly into the other (*top*). Notice that this entire image is slightly transparent: in other words, the whole image is masked but there is heavier masking in the lower half, as you can see in the dialogue box (*above*). The overall effect of applying this mask is that the lower image will show through the top layer.

3 Final effect

Blending the two exposures and the mask produces an image that is closer to the visual experience than either original shot. This is because our eyes adjust when viewing a scene, with the pupil opening slightly when we look at darker areas and closing slightly when focusing on bright areas. A camera cannot adjust like this (although certain professional digital cameras can partly compensate). Image-manipulation techniques can thus help overcome limitations of the camera.

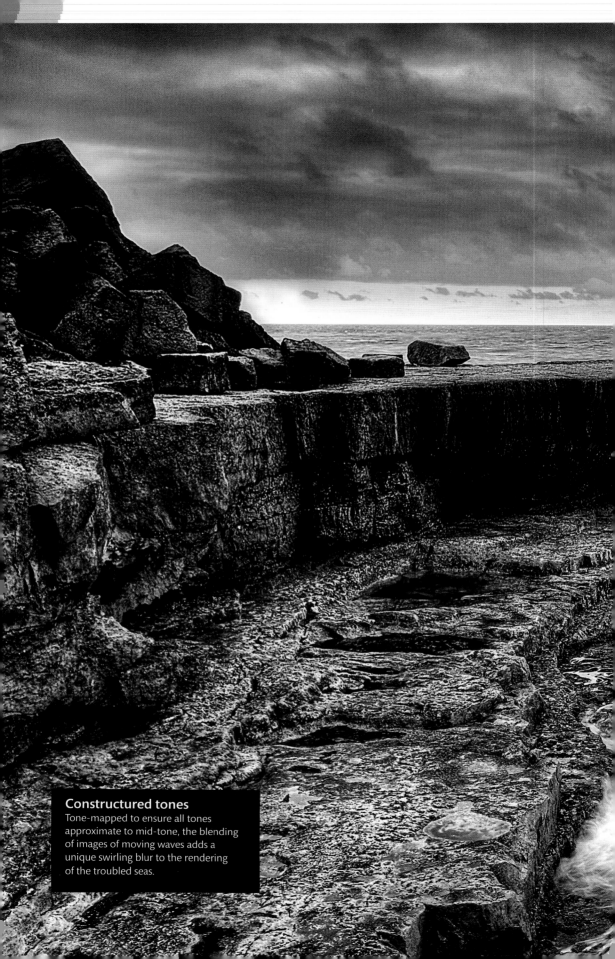

Constructured tones
Tone-mapped to ensure all tones
approximate to mid-tone, the blending
of images of moving waves adds a
unique swirling blur to the rendering
of the troubled seas.

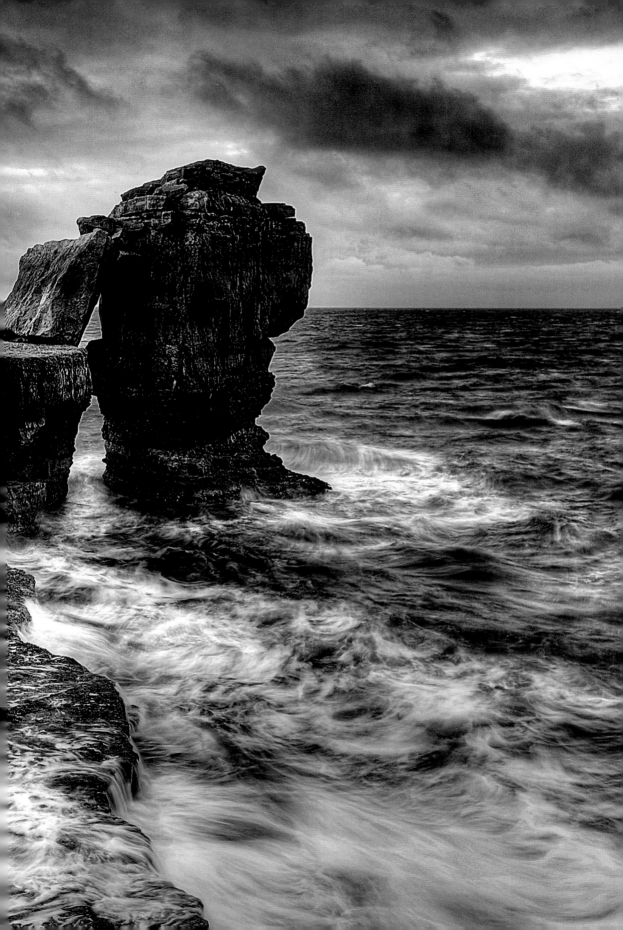

SELECTING PIXELS

There are two methods of localizing the action of an image-manipulation effect. The direct way is to use a tool that applies the effect to a limited area, such as the Dodge tool or any Brush. The other method is to first select an area or certain pixels within the image, then apply the effect. This ensures that only the selected pixels will be affected. Selection is founded on a continuous boundary of difference between two areas. This means that, with a bit of guidance from you, the software can compute the rest.

Masks and selections

It is important to understand that fundamentally there are two different ways of applying effects to a limited area of an image. Both define the areas that you can edit or in which you can apply an effect: these are called editable areas. A mask works by protecting an area from an effect – like an umbrella keeping you dry while all else gets rained on.

A selection does the opposite: it limits an action to the area it encloses – like watering only on a flower bed but not outside it.

There are also other differences. First, a selection is essentially a temporary mask – it disappears as soon as you click outside the selected area (some programs allow you to save a selection, to reapply it later or to use it on another image). If it can be saved for re-use, it is known as an alpha channel (technically a mask). Second, in software with Layers, the selection applies to any layer that is active. Third, you can copy and move selected pixels – something that cannot be done with a mask. In practice you will switch frequently between masks and selections.

Selections

A selection defines the border of the editable area, usually by showing a line of "marching ants" or moving dots. In fact the line joins the mid-points

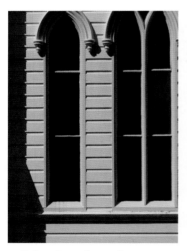

▲ Selecting clean shapes
This view of a church in New Zealand shows the clean lines of the wooden windows, but they look too dark and colourless. In order to make the windows lighter, but without affecting the pale wooden walls, we need to select the windows individually.

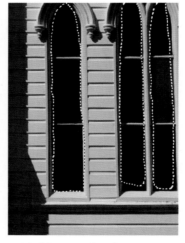

▲ Making a selection
Using Photoshop's Lasso, with a feathering width set to 11 pixels, I selected the dark glass within the window frames. To start a new area to be selected, hold down the Command key (for Macs) or the Control key (for PCs) – the selected area is defined by moving dashes, known as "marching ants". When the Levels command is invoked, settings are applied only to the selections.

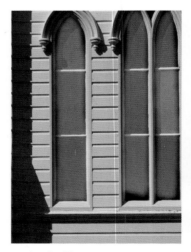

▲ Final effect
In some circumstances, the somewhat uneven result of using the Lasso selection can produce more realism than a perfectly clean selection would give. The dark areas remaining towards the bottom of the right-hand windows correspond to the area omitted from the selection in the previous image (*above left*).

between pixels that are wholly selected and those that are fully ignored – others lie on a transitional zone, which is known as the "feather" region. It follows that selections are most accurate when the feather region is not wider than a few pixels; with a wide feather region it becomes difficult to know exactly where the editable area starts and stops. An important option is the ability to partially select a pixel near the edge of a selection. This is called "feathering". It creates a gradual transition across the boundary from pixels that are fully selected, through those that are partially selected, to those that are unselected, thus smoothing out the effect you apply. A feathering of 0 means that the transition will be abrupt; more than 1 pixel will give a more gradual transition. Note that the effect of increased feathering is to smooth out any sharp angles in the selection.

The appropriate feather setting depends on the subject and type of selection you want. Cleanly bounded subjects, such as buildings against the sky or a figure against a white background, benefit from a narrow feather range. On the other hand, a wide feathering suits images with blurred outlines due to limited depth of field.

Quick mask

When you make a selection it is very useful to be able to judge its effect – to see what has been blocked out and what is left in. The quick mask mode, available in many applications, switches between showing the selection and showing the equivalent mask – usually as a red overlay. In this mode, you can adjust the mask by erasing parts you wish the selection to reach, or painting to increase the reach of the selection.

Make a choice

There are two fundamentally different ways of making selections. Some, like the Lasso or Marquee

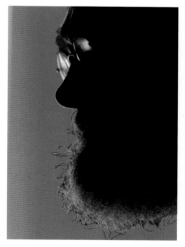

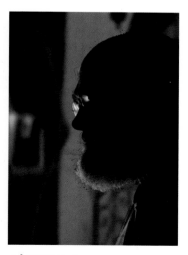

▲ Selecting irregular shapes
This back-lit portrait is rather harshly lit by the open window, although the darkness behind the curtains softly rim-lights the face. Clearly, removing the face from the background will be a challenge because of the man's beard.

▲ Quick selection
The Quick Selection tool in Photoshop selected the head swiftly, but as the darkness at the top blended into the background, the selection extended too far, so had to be reduced. Then, zooming in, a small Brush was used to apply Quick Selection to individual hairs. In Quick Mask mode you can see that the background will be removed so we can apply the face to a different background.

▲ Layer over
When you have masked away the original background, you are free to apply any other image as the background. I chose an alleyway in Greece at night, as the lighting matches that of the portrait yet provides a much softer backdrop – one which makes the most of the sparkle in the spectacles.

SELECTING PIXELS CONTINUED

tool, indiscriminately gather up all the pixels within the area they define, taking no account of pixel values. On the other hand, value-sensitive selections, such as Magic Wand or Color Range, look at values and the location of pixels – for example, whether they are touching similar pixels or not – when calculating the selection.

The basic Lasso tool is best for selecting disparate areas with different colours and exposure. Where you have clearly defined objects that are distinguished by colour and exposure from the background, Magnetic Lasso or the equivalent, is a good choice. If you need to select irregular areas with straight-line borders, the Polygonal Lasso is the obvious tool.

Tools that select like pixels include the Magic Wand tool; you can click directly on the image to select pixels that are similar to the sampled area. With the Color Range command you click on a preview to select all related pixels. The control is useful for locating out-of-gamut colours in order to bring them into gamut. More sophisticated tools can select pixels by computing their degree of similarity, which can give excellent results, even for the unskilled.

Computed choice

Some boundaries are extremely complicated or subtle, or both, with hair and glass commonly regarded the trickiest subjects. Tools in software such as Topax Remask and Adobe Photoshop have eased the problem. All work by first defining a transition region, such as the edge of a wine glass. Then you define the region to keep and the region to cut. The boundaries do not have to be drawn with great precision, but the tighter and more accurately drawn the transition area – so that unwanted colours are not included – the more accurate the selection will be. The software then computes the mask to apply; the best create soft and hard edges as demanded by the image.

▲ Transparent choice
A wine-glass of water presents the paradox of a transparent edge. Colour shows through the glass, but if we want to add another glass to the table we do not want to lose the edge. A combination of personal judgement and computation will be needed.

▲ Remasking
Using a masking plug-in, such as Remask (illustrated) or Perfect Mask, takes several stages. After defining the transition area – the areas to keep and areas to lose – you need to refine it. Here, parts of the glass will be lost (red) but other parts will be kept. The transition area is not perfect but computation will clean it up.

▲ Double or dare
The masked image is placed on a layer over the original, so it can be moved easily. Here, it was moved to occupy the empty space, the water was turned to wine with a brush loaded with yellow, and the glass was made slightly smaller than the original as it is a little further away.

HINTS AND TIPS

- Learn about the different ways of making a selection. Some are obvious, such as the Lasso or Marquee tool, but your software may have other less-obvious methods, such as Color Range in Photoshop, which selects a band of colours according to the sample you choose.

- Use feathered selections unless you are confident you do not need to blur the boundaries. A moderate width of around 10 pixels is a good start for most images. But adjust the feathering to suit the task. For a vignetted effect, use very wide feathering, but if you are trying to separate an object from its background, then very little feathering produces the cleanest results. Set the feathering before making a selection.

- Note that the feathering of a selection tends to smooth out the outline: sudden changes in the direction of the boundary are rounded off. For example, a wide feathering setting to a rectangular selection will give it radiused corners.

- The selected area is marked by a graphic device called "marching ants" – a broken line that looks like a column of ants trekking across your monitor screen: it can be very distracting. On many applications you can turn this off or hide it without losing the selection: it is worth learning how to hide the "ants".

- In most software, after you have made an initial selection you can add to or subtract from it by using the selection tool and holding down an appropriate key. Learning the method provided by your software will save you the time and effort of having to start the selection process all over again every time you want to make a change.

- Examine your selection at high magnification for any fragments left with unnatural-looking edges. Clean these up using an Eraser or Blur tool.

- Making selections is easier to control with a graphics tablet (*see p. 358*) rather than using a mouse.

▲ Selecting like colours

The brilliant red leaves of this Japanese maple seem to invite being separated out from their background. However, any selection methods based on outlining with a tool would obviously demand a maddening amount of painstaking effort. You could use the Magic Wand tool but a control such as Color Range (*right*) is far more powerful and adaptable.

▲ Color Range screen shot

In Photoshop, you can add to the colours selected via the Eye-dropper tool by using the plus sign, or by clicking the Eye-dropper tool with a minus sign (beneath the Save button). However, you can refine the colours selected. The Fuzziness slider also controls the range of colours selected. A medium-high setting ensures that you take in pixels at the edge of the leaves, which will not be fully red.

▲ Manipulated image

Having set the parameters in the Color Range dialogue box (*above left*), clicking "OK" selects the colours – in this case, just the red leaves. By inverting the selection, you then erase all but the red leaves, leaving you with a result like that shown here. Such an image can be stored in your library to be composited into another image or used as a lively background in another composition.

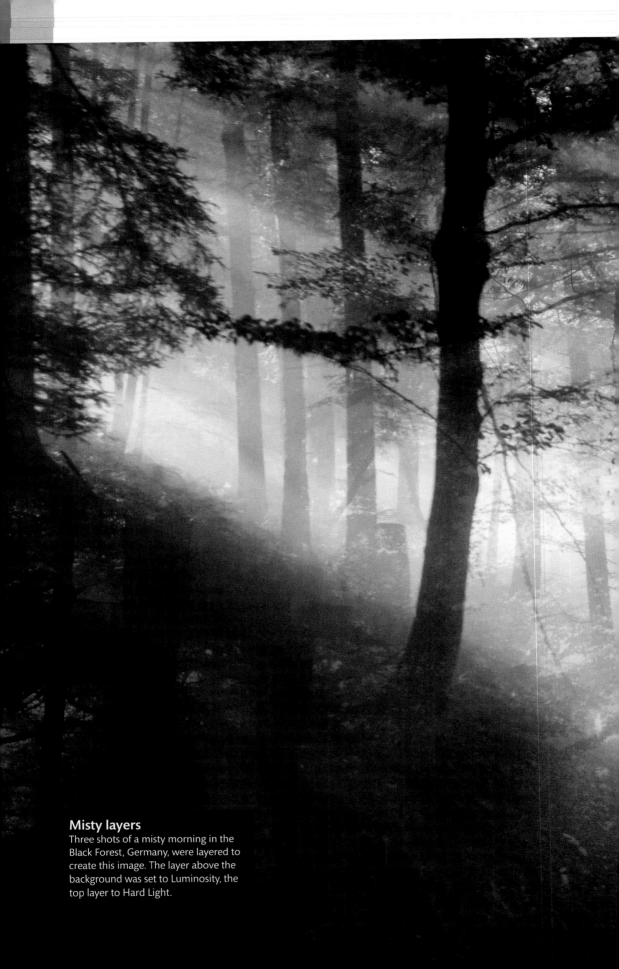

Misty layers
Three shots of a misty morning in the
Black Forest, Germany, were layered to
create this image. The layer above the
background was set to Luminosity, the
top layer to Hard Light.

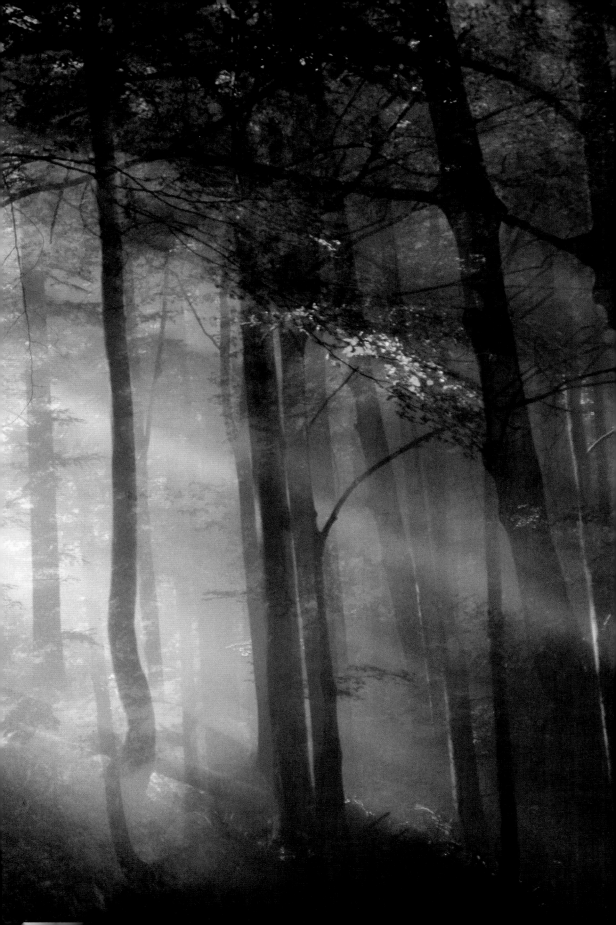

CLONING TECHNIQUES

Cloning is the process of copying, repeating, or duplicating pixels from one part of an image, or taking pixels from another image, and placing them on another part of the image. First, you sample, or select, an area that is to be the source of the clone, and then you apply that selected area where it is needed. This is a basic tool in image manipulation, and you will find yourself constantly turning to it whenever you need, say, to replace a dust speck in the sky of an image with an adjacent bit of sky, or remove stray hairs from a face by cloning nearby skin texture over them.

This is only the start, however. Such cloning makes an exact copy of the pixels, but you can go much further. Some applications, such as Corel Painter, allow you to invert, distort, and otherwise transform the cloned image compared with the source you took it from.

▲ **Original image**
An unsightly tarred area of road left by repairs marred this street scene in Prague. All it will take is a little cloning to bring about a transformation.

▲ **History palette**
The screen shot of the History palette shows the individual cloning steps that were necessary to bring about the required transformation.

▲ **Manipulated image**
The result is not perfect, since it has none of the careful radial pattern of the original, but it is far preferable to the original image. It was finished off by applying an Unsharp Masking filter plus a few tonal adjustments.

HINTS AND TIPS

The following points may help you avoid some of the more obvious cloning pitfalls:

- Clone with the tool set to maximum (100 per cent). Less than this will produce a soft-looking clone.

- In areas with even tones, use a soft-edged, or feathered Brush as the cloning tool; in areas of fine detail, use a sharp-edged Brush.

- Work systematically, perhaps from left to right, from a cleaned area into areas with dust specks – or else you may be cloning the specks themselves.

- If your cloning produces an unnaturally smooth-looking area, you may need to introduce some noise to make it look more natural: select the area to be worked on and then apply the Noise filter.

- You can reduce the tendency of cloning to produce smooth areas by reducing the spacing setting. Most digital Brushes are set so that they apply "paint" in overlapping dabs – typically, each dab is separated by a quarter of the diameter of the brush. Your software may allow you to change settings to that of zero spacing.

- If you expect to apply extreme tonal changes using, say, Curves settings, apply the Curves before cloning. Extreme tonalities can reveal cloning by showing boundaries between cloned and uncloned areas.

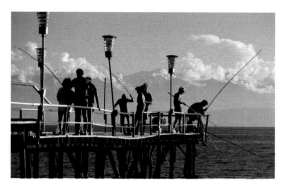

◄ Original image

Suppose you wished to remove the lamp on the far left of this image to show an uninterrupted area of sky. You could use the cloning tool to do this, but it would be a lot of work and there would be a danger of leaving the sky's tones unnaturally smoothed-out in appearance.

1 **Marquee tool**

The Marquee tool was set to a feather of 10 pixels (to blur its border) and placed near the lamp to be removed to ensure a smooth transition in sky tones.

2 **Removing the lamp**

By applying the Marquee tool, you can see here how the cloned area of sky is replacing the lamp. Further cloning of sky was needed in order to smooth out differences in tone and make the new sky area look completely natural.

3 **Looking at details**

The final removal of the lamp was done with a smaller Marquee area, with its feather set to zero (as sharp as possible). Finally, the lamp behind the one removed was restored by carefully cloning from visible parts of the lamp.

4 **Cleaned-up result**

As a finishing touch, a small area of cloud was cloned over the top of the lamp and its lid was darkened to match the others left on the pier.

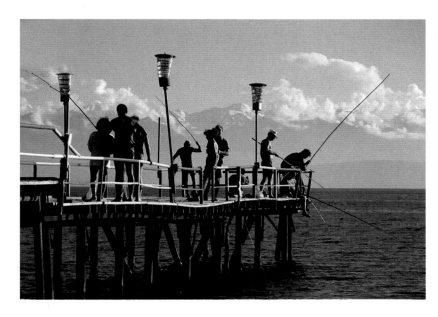

CLONING TECHNIQUES CONTINUED

Special cloning

In addition to the corrective type of cloning seen on pp. 288–9, it is possible to take the process further and use it creatively.

In most software, there are two main ways of applying a clone. The basic method is what is now known as non-aligned, or normal: the first area you sample is inserted to each new spot the Brush tool is applied to. The other cloning method keeps a constant spatial relationship between the point sampled and the first place the sample is applied to – in other words, an offset is maintained so that the clone is aligned to the source point.

However, software such as Corel Painter offers as many as nine other ways of aligning the clone to the source. You can distort, shear, rotate, mirror, scale up or down, and so on. The procedure is more complicated than with normal cloning because you need to define the original scale and position prior to applying the clone. You first set the reference points in the source image, then set the transformation points; this can be either in the original image or in a new document. It is this latter feature that gives Painter's cloning tools tremendous power.

One interesting feature is that as your cloned image is being built up, it can, itself, become the source material for more cloning.

The examples below illustrate just how far it is possible to move away from the source material, as well as how diverse the results can be. Remember, though: with all cloning experiments, you should work on a copy of the original image.

◄ Original images
Both of these originals (*left*) were taken in New Zealand. Note that images do not have to be the same size or shape for cloning to take place, but look for originals with strong, simple shapes. Sharpness and colour were improved prior to the cloning: increasing sharpness after cloning can exaggerate the patches of cloned material.

▲ Manipulated images
The originals were first cloned into a new file, but with added textures and overlaid with several layers. The first image (*above*) is intended to give a modern feel to the Chinese character "good fortune"; the other (*right*) has been given a distressed look.

▲ Original image

Any original image can be cloned onto itself to make complexes of line and form. Starting with an image with clear-cut lines and simple colours, such as this, special cloning techniques can make images that are difficult to produce in any other way.

▲ Rotation and scale

Cloning with rotation and scale calls for two points to be set to define the source and a corresponding two points to determine the clone. By experimenting with different positions of the source and clone points, you can create a wide range of effects: here the boy appears to be spinning into an abyss.

▲ Perspective tiling

Here, the boy was cloned with perspective tiling applied twice to different parts of the image. This requires four points to be set as the source, and four for the clone. By switching around the positions of the reference points, wild perspective distortions are produced, which could have come from a sci-fi comic.

PROOFING AND PRINTING CONTINUED

of managing the colour data can be handled by image software such as Adobe Lightroom or Apple Aperture, or you can elect to have it managed by the printer. Results vary depending on software and printer, so it is best to try both strategies and gain experience with your own set-up.

Previewing

Making a print takes up valuable resources such as ink, paper and, above all, your precious time. Central to efficient printing practice is to soft-proof as much as possible – that is, check and confirm everything you can on the monitor screen (make pre-flight checks) before sending the image to the printer. Ensure first that you have the output profile for the paper and printer combination that you plan to use. Set this up, usually in the View menu, called "Proofing profile" or "Proof set-up", or similar.

In order to check exposure and colour, set the software to Print Preview. There may be a change in the appearance of the image: if you have one with brilliantly bright colours, the soft-proof image may suddenly become dull and a little darker. If your image is not brilliantly coloured, or is black and

▲ **Textile colour**
For accurate records of decorative objects, such as this piece of textile (above), precise colour control is essential. Reds are visually very important but deep reds can vary considerably between monitor image and paper output. The subtle variations in deep tone are easily lost if a print-out is too dark.

WHAT ARE RENDERING INTENTS?

Converting from one colour space to another involves an adjustment to accommodate the gamut of the destination colour space. The rendering intent determines the rules for adjusting source colours to destination gamut: those that fall outside the gamut may be ignored or they may be adjusted to preserve the original range of visual relationships. Printers that are ColorSync-compliant will offer a choice of rendering intents that determine the way in which the colour is reproduced.

- Perceptual (or image or photo-realistic) aims to preserve the visual relationship between colours in a way that appears natural to the human eye, although value (in other words, brightness) may change. It is most suitable for photographic images.
- Saturation (or graphics or vivid) aims to create vivid colour at the expense of colour accuracy.

It preserves relative saturation so hues may shift. This is suitable for business graphics, where the presence of bright, saturated colours may be important.

- Absolute Colorimetric leaves colours that fall inside the destination gamut unchanged. This intent aims to maintain colour accuracy at the expense of preserving relationships between colours (as two colours different in the source space – usually out-of-gamut – may be mapped to the same colour in the destination space).
- Relative Colorimetric is similar to Absolute Colorimetric but it compares the white or black point of the source colour space to that of the destination colour space in order to shift all colours in proportion. It is suitable for photographic images provided that you first select "Use Black Point Compensation".

white, you may see no difference. Check that the soft-proof image is acceptable: this helps manage your expectations about what will print, so you will not be disappointed at the loss of those deep purples and gorgeous reds – which can be seen on-screen but cannot be printed. Modern printers using up to 12 different inks are improving the range of colours which can be printed, but they still fall well short of what can be seen in real life.

Sizing up

Another basic pre-flight check is to ensure that the output size makes use full use of the paper, printing with the border suited for the end use, or borderless if your printer offers this feature. Image applications and printer drivers will show a preview of the size and position of the image on the page. Many printer drivers can automatically resize the image to fit the paper size you have chosen.

Some printers will warn you if the resolution of the image is insufficient for a top-quality print (missing the optimum resolution by a small amount is not fatal to print quality), or if the print is larger than the paper.

Summary of set-up

■ Working on a calibrated monitor, complete all post-processing. Check for defects such as spots by examining the print at 200 per cent.

■ Soft-proof output: check that no important colours are compromised and that any highly saturated colours in the image are not posterized: reduce saturation locally if necessary.

■ Re-size the image to fit the print size so that resolution is not more than 300 pixels per inch (120 pixels per cm) of output. Much lower resolutions are sufficient if you are printing on rough-textured papers such as water-colour rag, but you may wish to increase sharpening. Sending unnecessarily large files can slow down printing.

■ Command the software to print: check the preview for size and location of the print in relation to the paper used.

■ Insert the paper, ensuring that the correct side will be delivered to the ink. If you have not used the printer before, run a test – with some printers the paper comes out with the same side facing up as when it went in, with others the paper comes out the opposite way round.

◀ Print preview
All digital images are virtual and thus they have no dimensions until they are sized for output. In this screenshot, from Apple Aperture, many controls for sizing and positioning the print on the paper, as well as different presentation styles (*top left*) can be seen. There are also controls for increasing brightness, saturation, and contrast, but it is best to give the printer a perfect image in the first place. Here, the print has been set up to print to the edge of the paper, with a black border.

OUTPUT TO PAPER

One great advantage of ink-jet printers is that they can print on a wide variety of surfaces. In fact, some desktop models will print on anything from fine paper to thin cardboard.

For the digital photographer, there are three main types of paper available. Most papers are a bright white or a near-white base tint, but some art materials may be closer to cream.

Paper types

Office stationery is suitable for letters, notes, or drafts of designs. Quality is low by photographic standards and printed images cannot be high in resolution or colour saturation. Ink-jet paper that is described as 360 dpi or 720 dpi is a good compromise between quality and cost for many purposes.

Near-photographic quality is suitable for final print-outs or proofs for mass printing. These papers range from ultra-glossy or smooth to the slightly textured surface of glossy photographic paper. Paper thickness varies from very thin (suitable for pasting in a presentation album) to the thickness of good-quality photographic paper. Image quality can be the best a printer can deliver with excellent sharpness and colour saturation. However, paper and ink costs may be high.

Art papers are suitable for presentation prints or for special effects and include materials such as hand-made papers, watercolour papers, or papers with hessian or canvas-like surfaces. With these papers, it is not necessary to use high-resolution images or large files that are full of detail.

Paper qualities

If you want to experiment with different papers just ensure that the paper does not easily shred and damage your machine and clog the nozzles of the ink-jet cartridge. If using flimsy papers, it is a good idea to support them on thin card or a more rigid piece of paper of the same size or slightly larger. The main problem with paper not designed for ink-jets is that the ink either spreads too much on contact or else it pools and fails to dry.

Dye-sublimation printers will print only on specially designed paper – indeed some printers will even refuse to print at all when offered the wrong type of paper. Laser printers are designed only for office stationery and so there is little point in using other types of paper.

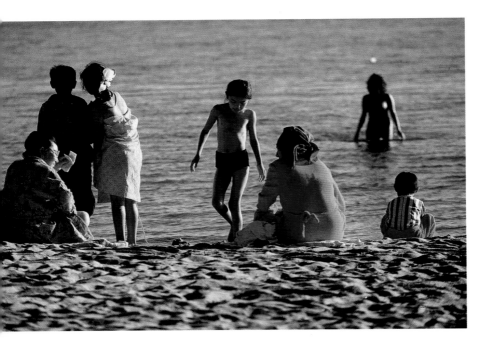

◄ Crucial colour
Not only does the blue of this scene test the evenness of printing, it also tests colour accuracy. Very slight shifts away from blue will make the image look unbalanced in colour and distract the viewer's attention from the relaxed, sun-filled scene. In fact, blue ranks with skin tones as the most important of colours that must be correctly printed, or else the foundation of an image will be seen as unsound.

▲ Dark subjects

The blacker a colour image, the more ink will be needed to print it. If your subject is full of very dark areas, such as this scene, the paper could easily be overloaded with ink. The ink may then pool if it is not absorbed and the paper could buckle or become corrugated. To minimize this problem, use the best quality paper and tone down the maximum of black as much as possible by reducing the black output level in the Levels control.

TRY THIS

To determine the minimum resolution that gives acceptable results on your printer, you need to make a series of test prints with the same image printed to the same size but saved to different resolutions. Start by printing out a good-quality image of about 25 x 20 cm (10 x 8 in) or A4 size at a resolution of 300 dpi – its file size is about 18 MB. Now reduce resolution to 200 dpi (the file size will get smaller but the output size should be the same) and print the file, using the same paper as for the first print. Repeat with resolutions at 100 dpi and 50 dpi. Compare your results and you might be pleasantly surprised: depending on the paper and printer, files with low output resolution can print to virtually the same quality as much higher-resolution files. With low-quality or art materials, you can set very low resolutions and obtain results that are indistinguishable from high-resolution files. In fact, low resolutions can sometimes give better results, especially if you want brighter colours.

◄ Even tones

Subjects with large expanses of even and subtly shifting tone present a challenge to ink-jet printers in terms of preventing gaps and unevenness in coverage. However, in this image of a frozen lake in a Kazakh winter, the challenge is not so great as the colour is nearly grey, which means that the printer will print from all its ink reservoirs. If there is only one colour, most often the blues of skies, you are more likely to see uneven ink coverage.

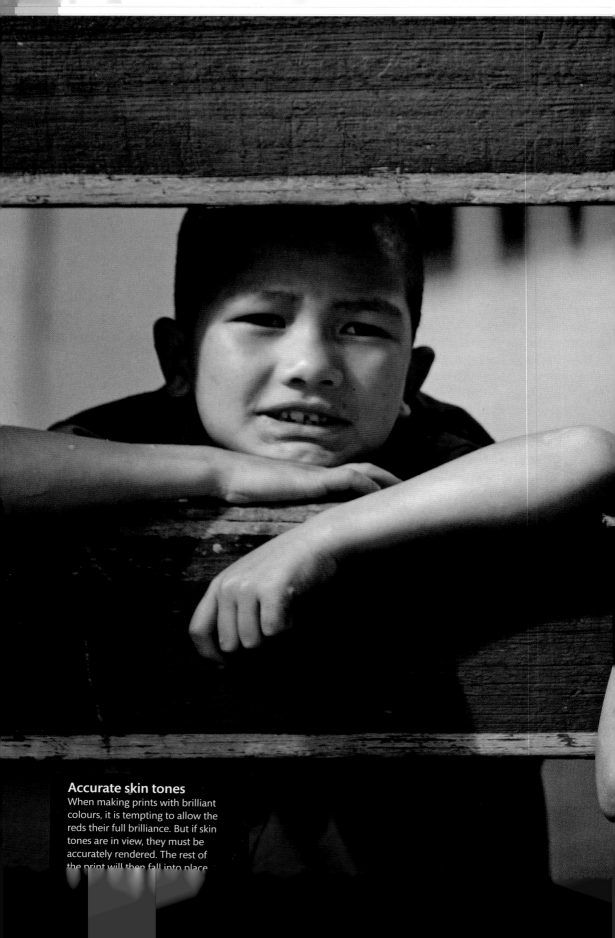

Accurate skin tones
When making prints with brilliant colours, it is tempting to allow the reds their full brilliance. But if skin tones are in view, they must be accurately rendered. The rest of the print will then fall into place.

PRESENTING PRINTS

Digital photography hugely expands the options for presenting images. The choice ranges from a handheld tablet screen to single wall-sized prints. In between, you can create installations to present photocopied prints or frame them behind archival window mattes and glass. The biggest change is the ease with which you can turn still images into multimedia shows, adding moving transitions and sound tracks. The key is finding a style of presentation that is appropriate to your work and intentions.

Stages of show

There is a difference between preliminary and final presentations: current practice accepts small digital images for a first viewing. Ensure it is easy for people to view and assess the images quickly and easily.

When presenting personally, you may use a laptop, and one with 17-inch screen is ideal. Glossy screens deliver high-impact images, but reflections can be troublesome. For informal purposes, a tablet device is a good alternative. Art galleries and collectors may expect to see large unmounted prints. Publishers of books, magazines, and journals may ask to see prints up to A3 in size.

For the final display, remember that the colour temperature of the illumination affects the final colour of your print. If colour accuracy is truly vital, you must take account of the lighting at the point of viewing when making the print. In practice, you need simply to ensure that your prints have the correct brightness and tonality, with correct white balance and pleasing colours. (*See also pp. 372–3.*)

▲ Group display

Images are almost never seen singly: even when displayed one-by-one, you are aware of neighbouring images out of the corner of your eye, or well inside your view. These juxtapositions create dynamic interactions between adjacent images, which is why the order in which images are shown is important. But you can be explicit about adjacency effects and show pictures in pairs – diptychs – or in threes – triptychs. As painters of the Italian Renaissance knew, three images grouped together are more powerful and resonant than the same images shown separately.

Presenting methods

Prints should be presented to help the viewer appreciate the images and to understand the message you wish to put across. Conventionally, this means that the prints should be at a comfortable eye-level (usually between 1.4 and 1.7 m above ground), be hung level, and be equally spaced in proportion to print size. And it should go without saying that the prints should be well lit.

There are many ways to counter the conventional. You can enclose small prints in the bottom of boxes, hang them on a single pin so that they flop about, wrap them around objects, and so on. Creating an installation for your images encloses them in an environment that removes them from normal exhibition space into a conceptual or critical orbit.

TRY THIS

If you have never combined images with sound, you may be in for a thrilling discovery. It is easy to create a multimedia show. Put your images into sequence: if your software does not do that for you, re-name your images in order – for example, show01.jpg, show02.jpg. Start up a slide-show application such as Photostage or Photoshare, or a management software package, such as Apple Aperture or Adobe Lightroom. Create transitions between images if needed: usually the best is a simple fade from one to the next. Add the soundtrack by simply ticking the soundtrack option and choosing from your collection of downloaded music. Try different tracks to experience the differences in their effect. The music gives depth and dimension to the slide-show.

▲ Any which way

The display of prints is no longer confined to neatly trimmed, mounted, and glass-framed exhibits. These examples from formal events show that there are only practical limits and conceptual considerations. Feel free to experiment. Stick landscape images on the ground, put portraits on trees, put scenes on the ceiling. Take the view that if it works, it stays up.

SHARING IMAGES

Since the first websites dedicated to the public displaying of photographs started in 1999, photo sharing has become the most important and fastest growing way for images to be viewed. Photo-sharing sites are now truly gigantic, still growing in number, and all rapidly growing in size. It is one of the most feverishly active areas of photography. If you want a snapshot of what is going on in amateur photography, you need only visit a few photo-sharing websites.

Staggering figures

Photo enthusiasts all over the world upload millions of images every minute of the day, every day of the year. Between them, sites such as Webshots, Photobucket, Flickr, Snapfish, Kodak Gallery, and Windows Live Photos hold tens of billions of images. Their membership alone totals over 230 million – probably with insignificant overlap.

The reason for the popularity is that photo sharing enables photographers to join a community of people that share their passion for images. You can show off images that you are proud of, and receive praise. You can also show work to invite constructive criticism that can help you to improve

your technique, composition, or general approach. Photo-sharing sites enable you to connect to a vast number of like-minded photographers: after a simple registration that takes a couple of minutes, you can suddenly reach millions of people. A picture uploaded to the site is exposed within seconds to a global community, and if it receives notice, will actually be seen by millions within days. The possibilities for self-promotion are heady.

Setting up

You will already have a collection of images that you want to share. Run an internet search for "photo sharing" or "picture sharing" and visit the many sites available. See which one you like the most and sign up or register. This is usually free, and enables you to view images, post comments, and upload a limited number of images: daily quotas vary but are ample for most purposes. If you wish to upload more images than the quota allows or larger images, and would like extra features such as building galleries and albums, you can subscribe for a higher level of membership.

Remember that an important part of uploading your images is ensuring that they carry useful tags

◀ **Social tokens**
Picture sharing admirably fulfils the needs for a virtual community. Images offer attractive tokens for social exchange – to be admired, to be tagged as "favourite", and to trigger invitations to join specialist groups. And in return, the images offer the photographer multiple opportunities to improve their status – the more people tag your images as favourites, or the more numerous the comments you attract, the higher rises your status in the group.

that key-word the image's content. Remember that within a day of being uploaded, your images will be "under" a pile millions of others that have been more recently uploaded, and therefore more likely to be seen. Even if your images are visually stunning, they are essentially invisible until they are found, and the easiest way for people to find your images will be for them to carry a tag that matches what someone is searching for.

Once able to access site features, you will find that not only can you post pictures and view others' work, but you have become part of a world-wide community humming with help, advice, information, and rumours. Furthermore, site members can be very generous with their assistance for beginners, so it is always worth asking for advice.

Storage and world access

Another useful but not often mentioned advantage of photo-sharing sites is that you are effectively backing up your portfolio of best work off-site – in fact your files exist in multiple locations all around the world. This is particularly valuable in the case of sites that accept large files, of 30MB or more in size. However, although the reliability of these sites is impeccable while in operation, there is always a danger that they will go out of business.

This back-up can be invaluable for professionals as it allows access to your image library from anywhere in the world. Any request for an image can be serviced wherever you are. One result is that photo-sharing sites have become an essential part of a photographer's marketing and operating "toolkit".

CODE OF COMMENT
The quality of comment, constructive criticism, and exchange of information is a vital element in the vigour of a photo-sharing site. You need to play your part by understanding a code of acceptable behaviour that may or may not be unwritten, but is in common with codes elsewhere on the internet:
- Be fair and temperate in your comments.
- Compliments are always welcome but being more specific is more helpful: "Lovely harmony of colours" is more informative than "Love it!".
- If you have critical but constructive comments to offer, it may be best to send a personal message to the photographer.
- Never shout by using CAPITAL LETTERS or strings of exclamation marks!!!!
- If you welcome critical comments, say so.

◄ **Ticking boxes**
Picture sharing is about social interaction, so images with identifiable people go down well. This image could easily be shared on social networks and could also be used in a guide to the region, as it shows a lively local event at a recognizable location – Lincoln Cathedral, England.

SHARING IMAGES CONTINUED

Shares management

Photo-sharing sites can be treated as data warehousing for your images. This is practicable if you have access to fast broadband free of quota limits. But before you gleefully upload your entire image collection online, it is wise to organize the material to suit internet use. You will not wish your high-resolution images to be freely available. If a publisher wants to use one of your images, you need them to pay you a licence fee before they have access to the high-resolution files. On the other hand, you need to ensure that all your images can be easily viewed by anyone.

Set up two types of viewing rights: some sites organize by albums or galleries, others by tagging individual images. For public viewing by anyone, use your smaller images; these can be reviewed quickly but the files are too small to be used for any purpose other than on a website. As a further precaution, images in this album may be watermarked (see p. 376). The high-resolution files reside in restricted, "invitation-only" albums or are tagged as "private". As the number of images can be overwhelming, the best way for a potential buyer to locate images is to search by tags. If you wish your images to be found it is essential that the caption is accurate and concise, and that your tagging is complete and skilful (see p. 327).

Preparing images

The size of the images you show on a website always depends on balancing quality with the speed of loading the web page. Quality depends on both the pixel dimension of the image and the level of compression: fewer pixels and higher compression make for smaller files and quicker loading; the downside is compromised image quality. Using high-quality images – measuring 1,024 pixels or more on the long side – may also expose your images to unlicensed use.

There are four main steps in preparing images for use on the web:

■ **Evaluation:** Assess the image quality and content. If it is photographic, you can convert it to JPEG; if it is a graphic with few subtle colour gradations, you can convert to GIF. Also adjust brightness and colour so the image will be acceptable on a wide range of monitors.

■ **Resizing:** Change the size of copies of the images (not the original files) to the viewing size intended, so that the file size is no larger than necessary. Images may be tiny, perhaps 10 x 10 pixels (for use as buttons), or large, say 640 pixels on the longest side (for displaying work).

■ **Conversion:** Convert photographic images to JPEG. Set a compression slightly greater than you would like (the image is degraded just a little more than you would wish) to optimize loading speed. (See also the box left.)

■ **Naming:** Give your files a descriptive name using letters and/or numbers. The only punctuation marks you should use, if desired for clarity, are dashes (-) or underscores (_). Always put a full stop before the jpg suffix (.jpg).

OPTIMIZING YOUR PICTURES ON THE WEB

You will want those who access your site to receive your images quickly and to have the best experience of your images the system permits. Here are some tips for optimizing your images on the internet.

■ Use Progressive JPEG if you can. This presents a low-resolution image first and gradually improves it as the file is downloaded. The idea is that it gives the viewer something to watch while they are waiting for the full-resolution image to appear.

■ Use the WIDTH and HEIGHT attributes to force a small image to be shown on screen at a larger size than the actual image size.

■ Use lower resolution colour – for example, indexed-colour files are much smaller than full-colour equivalents. An indexed-colour file uses only a limited palette of colours (typically 256 or fewer), and you would be surprised at how acceptable many images look when reproduced even with only 60 or so colours (see p. 222).

◄ JPEG compression

Maximum quality is the reward for minimum file compression. Even at high magnifications it is hard to see any loss in detail. At the magnification shown here you can just make out, with careful examination, a very slight blurring of detail in the right-hand image compared with the original on the left. The advantage, of course, is that the file is compressed from nearly 7 MB to only about half the size, 3 MB.

 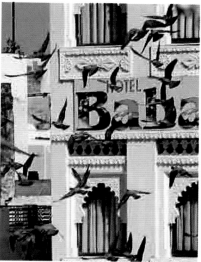

◄ Small file, low quality

At the minimum quality setting, the file size is pared down to an impressive 200 K from 7 MB – to some 3 per cent of the original size. The loss of image quality is evident but only at high magnification: the clarity of the lettering and the pigeons' wings are now blurred and labour under artefacts. The evenness of tone of the wall is also broken. However, this is a 500 per cent view, and the full image, at its normal size on screen, reveals none of these artefacts.

◄ Medium quality

With a medium-quality setting, here showing a different part of the same image, there is a substantial and useful reduction in file size – from nearly 7 MB to just 265 K – more than 25 times smaller, or 4 per cent of the original file size. Download times are accordingly reduced by a large factor. Yet there is barely visible or practical loss of quality, even at high magnification. With the loss of resolution that accompanies printing, there will be no visible differences..

SELLING YOUR PICTURES

There can be few photographers who would not be delighted to earn cash from their passion. It is possible to earn money through your photos, and there are some professionals who earn a comfortable living; but make no mistake, it is not easy. It is not only that digital photography has enabled millions of amateurs to produce work of professional standard. Thanks in part to the incredible ability of the internet to disseminate to the entire world at zero cost, the structure of the market for photography has been turned inside out and upside down. As a result, some old strategies work, others are hopelessly outmoded.

Cost and value

With so many photographers all around the world creating images of publishable quality, the unit cost of a picture taken of the west coast of Australia, for example, has been driven down to a small fraction of what it was in the days of film. So, while it may cost you a small fortune to equip yourself and travel to a location, the value of the resulting image is relatively low: hundreds, if not thousands, of other photographers have produced a similar shot.

However, you can drive up the value of your photographs by striving to meet specific needs: that is why you can charge more for photographing weddings, portraits, and products.

Microstock

The ready supply of highly competent photography has created the market formerly called "royalty free" but now more commonly referred to as "microstock". These are websites containing millions of images whose rights can be licenced for what amounts to loose change. These rights may cover virtually any use at all, including commercial, and last for the life of the licensee. In return, the photographer earns a royalty – around 30 per cent of what the site receives for your image.

Many photographers earn from these sites, though making a living requires the submission of thousands of images. The best sites are the hardest to contribute to, but there are so many that there are even sites dedicated to their review. Once you have chosen a site you wish to work with, you will need to submit a small selection of images for initial review. If these pass for technical quality and saleability, you can submit freely. Your pictures will be reviewed, then posted on the site. Buyers visit the site in search of images: if they choose one of your pictures, they pay the site to download a

◄ Twelve Apostles
Even on the remote western coast of Australia, a popular landmark can attract thousands of photographs. Search engines reveal that there are over 700,000 images of this location alone – some are shown here. Your task is to make your shot a distinctive and individual, yet truthful depiction.

high-resolution copy of the image. You will then be credited with the royalty. This can be turned into cash, be used to top up your Paypal account, or be used to obtain rights to images.

Playing tag

The larger microstock sites hold tens of millions of images. One result is that it is easier to search for images by using words or tags. It follows that the key to making your image visible to searches conducted by potential clients is accurate, concise, and inclusive tagging of your images. In general, the more tags you can append to an image, the more likely it is to be found when someone searches.

▼ Topical coverage

The images most likely to sell are those that cover contemporary issues. Landscapes and views of famous monuments are least likely to sell. This image is clearly about modern transport and its effect on the environment, and gives an impression of the scale and numbers involved.

TAGGING PHOTOS

Tags are keywords that describe images in terms of their subject matter. Tags are different from the image caption which is a plain-language description of subject. Keywords in the caption should also be used as tags. A caption may say "Shadow of a Boeing 727 flying over Highway 66, Santa Fe, New Mexico, USA" (*see below*). The tags should include: "shadow", "aircraft", "flight", "highway", "road", "route", "cars", and "traffic". Other tags for the same image may include more abstract concepts such as: "sunny', "yellow-green", "aerial", "environment", "transport", "greenhouse gas", and "global warming".

Tags can also be used to organize images: for example, all your images taken in New Mexico over a period of years can be quickly gathered together if all are tagged "New Mexico", even if they are kept in separate folders.

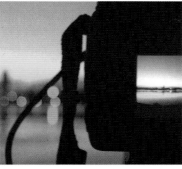

5 BUYING GUIDE

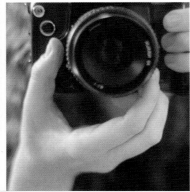

COMPACTS

Palm-sized and as easy to use as to carry around, compact point-and-shoot cameras did more than take photography to the masses – they took photography into every corner of modern life. From the most private and prosaic tasks, such as brushing your teeth or cooking last night's meal, to the most important occasions, from births to weddings, anything and everything was caught on camera.

Point and shoot cameras

Compact point-and-shoot cameras are so ubiquitous and widely used that it is easy to take them for granted. With more computing power and high-grade optics in each camera than took man to the moon, they are capable of amazingly good results in a wide range of conditions. And no longer are the colour choices black or silver: many models offer body colours ranging from pink to purple through yellows and blues.

■ Ensure the camera is not too small: you should be able to use the controls while holding it.

■ Compacts are high-precision optical instruments: they will not survive for long in the bottom of a handbag, and will need to be looked after.

Enthusiast or advanced compacts

When images from camera phones can make it on to newspaper front pages and be seen all round the world, keen photographers should not dismiss simple point-and-shoot cameras too quickly. But if

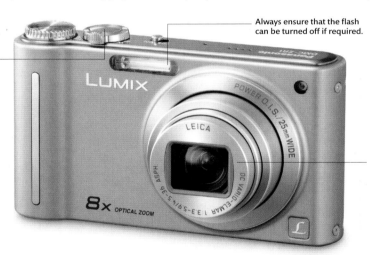

The shutter release is always sited for the right forefinger.

Always ensure that the flash can be turned off if required.

▶ **Autofocus compact**
These small cameras offer a winning combination of high performance in a stylish and compact design.

A high-quality 8x zoom makes for a versatile camera.

▲ **Stylish compact**
Sleek and beautifully made and finished, today's compact cameras can be very stylish yet still give excellent results. Extensive use of touch-screen controls eliminates virtually all buttons, and compact dimensions make for easy portability.

▲ **Entry-level compacts**
Basic cameras are very easy to use and can produce very good results despite their low cost. Although perfect as a back-up camera, they may not be ideal for a beginner as their basic controls limit experimentation.

▲ **Rugged camera**
A compact camera can be made very rugged by the addition of rubber bumpers all round, sealing against dust and water to allow underwater operation, and with over-sized controls to allow for use with gloves in cold weather conditions.

you enjoy cameras with many features, such as fully manual controls plus a choice of capturing in raw or JPEG, then enthusiast compacts will fit the bill. Some models offer zooms that are wider than usual (for example, 24 mm or 25 mm), some offer fast lenses with maximum apertures of f/2 or better and, as a class, every aspect of handling and image quality can be expected to be superior to that of less costly point-and-shoot models.

■ If you wish to shoot raw format images, check how quickly the camera works with the resulting large files.

■ If your camera is a back-up to a larger model, ensure that you can share the same type of memory cards and cables.

■ Check the availability of a hot-shoe if you may wish to use an accessory flash-gun.

Super-zoom cameras

Advances in lens technology have enabled extremely long-range zooms to be squeezed into very compact housings. Ranges of 16x are not uncommon: the wide-angle end is as short as 24 mm (more usually 28 mm or 35 mm), while the long end of the range reaches 350 mm or more. This means that you can expect a lion's head to fill the frame at usual safari-viewing distances.

To ensure that you can obtain sharp images at the longest zoom settings, built-in image stabilization is a must. Maximum apertures at the long end may be limited to as small as f/8; this is a severe limitation on working in low light or if you wish to obtain short depth-of-field effects. These cameras are ideal for travel and holiday photography as they are very compact yet highly versatile.

■ Check the sturdiness of the lens housing at full extension: it will be a little loose, but should not bend visibly.

■ Limit use of the zoom in very dusty conditions to avoid sucking up dust into the mechanism.

RESOLUTION AND QUALITY

The word "resolution" is used in several different senses in photography. Applied to camera sensors, it measures the number of photo-sites used to capture the image. The resolution of the image itself is often equated with image size, or its number of pixels. In the context of lens performance or image quality, it is a measure of how well a system separates out fine detail.

These measures are related, but not directly. For example, the resolution of a sensor sets the upper limit of image quality, but not the lower limit: a high-resolution sensor may deliver a poor-resolution image if the quality of capture, lens, or image-processing is poor.

▲ **GPS enabled**
Even small cameras can be equipped with a GPS (Global Positioning System) to tag coordinates to images. This makes an ideal partner for waterproof, dust-proof, and very rugged cameras that can be taken anywhere on your travels.

▲ **Enthusiast zoom**
Even in a compact body, modern cameras can offer extensive zoom ranges of 14x or greater. However, maximum aperture at the telephoto end may be limited to f/8 or less, which restricts photography in low-light conditions.

▲ **Super zoom**
By compromising on a slightly larger camera, the lens can be of larger aperture and focal range. Modern super-zooms offer very wide-angle performance, for example from 24 mm to 350 mm extreme telephoto with full camera controls.

COMPACTS CONTINUED

Advanced compact cameras are now very diverse, ranging from the hybrid "bridge" camera with an SLR body and fixed zoom lens to complete interchangeable systems based on various sizes of sensor. Imaging qualities are reliably high, while prices range from the affordable to the stratospheric.

All-in-one hybrid

The "bridge" category occupies the space between compact cameras and SLR cameras: stuffed full of functions, they present extreme versatility.

Zoom ranges of 35x or more, that once would have been considered science fiction, are no longer uncommon. This type of camera lets you view with either the electronic viewfinder (EVF) under an eyepiece or the usual monitor screen at the back of the camera.

■ Check the zoom action: ensure it is smooth and rapid and that you can easily set small changes: some models jerk from one setting to another and it is very difficult to make in-between settings.
■ Check the quality of the EVF image: early models

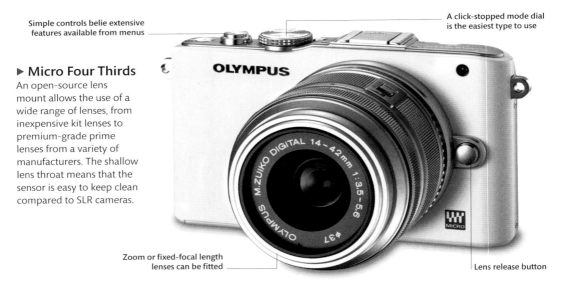

Simple controls belie extensive features available from menus

A click-stopped mode dial is the easiest type to use

▶ **Micro Four Thirds**
An open-source lens mount allows the use of a wide range of lenses, from inexpensive kit lenses to premium-grade prime lenses from a variety of manufacturers. The shallow lens throat means that the sensor is easy to keep clean compared to SLR cameras.

Zoom or fixed-focal length lenses can be fitted

Lens release button

▲ **Super zoom**
Several relatively compact cameras pack very considerable zoom ratios – of 35x or greater – covering focal lengths from 24 mm to an amazing 840 mm. They are excellent for travel and holiday photography.

▲ **High-specification**
By opting for a larger, heavier body, you can obtain a sturdier and more fully specified camera than is possible with a compact model. Expect higher resolution, better low-light performance, and better reliability.

▲ **Prime-lens compact**
For the enthusiast or purist who does not need a zoom lens, a compact such as this model, with a fixed zoom (28 mm or 35 mm equivalent), may be a good option. It is easy to operate and emphasizes quality of image capture.

gave a low-quality representation of the scene.
■ Check the quality of the image stabilization: at very long focal lengths effective stabilization is vital for obtaining sharp images.

Compact interchangeable lens

As sensors improved in quality, the search began for camera designs that could combine the image quality and versatility of single-lens reflex (SLR) cameras with the compactness and portability of point-and-shoot models.

The Four Thirds (4/3) format is an open standard for single-lens reflex cameras – they have a mirror box and reflex optical viewfinder behind a standard lens mount. The sensor has an imaging area of 17.3 mm x 13.0 mm (21.63 mm diagonal) with an aspect ratio of 4:3. This results in a focal length factor of 2x – for example, a 25 mm lens on 4/3 format is equivalent to a 50 mm lens on full-frame (*see p. 340*).

The Leica M digital camera is a special case of a relatively compact interchangeable lens camera using a full-sized sensor of 24 x 36 mm using manual focused, mostly fixed focal length lenses.

Micro Four Thirds

Although Four Thirds format cameras and lenses are much more compact and lightweight than their full-frame equivalents, they were not small enough or light enough for some. This led to the creation of the Micro Four Thirds format, which disposes with the mirror-box and reflex viewfinder. This results in much more compact camera bodies and somewhat smaller lenses.

As the space between the lens mount and sensor is less than 20 mm – much narrower than other SLR cameras – it is possible to use many other lenses with adapters that fill the space to the correct distance. This enables you to use your current lenses with Micro Four Thirds.

APS-C-derived

In recognition of the merits of the Micro Four Thirds, but in competition to it, Samsung developed its own mirrorless system, called NX. Soon after, Sony announced the E-mount for what they confusingly called the NEX system. Both trump the Four Thirds standard by using a larger sensor that 23.4 x 15.6 mm (APS-C) in size.

In view of the fact that Micro Four Thirds already offers high image quality that is more than sufficient for most needs, the best basis for choosing between the various models is what you like best and find easiest to use, and with the lenses you need, all at a price point that is affordable.

▲ Full-format interchangeable
For the enthusiast or purist with a large budget, the Leica system offers the most compact full-format sensor camera. It accepts very-high-quality interchangeable lenses and operates discreetly with low noise.

▲ Compact CIL
Interchangeable lens cameras do not have to be bulky. Some are almost as small as compact point-and-shoot models but offer a full range of camera functions as well as the advantages of a free choice of lenses.

▲ Advanced CIL
Compact designs utilizing large APS-C sensors coupled with interchangeable lenses offer a winning combination of high image quality with all the photographic controls that any enthusiast could ask for.

CHOOSING LENSES

Modern camera lenses benefit from the adoption and merging of several technologies to deliver high performance with good quality in compact form and at low prices. Nonetheless, it remains as true now as ever that larger lenses with heavier construction, modest specifications, and built from costlier materials will perform better and more reliably than small, lightweight lenses or those with ambitious specifications. The most popular type of lenses are made to zoom – that is, to be able to vary their focal

length (*see opposite*) while remaining focused on the image. Lenses are also designed with fixed focal length (prime lenses), wide aperture, extreme focal length, or with an emphasis on specialist use.

Fixed lenses

Compact cameras and many EVF (electronic view-finder) cameras use a permanently mounted lens. This arrangement saves weight, allows a compact design, and virtually eliminates problems from dust

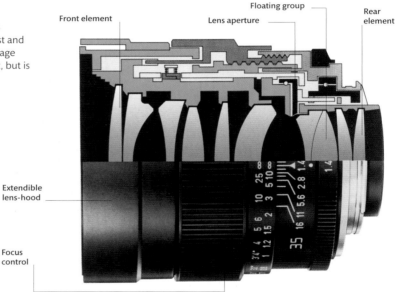

▶ **35 mm lens**
This lens is very fast and offers top-class image quality in low light, but is large and heavy.

Front element

Floating group

Lens aperture

Rear element

Extendible lens-hood

Focus control

▲ **Ultra-fast telephoto**
Fixed focal length lenses, such as this 85 mm optic offering an ultra-fast f/1.4 full aperture, can produce fine effects with superb quality but at premium costs.

▲ **Ultra wide-angle**
An ultra wide-angle lens for APS-sized sensors must offer very short focal lengths, such as this 10–20 mm optic, but can be surprisingly bulky due to complicated construction.

▲ **Standard lens**
A growing appreciation of the value of fixed focal length lenses has given rise to exquisitely compact, high-quality lenses for compact interchangeable lens camera systems.

on the sensor. While it is tempting to opt for a fixed lens with a very large zoom range, such as 26–520 mm, bear in mind that more modest ratios are likely to give higher overall image quality, with less vignetting at long focal lengths (*see p. 45*) and less distortion at wide-angle settings.

Lens specifications

The main specification for a camera lens is its focal length, or range of focal lengths if a zoom. Focal length measures the distance between the point from which the image is projected by the lens

to the sharp image at the sensor, where the subject is very far away (at infinity). In practice, we use it to indicate the magnification and field of view of the lens: longer focal length lenses magnify a small portion of the view, whereas shorter focal lengths reduce a larger portion of the view.

Zoom lenses shift elements within the optics to change the focal length without changing the focus setting. From this we obtain the zoom range, or ratio, measuring the longest to shortest focal length, or vice versa. For example, a 70–210 mm lens offers a zoom ratio of 1:3.

EQUIVALENT FOCAL LENGTH

The focal length of a photographic optic tells you if a lens is wide-angle, normal, or telephoto. A "normal" lens is one in which focal length is about equal to the length of the diagonal of the format. With the 24 x 36 mm format, the diagonal is about 43 mm, which is usually rounded up to 50 mm. Because the sizes of sensors, and therefore format, of digital cameras vary so greatly, the accepted approach is to quote the equivalent focal length for the 35 mm format (35efl). For example, on one camera the 35efl of a 5.1 mm lens is 28 mm, but it may be 35 mm on another. The equivalence is only an approximation, because the proportions of picture rectangles also vary.

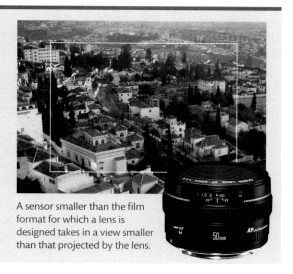

A sensor smaller than the film format for which a lens is designed takes in a view smaller than that projected by the lens.

▲ **High-quality standard zoom**
For a standard lens – such as this zoom covering the 35 mm equivalent of 24–120 mm – you should buy the best quality you can afford, because you will use it extensively.

▲ **High-ratio zoom**
A zoom lens that offers high ratios between wide and telephoto settings, such as the 15x of this model, is a tempting option, but performance may be compromised for convenience.

▲ **Telephoto zoom**
A zoom limited to the telephoto range, such as this 70–300 mm model, can produce results almost equal to those of fixed focal length lenses but with greater versatility.

CHOOSING LENSES CONTINUED

The other key measure is the maximum aperture. Lenses with a large maximum aperture – such as f/1.4 – are said to be fast. They collect more light than lenses with a small maximum aperture – for example, f/4 – allowing for shorter exposure times.

Comparing focal lengths

As a result of the earlier dominance of the 35 mm format, the focal length of a lens is usually related to that of the equivalent 35 mm format lens. For example, the 35 mm equivalent of a 10–22 mm lens for APS format is 15–33 mm. Note that the maximum aperture of the lens does not change; only the field of view changes. Therefore, a 135 mm f/1.8 lens for 35 mm is effectively a 200 mm f/1.8 lens for APS-format sensors. (*See also the box on p. 343.*)

Match to format

The growth of SLR cameras using APS-sized sensors (around 24 x 16 mm) has resulted in the development of two lines of interchangeable lenses. Generally, full-format (also called full-frame) lenses – that is, those designed for the 35 mm format – can be used on APS-sensor cameras, but not vice versa. Some full-frame cameras automatically match the active sensor to the type of lens in use. The Four

POINTS TO CONSIDER

- Use a lens-hood: stray non-image-forming light within the many internal lens elements can seriously degrade otherwise excellent image quality.
- Avoid using the maximum aperture or the minimum aperture. With most zoom lenses, at least one stop less than maximum is required to obtain the best image quality.
- Adjust focal length first and focus on the subject just before releasing the shutter. Avoid altering focal length after you have focused as this can cause slight focusing errors to occur.
- When using a wide-ranging zoom remember that a shutter setting that will ensure sharp results at the wide-angle setting may not be sufficiently short for the telephoto end of the range.

WHAT IS LENS APERTURE?

The terms lens aperture, f/number, and f/stop all mean roughly the same thing: they measure the size of the aperture sending light to the film or sensor. The actual size of the aperture depends on a control called a diaphragm – a circle of blades that open up to make a large hole (letting in lots of light) or overlap each other to reduce the aperture and restrict (stop down) the amount of incoming light. The maximum aperture is the setting of the diaphragm that lets in the most light. Lens aperture is measured as an f/number and is a ratio to the focal length of the lens. For example, with a lens of 50 mm focal length, an aperture of 25 mm gives f/2 and an aperture of 3.125 mm gives f/16.

▲ Macro lens
Invaluable not only for close-up work and copying flat originals, macro lenses offer the very best image quality, with high resolution, excellent contrast, and freedom from distortion.

▲ Fish-eye lens
An ultra wide-angle lens that distorts any line not running through the centre of the lens, the fish-eye is excellent for special effects. The most useful type fills the frame with the image.

▲ Converter lens
The focal length range of permanently attached lenses can be increased by using a coverter lens. The telephoto increases, and the wide type decreases, the basic focal length settings.

Thirds format is a third line of interchangeable lenses, and it uses its own unique mount.

Lens accessories

The zoom ranges of permanently attached lenses may be extended by using supplementary lenses. Those marked, for example, 1.7x will increase the zoom-set focal length by 1.7x to improve telephoto reach. Those marked 0.6x will decrease it by 0.6x, with the effect of increasing wide-angle views.

Interchangeable lenses accept accessories such as filters that mount on the front of the lens, as well as accessories that mount between camera and lens. Converters, also called extenders, are rear-mounted accessories that multiply the focal length of a lens. A 2x extender doubles the focal length of the lens – from 135 mm to 270 mm, for example, or giving a 100–300 mm zoom a 200–600 mm capability. But light transmission is also reduced: a 2x extender causes a 2-stop loss in aperture. Extension rings are just like converters but without a lens: they increase the focusing extension of the lens so that it can focus on very close subjects.

Specialist lenses

Lenses can be designed for specialist photographic tasks such as close-up dental photography, architectural or photogrammetric (measuring) work.

Lenses offering shift and tilt movements are very useful tools. Shifting allows you to reduce or increase, say, foreground coverage without moving the camera. Tilting the lens allows you to position the plane of best focus, to give very deep or shallow depth of field, without adjusting the aperture – ideal for architectural and landscape work, and invaluable for still-lifes and portraiture.

The most popular specialist lens is the macro lens, designed for high-performance close-ups. A 50 mm macro lens is good for copying work; the 100 mm focal length is useful for general macro photography. A long telephoto lens is essential for photographing wildlife from a distance.

HIGH IQ

The three main ways to ensure high image quality from your lens is steadiness during exposure, accurate focus, and use of the optimum lens aperture. Focus manually with SLRs, guided by the focusing screen. Manual fine-tuning as a supplement to auto-focus gives good results. All but the best lenses perform only adequately at full aperture and provide sharpest results two to four aperture stops smaller. For example, if the full aperture is f/4, best results are found between f/8 and f/11. With smaller apertures, quality falls. Shooting the same target at different apertures will soon show you the best apertures to use.

▲ Moving views

With the camera held level, the use of lenses with tilt or shift or swivel joints allows you to move the lens assembly to point at and focus on different parts of the image.

▶ Adjustable lens

The Lensbaby mounts a lens on a swivel joint allowing you to point the lens freely to produce tilt and unusual blur effects with a wide range of lens mounts.

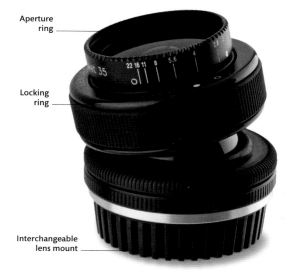

Aperture ring

Locking ring

Interchangeable lens mount

PHOTOGRAPHIC ACCESSORIES

Carefully chosen accessories can make a big difference to the quality and enjoyment of your photography. It is very tempting to load up with numerous accessories, but too many items can slow you down more than they aid you.

Tripods

Tripods can make the biggest single contribution to improving the technical quality of your photography. The best are heavy, large, and rigid, while small, lightweight ones can be next to useless. As a rough guide, a tripod should weigh twice as much as the heaviest item you put on it.

Carbon-fibre tripods offer the best balance between weight and rigidity, while aluminium alloy models are heavier but less expensive. Models that telescope with four or more sections are very compact when folded but less rigid when extended compared to those with fewer sections. Collars that twist to lock a section are compact, and do not snag on clothes, but slower to use than lever locks.

Very small table-top tripods are handy for steadying the camera on flat surfaces. Where space is limited, and you need to be able to move easily, the monopod is a popular compromise: the single leg helps steady the camera, reducing movement in two axes, and it also helps take the weight of th equipment. Shoulder stocks, which enable you to brace the camera against your shoulder, can help reduce camera shake and work well in combination with a monopod.

Tripod head

The choice of tripod head is as important as the choice of tripod itself. Choose one that is quick and easy to use but that holds the camera firmly.

Ball-and-socket heads are quick to adjust with smaller cameras and lenses as you have to control just one locking knob. The most convenient also feature a panning lock, allowing you to turn the head about the vertical axis.

3-D heads are easy to adjust with fair precision, but are slower to operate than ball-and-socket heads, as you have three separate movements to control and lock down. However, the handles improve leverage on the head when equipment is

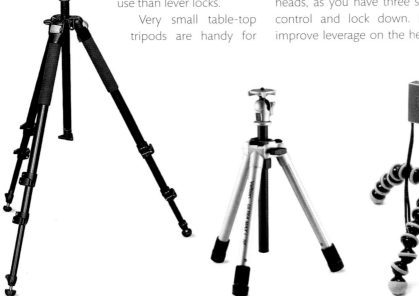

▲ **Telescopic Tripod**
A bulky and heavy tripod is the best way to ensure that images are free from camera shake. Carbon-fibre models are expensive but lighter than metal types.

▲ **Travel Tripod**
A lightweight, compact tripod is useful for lighter equipment and to supplement supports such as table tops. Press the camera down on the tripod to improve stability.

▲ **Gorillapod**
Unconventional supports, such as this design with flexible legs or those using clamps, are handy for compact cameras and quick set-ups that do not call for long exposures.

larger or heavier. The slowest heads to operate are those driven by gears, but the reward is very precise adjustment. However these work best with the camera in landscape or horizontal orientation as tilting the camera to one side unbalances the whole. For extremely heavy lenses, use centre-of-gravity pivots or gimbal heads such as the Wimberley head. The camera and lens assembly is balanced so that only finger-tip pressure is needed to adjust the aim and tilt of the camera.

Quick-change

Attach the camera to the head with a quick-release mount: this is a plate locked to the camera that "mates" with a trap on the tripod. Ensure that the plate is large enough for your largest equipment and does not rotate too easily. This results in swift interchange of cameras or disassembly. While adding the plate adds a little to the weight and bulk of the camera, it can help improve hold on the camera and also protects the base.

LENS FILTERS

Filters that attach to the front of lenses are not obsolete in the era of image manipulation. At their simplest, a plain or UV filter protects the vulnerable front element from dust and scratches. Plastic moulded filters with prismatic or diffraction lines can give special effects that are very hard to recreate in post-processing. Graduated filters – with denser colour at the top fading to clear at the bottom – help to capture landscape images that reduce the need for highlight/shadow or tone-mapping manipulations. Polarizing filters can reduce

reflections and intensify sky colours. When you need to reduce the light entering the lens to work at full aperture, you can use a neutral density filter.

▲ Ball-and-socket head
Lightweight versions are ideal for travel where long exposures are not needed. For more serious work and heavier equipment, use heavy-weight models that work very smoothly.

▲ 3-D head
Excellent for the flexible control of a heavy camera and lens combination, a 3-D head is easy to control and easiest to use with a quick-release plate. Some models are equipped with levels.

▲ Gimbal head
An off-axis head balances extreme telephoto lenses and large cameras, making it effortless to line up shots. But the units themselves are large, heavy, and almost as expensive as a tripod.

PHOTOGRAPHIC ACCESSORIES CONTINUED

Exposure control

Image previewing on digital cameras has not made separate light-meters obsolete. The best practice is to make exposures as accurately as possible, which reduces the time needed to make post-processing corrections. Handheld meters are also the best way to make incident-light readings – that is, readings of the light falling on the subject. Some hand-held meters also offer far greater accuracy, especially in low-light conditions. And spot meters, which read reflected light from a very narrow field of view – commonly 1° or less – offer unsurpassed accuracy in tricky lighting.

Flash meters enable speedy work in the studio, without the need to refer to previews again and again. Most modern hand-held meters can measure flash exposures as well as ambient light and, indeed, indicate the balance between the two. A flash meter is an essential accessory for serious still-life and portrait work.

Another aspect of exposure control is the use of standard targets such as grey cards, standard colour targets, and other aids. By including these in a test shot under the same lighting as the subject, you create an invaluable reference of guaranteed neutral tones and colours which improve the accuracy of any post-processing.

TIMER REMOTE RELEASE

The mechanical cable release to trip the shutter without disturbing the camera has been replaced by the electronic switch. These range from models that simply trip the shutter to those that can open the shutter for a pre-set time, which is useful for making accurately timed exposures. More sophisiticated models also work as intervalometers: you set a time interval, for example 5 seconds, and the timer makes repeated exposures every 5 seconds. This can turn a stills camera into a video camera, making time-lapse movies: 200 exposures made 5 seconds apart turns 1000 seconds of real-life into about 8 seconds of movie.

Timer and remote release with a connector dedicated to a camera model

▲ Simple meter

A simple exposure meter is excellent for checking your camera's performance and in teaching you to judge lighting by eye.

▲ Neutral target

This ingenious target, from Datacolor, combines specular highlight (top) and deep shadow (bottom) with five neutral grey tones.

▲ Advanced exposure meter

Professional exposure meters can measure flash as well as ambient light, and some models also function as a spot-meter.

Bags

Modern, padded soft bags combine high levels of protection with lightweight construction. Bags hung over the shoulder are easiest to access but can be tiring to carry for long distances. Shoulder bags tend to be the lightest designs, so may be best for use as cabin luggage.

Back-pack styles are easy to carry for long distances, and comfortable even with quite heavy and awkward loads such as a tripod. However they tend to be slower to use as you have to take them off your back before getting into them.

A working compromise is to use a shoulder bag with a waist-strap that is tightly strapped to your body. This displaces some mass onto the hips and relieves your shoulders.

For work in highly challenging conditions, or if you fear your precious lenses and laptop might have to travel in cargo holds or be slung into the backs of trucks, a hard case with a waterproof and dustproof seal is essential. However, even when empty they are heavy, so expect to have to pay excess-baggage charges.

Waterproofing

A waterproof camera housing is not only needed if total immersion is likely, but also in situations such as shooting from a canoe or when sailing. Camera housings are also ideal for particularly dusty conditions, such as industrial sites and deserts. Housings vary from flexible plastic cases for shallow water, to sturdy cases for deep water. They are available for compact cameras through to professional models, but they may cost at least as much as the camera they are made to protect. The key to their maintenance and longevity is to keep the O-ring seals meticulously clean and lubricated with silicone grease.

CAMERA RAINCOAT

For sports and nature photographers, the invention of camera raincoats has been a boon. There are generic models and those made for specific cameras, and they usually come in plain grey or in camouflage patterns.

▲ **Camera bag**
Back-pack designs are best for comfort and carrying awkward loads, but are slower to use than shoulder-hung models.

▲ **Equipment case**
Rigid cases can be waterproof and provide sturdy protection for rough conditions. Rolling models equipped with wheels are easiest to transport.

▲ **Waterproof housing**
Inexpensive plastic housings protect your digital camera in adverse conditions involving dust and water, but allow access to all functions.

DIGITAL ACCESSORIES

The modern digital camera has to work with a retinue of digital accessories to ensure that it is powered and has the capacity to record images.

Memory cards

Memory cards use banks of memory registers that hold their state – on or off – without needing power. They can hold data indefinitely yet can easily write new or altered data. Their compact size, low power requirements, and large capacity make them ideal for image data. When an image is written to them, the registers are flipped on or off according to the data. To read the memory, the registers are turned into a stream of data. Modern cards can hold more than 100 GB of information and read or write 300x faster than a standard CD.

There are many card types in circulation: some are extra-compact for use in mobile phones, others are optimized for speed or sturdiness. If you own

CARD CARE

- Keep memory cards well away from magnetic fields, such as in audio speakers.
- Keep cards dry.
- Keep cards away from extreme heat.
- Keep cards dust-free.
- Keep cards in protective cases when not in use.
- Do not bend or flex cards.
- Avoid touching the contacts with your fingers.

MEMORY CARD READERS

There are two ways of transferring images taken on your digital camera to your computer. You can connect the camera to your computer and instruct the camera's software to download images, or you can take the memory card out of the camera and read it to the computer. To do this, you need a memory card reader, a device with circuitry to take the data and send it to the computer, via a USB or FireWire cable. There are many card readers on the market that can read almost every type of memory card.

Multitype card reader

▶ Using a reader
When slotted in, the reader opens the card as a volume or disk. You can then copy images straight into the computer.

CompactFlash card reader

▲ CompactFlash
Very widely used in dSLR cameras and others, this is a sturdy card in a range of capacities, up to at least 100 GB, and read/write speeds to suit different budgets and camera requirements.

▲ Secure Digital
Very widely used in compact and dSLR cameras, SD (and SDHC) cards are very small yet offer capacities of 64 GB and over with low draw on current. They are also sturdy and reliable.

▲ Micro SD
These cards are widely used in mobile-phone cameras but their small size restricts capacities from reaching over 64 GB. Via an adaptor, they can also be used in devices that take the larger Mini SD and SD cards.

▲ MemoryStick
Proprietary to Sony, this family of cards is used in a variety of digital equipment, including Sony video cameras, allowing interchange with good capacities and performance.

Video viewfinder

Video viewfinders use a tiny camera to capture the image of the focusing screen to display on a larger, outside screen. They can also be used for automatic remote release: the system trips the shutter when it detects movement in the image.

more than one camera or want to use another device, try to ensure intercompatibility.

CompactFlash and SD

The most widely used memory cards for digital photography are the CompactFlash (CF) and Secure Digital (SD) cards. SD cards are more compact and less prone to failure as the pins are flat and less numerous than those in CF cards. You can remove the card from the camera at any stage before it is full and slot it into a reader to transfer files to a computer, but do not remove it while the camera is trying to read the card, usually indicated by a red light blinking. You can also erase images at any time to make room for more.

Digital image storage

When travelling with a digital camera it is often impractical, and always inconvenient, to carry a laptop computer for storing image files. One option is what is essentially a portable hard-disk equipped with an LCD screen and card-reading slots. The screen may be colour for reviewing images on the device, or it may simply show the copying status and basic file data. Some of these units can hold several terabytes (TB) of data and are equipped with slots for reading memory card devices. Data can be copied straight from the card devices onto the drive, then the drive can be connected to your computer to transfer your images once you are back at home.

Viewing images

It is as important to view and show images as it is to capture them. You can use tablets, such as the iPad, and photo frames to display your images, and use simple transitions such as fading between images and even add a suitable sound-track.

▲ **Mobile storage**
Freeing you from taking a computer outdoors, these small hard-disk drives allow you to back up photos and so continue using your memory cards. They also allow you to review and show images as you shoot.

▲ **USB drive**
As small as a key ring, a USB drive is a most convenient way to transfer quantities of files from one machine to another. USB drives are solid-state memory devices with storage capacities of 64 GB and more.

▲ **Photo frame**
These devices display a single image or a slide show of images downloaded from a memory card or picture store. They are useful for personal use, such as in living rooms, or for shop displays and gallery exhibitions.

ELECTRONIC LIGHTING

The invention of portable flash had a tremendous impact on photography: it opened the night world to the camera, with compact, easily carried equipment. Today, electronic flash is standard to all compact digital cameras, found on many mobile phone cameras, and fitted to the majority of dSLRs. However, the position of the fitted flash is just about the worse possible, in terms of the quality of lighting. Accessory lighting units are a necessity for versatile and attractive lighting.

Power and recycling

A further problem is that flash built into a camera relies on the camera's own batteries for power. To curb their hunger for energy, built-in flashes are designed to be low-powered – usually sufficient to light to a distance of 1–2 m (3–7 ft) but little further. In addition, the recycling rates – how quickly the flash can be fired in sequence – is also limited.

Flash power

Portable, or accessory, flash units overcome the limitations of built-in flash by carrying their own power and circuitry; this makes the units much larger than compact cameras. Accessory flash units

also offer more control over flash power, direction of flash, and angle of coverage.

Accessory flashes fit onto the hot shoe, which combines electrical contacts with a slot that "mates" with a corresponding, locking part on the bottom of the flash unit. While the majority of cameras use a standard hot-shoe design, the contacts may be specific to the camera producer, and some manufacturers – such as Sony – use proprietary hot-shoe designs.

Adjustable angle

Many portable flash units place the flash on a swivelling turret so that it can be directed to the sides, or even backwards, according to the nearest surface for bounce flash (*see pp. 82–9*). Some offer a tilting head so that you can point the flash upwards, or downwards for close-up work. A fully adjustable head increases flexibility, so is a must for wedding and paparazzi photography.

Adjustable coverage

On many flash units you can also adjust the coverage, or the angle over which light is spread. This ensures that when you use a wide-angle lens or

▲ **Small supplementary flash**
Units like this can augment the power of built-in flash units. It is triggered by the camera's own flash, so it does not need a hot-shoe, and adds its output to that of the camera's unit. It is an inexpensive solution to lighting problems, but control is limited.

▲ **Slave flash unit**
Slave units can add to the power of built-in flash units. This unit synchs with the on-camera flash for the most accurate exposure, after which operation is fully automatic. Position it to one side of the camera to improve modelling effects.

▲ **Powerful on-camera flash**
Accessory flash mounted on a camera's hot shoe can be sufficiently powerful for all normal needs, offering a tilt-and-swivel head for bounce, multiple-exposure facilities, and focusing aids for working in complete darkness.

setting, the flash coverage is sufficient to light the angle of view: this causes a lowering in the maximum power of the flash. When you make a telephoto setting or use a long focal length lens, the coverage is narrowed to match, approximately, the angle of view. This causes a gain in the maximum power of the flash, since the light is concentrated into a narrower beam.

Adjustment may be carried out automatically, with the camera instructing the flash according to the zoom setting on the lens, or it can be manually set. Zoom-like optics in the flash tube alter coverage, and a diffuser may be used for ultra wide-angle coverage.

Red-eye

The unsightly red dot in the middle of eyes lit by flash – commonly known as red-eye – is caused by two factors: the flash being so close to the optical axis that the light reflects off the blood-rich retina of the eye, while, at the same time, the eye's pupil is dilated in dark conditions. Accessory flash mounted on the hot shoe or to one side moves the source of flash relatively far from the optical axis, with the result that red-eye is avoided.

GUIDE NUMBER

The light output of accessory flash units is usually measured by the Guide Number (GN). The figure is for a specific film/sensor speed – usually ISO 100 – in either metres (m) or feet (ft), and for a specified angle of coverage. The GN for a unit will be higher for narrow coverage – suitable for medium-telephoto lenses – and lower for wide coverage – suitable for wide-angle lenses. A Guide Number may be quoted as, for example, GN45 (m), indicating the distance scale is metres. A typical small camera GN is 5–10 (m); accessory flash units offer 30–50 (m). The standard practice is that that the GN figure is quoted for the coverage of a standard lens but may be inflated in specifications by being quoted for a narrow coverage. The Guide Number scale is defined:

Guide Number = subject distance x f/number

The f/number for a correct exposure is the result of dividing the GN of your unit by the distance between the flash/camera and the subject. Using GN to set an f/number is generally more accurate than relying on automatic systems.

▲ Macro ring-flash
For shadowless flash photography of insects, flowers, and other small objects, a ring-flash is ideal. The brief flash can stop inadvertent movement, and very small apertures can be set for maximum depth of field.

▲ Adjustable macro flash
For controlled lighting in macro work, units with two or more small flash units that can be set to different positions around the lens give the most flexibility. They can be set to different power levels and point in different directions.

▲ LED unit
Lightweight LED lights produce a daylight-balanced, continuous beam of light that is ideal for video recording. But it also provides a source of easy visible light that can be used off-camera and precisely positioned to control modelling.

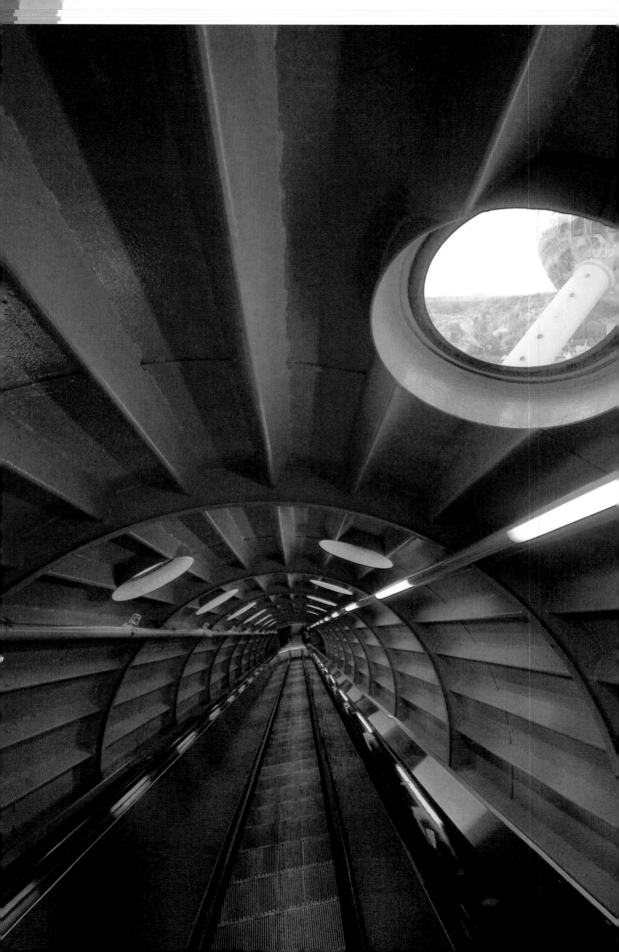

6 GOING FURTHER

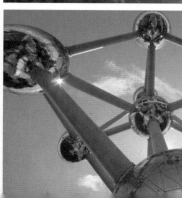

LEARNING MORE

With the vast quantity of information available it is relatively easy to find out all you need to know about the many aspects of digital photography. There are numerous sources of information on the web – although these vary in both quality and depth, the best-known sites have excellent, in-depth and up-to-date information on photography, image manipulation, and equipment. There are also videos and interactive courses on DVD that guide you step-by-step, and there are also numerous books, some of which you will find listed in Further Reading (*see pp. 398–9*). The best way to learn from these sources is usually to have a specific task to complete: having a clear direction in mind, rather than just picking up unrelated snippets of information, will greatly speed up your learning.

Another option to help you go further is to attend a training course. Many are available, but the most cost-effective are usually those offering intensive or residential tuition. These are often run as summer schools in which you immerse yourself in a completely "digital" environment. Such courses will enable you to concentrate on problem-solving, and being able to ask for help from experts at the immediate time that you need clarification can greatly accelerate the learning process. However, if you do not have the equipment to continue at the same level once you return home, you may quickly forget all you have learned. To make the most of immersion teaching, you need to continue using your newly acquired skills. To check if an intensive or residential course is suitable for you, ask these questions when you speak to the administrator or when you read through the prospectus.

- Do the fees include all materials, such as paper, ink, and removable media?
- Will there be printed information to take home and keep?
- Which software, and version, will be taught?
- Which computer platform will be used?
- Do students have individual computers to work on or will you have to share?
- What standard is expected at the start; what standard is to be attained by the end?
- What are the qualifications of the tutors?
- You will gain most from any course if you first thoroughly prepare yourself. Having a project or two in mind to work on prevents your mind going blank when you are asked what you would like to achieve. And take along some image files or a scrapbook of pictures to use or to scan in. The best way to learn how to use computer software is to have a real task to complete – this might be a poster for a community event you are involved in, making a greetings card, or producing a brochure for a company.

GETTING ON A COURSE

To help ensure that you get onto the course of your choice, consider the following points.

- **Plan ahead:** most courses recruit and interview only at certain times of the year.
- **Prepare a portfolio** (*see pp. 370–1*).
- **Read up:** if the course contains elements you are not familiar with, such as art history, media theory, and so on, check that you are interested in them before applying. Further, if you know what the course objectives are, you will then know that what you want to do is in line with what the institution wants to achieve. This is important for you – and it is likely to impress the interviewer.
- **Check on any formal requirements:** some colleges insist that you have certain minimum educational qualifications before you are considered. You may need to attend an access or refresher course before entering college.
- **Plan your finances:** attending a course affects your ability to earn and can itself be a financial drain. Calculate the course fees, then add the materials, equipment, and travel costs to your living expenses to work out how much you need to put aside.

Courses and qualifications

If you want more in-depth training and a broader educational approach to the subject of digital photography and image manipulation, then higher or further education courses at college or university are the best route. They are good for meeting other

like-minded individuals: over a period of a few years you can make lasting friends and valuable contacts, and a shared course of study also makes it far easier to share interests and solve problems. A longer period of study also gives you time to work out future plans and develop in-depth projects.

In some countries you may need a qualification in order to gain a licence to work professionally – in which case completing a formal course is a necessity. In the English-speaking world, qualifications are seldom a prerequisite for professional practice unless you wish, for example, to teach digital photography in college. Indeed, formal qualifications may even be discouraged in some sectors of practice. Don't be afraid to ask local professionals for their advice – most will recall their own initial struggles and will be prepared to help others.

If undertaking a college-based course is not possible, then you may want to consider some type of distance-learning or on-line study. In these, you communicate with your tutor by mail or email, working with printed materials or from a website. A distance-learning course enables you to be flexible about your rate of progress and when you work, and so is ideal for fitting into a busy schedule, but it can be a lonely process. You may have no contact with fellow students or teaching staff beyond brief summer seminars.

Multi-skilling

Digital photography is just one expression of an enormous growth in employment and career opportunities based on new technologies that has taken place over the last few years. One important feature of these recent developments is that the need to have multiple skills makes it relatively easy for, say, competent digital photographers to transfer to print publication, or for people talented in the field of, for example, page design, to transfer their skills to internet-based work.

Careers in digital photography

Working as a digital photographer is not solely about the glamorous areas of fashion, advertising, photojournalism, or celebrity portraiture. Many varied and satisfying ways of doing what you enjoy and earning a living are available.

Those, for example, who have some sort of specialist interest – say, archaeology, architecture, music, or natural history – may find work with institutions relevant to their interests, such as museums, heritage-preservation organizations, humane societies, and so on. In such an environment, a likely job description will require not only photographic skills but also an enthusiasm for and knowledge of the subject. Other career opportunities could take you in the direction of becoming an in-house photographer for specialist magazines – those covering an industry or particular sport, such as sailing, fishing, or biking. If you like working with animals, you might want to consider offering a photographic service to pet owners by taking their animals' portraits in an inventive and creative way (*see pp. 140–3*).

Those who enjoy photography may also find work in the background to other activities – for example, as technicians in laboratories, manufacturers, or universities. This type of work often has the advantage of letting you do the things you enjoy – perhaps scanning and then the digital manipulation of pictures – without the stresses associated with working as an independent professional photographer. At the same time, you may enjoy access to the type of equipment that only large organizations can afford – astronomical telescopes or electron microscopes, for example.

Another burgeoning area of photographic interest is in the field of scientific and medical imaging. This ranges from remote satellite sensing to unravelling the secrets of the atom. The work is highly technical but could perfectly suit those with physics or medical degrees who have an interest in both digital photography and aspects of computer technology.

Those with the requisite depth of knowledge and industry experience can also find a welcome in teaching and training institutions: it is widely recognized in many countries that high-technology industries and service providers are being held back by a skills shortage. If you are an experienced

LEARNING MORE CONTINUED

photographer or a designer who has developed a professional grasp of key applications – including Photoshop, Aperture, Lightroom, InDesign, web-authoring applications such as Flash and Dreamweaver, or vector-based graphics software such as Adobe Illustrator – then there are many opportunities for training the thousands of people who need to learn how to use these computer programs.

Finally, the digital photographer is but a step away from working with time-based media, such as animations and video. Indeed, Photoshop was originally invented to clean up images for the film industry, and today the distinction between software for stills images and software for moving images is becoming increasingly blurred, especially with the internet carrying more and more moving imagery.

Another dimension of time-based media is multimedia production, whether for computer games, websites, or educational presentations. All of these career applications have an enormous appetite for well-taken pictures that display a careful judgment of tonality and colour.

Careers advice

The key requirement for a career in digital photography today is versatility: having a wide range of skills covering diverse fields and the willingness to apply them to different and sometimes untried ends. You need to be competent in photography – to understand lighting, exposure, composition, and the nature of the recording medium. You need to be comfortable with computers and working with varying pieces of hardware to get the most out of them: the more extensive your technical experience, the easier it will be to solve production problems. And you need an understanding of how images work in contemporary society and the wider cultural context in which they operate. A base in visual and contemporary culture and an awareness of art history are great assets.

Needless to say, you have to be competent with software. This means more than being able to use standard software; rather, you have to be able to obtain the results you want effortlessly and rapidly so that your thinking and creative processes are not hampered by imperfect knowledge or lack of experience. All professional imaging artists use only a fraction of the capabilities of their software – just as photographers use a very limited range of equipment – but their command of what they use is so fluent that the software becomes almost an extension of their thinking. Much of today's professional work is the creation of a visual solution to a conceptual or communication problem, so it helps to understand how to translate abstract concepts into an attractive, eye-catching image.

And because operating professionally means working successfully in a commercial environment, you need some business sense, or at least access to good advice, as well as a desire to act professionally – to commit yourself to working to the highest standards, to work honestly, and to take your commitments, such as keeping to agreed deadlines, seriously.

Digital photographers may, therefore, have graphics, illustration, design, or photography backgrounds. While the list of competencies may seem demanding, the good news is that the need is growing much faster than the supply. Anybody who offers technical skills combined with artistry, creativity, and business acumen will be kept busy.

Turning professional

Having the right attitude and doing your homework are essential if you are thinking of turning professional. Here is a basic checklist of points to consider before taking the plunge.

■ Be positive, decide what you really want to do, and decide that you are going to do it.

■ Be prepared to start small, with work you may not want to do long-term, to gain experience, build confidence, and provide the capital reserves to take you in the direction you really want to go.

■ Check out the competition: if you want to be a portrait photographer, then you need to know if there are already two other portrait photographers in your immediate locality.

- Decide what to charge for particular types of work: it is embarrassing to be asked "How much will it cost?" when you cannot give a quick answer.
- Consider a loan to finance your start-up: this means preparing a business plan (see below).
- Check any legal and local regulations: do you need to register with an authority; are you allowed to carry on business on your property; do you have to insure against third-party claims?
- Check your supply lines: can you get materials quickly or hire equipment if you need something more specialized than you already own?
- Raise your profile: make sure local newspapers and magazines know you are in business.
- Prepare a portfolio (see pp. 370–1) – potential clients will want to see what you can do – and other advertising, such as a website or posters for your local library and meeting places.
- Consider joining a professional organization or Chamber of Commerce to network with others.

Preparing a business plan

A business plan makes you consider whether you have a viable prospect. It makes you think about what you want to do and if you have the means to do it, in terms of money and management skills. Just as important, a business plan demonstrates to your bank manager or accountant that you should be taken seriously. It is no exaggeration to say that merely possessing a well-presented, clearly argued business plan takes you half way to the finances your business might need.

The business plan is a report: it summarizes your aims and objectives while honestly presenting your strengths and weaknesses. It should assess the competition and market to arrive at an honest appraisal of your chances of success. The plan also presents a cashflow forecast of how your business will develop over the first two years or so.

A typical cashflow will show that in the early months more money will be spent than income is earned. As the business becomes established, income increases while overheads (rent, heating, utilities) remain steady: your business is starting to make money. But at predictable times during the year – when insurances need renewing, perhaps – there will be heavy costs, and these might coincide with times when business is slow. By working this out, you know when to expect a few tricky months and can warn the bank in advance. This confirms your financial competence and makes it easier to obtain short-term loans or an extended overdraft. The cashflow will also show when an injection of extra cash may be needed to take on more people or invest in new equipment.

All banks give advice or literature on writing a business plan and constructing cashflow forecasts. These may be alien concepts, but you should keep in mind that they are essentially works of fiction – they mix a good deal of fact with the potential and the probable. They should not, however, be works of fantasy, which combine the improbable with the potential. Finally, bear in mind that as your work develops it may move away from the projected business plan. But with it written, at least you know you are changing direction. A business plan is a map – drawn by you – by which you can plot your future.

KEEPING RECORDS

Good records are essential for a well-run business, minimizing the time involved in completing tax returns, dealing with the bank, or setting prices for particular types of work. Get into the habit of keeping all your receipts. Try to make a brief note of the phone calls you make and receive, and keep a book on the projects you work on. In addition, keep a note on everything you are paid. Good records keep you on the right side of the law and tax authorities. They also put you in a good position if you are ever involved in litigation – you can refer to your notes and give times and dates on what was discussed and agreed. Good records will also lower your accountancy costs. Accurate financial records enable you to regulate your cashflow and the resulting soundness of your money affairs will also lower bank and other finance charges.

BUILDING UP YOUR BUSINESS

Your aim as a photographer is to provide a service for potential clients: in short, people will offer you work if you give them what they want. To that end, you need to bring all your photographic skill, inventiveness, flexibility, and professionalism to bear on the task, as well as honesty and as much charm as you can muster under what will sometimes be very testing circumstances. The qualities that help you attract business in the first place are the same ones that help you retain and build up your client base.

Promotion and marketing

One of the keys to building a successful business is good communication. To start with, clients must be able to find you, and to find you they must first know about you. This is the task of promotion and marketing. Start small – perhaps by placing advertisements locally in community newspapers and magazines, cards or posters in shop windows or library noticeboards, even leafleting homes and businesses in your neighbourhood. Visit local businesses and leave contact details – preferably a promotional card featuring a picture of yours. If there is any interest, be prepared to show your portfolio (*see pp. 370–1*): pay particular attention to businesses that are likely to be visually more aware, such as architects, estate agents, interior designers, garden architects, and, of course, local publications. Remember, there is no shame in starting by visiting homes to take pictures of babies before making your move on the competitive world of celebrity portraits; hone your skills on interiors of homes for sale or flower arrangements before tackling a multinational's annual report. And, of course, the web is an increasingly important place for self-promotion, and a natural choice for the digital photographer. A web presence has to be supported by targeted marketing, however, such as mailings of your photographic calling card or sending out CDs of work.

Once you have made contact with potential clients, you then need to enter into discussions with them to help bring about a successful conclusion to the exercise.

WHAT IS A CONTRACT?

A contract creates legal relations between two parties in which one offers to carry out some work or service and the other party accepts an obligation or liability to pay for that work or service. The contract may not have to be a formal legal document: an exchange of letters, even a conversation, may be sufficient to form a contract and, with it, corresponding legal obligations (depending on local law: ask your lawyer if you are not sure). However, in general, both parties must want to enter into a relationship. This may carry with it conditions that both sides agree. In addition, a contract is generally legally binding only if it is possible to carry it out, is not illegal, and is not frustrated by circumstances beyond the control of either party. Many photographers do not realize that when they are commissioned to carry out work to an agreed specification, they are legally bound to do so: artistic licence and freedom of expression do not come into the debate. By the same token, if a client commissions a photographer to take ten portraits, to ask in addition for shots of the building is to vary the contract. It is reasonable for other terms, such as payment, to be renegotiated. An important issue is who retains copyright on a commission: in some countries, national law allows copyright to be assigned from the creator to the commissioner; but in other countries, copyright is held to be an inalienable right of the artist and cannot be assigned to anybody else.

Clarity

Be specific (not "as soon as possible", but "within five working days"); be precise (not "digital images", but "high-resolution 10 x 8 images at 300 dpi"); be straight (not "of course I can do it" when you don't really know, but "I'll shoot a free test and you can see how it works").

Honesty

Evaluate your skills objectively. Certainly you can take risks and push yourself, but don't let others down – in the end you only damage yourself. If you don't like something – perhaps an element of

the commission is dangerous or unethical – then say so (and the sooner the better).

Repetition

Summarize the conclusions after any discussion has taken place; summarize and agree the action points; repeat and agree the schedule with everybody concerned; and repeat and agree all task allocations and responsibilities.

Follow-up

Construct a paper trail with a written or emailed note after all meetings. Record phone conversations pertinent to a commission, particularly if detailed changes are being discussed. Keep records of what you do, why you're doing it, and how much it is costing you. If, right from the beginning, you make a habit of keeping good records, even with small jobs, you will be able to cope better with the larger ones.

Legality

Introduce into the discussion anything to do with copyright, licensing, or other legal aspects of the commission that may concern you as soon as they become relevant. Doing this will add to, rather than detract from, the air of professionalism you project. And more often than not, the client will be pleased to know about any possible legal complications at the earliest possible point.

Finances

Talk about money – fees, day rates, equipment hire charges, and any associated charges that will affect the final bill – early on. You will not seem greedy by doing this; you will look more professional. And if you don't think that the money is right, then tell your client. If the finances are going to be a sticking point, then the sooner you know about it the better.

Repeat business

Clients will appreciate any sign of your involvement in the project over and above that engendered by the fee. For example, suggesting new approaches to the task, offering additional shots that were not specified, or trying out different angles or a more interesting and creative approach all represent "value-plus" from a client's point of view while, in fact, costing you very little.

CALCULATING YOUR DAY RATE

The basic day rate is your benchmark for survival: it measures the average cashflow (*see p. 369*) you need to keep going. After all, the fees you charge must at least pay for your survival. If you hit the rate, you can survive, but your profits will be minimal.

The first step is to add up your living expenses, including your rent or mortgage, the cost of any loans or hire purchase, utilities and food bills, and business overheads, such as insurance, bank charges, loan charges, motoring and travel expenses, and so on. These are the expenses you must meet before you can move into profit. Don't forget to add depreciation of capital items, such as your camera equipment and car: you will need money to pay for their replacement.

The next step is less objective – you need to evaluate how many chargeable days you wish for and can reasonably expect to work in a year. Be realistic, so allow yourself vacations, days off for illness, and other days on which you may not be earning any money but you will still be working – going to meetings, for example, researching new projects, taking your portfolio around. A figure of around 100–150 non-chargeable days per annum is not an unreasonable figure.

Now, simply divide the figure for total costs by the number of chargeable days. Many photographers arrive at a figure much higher than they expected. To this, of course, must be added your profit element, without which a business cannot grow and improve. An alternative approach, having worked out how much you need a year, is to divide the figure by the day rate you think the local market will bear: that will tell you how many days you need to work.

COPYRIGHT CONCERNS

Copyright is a vital subject, as it regulates the intellectual content of digital media and all information. Different traditions of copyright law in different countries lead to variation not only in the detail but also in the entire approach to this subject, but the broad outlines are regulated by international treaty and, for the web, by usage. The following are some frequently asked questions and answers framed to have as wide an applicability as possible. However, always seek professional advice if you are not sure what your rights are or how you should proceed. You may not need to hire a lawyer, as many photographic organizations provide basic copyright advice. Other sources of help can be found on-line (*see pp. 392–4*).

Do I have to register in order to receive copyright protection?

No, you do not. Copyright in works of art – which includes writing, photographs, and digital images – arises as the work is created. In more than 140 countries in the world, no formal registration is needed to receive basic legal protection.

Can I protect copyright of my images once they are on the web?

Not directly. This is because you cannot control who has access to your website. Make sure you read the small print if you are using free web space. You may be asked to assign copyright to the web server or service provider. Do not proceed if you are not happy with this condition.

Do I have to declare copyright by stamping a print or signing a form?

In most countries, no. Copyright protection is not usually subject to any formality, such as registration, deposit, or notice. It helps, however, to assert your ownership of copyright clearly – at least placing "© YOUR NAME" – on the back of a print or discreetly within an image on the web, such as in a corner.

What is a "watermark"?

It is information, such as a copyright notice or your contact details, incorporated deep in the data of an image file. The "watermark" is usually visible but it may be designed to be invisible. In either case, watermarks are designed so that they cannot be removed without destroying the image itself.

Can I be prosecuted for any images I place on the web?

Yes, you can. If your pictures breach local laws – for example, those to do with decency, pornography, or the incitement of religious or racial hatred, or if they feature illegal organizations – and if you live within the jurisdiction of those laws, you may be liable to prosecution. Alternatively, your Internet Service Provider (ISP) may be ordered to remove them.

Is it wrong to scan images from books and magazines?

Technically, yes, you are in the wrong. Copying copyright material (images or text) by scanning from published sources does place you in breach of copyright law in most countries. However, in many

CAN I PREVENT MY IDEAS FROM BEING STOLEN?

There is no copyright protection covering ideas to do with picture essays, for example, or magazine features or books. The easiest way to protect your concept is by offering your ideas in strict confidence. That is, your ideas are given to publishers or editors only on the condition that they will not reveal your ideas to any third party without your authorization. Your idea must have the necessary quality of confidentiality – that is, you have not shared the information with more than a few confidants – and the idea is not something that is widely known. The most unambiguous approach to this issue is to require your publisher or the commissioning editor to sign a non-disclosure agreement – a written guarantee. However, this may be an unduly commercial-strength approach. You may preface your discussions with a "this is confidential" statement. If the person does not accept the burden of confidentiality, you should not proceed.

countries you are allowed certain exceptions – for example, if you do it for the purposes of study or research, for the purposes of criticism or review, or to provide copy for the visually impaired. Bear in mind, though, that these exceptions vary greatly from country to country.

If I sell a print, is the buyer allowed to reproduce the image?

No – you have sold only the physical item, which is the print itself. By selling a print, you grant no rights apart from the basic property right of ownership of the piece of paper – and an implied right to display it for the buyer's personal, private enjoyment. The buyer should not copy, alter, publish, exhibit, broadcast, or otherwise make use of that image without your permission.

What are "royalty-free" images?

These are images that you pay a fee to obtain in the first instance, but then you do not have to pay any extra if you use them – even for commercial purposes. With some companies, however, certain categories of commercial use, such as advertising or packaging, may attract further payments. Royalty-free images can be downloaded from websites and also come on CDs.

How is it possible for images to be issued completely free?

Free images found on the internet can be an inexpensive way for companies to attract you to visit their site. You can then download these images for your own use, but if you wish to make money from them, you are expected and trusted to make a payment. This fee is usually relatively small, however, so you are encouraged to behave honestly and not exploit the system.

Does somebody own the copyright of an image if that person pays for the film or the hire of the equipment?

In most countries, no. In some countries, if you are employed as a photographer then it is your employer who retains copyright in any material you produce; in others, however, it is the photographer who retains the copyright. In any circumstance, the basic position can be overridden by a local contract made between the photographer and the other party prior to the work being carried out.

What is the Creative Commons?

This is a type of licence designed to allow a flexible range of protections and freedoms for authors, artists, and educators to encourage wide use of intellectual property while discouraging abuse. Works can be used provided: the author is credited, the use is not for commercial purposes, and no derivative works are made. This allows a widespread sharing of creative and other works without loss to the copyright owners by those who otherwise would not be able to benefit from the works. It is in widespread use in the photo-sharing community. See creativecommons.org.

If I manipulate someone else's image, so that it is completely changed and is all my own work, do I then own the copyright in the new image?

No. You were infringing copyright in the first place by making the copy. And then, altering the image is a further breach of copyright. Besides, the new image is not fully all your work: arguably, it is derived from the copy. If you then claim authorship, you could be guilty of yet another breach – this time, of a moral right to ownership.

Is it okay to copy just a small part of an image – say, part of the sky area or some other minor detail?

The copyright laws in most countries allow for "incidental" or "accidental" copying. If you take an insignificant part of an image, perhaps nobody will object, but it is arguable that your action in choosing that particular part of an image renders it significant. If this is accepted, then it could be argued that you are in breach. If it makes no real difference where you obtain a bit of sky, then try to take it from a free source.

SHOPPING FOR EQUIPMENT

Purchasing all the equipment needed for digital photography can be either bewilderingly off-putting or delightful fun and full of new things to learn. There is undoubtedly a lot to consider, but if you are not lucky enough to have a knowledgeable friend to help, don't worry. A lot of information is available on the web – and all of it is free.

Where to look for help

The web is the prime resource for information about equipment, followed a long way second by printed magazines. Web sources fall into four broad categories: large retail stores such as B&H (bhphotovideo.com); review sites such as dpreview.com; general photographic websites or web versions of printed magazines, such as What Digital Camera; and manufacturer's websites.

Large retailers with a web presence are a good starting point for information on photographic equipment. Their websites may even be superior to the manufacturer's own sites for quality and ease of access to information, and you can easily compare specifications of different models. Of course, you can learn about prices, too.

Review sites are numerous. Some do little more than take the camera out of the box and describe it, while others perform exhaustive technical checks. The quality of information, and the depth of knowledge applied, is variable. It is unfortunate but inevitable that only the more glamorous models tend to be reviewed in depth. Obtain a consensus from as many sources as possible.

Other photography websites offer large amounts of information and are constantly updated; they may know more about new products than retailers do. Again, the quality is variable, since they may be written by people who are journalists first and photographers second. Also, magazines may come under pressure to say good things about a product, so you may have to read between the lines.

The manufacturers' websites can offer useful information and other resources such as tips on photographic technique or features on the technology of digital cameras.

Buying on-line

On-line purchases can be safe, efficient, and economical. The sensible precautions for on-line transactions apply equally for photography. Buy from sites that: guarantee secure transactions; you know about or have been recommended; offer guarantees that cover your purchase, particularly if you are buying abroad. Note that equipment purchased from a foreign website may have instructions in a language other than your own. If possible, use a credit card that protects against fraud. Always print and retain transaction details.

Beware of items that are much cheaper from one source than any others. The importer may not be officially recognized, the guarantee might not cover your region, or the language of the instructions – even on the camera itself – may be foreign to you.

Buying second-hand

The rise of digital photography has helped create a swollen market for second-hand film-based

HIRING EQUIPMENT

Do you ever need expensive equipment but cannot really afford it or would use it only occasionally? You may, for example, need a super-long telephoto lens for a safari trip, a data projector for a talk, a superior-quality scanner, or a replacement computer while yours is under repair. One answer is to hire items you need – you will save on the purchase price, pay only when the item is really needed, and the hire cost should be fully tax deductible if you are in business. Note the following points.

- Research possible equipment sources and set up account facilities. Some companies will send items if you live far from them if you are a known customer, while new customers may need to provide a full-value cash deposit.
- Contact the supplier to reserve the item as soon as you think you might need it.
- Try to pick up the item a day or two early so that you can familiarize yourself with it and fully test it.
- Ensure your insurance covers any hired items.

cameras; even professional-grade models can be bought at bargain prices. The rapid development of digital cameras has also created a burgeoning supply of keenly priced digital equipment. Make sure that digital cameras are sold complete with all original software, chargers, and cables, since some use non-standard items that could be difficult to source.

The world's largest market for second-hand or pre-used equipment is eBay, on-line at ebay.com. This site offers copious help for the uninitiated, but local retailers are likely to offer stocks of equipment that you can examine in person and return easily if found to be faulty.

Shopping for specific interests

Today's photographer is spoilt for choice, thanks to the numerous camera models with features for every occasion. However, it can take a good deal of research to find the right camera for you.

Challenging conditions: Cameras should be sealed against dust and rainfall, and have a rugged construction. Cameras with minimal moving parts are best, and avoid those with lenses that zoom forward on turning on.

Collections: Modern digital cameras offer excellent close-up qualities, but many distort the image. Choose an SLR with a macro lens, and avoid zoom lenses. For flat objects where precision is essential, such as coins or stamps, use a flat-bed scanner.

Nature: Electronic-viewfinder (EVF) or micro 4/3 digital cameras are good for nature photography: some offer focal lengths of 400 mm or more, allowing high-magnification images of distant animals. A tripod will be invaluable.

Low light: Fast lenses – that is, those with a large maximum aperture – are limited to costly prime optics for SLRs. A cheaper solution is to use the highest ISO setting available, and select cameras with image stabilization.

Portraiture: Use fast, high-quality lenses. If possible, use full-frame sensors, as digital cameras with small sensors suffer from excessively large depth of field.

Sports: Rapid response and long lenses are essential. Many EVF cameras give fair results in good lighting. If lighting is poor, you may need an

SHOPPING CHECKLIST

- Try to shop with somebody knowledgeable.
- Write down the details of your computer model, operating system, and the other equipment that needs to work with the item you need.
- If it is second-hand, check that the equipment appears to have been well treated.
- If it is second-hand, enquire about the history of the equipment – for what purpose was it used, and for how long?
- Check that there is a guarantee period and that it is long enough for any likely faults to appear.
- When buying computer peripherals, make sure they will work with your exact computer model and operating system. You may, nonetheless, still need to test equipment at home with your computer, so if any compatibility problems arise, make sure the store will provide you with free technical support. If these problems prove to be insurmountable, enquire about the store's policy regarding refunds.
- Ask about anything that may be causing you confusion. You will not look foolish – the only foolish thing is to pay for equipment that later proves useless.

SLR and fast, long focal length lenses with large maximum apertures, and a monopod or tripod.

Still-life and studio: Ensure your digital camera can synchronize with studio flash. Some cameras may be controlled from a computer, and some can even send pictures direct to the computer.

Travel: EVF cameras offer a winning combination of compact, lightweight bodies, with extensive versatility and freedom from dust. Cameras that use standard AA batteries free you from worries about power, but try to choose cameras with long-lived batteries. For wide-angle views, you may need supplementary lenses – awkward on location.

Underwater: Housings are available for several models – from entry-level to professional – allowing you to reach all controls. The least expensive are flexible plastic bags but access to controls is limited.

GLOSSARY

2D Two-dimensional, as in 2D graphics. Defining a plane or lying on one.

3D Three-dimensional, as in 3D graphics. Defining a solid or volume, or having the appearance of a solid or volume.

24x speed The device reads or writes data at 24x the basic rate for the device – for CDs and memory cards, 150 KB per second. DVDs read and write at a basic speed about 9x greater than CDs.

24-bit A measure of the size or resolution of data that a computer, program, or component works with. A colour depth of 24 bits produces millions of different colours.

35efl 35 mm equivalent focal length. A digital camera's lens focal length expressed as the equivalent focal length for the 35 mm film format.

36-bit A measure of the size or resolution of data that a computer, program, or component works with. In imaging, it equates to allocating 12 bits to each of the R, G, B (red, green, blue) channels. A colour depth of 36 bits gives billions of colours.

5,000 The white balance standard for pre-press work. Corresponds to warm, white light.

6,500 The white balance standard corresponding to normal daylight. It appears to be a warm white compared with 9,300.

9,300 The white balance standard close to normal daylight. It is used mainly for visual displays.

A

aberration In optics, a defect in the image caused by a failure of a lens system to form a perfect image.

aberration, chromatic An image defect that shows up as coloured fringes when a subject is illuminated by white light, caused by the dispersion of white light as it passes through the glass lens elements.

absolute colourimetric A method of matching colour gamuts that tries to preserve colour values as close to the originals as possible.

absolute temperature A measure of thermodynamic state, used to correlate to the colour of light. Measured in Kelvins.

absorption Partial loss of light during reflection or transmission. Selective absorption of light causes the phenomenon of colour.

accelerator A device that speeds up a computer by, for example, providing specialist processors optimized for certain software operations.

accommodation An adjustment in vision to keep objects at different distances sharply in focus.

achromatic colour Colour that is distinguished by differences in lightness but is devoid of hue, such as black, white, or greys.

ADC Analogue-to-Digital Conversion. A process of converting or representing a continuously varying signal into a set of digital values or code.

additive A substance added to another, usually to improve its reactivity or its keeping qualities, especially in lengthening the life span of a print.

additive colour synthesis Combining or blending two or more coloured lights in order to simulate or give the sensation of another colour.

address Reference or data that locates or identifies the physical or virtual position of a physical or virtual item: for example, memory in RAM; the sector of hard disk on which data is stored; a dot from an ink-jet printer.

addressable The property of a point in space that allows it to be identified and referenced by some device, such as an ink-jet printer.

algorithm A set of rules that defines the repeated application of logical or mathematical operations on an object: for example, compressing a file or applying image filters.

alias A representation or "stand-in" for the continuous original signal: it is the product of sampling and measuring the signal to convert it into a digital form.

alpha channel A normally unused portion of a file format. It is designed so that changing the value of the alpha channel changes the properties – transparency, for example – of the rest of the file.

analogue An effect, representation, or record that is proportionate to some other physical property or change.

anti-aliasing Smoothing away the stair-stepping, or jagged edge, in an image or in computer typesetting.

aperture The size of the hole in the lens that is letting light through. *See* f/numbers.

apps A commonly used abbreviation for application software.

array An arrangement of image sensors. There are two types. **1** A two-dimensional grid, or wide array, in which rows of sensors are laid side by side to cover an area. **2** A one-dimensional or linear array, in which a single row of sensors, or set of three rows, is set up, usually to sweep over or scan a flat surface – as in a flatbed scanner. The number of sensors defines the total number of pixels available.

aspect ratio The ratio between width and height (or depth).

attachment A file, such as a PDF or JPEG, that is sent along with an email.

B

back-up To make and store second or further copies of computer files to protect against loss, corruption, or damage of the originals.

bandwidth **1** A range of frequencies transmitted, used, or passed by a device, such as a radio, TV channel, satellite, or loudspeaker. **2** The measure of the range of wavelengths transmitted by a filter.

beam splitter An optical component used to divide rays of light.

bicubic interpolation A type of interpolation in which the value of a new pixel is calculated from the values of its eight near neighbours. It gives superior results to bilinear or nearest-neighbour interpolation, with more contrast to offset the blurring induced by interpolation.

bilinear interpolation A type of interpolation in which the value of a new pixel is calculated from the values of four of its near neighbours: left, right, top, and bottom. It gives results that are less satisfactory than bicubic interpolation, but requires less processing.

bit The fundamental unit of computer information. It has only two possible values – 1 or 0 – representing, for example, on or off, up or down.

bit-depth Measure of the amount of information that can be registered by a computer component: hence, it is used as a measure of resolution of such variables as colour and density. 1-bit registers two states (1 or 0), representing, for example, white or black; 8-bit can register 256 states.

bit-mapped **1** An image defined by the values given to individual picture elements of an array whose extent is equal to that of the image; the image is the map of the bit-values of the individual elements. **2** An image comprising picture elements whose values are only either 1 or 0: the bit-depth of the image is 1.

black **1** Describing a colour whose appearance is due to the absorption of most or all of the light. **2** Denoting the maximum density of a photograph.

bleed **1** A photograph or line that runs off the page when printed. **2** The spread of ink into the fibres of the support material. This effect causes dot gain.

BMP Bitmap. A file format that is native to the Windows platform.

bokeh The subjective quality of an out-of-focus image projected by an optical system – usually a photographic lens.

bracketing To take several photos of the same image at slightly different exposure settings, to ensure at least one picture is correctly exposed.

brightness **1** A quality of visual perception that varies with the amount, or intensity, of light that a given element appears to send out, or transmit. **2** The brilliance of a colour, related to hue or colour saturation – for example, bright pink as opposed to pale pink.

brightness range The difference between the lightness of the brightest part of a subject and the lightness of the darkest part.

browse To look through a collection of, for example, images or web pages in no particular order or with no strictly defined search routine.

Brush An image-editing tool used to apply effects, such as colour, blurring, burn, or dodge, that are limited to the areas the brush is applied to, in imitation of a real brush.

buffer A memory component in an output device, such as printer, CD writer, or digital camera, that stores data temporarily, which it then feeds to the device at a rate the data can be turned into, for example, a printed page.

GLOSSARY CONTINUED

D

D65 The white illuminant standard used to calibrate monitor screens. It is used primarily for domestic television sets. White is correlated to a colour temperature of 6,500 K.

daylight 1 The light that comes directly or indirectly from the sun. **2** As a notional standard, the average mixture of sunlight and skylight with some clouds, typical of temperate latitudes at around midday, and with a colour temperature of between 5,400 and 5,900 K. **3** Film whose colour balance is correct for light sources with a colour temperature between 5,400 and 5,600 K. **4** Artificial light sources, such as light bulbs, whose colour-rendering index approximates to that of daylight.

definition The subjective assessment of clarity and the quality of detail that is visible in an image or photograph.

delete 1 To render an electronic file invisible and capable of being overwritten. **2** To remove an item, such as a letter, selected block of words or cells, or a selected part of a graphic or an image.

density 1 The measure of darkness, blackening, or "strength" of an image in terms of its ability to stop light – in other words, its opacity. **2** The number of dots per unit area produced by a printing process.

depth 1 The sharpness of an image – loosely synonymous with depth of field. **2** A subjective assessment of the richness of the black areas of a print or transparency.

depth of field The measure of the zone or distance over which any object in front of a lens will appear acceptably sharp. It lies both in front of and behind the plane of best focus, and is affected by three factors: lens aperture; lens focal length; and image magnification.

depth perception The perception of the absolute or relative distance of an object from a viewer.

digital image The image on a computer screen or any other visible medium, such as a print, that has been produced by transforming an image of a subject into a digital record, followed by the reconstruction of that image.

digitization The process of translating values for the brightness or colour into electrical pulses representing an alphabetic or a numerical code.

direct-vision finder (or **viewfinder**) A type of viewfinder in which the subject is observed directly – for example, through a hole or another type of optical device.

display A device – such as a monitor screen, LCD projector, or an information panel on a camera – that provides a temporary visual representation of data.

distortion, tonal A property of an image in which the contrast, range of brightness, or colours appear to be markedly different from those of the subject.

dithering Simulating many colours or shades by using a smaller number of colours or shades.

d-max 1 The measure of the greatest, or maximum, density of silver or dye image attained by a film or print in a given sample. **2** The point at the top of a characteristic curve of negative film, or the bottom of the curve of positive film.

dodging 1 A digital image-manipulation technique based on the darkroom technique of the same name. **2** A darkroom technique for controlling local contrast when printing a photograph by selectively reducing the amount of light reaching the parts of a print that would otherwise print as too dark.

down-sampling The reduction in file size achieved when a bitmapped image is reduced in size.

dpi Dots per inch. The measure of resolution of an output device as the number of dots or points that can be addressed or printed by that device.

driver The software used by a computer to control, or drive, a peripheral device, such as a scanner, printer, or removable media drive.

drop-on-demand A type of inkjet printer in which the ink leaves the reservoir only when required. Most inkjet printers in use today are of this type.

drop shadow A graphic effect in which an object appears to float above a surface, leaving a fuzzy shadow below it and offset to one side.

drum scanner A type of scanner employing a

tightly focused spot of light that shines on a subject that has been stretched over a rotating drum. As the drum rotates, the spot of light traverses the length of the subject, thus scanning its entire area.

duotone **1** A photomechanical printing process in which two inks are used to increase the tonal range. **2** A mode of working in image-manipulation software that simulates the printing of an image with two inks.

DVD-RAM A DVD (Digital Versatile Disk) variant that carries 4.7 GB or more per side that can be written to and read from many times.

dye sublimation Printer technology based on the rapid heating of dry colourants that are held in close contact with a receiving layer. This turns the colourants to gas, which then solidifies on the receiving layer.

dynamic range **1** The measure of spread of the lowest to the highest energy levels in a scene. **2** The range that can be captured by a device, such as a camera or scanner.

E

effects filters **1** Lens attachments designed to distort, colour, or modify images to produce exaggerated, unusual, or special effects. **2** Digital filters that have effects similar to their lens-attachment counterparts, but also giving effects impossible to achieve with these analogue filters.

electronic viewfinder (EVF) An LCD or LCOS screen, viewed under the eyepiece and showing the view through a camera lens.

engine **1** The internal mechanisms that drive devices such as printers and scanners. **2** The core parts of a software application.

enhancement **1** Change in one or more qualities of an image, such as colour saturation or sharpness, in order to improve its appearance or alter some other visual property. **2** The effect produced by a device or software designed to increase the apparent resolution of a TV monitor screen.

EPS Encapsulated PostScript. A file format that stores an image (graphics, photograph, or page layout) in PostScript page-description language.

erase To remove, or wipe, a recording from a disk, tape, or other recording media (usually magnetic) so that it is impossible to reconstruct the original record.

EV Exposure value. A measure of camera exposure. For any given EV, there is a combination of shutter and aperture settings that gives the same camera exposure.

exposure **1** A process whereby light reaches a light-sensitive material or sensor to create a latent image. **2** The amount of light energy that reaches a light-sensitive material.

exposure factor The number indicating the degree by which measured exposure should be corrected or changed in order to give an accurate exposure.

F

f/numbers Settings of the camera diaphragm that determine the amount of light transmitted by a lens. Each f/number is equal to the focal length of the lens divided by diameter of the entrance pupil.

fade The gradual loss of density in silver, pigment, or dye images over time.

fall-off **1** The loss of light in the corners of an image as projected by a lens system in, for example, a camera or a projector. **2** The loss of light towards the edges of a scene that is illuminated by a light source whose angle of illumination is too small to cover the required view. **3** The loss of image sharpness and density away from the middle of a flatbed scanner whose array of sensors is narrower than the width of the scanned area.

feathering The blurring of a border or boundary by reducing the sharpness or suddenness of the change in value of, for example, colour.

file format A method or structure of computer data. It is determined by codes – for example, by indicating the start and end of a portion of data together with any special techniques used, such as compression. File formats may be generic – shared by different software – or native to a specific software application.

fill-in **1** To illuminate shadows cast by the main light by using another light source or reflector to bounce light from the main source into the

WEB RESOURCES CONTINUED

www.imatest.com

Imatest is used to test all major aspects of lens performance in digital cameras – widely used in the industry. It is worth using the evaluation runs on your digital camera. Windows only.

http://photoshopnews.com

A heavyweight site with high-quality material on many issues relating to the Photoshop user, covering not only the software but technical, market, and legal issues, as well as news and web links.

www.photoshopsupport.com

This valuable beginner's resource offers numerous tutorials and free resources such as brushes, fonts, actions, and so on. Also, links to plug-ins, video training, and extracts from Photoshop books. Supports other software, such as Lightroom and Dreamweaver, too.

www.photo-software.com

Douglas Software offers tools for calculating camera and lens details, as well as sun and moon positions.

www.pluginsworld.com

Comprehensive and constantly up-dated listings of plug-ins for Photoshop and other software.

www.versiontracker.com

The best site for keeping your software up-to-date and for trying out new software, with useful user reviews. Essential to bookmark.

PICTURE HOSTING AND SHARING

The internet allows anyone to place hundreds of their images onto photo-sharing websites for friends, family, and prospective clients. These sites operate as online, off-site storage for images, so your images are backed up in secure storage and can be accessed at any time from anywhere in the world.

www.digitalrailroad.net

Picture-hosting stock-photography site with a very wide range of work, including that of top agencies.

www.flickr.com

One of the most popular picture-sharing sites, offering good image management and low prices.

www.fotki.com

One of the largest social networking sites hosting images and videos for sharing.

www.photobucket.com

Offers a hybrid of community and picture-hosting features, catering for popular and social imagery.

http://pa.photoshelter.com

Picture-hosting photography site with a range of contemporary work. Strong North American bias.

http://picasa.google.com

Picasa's software integrates well with Google accounts and offers low-cost picture storage.

www.shutterfly.com

Unlimited uploads and many offers to make prints, books, and so on.

www.smugmug.com

Picture sharing of professional-quality images.

www.webshots.com

Low-cost picture storage on an easy-to-use site.

ONLINE PHOTO EDITING

These and similar sites allow you to enjoy image manipulation without buying your own software.

www.picnik.com

www.photoshop.com/express

www.fotoflexer.com

www.phixr.com

MANUFACTURERS

Many of the multinational manufacturers host different websites for each of their sales regions. It may be worth visiting those outside your region, since the quality and information can vary between sites: some, for example, simply present pages of their product catalogues, while others offer practical tips and technical resources, as well as product information. The following is a selection of photographic manufacturers, but inclusion does not imply recommendation.

Apple Computers, displays, software
　　www.apple.com
Canon Cameras, lenses and accessory systems, printers, scanners, data projectors
　　www.canon.com
Eizo LCD monitors
　　www.eizo.com
Epson Printers, scanners, picture storage
　　www.epson.com
Fujifilm Cameras and accessories
　　www.fujifilm.com
Hasselblad Medium-format cameras, lenses, accessory systems, scanners, software
　　www.hasselblad.com
Hewlett-Packard Printers, scanners, computers
　　www.hp.com
Jobo Picture storage, digital display, darkroom and other accessories
　　www.jobo.com
Kodak Cameras, film, papers, printers
　　www.kodak.com
LaCie Hard-disk drives and media, displays
　　www.lacie.com
Leica Cameras, lenses, accessory systems
　　www.leica.com
Lexar Memory cards and readers for digital cameras
　　www.lexar.com
Lexmark Printers
　　www.lexmark.com
Microtek Scanners
　　www.microtek.com
Nikon Cameras, lenses, accessory systems, film scanners
　　www.nikon.com

Olympus Cameras, lenses, printers, removable storage
　　www.olympus.com
Panasonic Cameras, lenses, data projectors
　　www.panasonic.com
Pantone Colour control, colour-matching systems
　　www.pantone.com
Pentax Cameras and lenses, medium-format cameras and lenses
　　www.pentax.com
Phase One Digital backs and medium-format camera systems and software
　　www.phaseone.com
RH Designs Enlarger timers, densitometers, and other darkroom aids
　　www.rhdesigns.co.uk
Ricoh Digital cameras
　　www.ricoh.com
Rollei Medium-format, specialist, and consumer digital cameras; medium-format film cameras; lenses
　　www.rollei.com
Samsung Cameras and SLR lenses, projectors
　　www.samsungcamera.com
Sandisk Memory cards, readers
　　www.sandisk.com
Sekonic Exposure meters
　　www.sekonic.com
Sony Digital cameras, SLR systems and accessories, data projectors, computers
　　www.sony.com
Studioflash Generic studio flash accessories: reflectors, soft-boxes, stands
　　www.studioflash.co.uk
Tamron Interchangeable lenses for SLR cameras
　　www.tamron.com
Tokina Interchangeable lenses for SLR cameras
　　www.tokinalens.com
X-Rite
Colour-management solutions: software, hardware, and support
　　www.xrite.com

ACKNOWLEDGMENTS

From the author

Five editions and ten years after the first publication of this book, it is clear that I owe the biggest thanks to the readers of my books, particularly those who keep coming back demanding more. The enthusiasm of the very many photographers who have written to me asking for advice, suggesting book ideas and criticising content has encouraged and shaped all my recent books, including this edition of the Handbook. To you, I extend warm thanks: do keep writing to me at info@tomang.com with suggestions and comments.

This is the latest in a line of books created with the editorial and art team at Dorling Kindersley, ably and purposefully led by Senior Editor Nicky Munro. Thank you, Nicky and the team, particularly Jo Clark. Finally, and certainly not least, I thank my wife, partner, mentor and manager Wendy, for creating ideal environments for me.

Tom Ang
Auckland, 2012

From the publisher

Many thanks also to David Summers and Hugo Wilkinson for editorial assistance, Simon Murrell for design assistance, and Margaret McCormack for compiling the index.